CANADA

A VISUAL JOURNEY

CANADA

A VISUAL JOURNEY

WHITECAP BOOKS
TORONTO/VANCOUVER

The information in this book is true and complete to the best of our knowledge.
All recommendations are made without guarantee on the part of the author or
Whitecap Books Ltd. The author and publisher disclaim any liability in connection
with the use of this information. For additional information please contact
Whitecap Books Ltd., 351 Lynn Avenue, North Vancouver, BC V7J 2C4.

Text by Tanya Lloyd
Edited by Elaine Jones
Proofread by Elizabeth McLean
Cover design by Susan Greenshields
Interior design by Margaret Lee

Printed and bound in Canada.

Canadian Cataloguing in Publication Data

Lloyd, Tanya, 1973–
 Canada

 ISBN 1-55285-085-4

 1. Canada—Pictorial works. I. Title.
FC59.L563 2000 971.064'8'0222 C00-910079-2
F1017.L563 2000

The publisher acknowledges the support of the Canada Council and the Cultural
Services Branch of the Government of British Columbia in making this publication
possible. We acknowledge the financial support of the Government of Canada through
the Book Publishing Industry Development Program for our publishing activities.

For more information on other Whitecap Books titles,
please visit our web site at www.whitecap.ca

CONTENTS

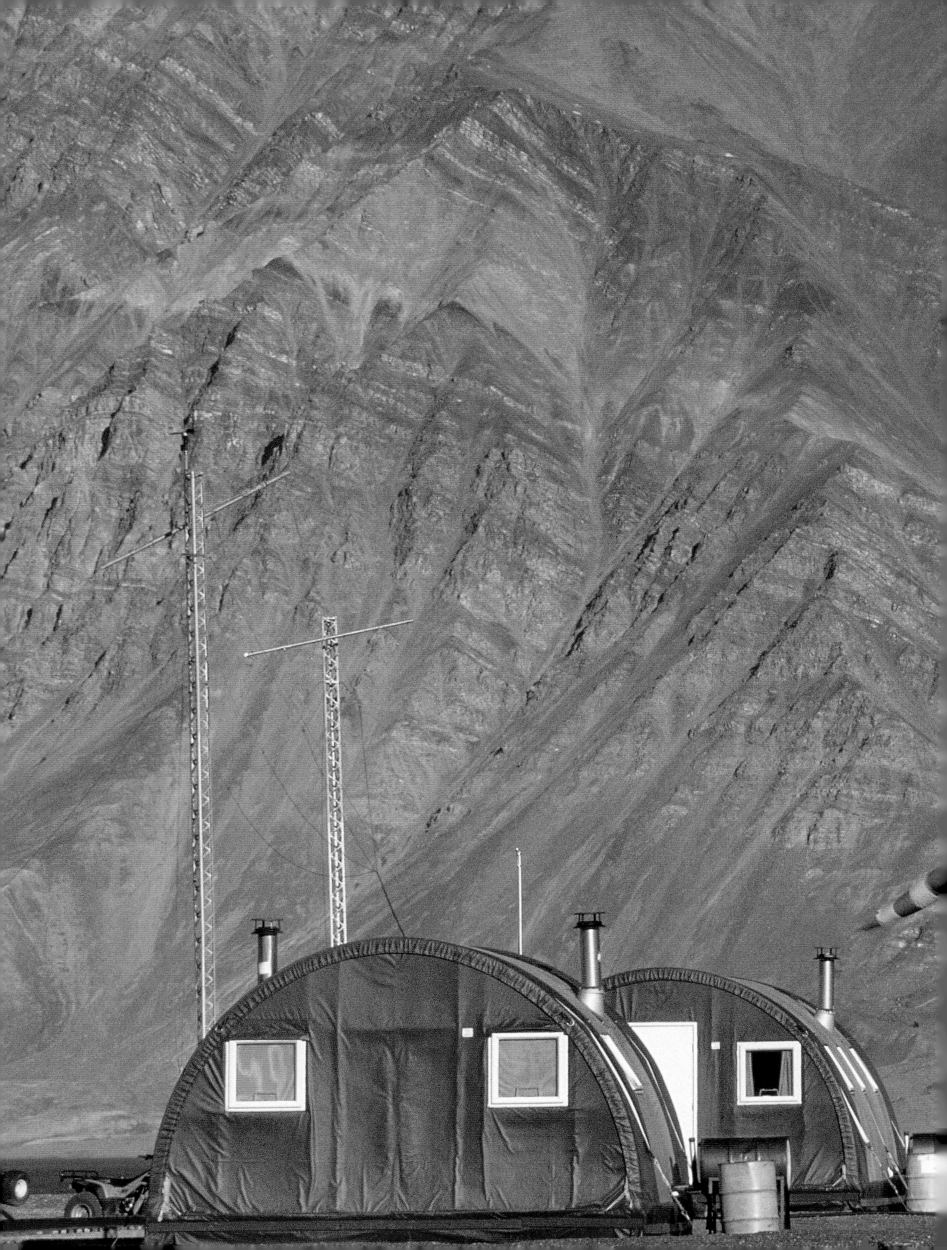

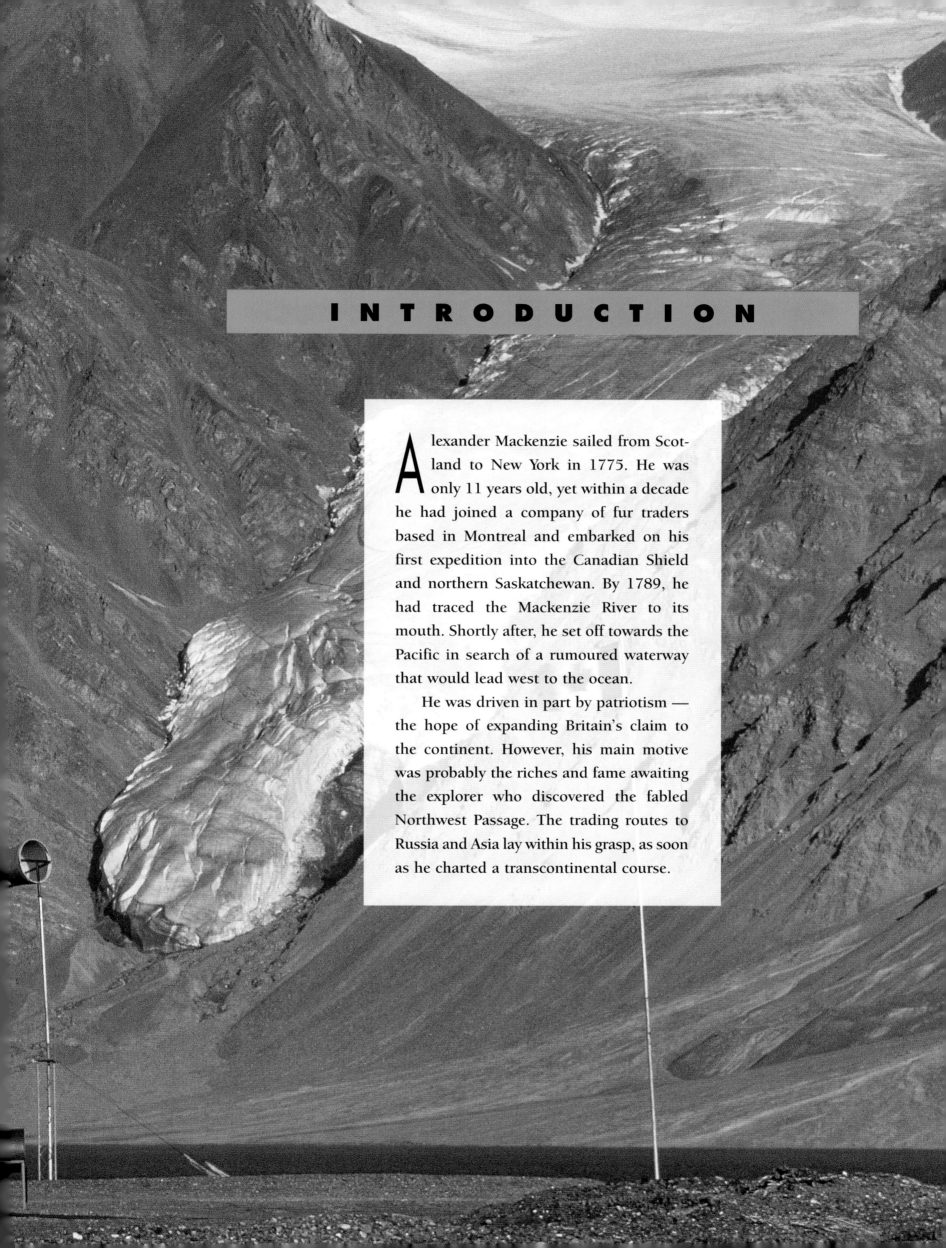

INTRODUCTION

Alexander Mackenzie sailed from Scotland to New York in 1775. He was only 11 years old, yet within a decade he had joined a company of fur traders based in Montreal and embarked on his first expedition into the Canadian Shield and northern Saskatchewan. By 1789, he had traced the Mackenzie River to its mouth. Shortly after, he set off towards the Pacific in search of a rumoured waterway that would lead west to the ocean.

He was driven in part by patriotism — the hope of expanding Britain's claim to the continent. However, his main motive was probably the riches and fame awaiting the explorer who discovered the fabled Northwest Passage. The trading routes to Russia and Asia lay within his grasp, as soon as he charted a transcontinental course.

We know now there was no such passage. The route Alexander Mackenzie carved was not the easy course that had been predicted. Despite these challenges, at age 31 he became the first European to travel through the Rockies to the Pacific.

He was not the only traveller to follow the rivers, creeks, and game trails of the north. Long before his arrival, this area was linked by hundreds of First Peoples hunting and trading routes. In fact, without the knowledge of the Native guides he consulted at each stage, Mackenzie had no hope of completing his travels. Still, his name painted on the rock by the rugged shores of the northern British Columbia coast is a testament to his sense of adventure and his strength of will. Because of his perseverance, a new corner of the continent was etched onto the maps of the world.

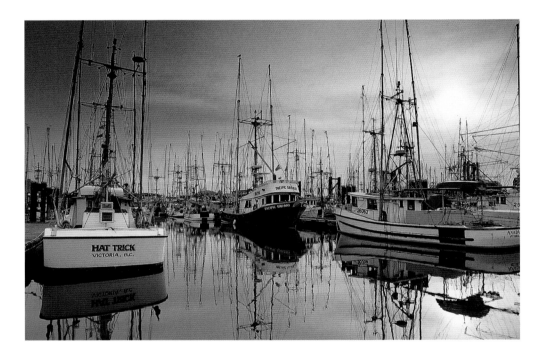

Recreational opportunities surround Victoria, B.C., from the sailboats and kayaks waiting at the city's marinas to the provincial parks of the Saanich Peninsula. Cycling routes such as the Galloping Goose Trail wind through the region and the sprawling gardens and lawns of Beacon Hill Park are just moments from downtown.

Explorers and entrepreneurs coursed after Mackenzie, opening trade along his route and forging new routes through the west. Simon Fraser followed the mighty Fraser River and David Thompson challenged the Columbia. And while these journeys were taking place, dreamers and visionaries in the east were forging new colonies from scattered settlements, and a new nation from disparate colonies.

In 1867, Ontario, Quebec, Nova Scotia, and New Brunswick united to become the Dominion of Canada. The province of Manitoba was created three years later. B.C. joined Confederation in 1871 and four years later the Canadian Pacific Railway hewed a path through the Rockies and linked the Atlantic and Pacific coasts for the first time. Prince Edward Island became part of Canada in 1873, Alberta and Saskatchewan in 1905, and finally Newfoundland in 1949.

Today, highways and railway tracks criss-cross the country. Logging roads and hiking routes intersect throughout the dense wilderness that challenged Mackenzie's party. Grocery stores on Baffin Island sell colas and potato chips, and the Internet reaches even the most remote points of the nation. The Rocky Mountains are no longer a continental barrier; the rivers are well charted and many are harnessed for hydroelectric power.

Yet none of this diminishes the sheer size of Canada. The nation spreads across almost 10 million square kilometres (4 million square miles). It is bounded by three oceans: the Atlantic to the east, the Arctic to

the north, and the Pacific to the west. To the south, the longest unguarded border in the world — 6379 kilometres (3964 miles)— runs between Canada and the United States. And harnessed or not, the country's rivers burst with more fresh water than in any other nation in the world.

In this enormous area, there remain many places where no one has ever stood. In fact, if the population of Canada were spread evenly over the land, there would be only two people per square kilometre (about one person per square mile). In the watersheds of northern British Columbia, the tundra of the Yukon, and the alpine slopes of the Rockies, there are pristine places untouched by development. Here, it's possible to recapture the mystery that Canada must have held for the explorers of the 18th century.

In the time of Alexander Mackenzie, the world awaited news of the frontier. Memoirs penned by successful explorers became bestsellers, and newspapers eagerly reported each new discovery. Publishers and cartographers offered the public glimpses of a world they might never see first-hand.

We are still a world of armchair travellers today. Those of us on the west coast may never visit the seaside villages of Newfoundland, yet we can picture the multi-hued houses lining the cliffs. Those of us in Newfoundland can imagine the orcas breaching in the Strait of Juan de Fuca. A child in Alberta can envision the migration of the polar bears onto the pack ice in Churchill, and a child in Nunavut can imagine the rolling wheat fields of Saskatchewan.

Canada is home to some of the world's best-known landscape photographers, and it is these artists who chart the contemporary world for our curious eyes. They capture the passion of Caribana in Toronto, the thrill of the Calgary Stampede, and the elegance of Victoria's Butchart Gardens. They reveal the exact hue of the maples in Quebec's Laurentian Mountains, the pose of a mountain goat in Jasper National Park, and the hum of Winnipeg's markets. These images travel in magazines, in books, and over the World Wide Web into our homes. As we turn our eyes to each new place, we mark it on our own map of the world just as 18th-century cartographers marked Canada's newly discovered geography on theirs.

In *Canada: A Visual Journey*, there are places so often photographed they have become ingrained in our collective imagination. They have become part of what we see when we think about Canada. There are also places not yet imagined, places newly explored and mapped by photographers—places waiting for us to discover.

The Fortress of Louisbourg in Nova Scotia was built by the French, captured by the New Englanders, and crushed by the British. Its destruction in 1760 signalled the end of France's hold on the colony. The fortress has been rebuilt and designated a National Historic Site.

PREVIOUS PAGES: Many visitors to Quttinirpaaq National Park in Nunavut begin their trip at the Tanquary base camp at the head of Tanquary Fiord. Here, wardens offer information on the unique challenges and rewards of travel in the far north.

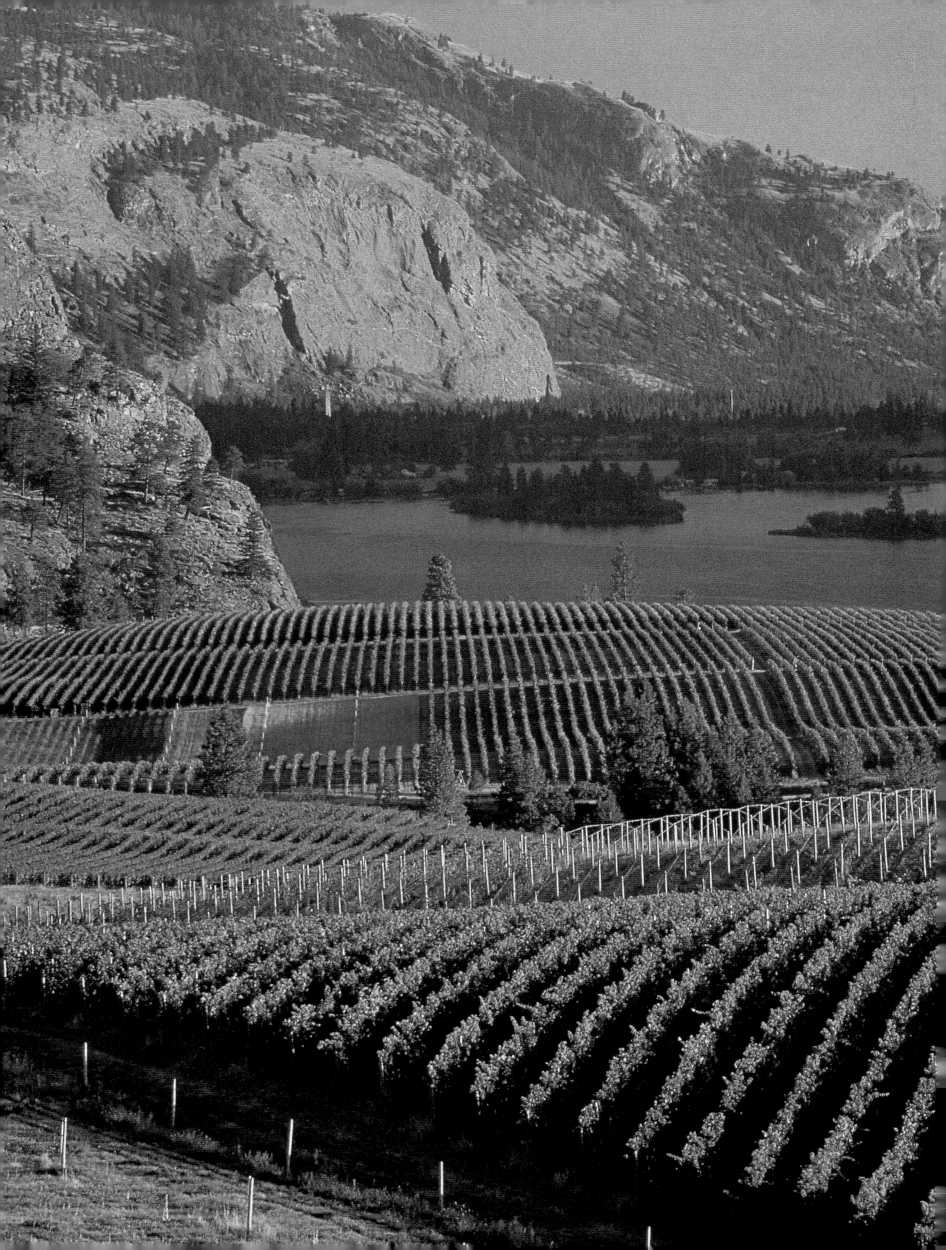

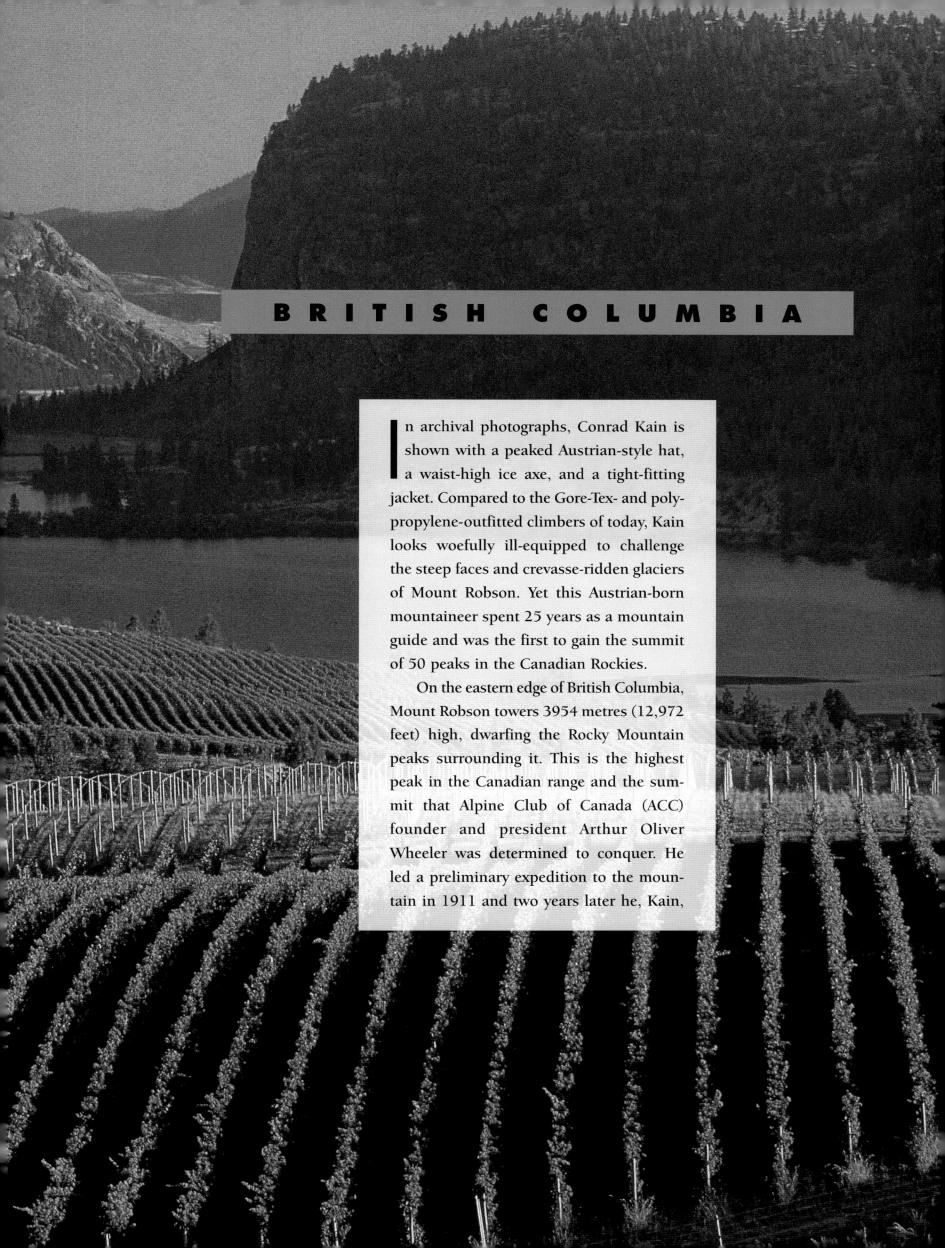

BRITISH COLUMBIA

In archival photographs, Conrad Kain is shown with a peaked Austrian-style hat, a waist-high ice axe, and a tight-fitting jacket. Compared to the Gore-Tex- and polypropylene-outfitted climbers of today, Kain looks woefully ill-equipped to challenge the steep faces and crevasse-ridden glaciers of Mount Robson. Yet this Austrian-born mountaineer spent 25 years as a mountain guide and was the first to gain the summit of 50 peaks in the Canadian Rockies.

On the eastern edge of British Columbia, Mount Robson towers 3954 metres (12,972 feet) high, dwarfing the Rocky Mountain peaks surrounding it. This is the highest peak in the Canadian range and the summit that Alpine Club of Canada (ACC) founder and president Arthur Oliver Wheeler was determined to conquer. He led a preliminary expedition to the mountain in 1911 and two years later he, Kain,

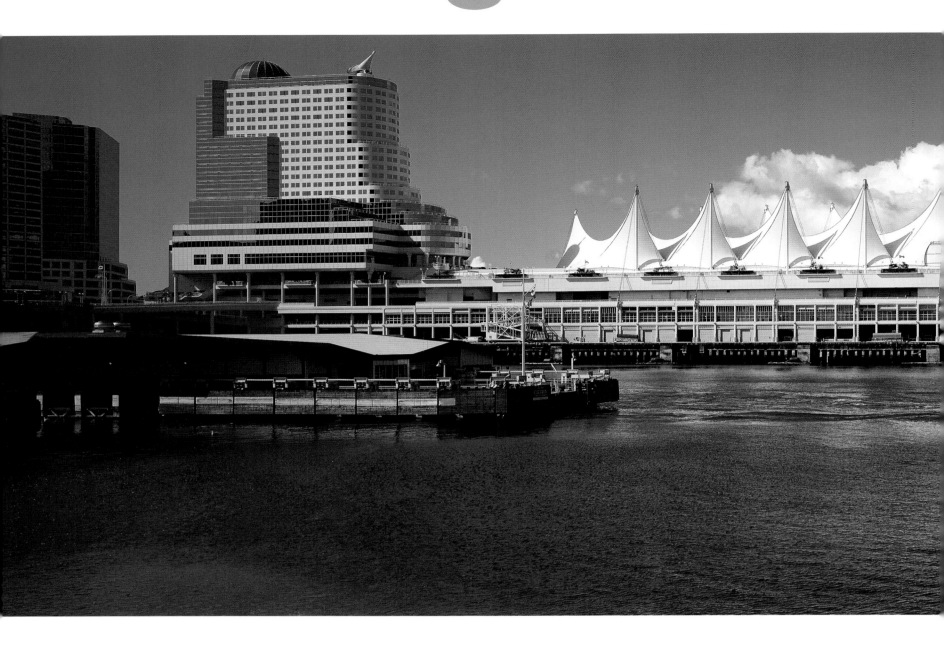

PREVIOUS PAGES: Sandy patches on the bottom of Kalamalka Lake in the Okanagan create patterns of blue and green, earning it the nickname "lake of a thousand colours."

and ACC member A.H. MacCarthy reached the peak. The same year as this remarkable achievement, the provincial government established Mount Robson Provincial Park, one of the first preserves in British Columbia. Encompassing 217,200 hectares (536,700 acres), the park includes both the mountain and the headwaters of the Fraser River.

Since the early 1900s, the government has set aside more than 670 parks, recreation areas, and ecological reserves, protecting more than 9.6 million hectares (24 million acres) of land. And though only a few people choose the rigorous climbs tackled by the ACC, the parks receive more than 25 million annual visits. Within these areas, there are 11,941 provincial campsites, 2387 kilometres (1500 miles) of hiking trails, and 122 boat launches. National parks, forestry recreation areas, and private facilities swell these numbers even further.

Almost half of British Columbia's population lives in Vancouver. Canada's third-largest city is a centre of Pacific Rim trade—10,000 vessels pass through the busy port each year, while more than 220 cruise

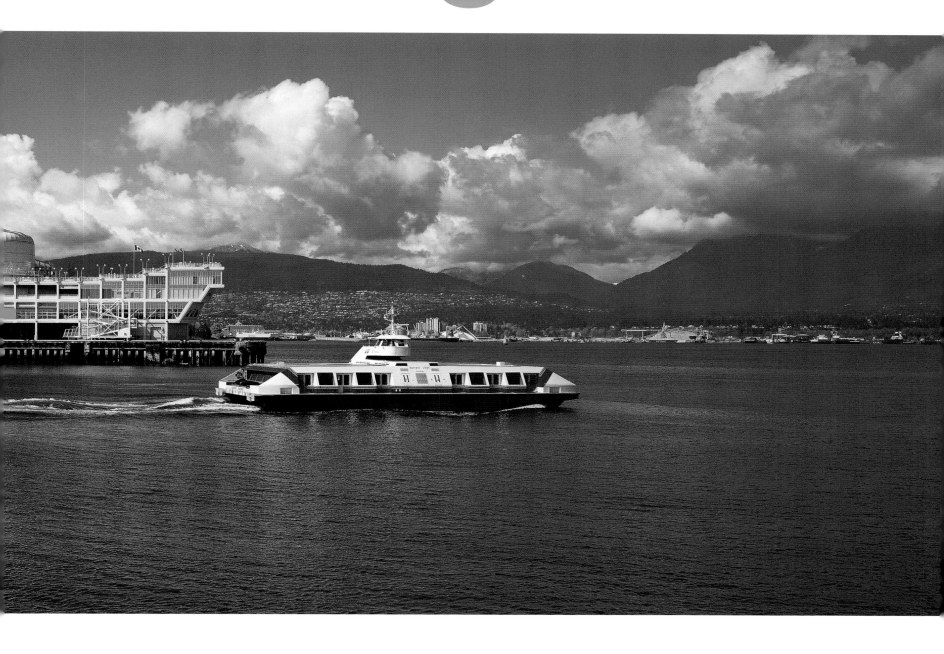

ships dock at Canada Place. Yet even from the centre of this metropolis, it is only a half-hour journey to the hiking trails or ski hills of the North Shore. Pleasure craft moored at Granville Island or Coal Harbour wait to whisk sailors and anglers onto the water, and golfers tee off above the banks of the Fraser River. The capital city of Victoria is similarly situated in a place where visitors can choose between an afternoon of shopping or whale-watching, a trip to the Royal British Columbia Museum or a trip to the temperate rainforest.

For decades, British Columbia's economy has been based on the harvesting and export of natural resources. Now ecotourism is steadily gaining ground. White-water rafting sweeps visitors down the Fraser Canyon and new trails allow access to pristine forests such as Clayoquot Sound. With the legends of risk-takers such as Conrad Kain, Arthur Oliver Wheeler, and A.H. MacCarthy to guide these travellers, it's no wonder B.C. residents cherish a spirit of adventure.

ABOVE: The five white sails of Vancouver's Canada Place, built for Expo 86, welcome visitors to the country's third-largest city. Nearby the SeaBus ferries passengers between downtown and the North Shore, moving amid the freighters and tugboats in the busy port.

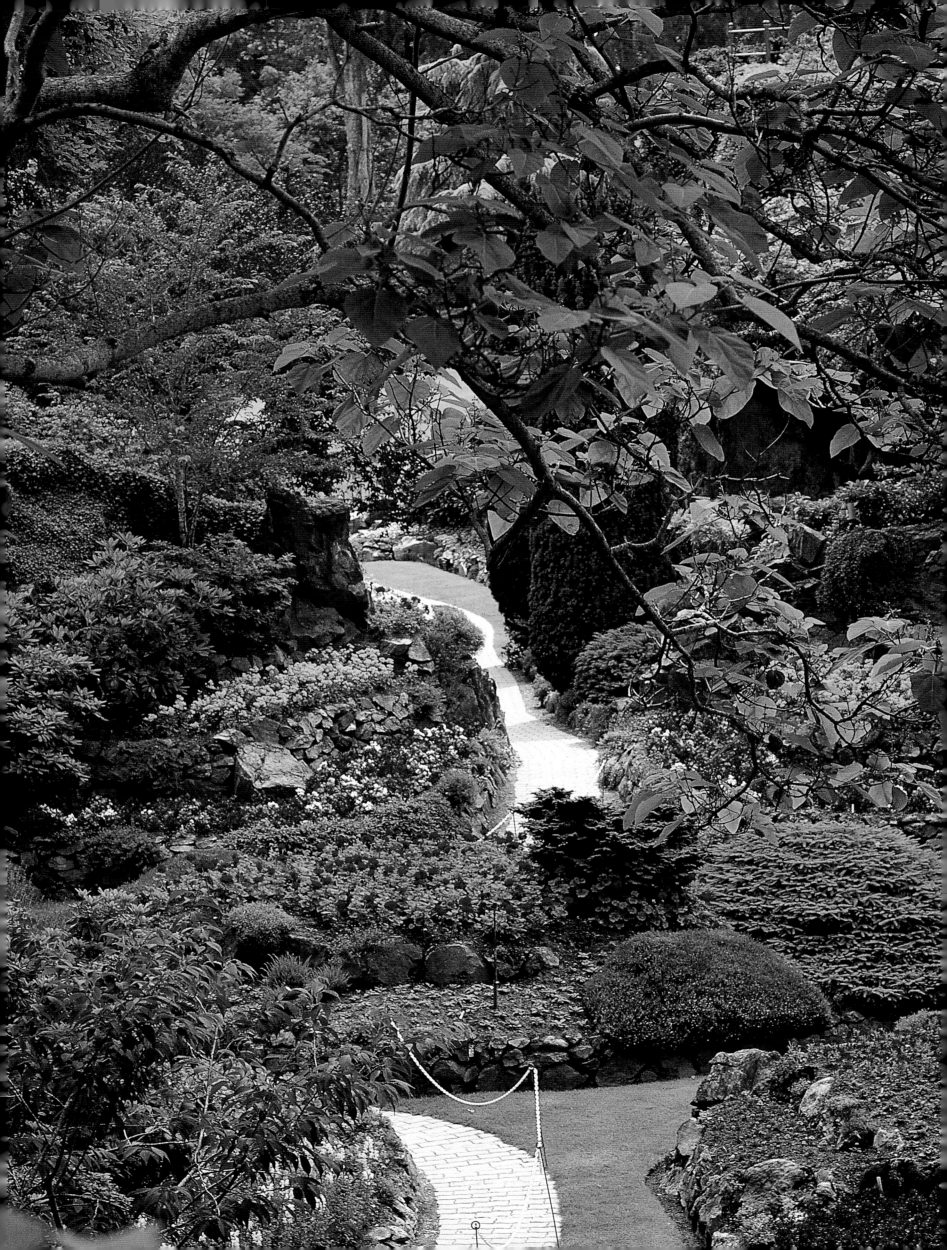

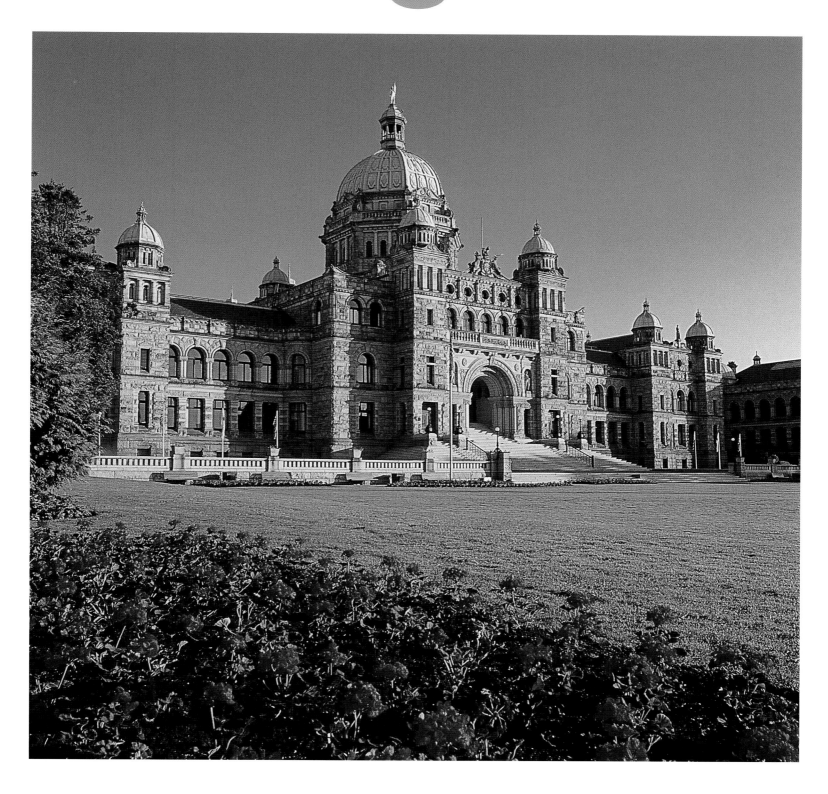

LEFT: The lush plantings of the Sunken Garden at Butchart Gardens cover a former limestone quarry, created by the Butchart family cement business. Jenny Butchart embarked on a plan to transform the land in 1904. By the 1920s, the gardens drew 50,000 visitors each year. Today they attract more than a million.

ABOVE: When James Douglas ordered the construction of a Hudson's Bay Company fort on the southern tip of Vancouver Island in 1843, he named it Fort Victoria for the queen who had come to the throne in Britain only six years before. The city's Legislative Buildings were officially opened in February 1898.

RIGHT: Pacific Rim National Park
protects three distinct areas: the
awesome expanse of Long
Beach, the offshore paradise of
the Broken Group Islands, and
the rugged 75-kilometre
(47-mile) West Coast Trail.

OVERLEAF: Weather-worn totems
and fallen house timbers mark
Ninstints, a once-thriving Haida
village in the Queen Charlotte
Islands that was decimated by
smallpox. Anthony Island
Provincial Park now protects the
poles and members of Haida
Gwaii Watchmen, park wardens
chosen by the Haida First Nation,
carefully maintain the site.

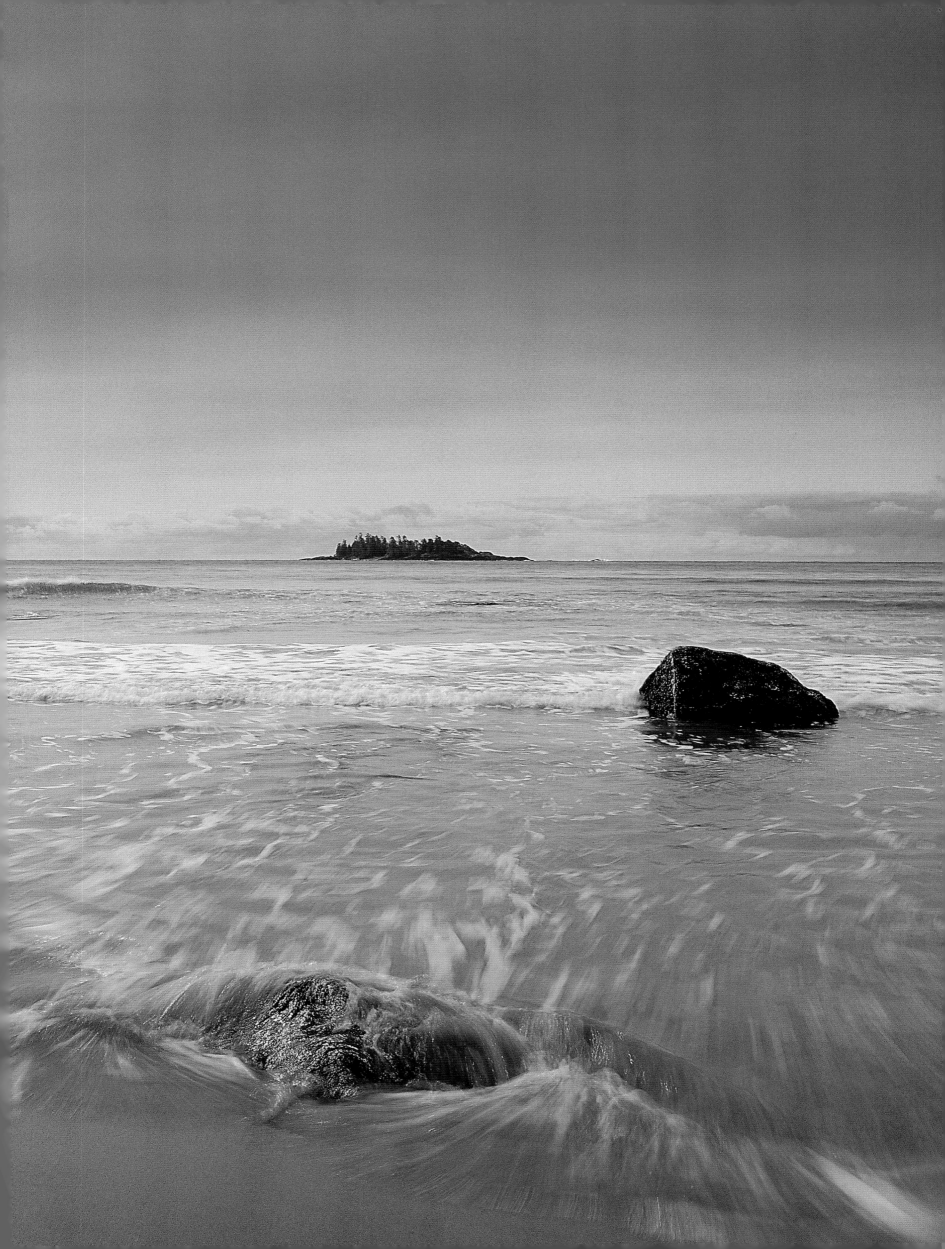

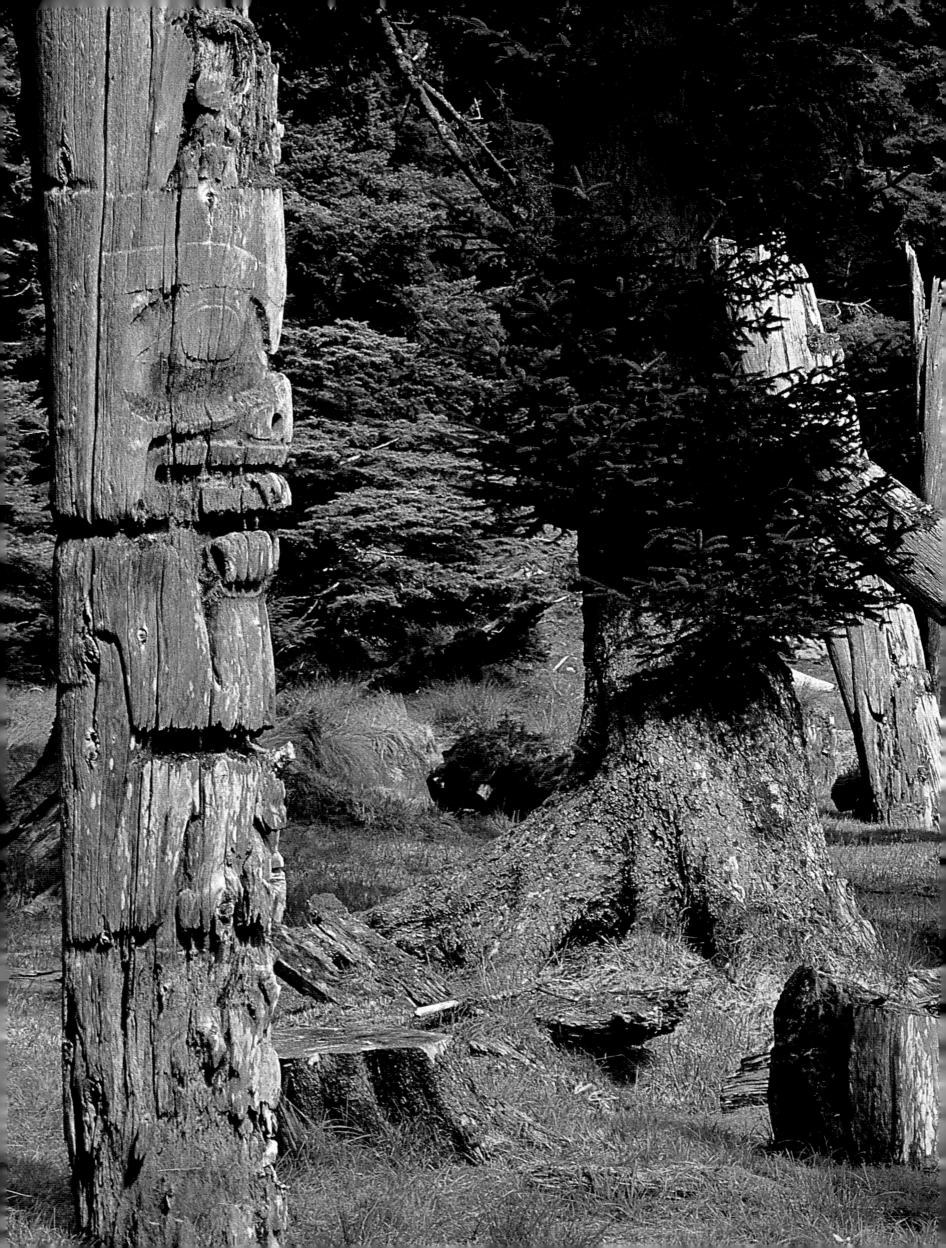

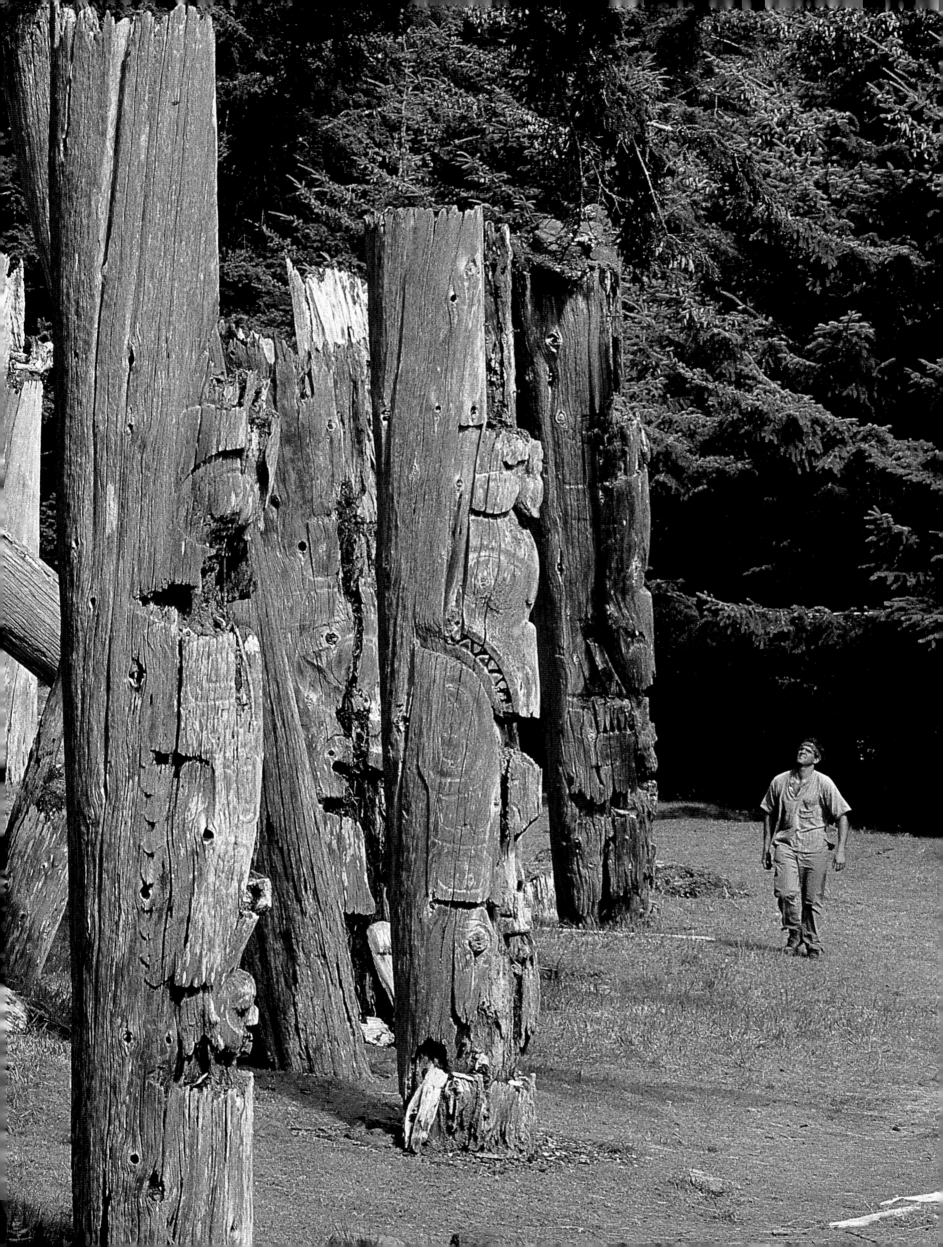

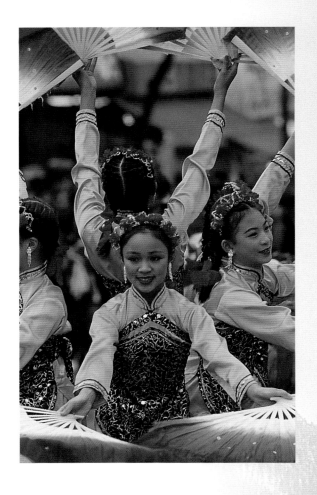

ABOVE: These brightly costumed dancers are part of the Chinese New Year celebrations, held in late January or early February. The boisterous parade, held in Chinatown as part of the festivities, draws thousands of spectators.

RIGHT: Vancouver has earned a number of nicknames, from Lotusland, in honour of the city's warm climate and relaxed atmosphere, to Hollywood North, a tribute to the booming local film industry.

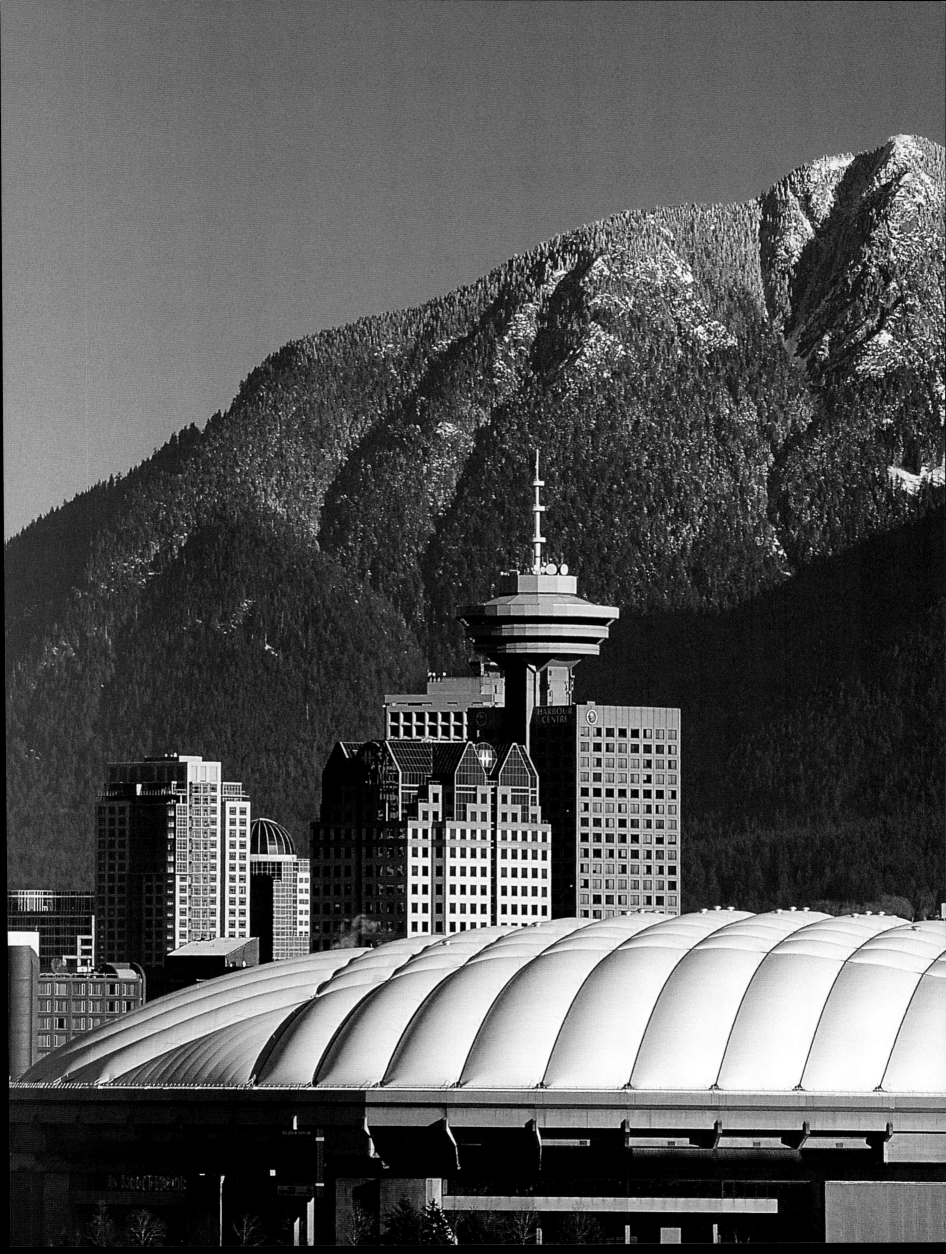

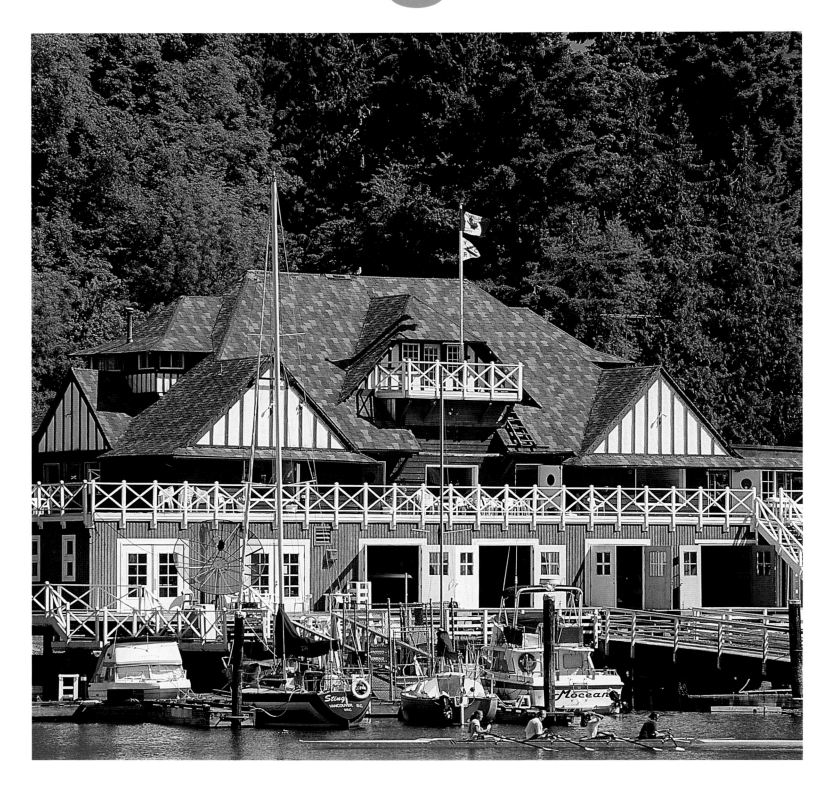

ABOVE: Vancouver's Stanley Park was dedicated to the public in 1889 by Governor General Lord Stanley. The 405-hectare (1000-acre) recreational haven is just minutes away from downtown.

RIGHT: About a three-hour drive north of Vancouver, Joffre Lakes Provincial Recreation Area holds three jewel-like glacier pools in basins below massive peaks and glaciers. A 30-kilometre (19-mile) hiking trail leads outdoor enthusiasts along the shores of all three lakes before reaching an alpine campground.

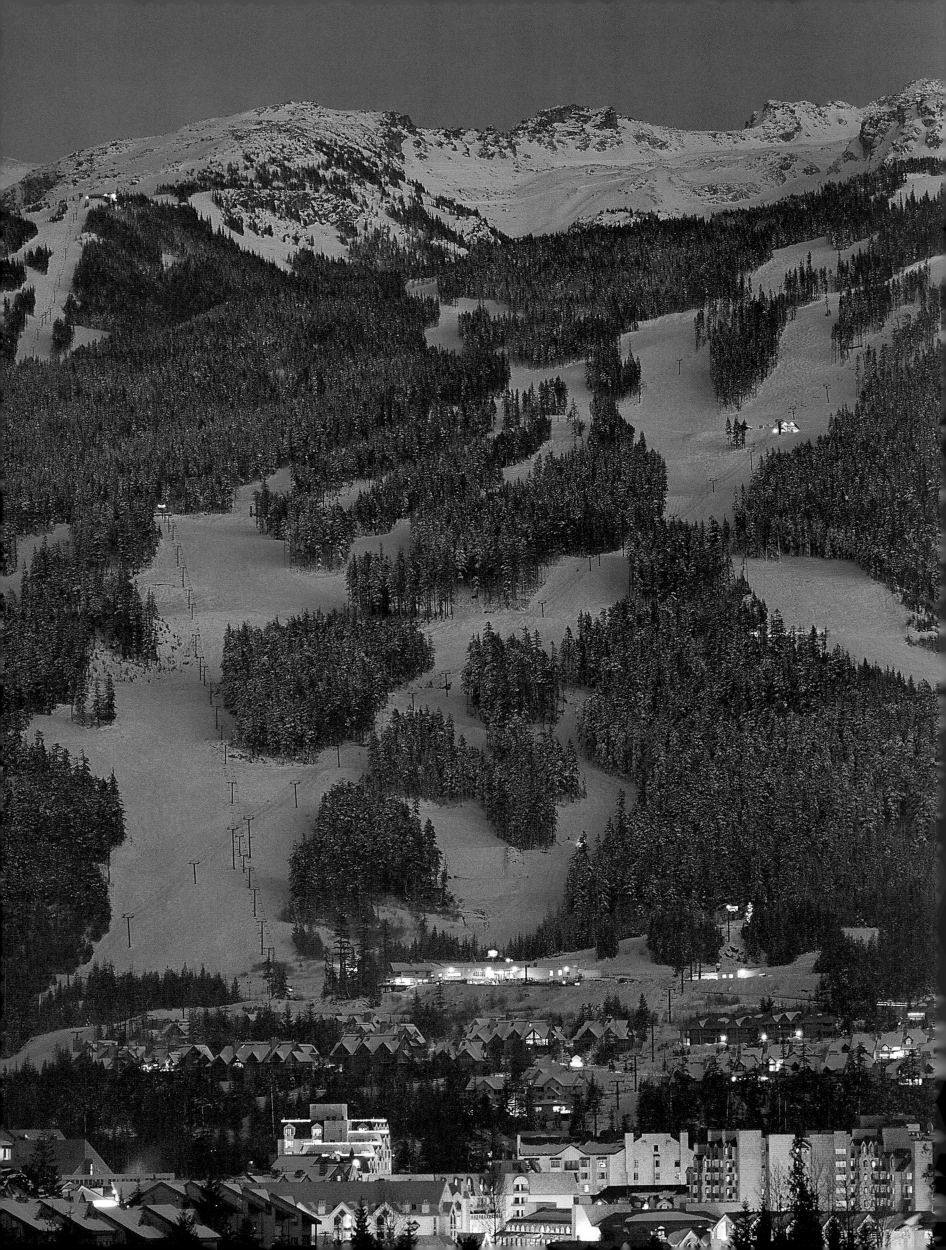

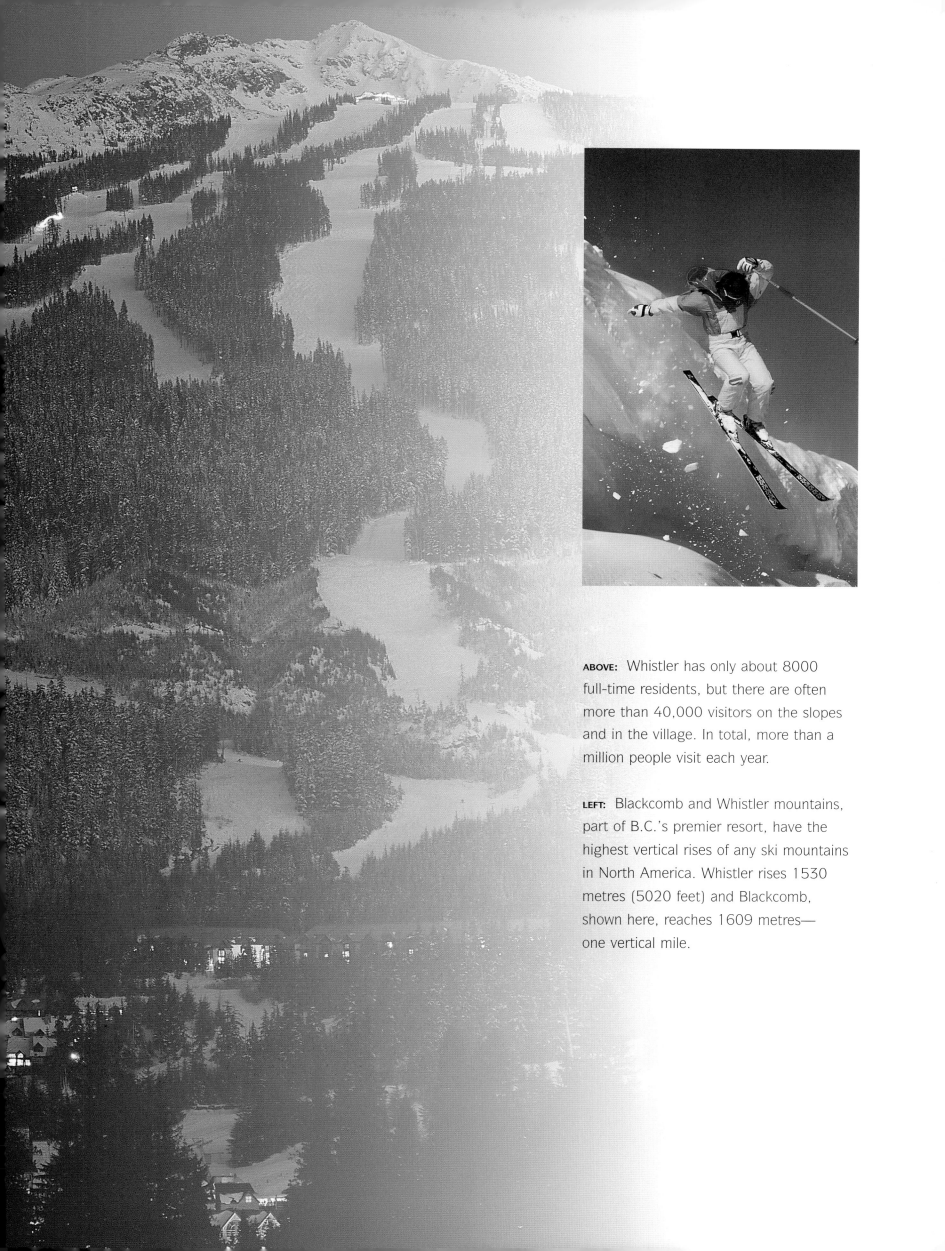

ABOVE: Whistler has only about 8000 full-time residents, but there are often more than 40,000 visitors on the slopes and in the village. In total, more than a million people visit each year.

LEFT: Blackcomb and Whistler mountains, part of B.C.'s premier resort, have the highest vertical rises of any ski mountains in North America. Whistler rises 1530 metres (5020 feet) and Blackcomb, shown here, reaches 1609 metres— one vertical mile.

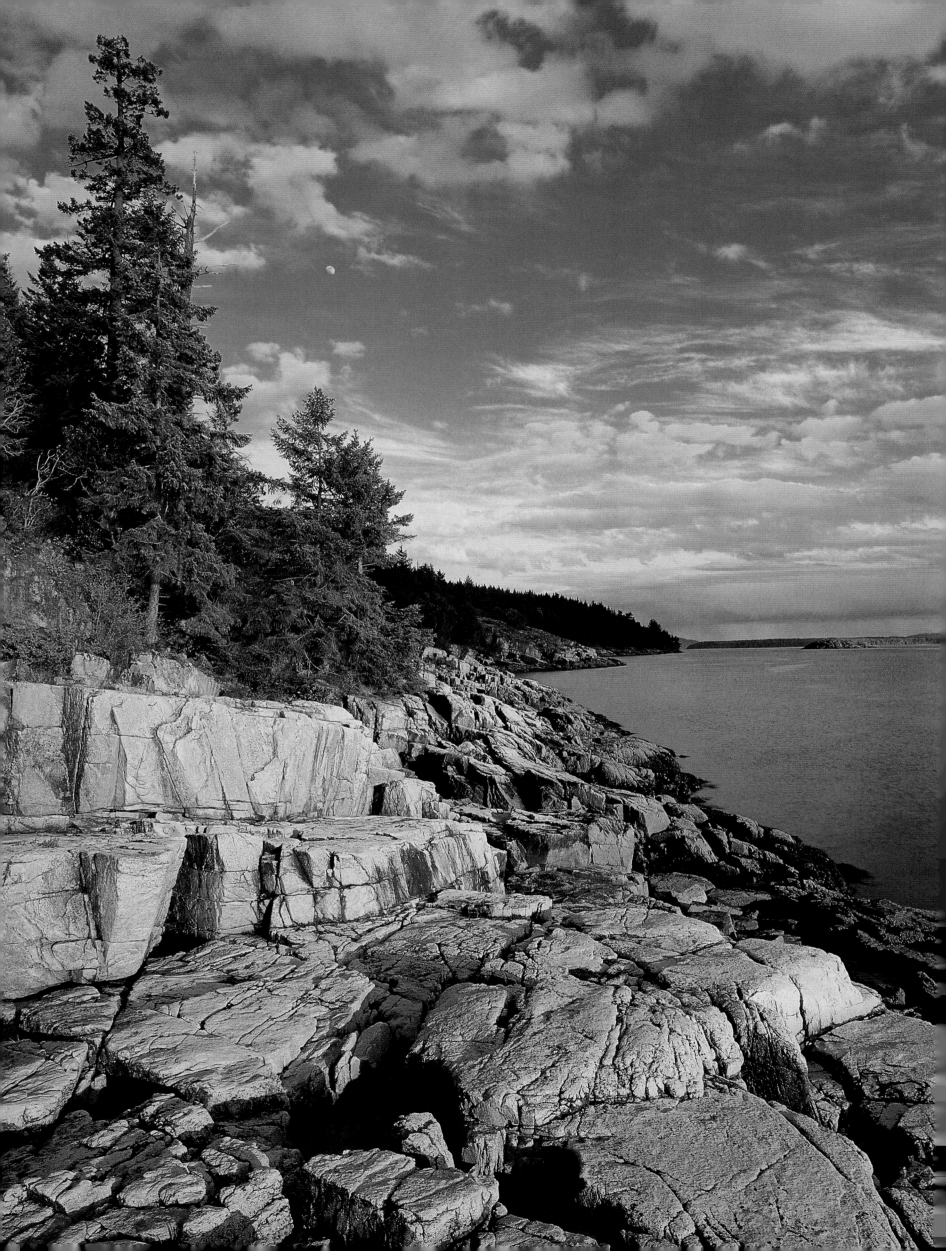

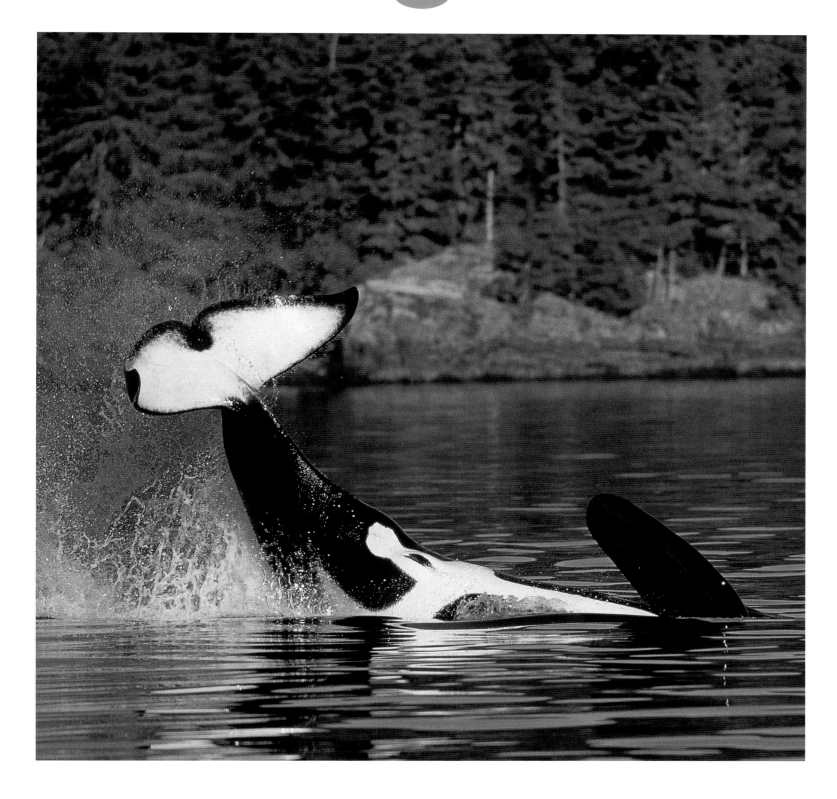

LEFT: Parts of the Sunshine Coast, a short ferry ride north of Vancouver, bask in almost 2500 hours of sunshine each year. Marine parks, campgrounds, and hiking trails ensure residents and visitors make the most of the weather.

ABOVE: Each orca, or killer whale, bears distinctive black and white markings, helping scientists to identify individuals. Scientists speculate that these patches may also help pods of whales track each other's movements during a hunt for seal or salmon.

OVERLEAF: Tchesinkut Lake, just south of Burns Lake in central B.C., is a popular fishing destination. Anglers try their skills against rainbow trout or char — some of which grow to more than 18 kilograms (40 pounds).

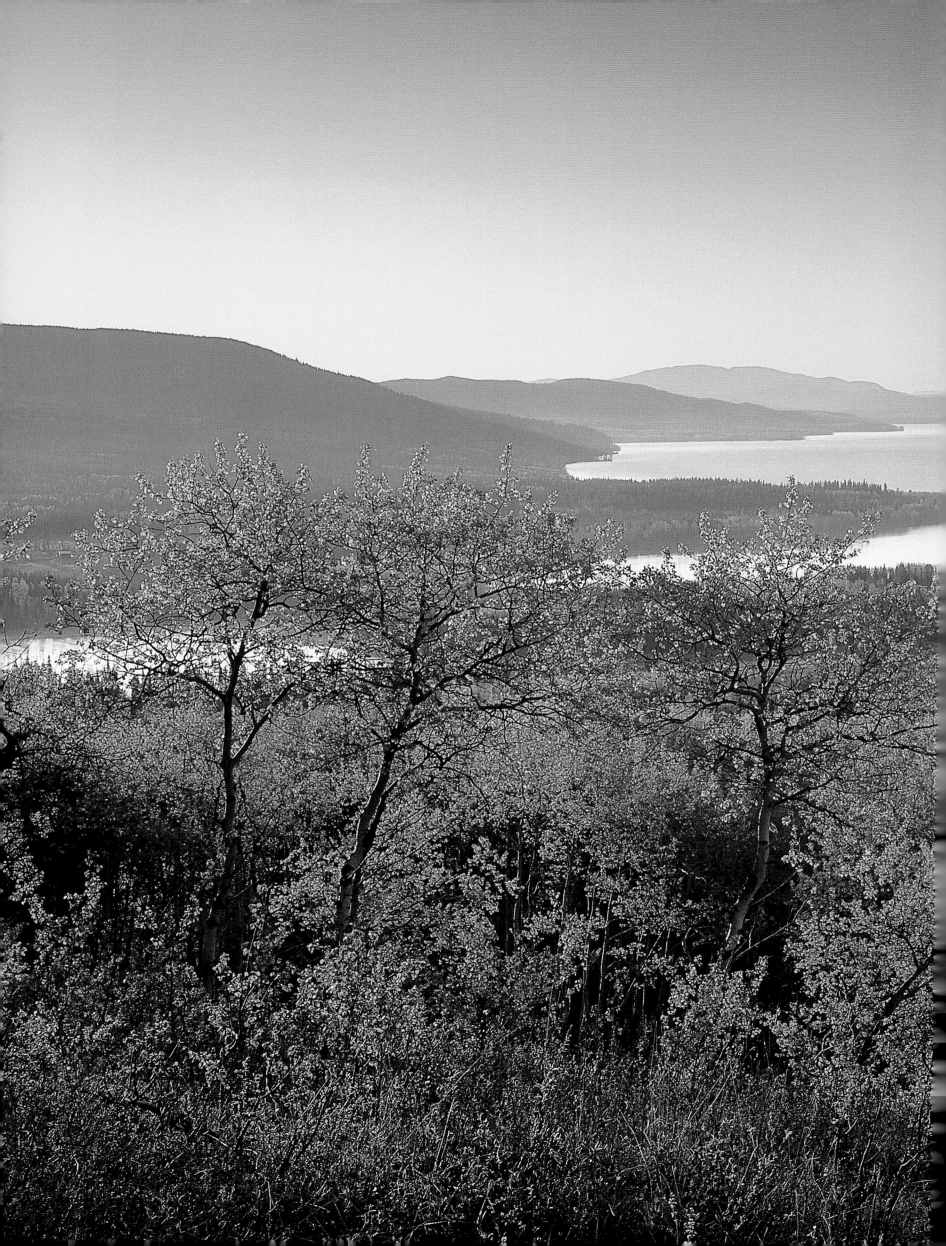

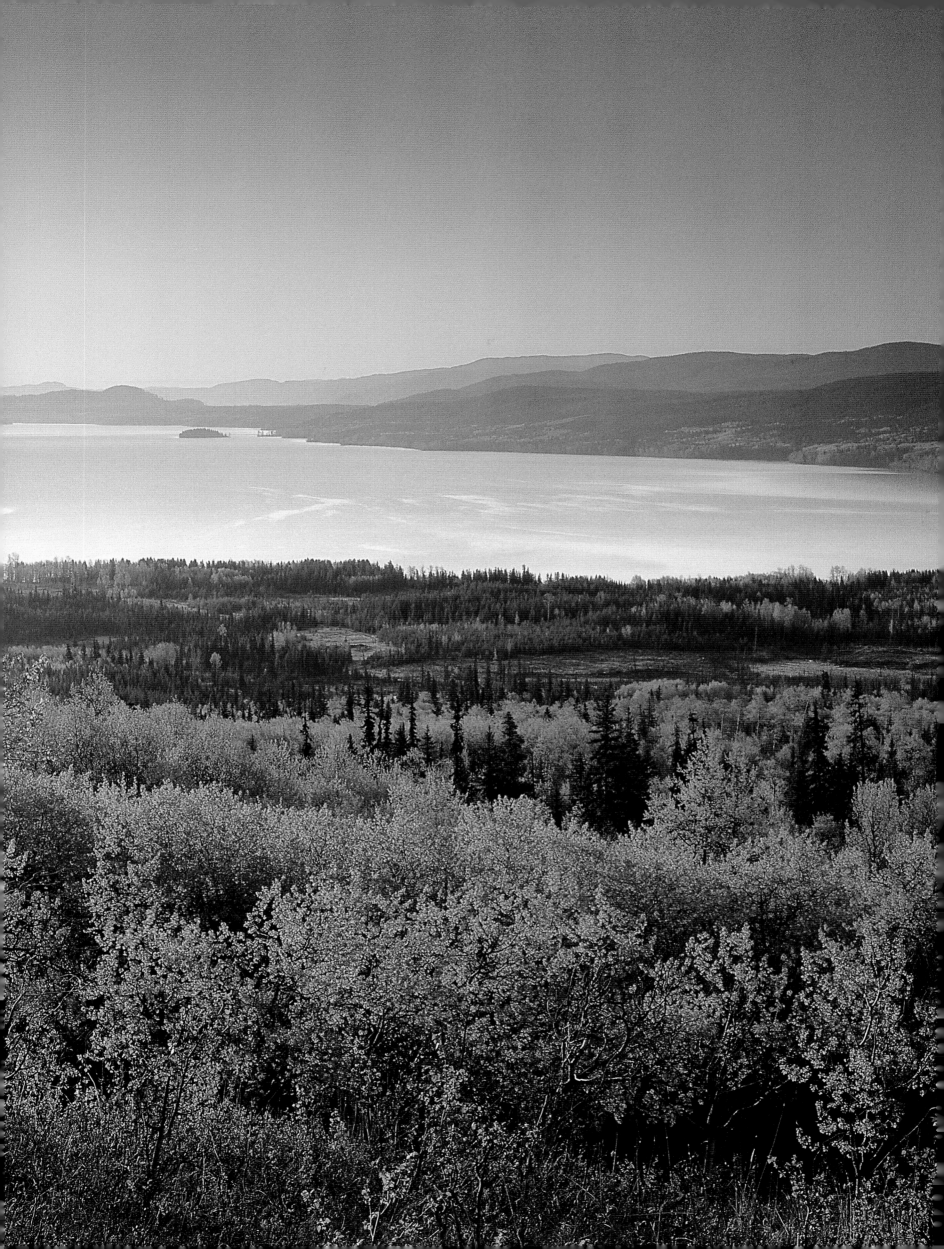

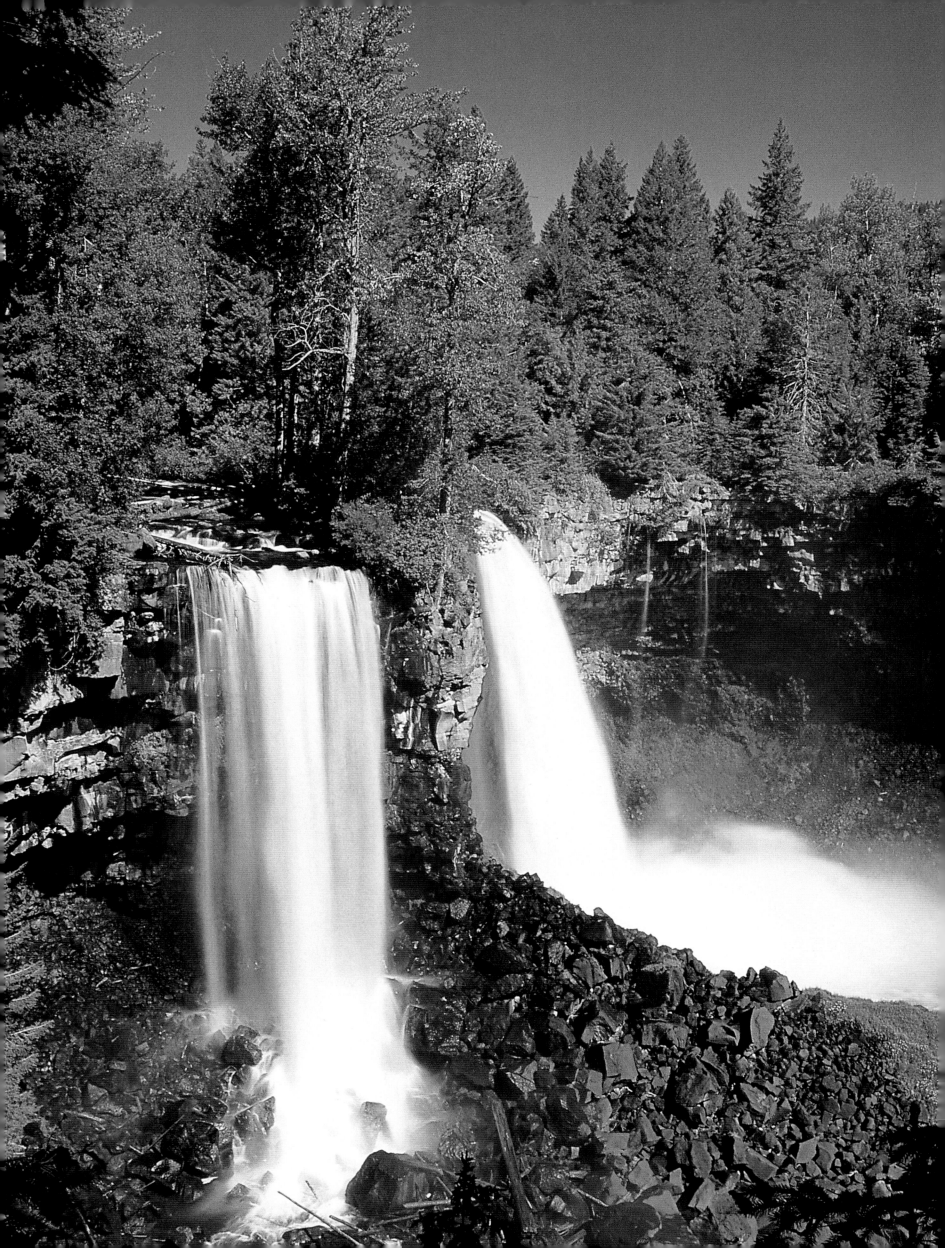

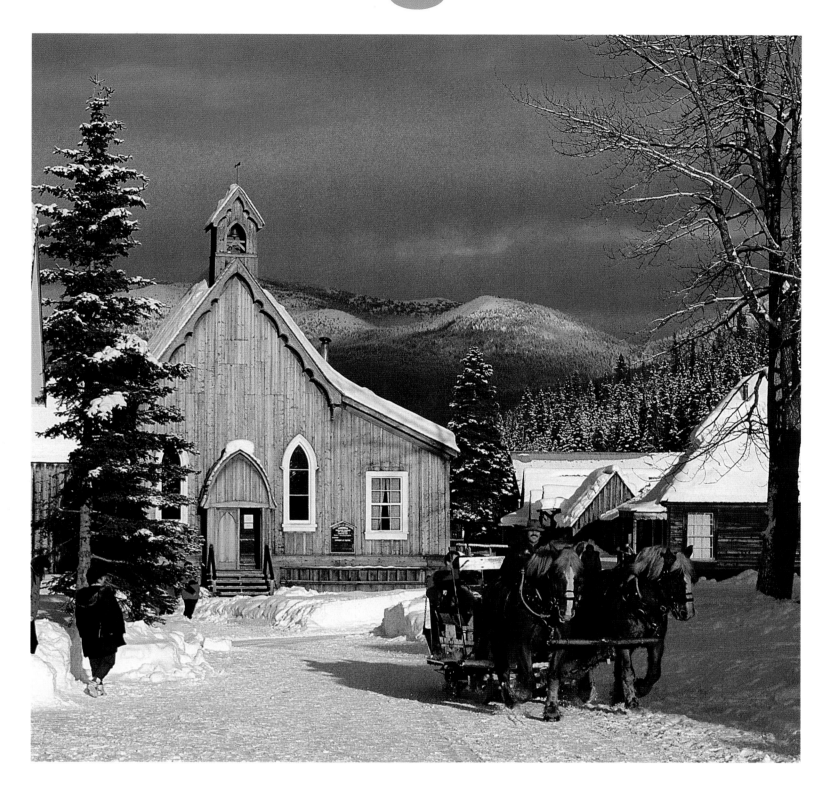

LEFT: Encompassing 516,000 hectares (1.3 million acres), Wells Gray Provincial Park is one of the largest in B.C. An array of hiking trails lead visitors from alpine peaks to spectacular waterfalls in summer, while cross-country ski trails wind through the preserve in winter.

ABOVE: Barkerville was built in the 1860s during the Cariboo gold rush. At one time, it was the largest city north of San Francisco and west of Chicago. The provincial government began restoring the boom town in 1957, and visitors can now wander through the historic buildings and experience some of the excitement of the gold rush days.

OVERLEAF: The flourishing greens at Predator Ridge offer a startling contrast to the arid hills that surround the golf course. Orchards and parks create similar scenes throughout the Okanagan Valley's desert-like landscape.

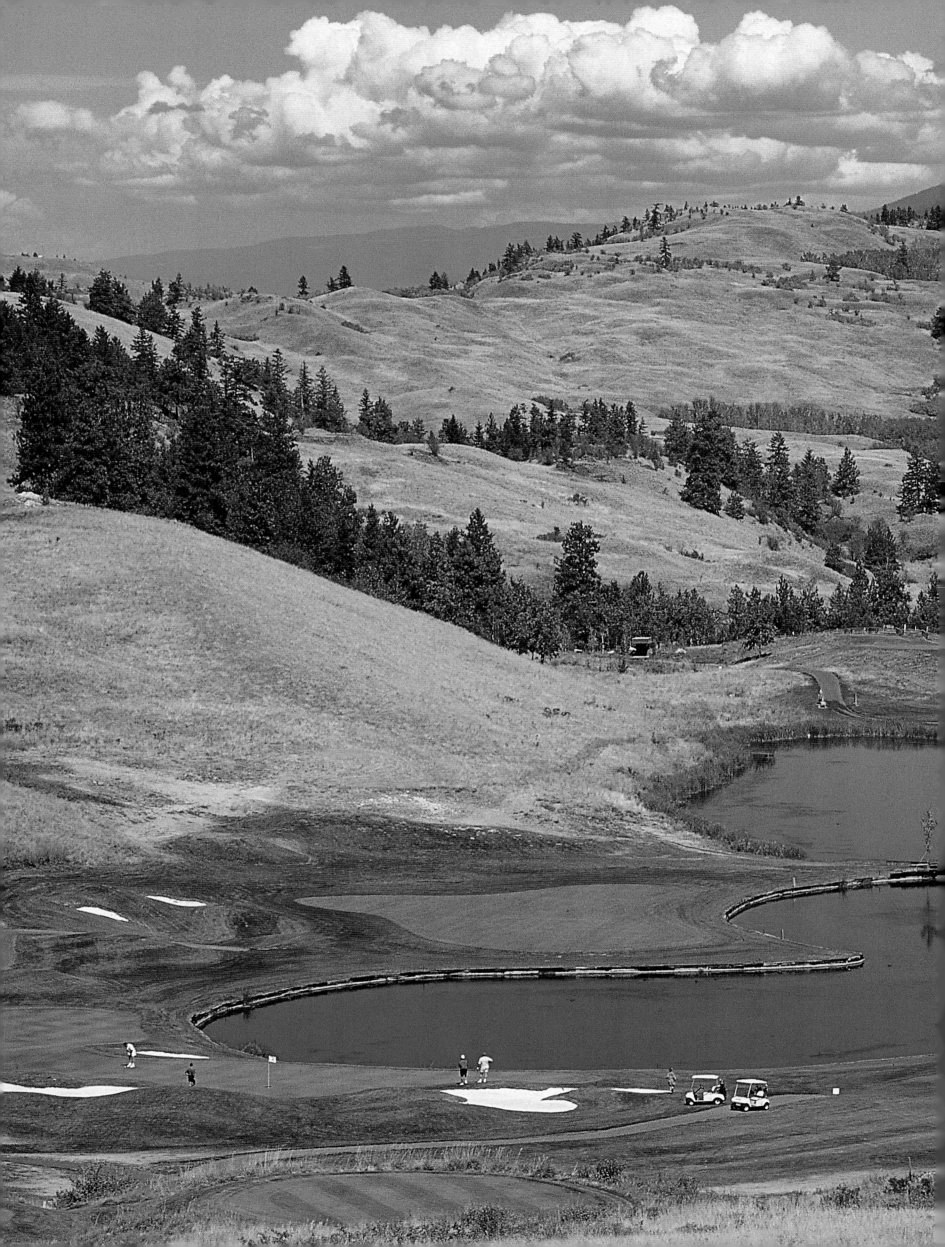

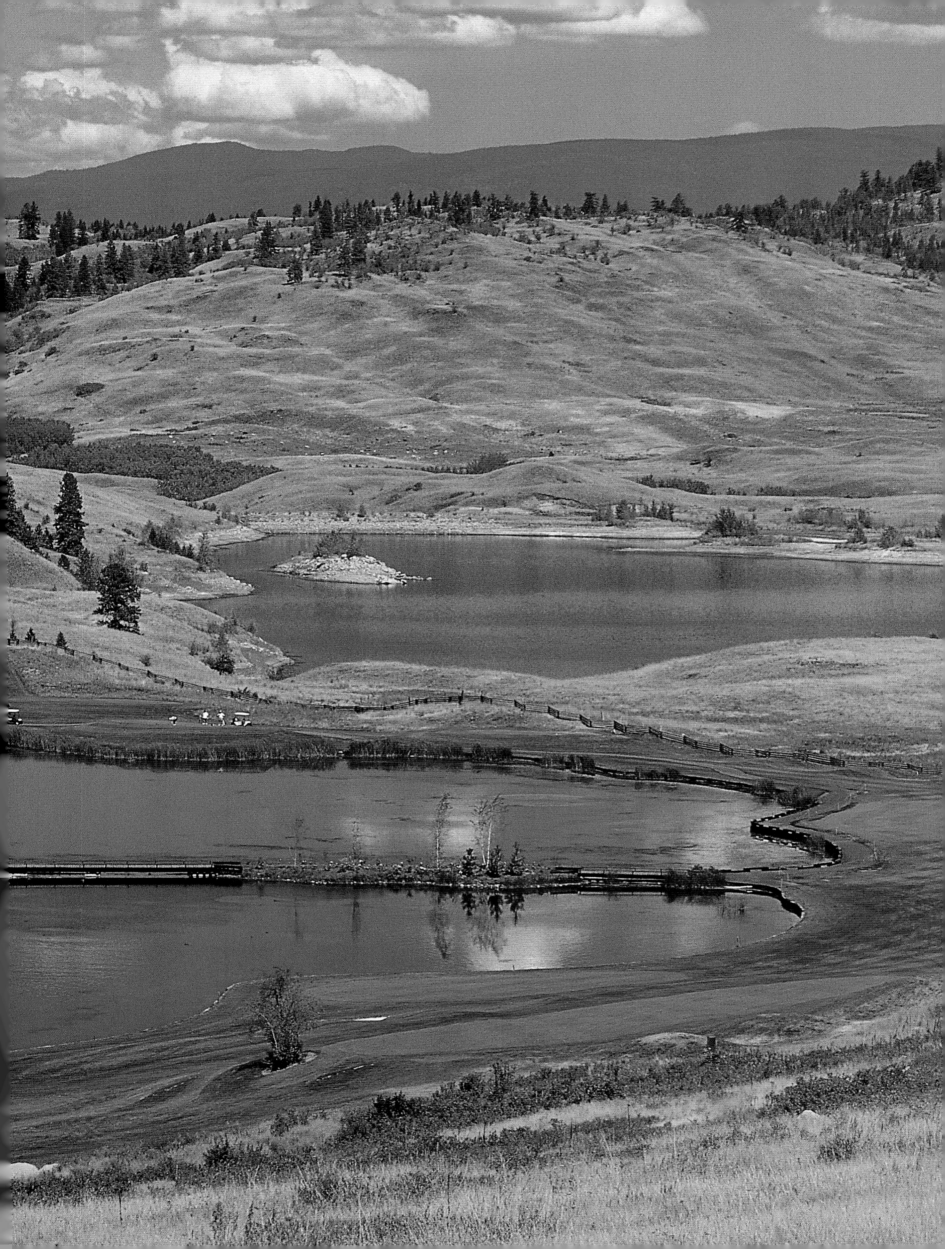

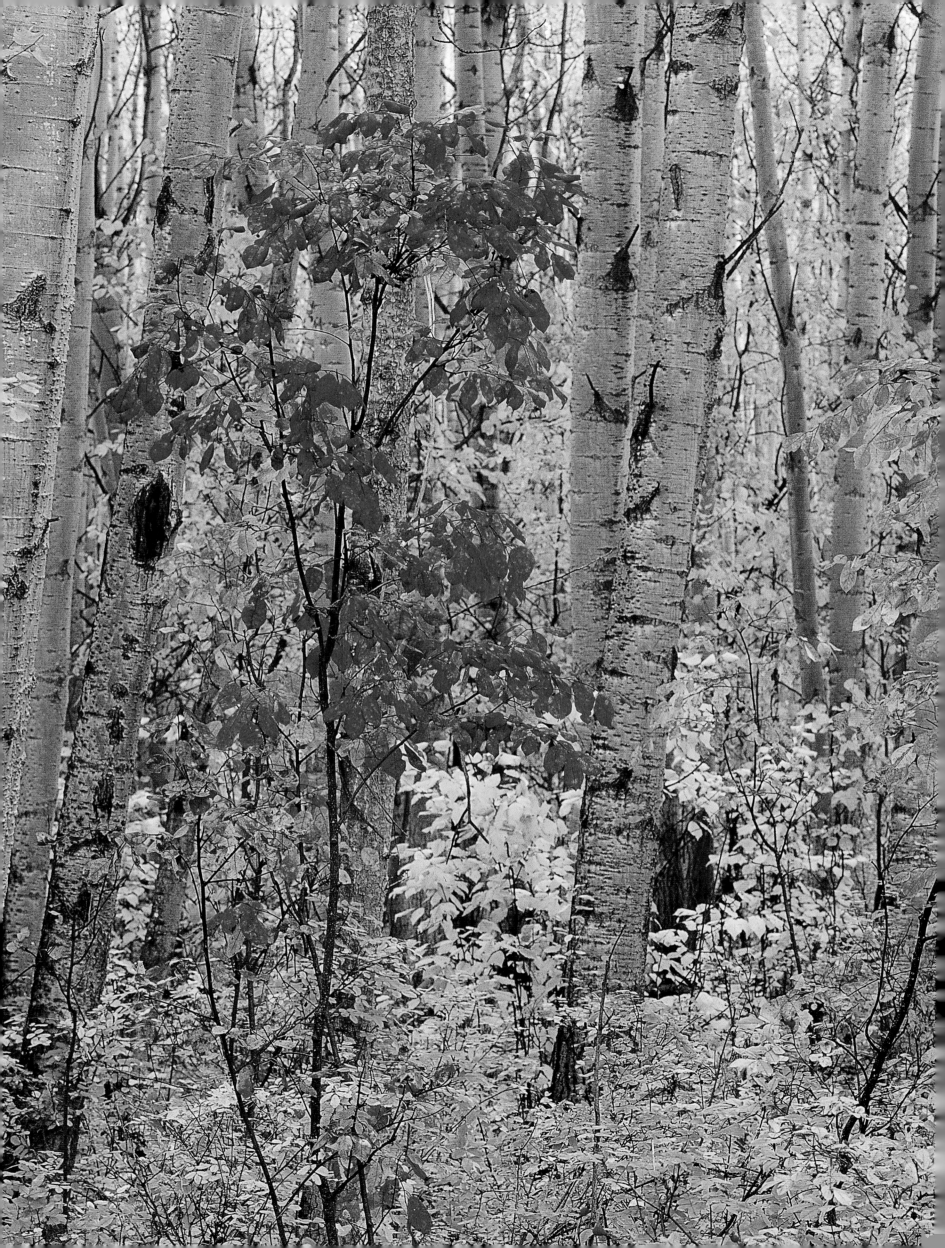

LEFT: Fall colours transform an aspen forest in northeastern British Columbia, near where the Peace River winds across the Alberta border.

OVERLEAF: The Okanagan boasts more than 30 wineries. Estate and farm-gate wineries grow most of the grapes they use. They crush, press, ferment, and barrel-age on site. While many commercial wineries produce vintages with only B.C.-grown fruit, they are also permitted to import grapes.

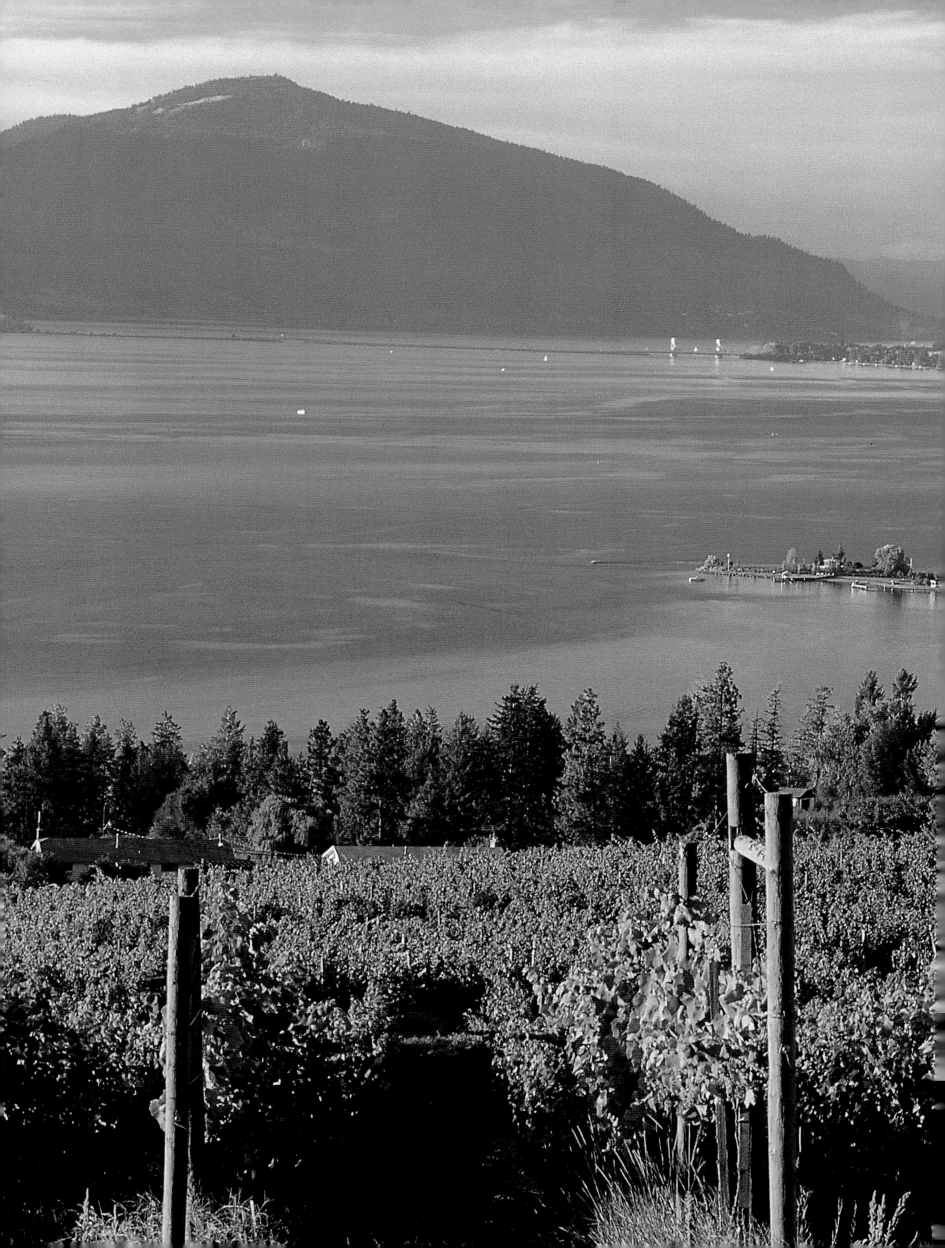

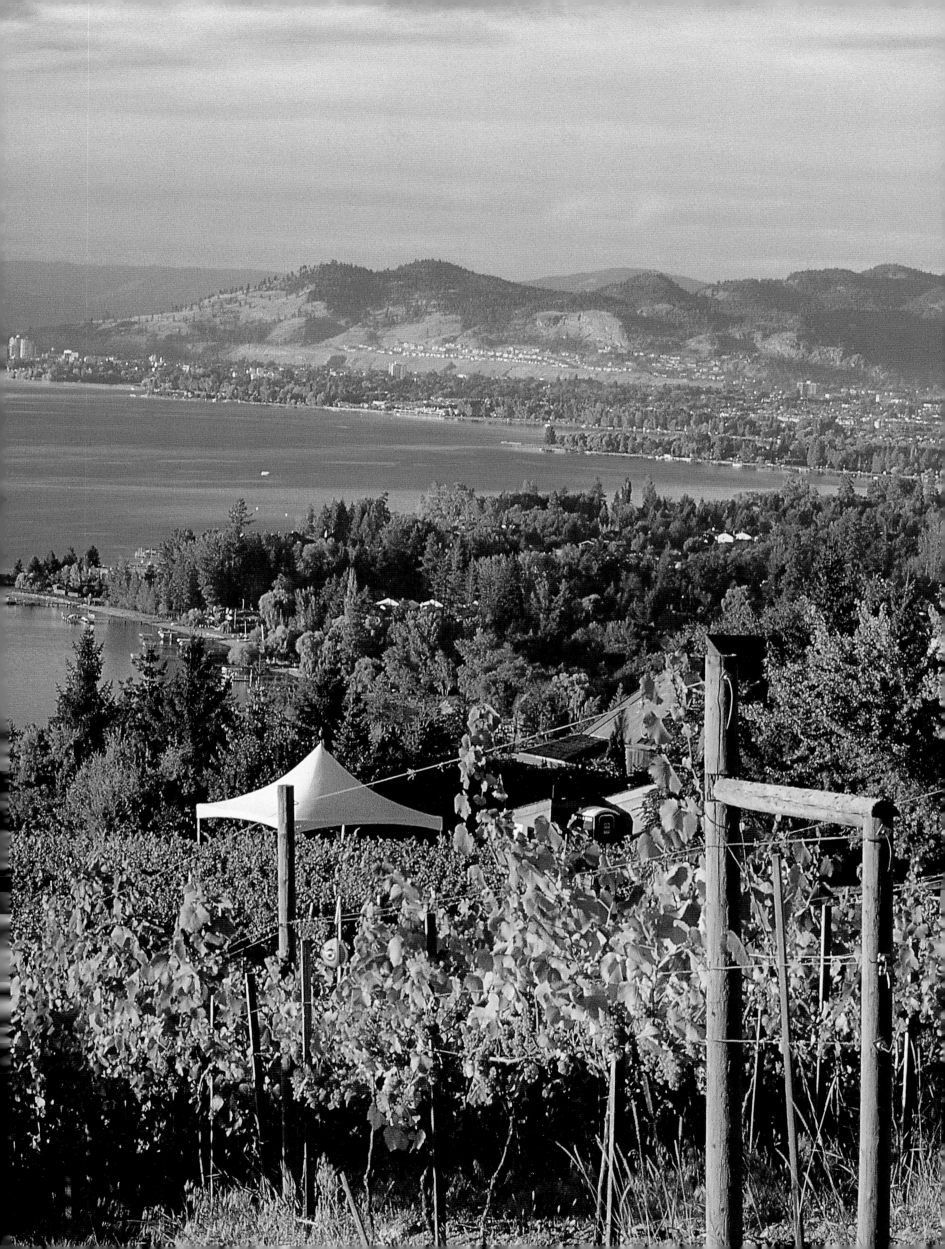

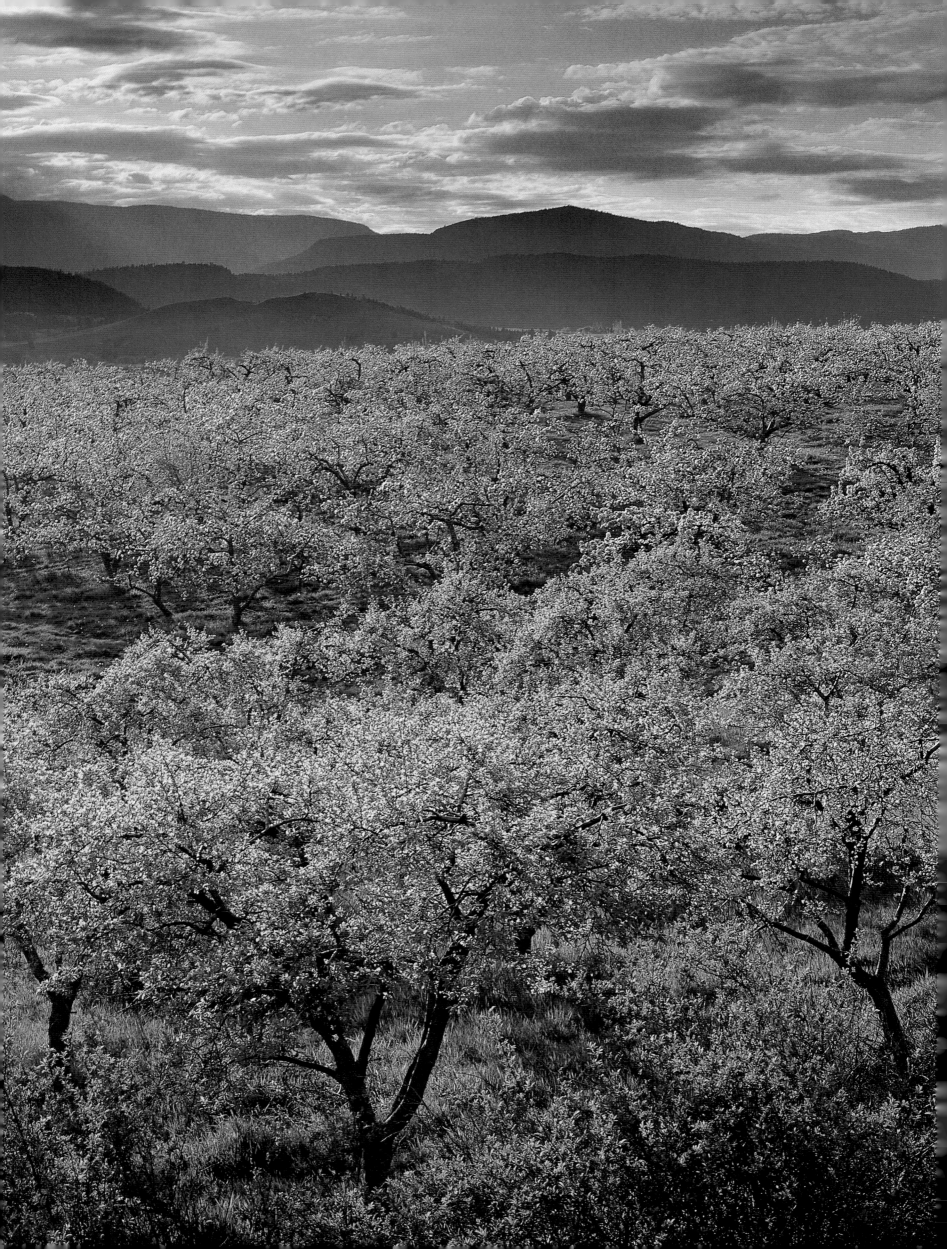

LEFT: In the early 1900s, there were already more than a million fruit trees in the Okanagan Valley. The valley now produces more than 90 percent of Canada's tree fruits, from apples and pears to apricots and cherries.

ABOVE: The village of Atlin, near the Yukon border, was born when prospectors Fritz Miller and Kenneth MacLaren discovered gold on Pine Creek in 1898, sparking an offshoot of the Klondike gold rush.

OVERLEAF: The peaks of the Rockies have challenged mountaineers since the first visitors arrived on the newly built railway in the late 1800s. In 1979, Alpine Club of Canada member Don Fores became the first person to reach the summits of all peaks in the Canadian Rockies over 3400 metres (1100 feet) high.

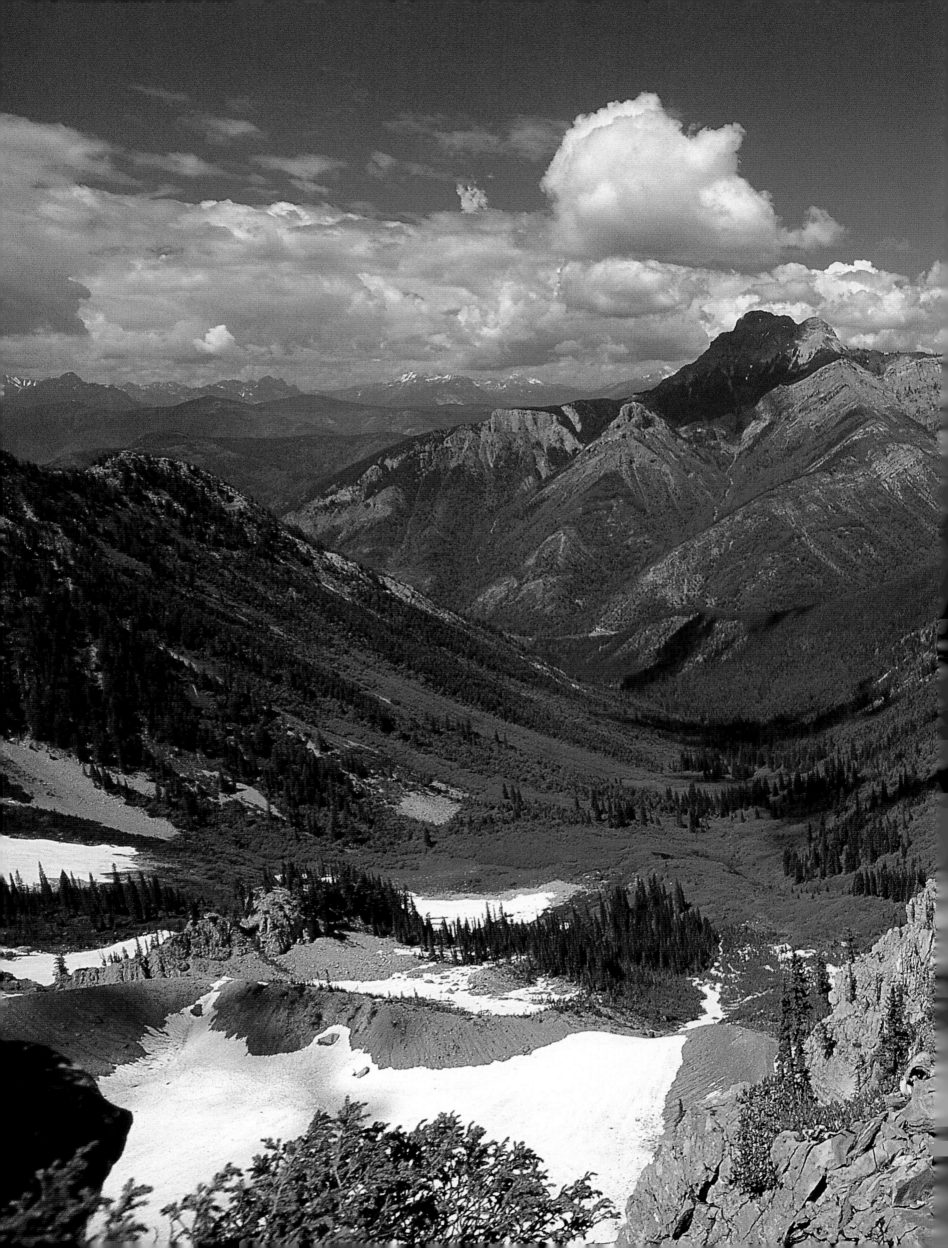

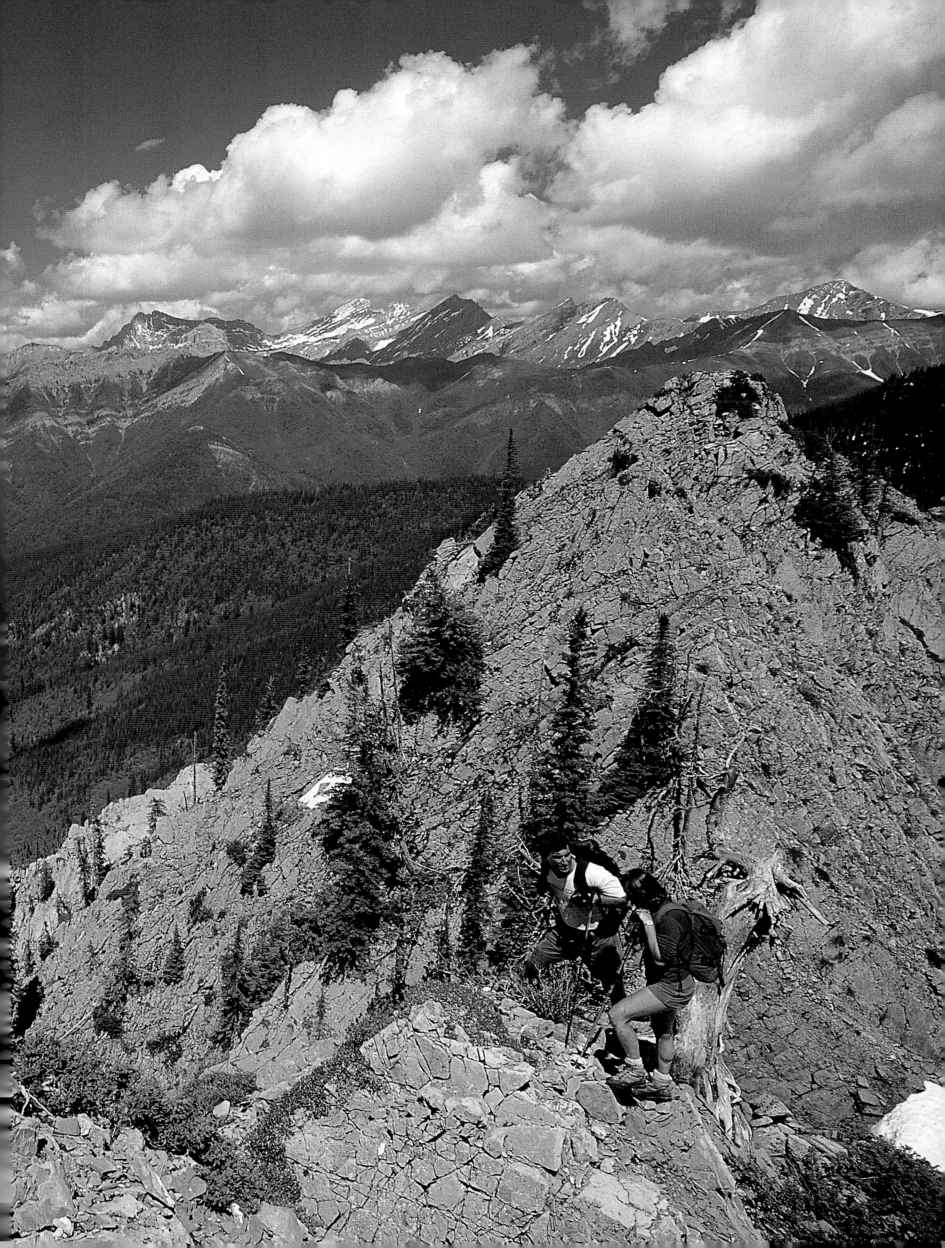

ABOVE: Home to mountain caribou, wolverines, grizzly bears, and hundreds of smaller animal, bird, and plant species, Mount Revelstoke National Park was first developed by the city of Revelstoke in 1908. Lobbying by local government and citizens led to the creation of a national park in 1914.

RIGHT: There are more than 630 provincial reserves in British Columbia, encompassing 8.2 million hectares (20 million acres) of land. One of the most popular is Manning Provincial Park in the southern mountains, near the U.S. border. Backcountry skiers flock here in winter, and the park is a favourite summer destination for hiking and camping.

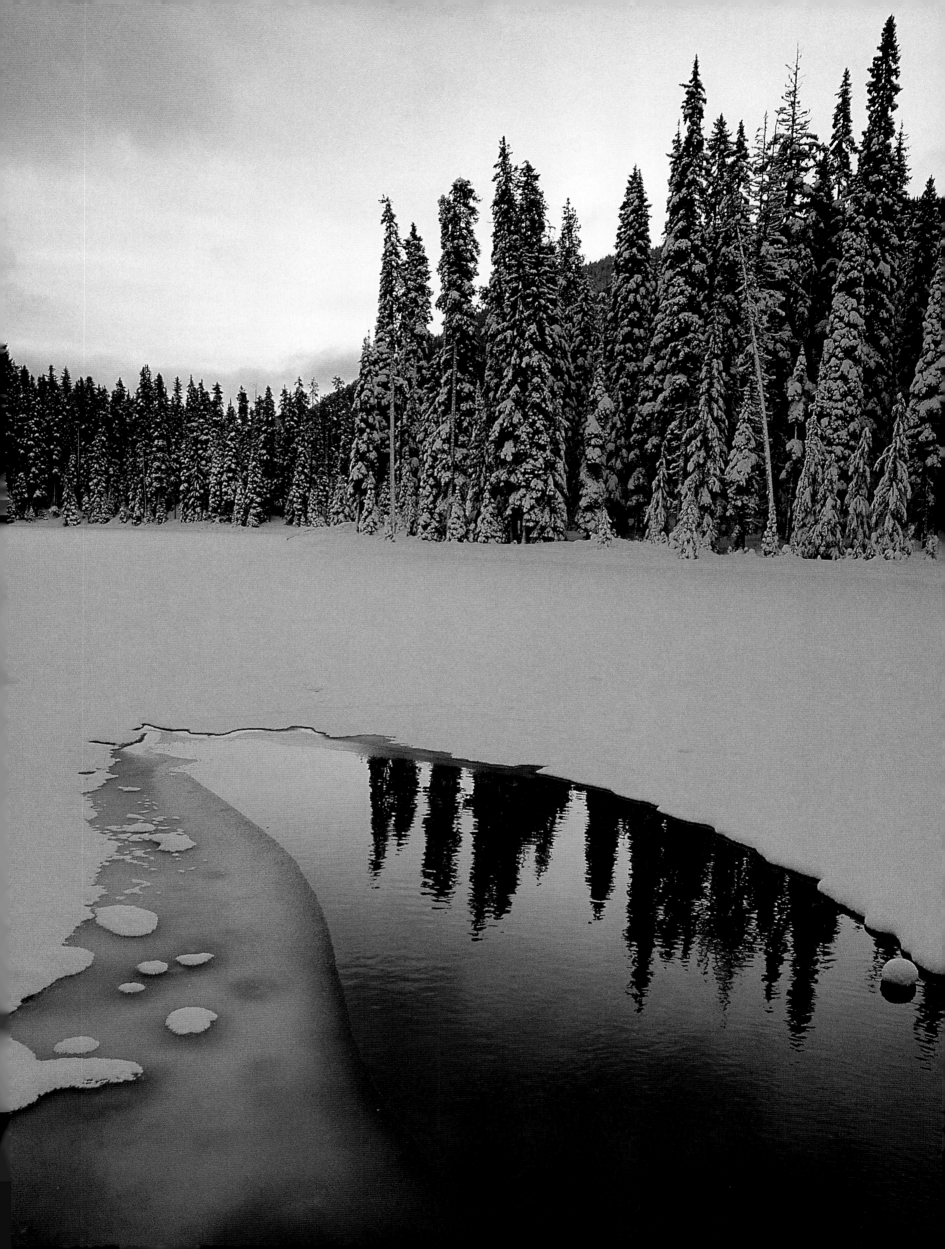

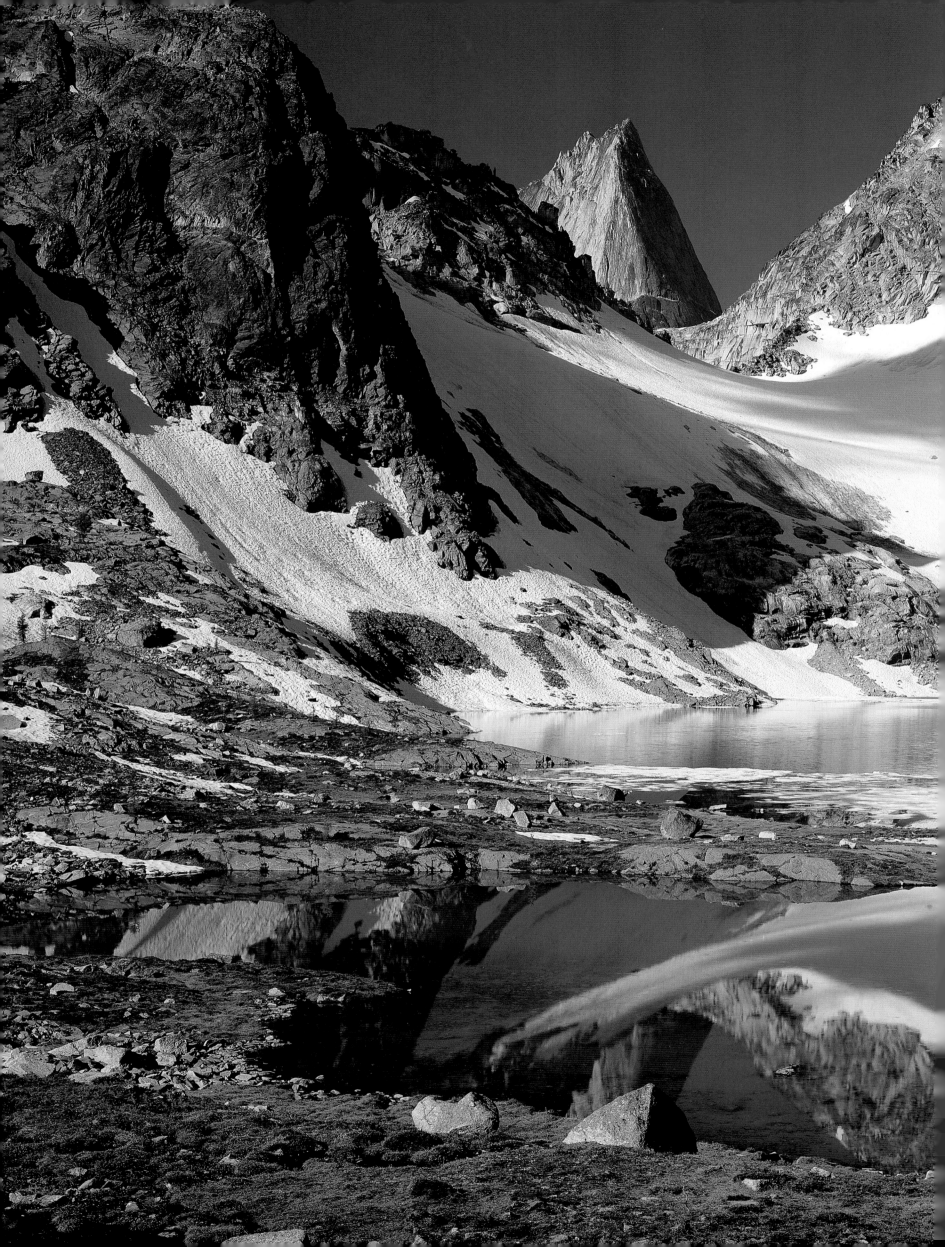

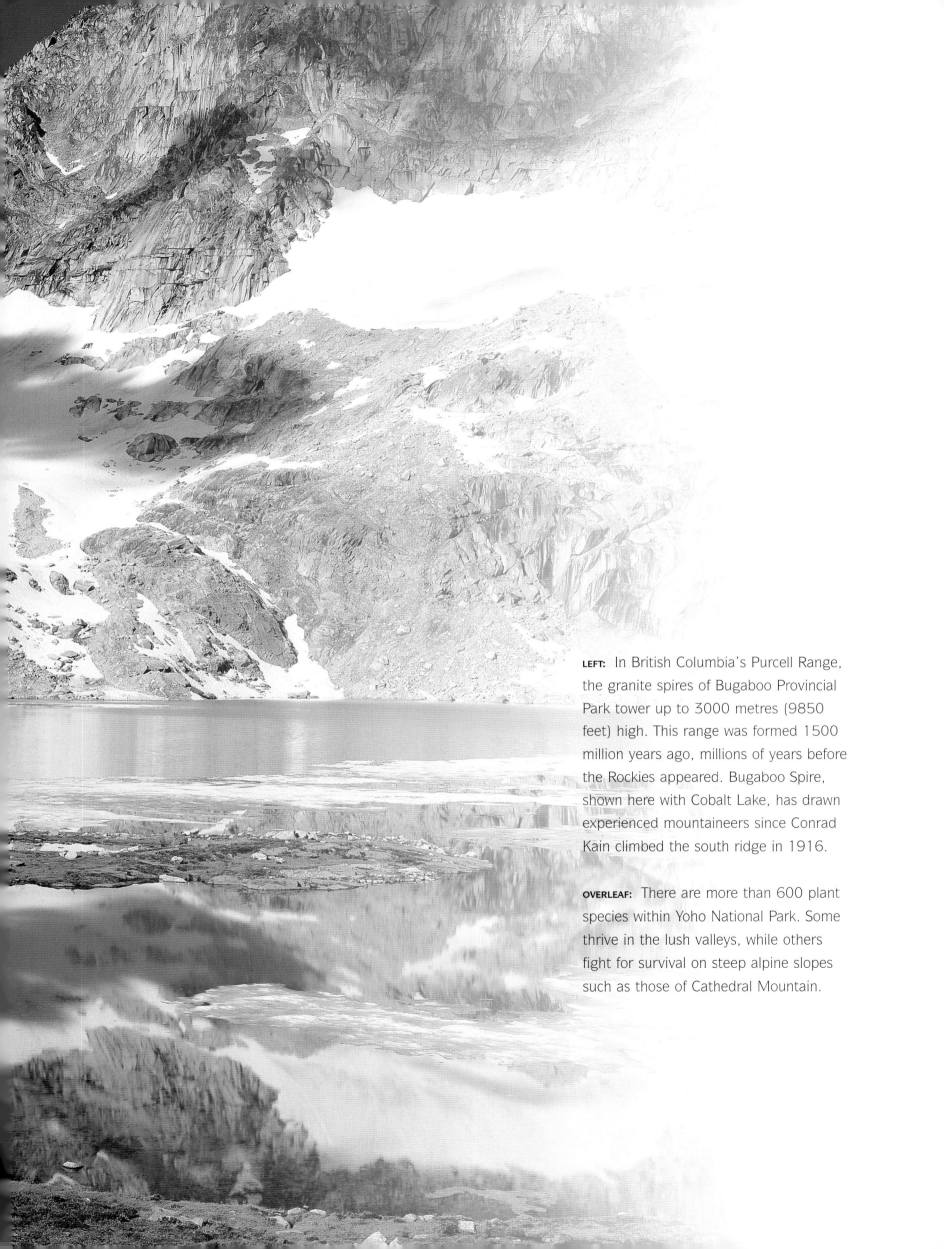

LEFT: In British Columbia's Purcell Range, the granite spires of Bugaboo Provincial Park tower up to 3000 metres (9850 feet) high. This range was formed 1500 million years ago, millions of years before the Rockies appeared. Bugaboo Spire, shown here with Cobalt Lake, has drawn experienced mountaineers since Conrad Kain climbed the south ridge in 1916.

OVERLEAF: There are more than 600 plant species within Yoho National Park. Some thrive in the lush valleys, while others fight for survival on steep alpine slopes such as those of Cathedral Mountain.

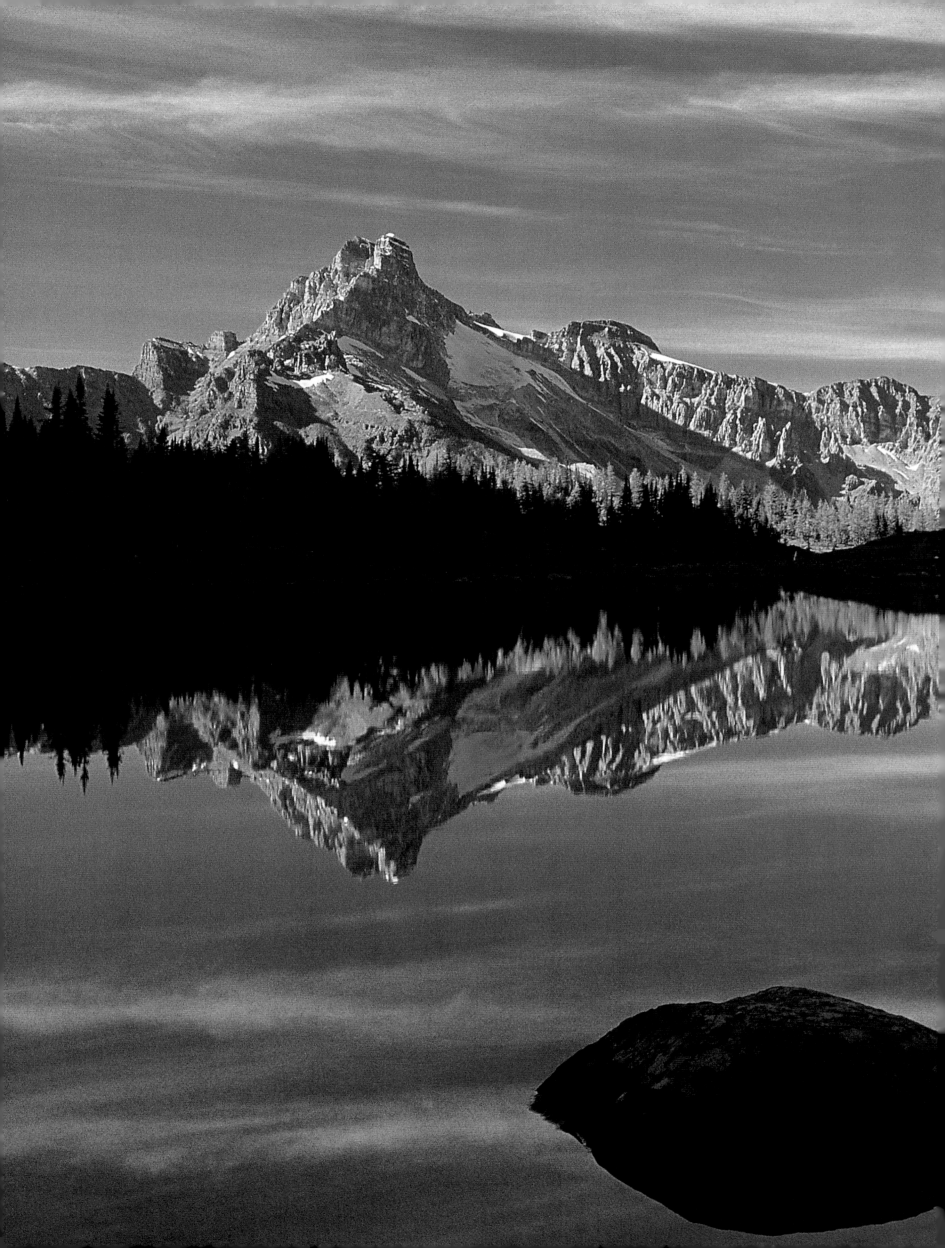

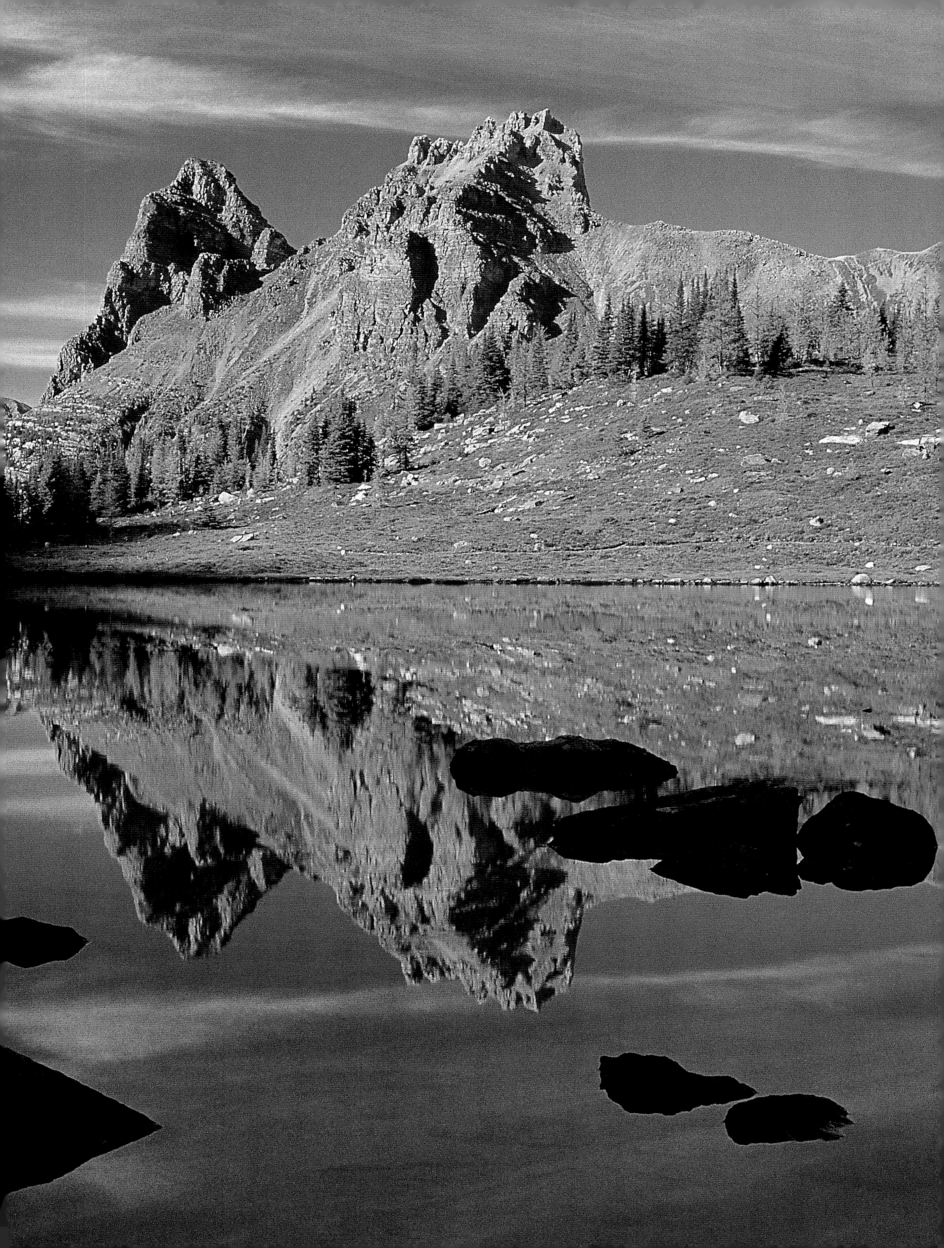

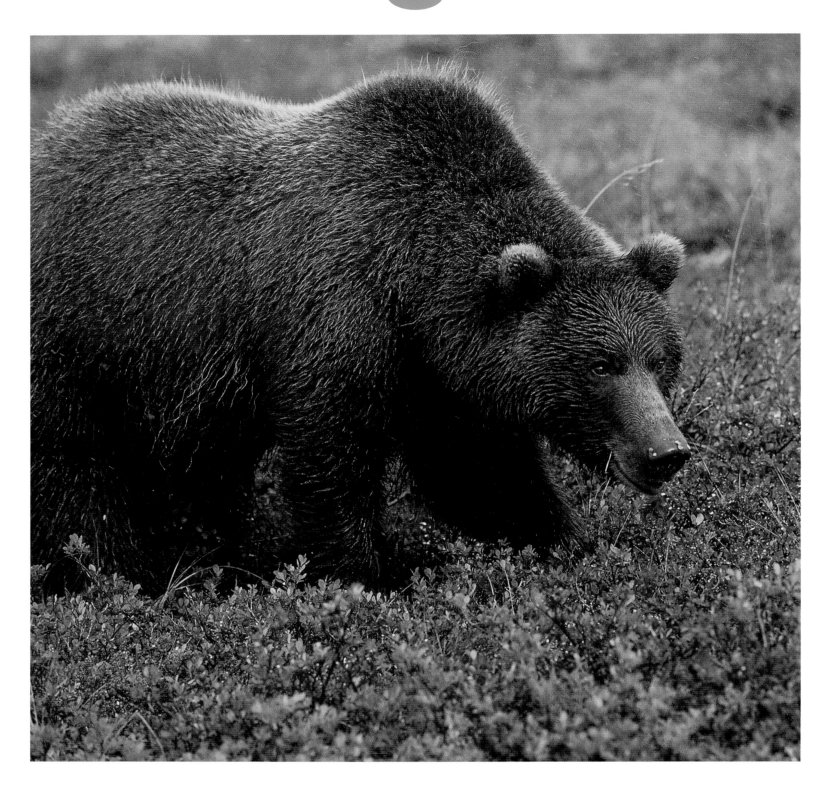

ABOVE: Grizzlies wander a huge range in search of food and potential mates. A male bear may take several years to travel a territory of 500 square kilometres (190 square miles). Many of these giants are protected by the million-hectare (2.4-million-acre) Tatshenshini-Alsek Provincial Wilderness Park in northern B.C.

RIGHT: The rugged slopes of Mount Robson Provincial Park are home to mule and whitetail deer, moose, elk, black and grizzly bear, caribou, mountain goat, mountain sheep and more than 182 bird species.

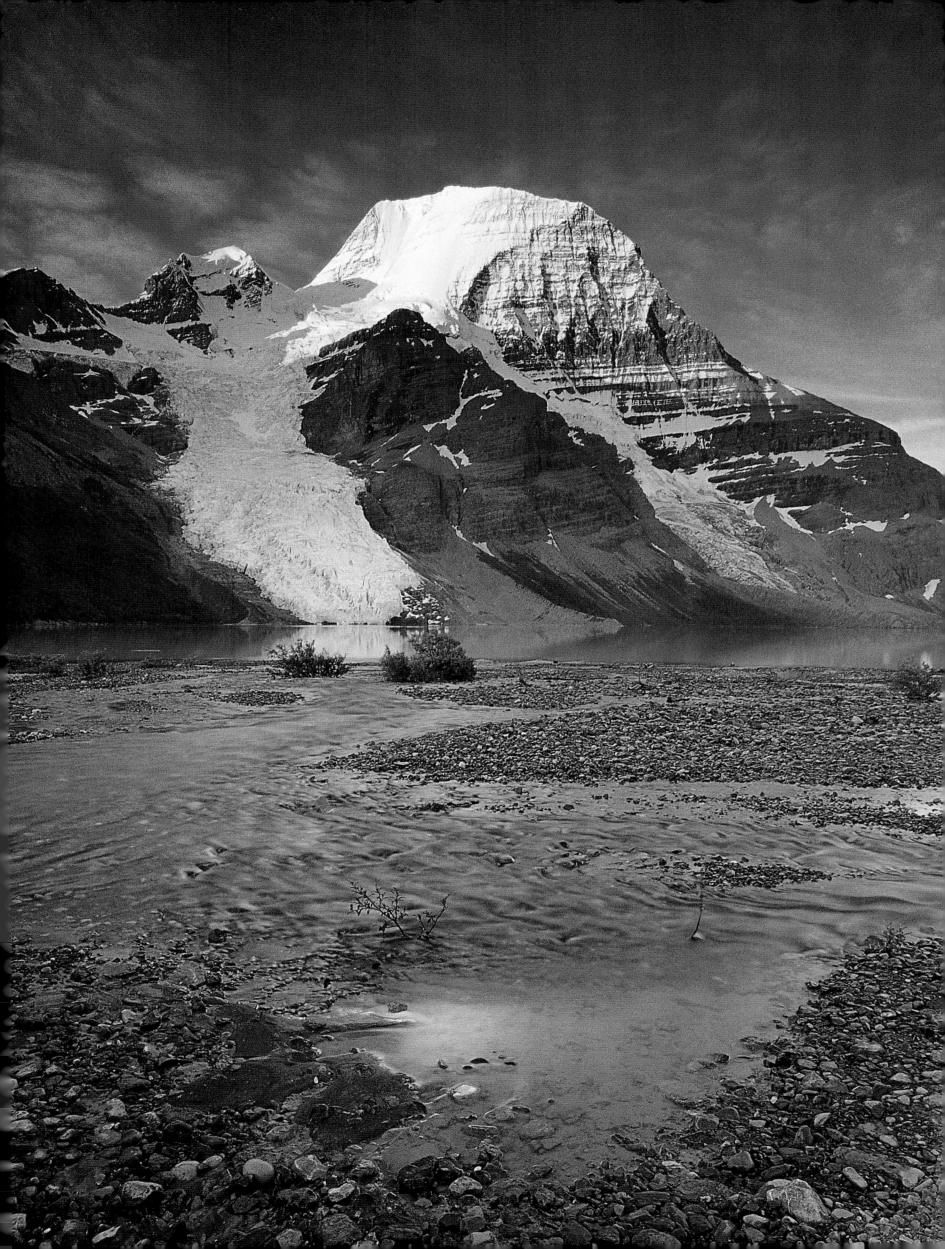

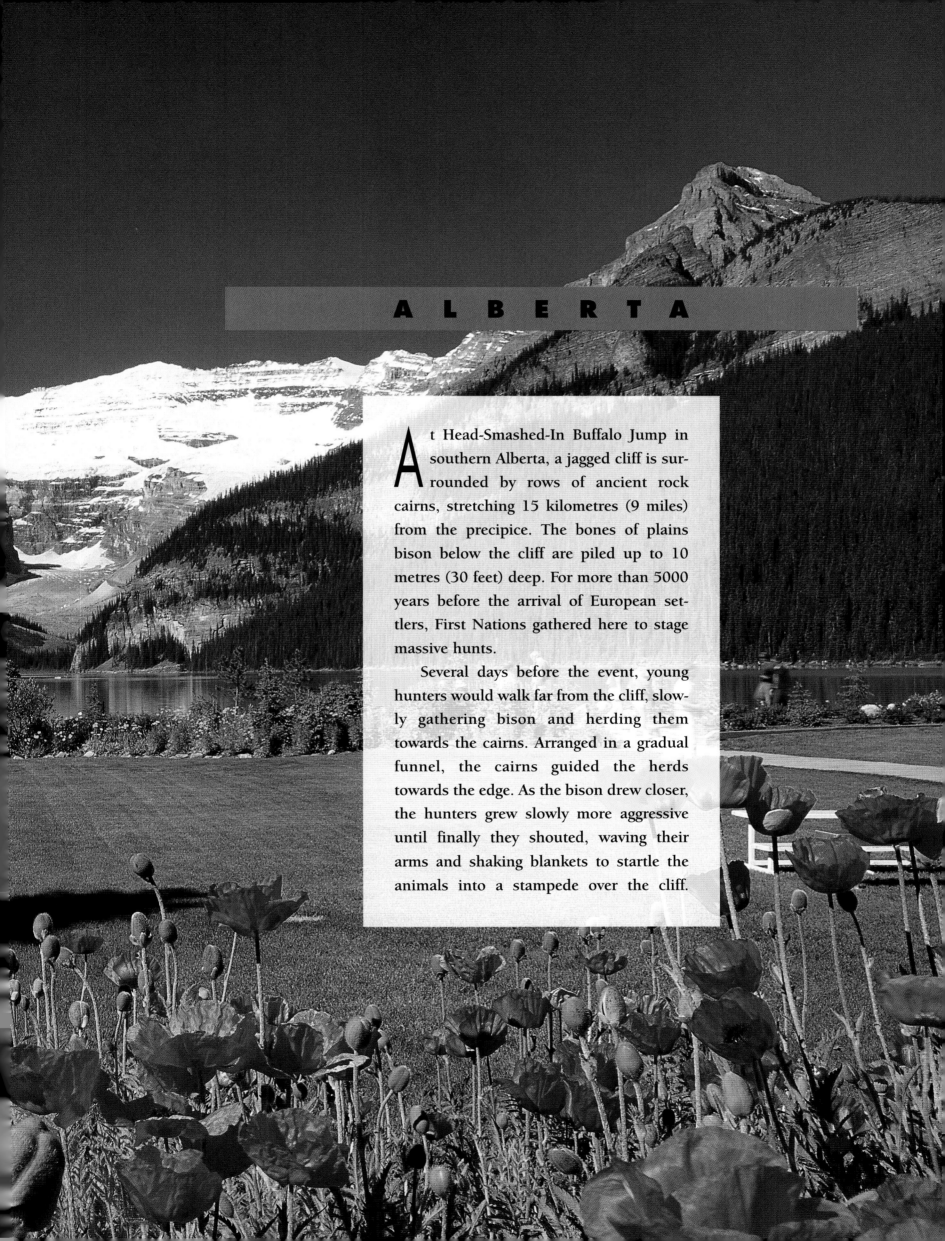

ALBERTA

At Head-Smashed-In Buffalo Jump in southern Alberta, a jagged cliff is surrounded by rows of ancient rock cairns, stretching 15 kilometres (9 miles) from the precipice. The bones of plains bison below the cliff are piled up to 10 metres (30 feet) deep. For more than 5000 years before the arrival of European settlers, First Nations gathered here to stage massive hunts.

Several days before the event, young hunters would walk far from the cliff, slowly gathering bison and herding them towards the cairns. Arranged in a gradual funnel, the cairns guided the herds towards the edge. As the bison drew closer, the hunters grew slowly more aggressive until finally they shouted, waving their arms and shaking blankets to startle the animals into a stampede over the cliff.

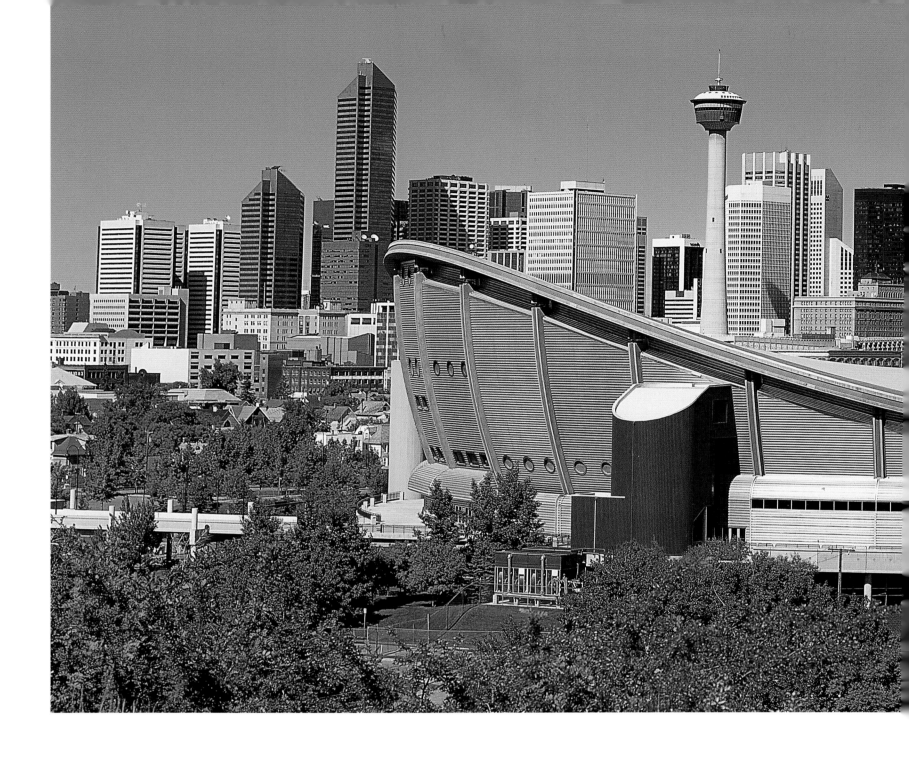

PREVIOUS PAGES: Wrangler and CPR employee Tom Wilson was the first European to see Lake Louise in 1882. He first named it Emerald Lake, but renamed it two years later. Some say the change was in honour of Louise Temple, whose father was a member of the British Association for the Advancement of Science. Most, however, believe the lake was named for Princess Louise Caroline Alberta, daughter of Queen Victoria.

Archeological records show that in some hunts, up to 1000 animals fell. After the hunt, teams flocked to the animals, killing the wounded with spears and clubs and beginning the preparation of meat and hides.

The arrival of Europeans in the early 1800s brought disease that decimated the Native population. Two-thirds of the Blackfoot Nation were killed in a single smallpox epidemic. And the bison met with a similar fate. Hunters and settlers slaughtered the animals until, by the late 19th century, only 1000 plains buffalo survived in the entire prairie region.

The extermination of the bison, the arrival of the railway, and the rise in the number of settlers and RCMP posts created an opportunity for cattle. The Alberta government leased up to 16,200 hectares (40,000 acres) per rancher for only a few dollars. Soon, thousands of cattle grazed on the prairie grasslands.

Within decades, ranchers were joined by oil barons. In 1912 William Herron and A.W. Dingman convinced a group of Calgary busi-

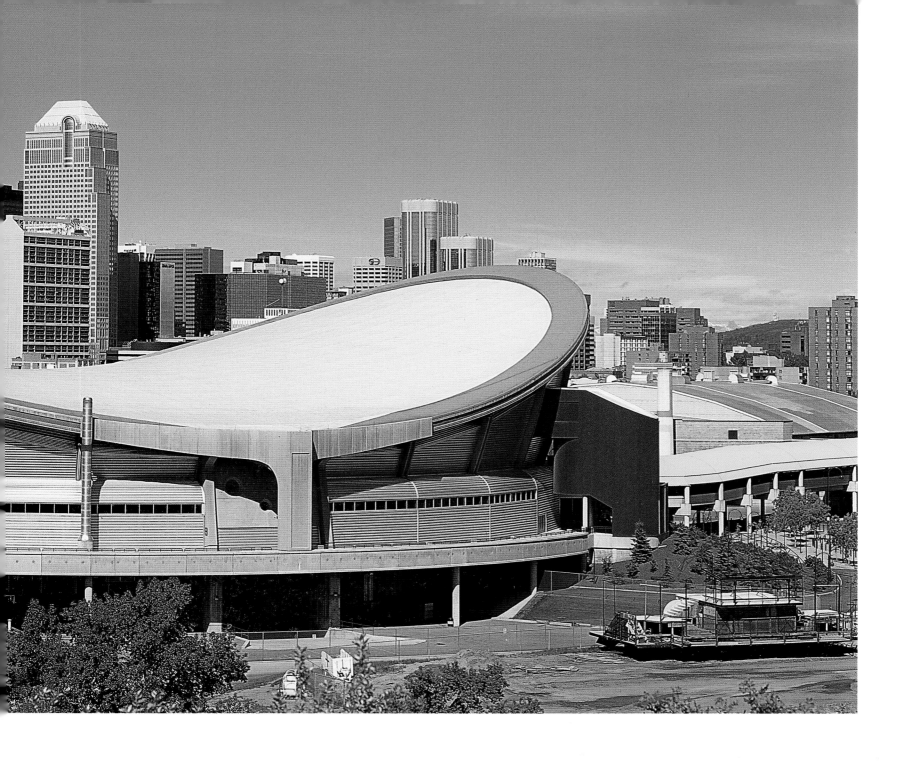

nessmen to finance drilling in Turner Valley. The entire city of Calgary celebrated in 1914 as a well burst with more than a million cubic metres (4 million cubic feet) of oil a day.

Today, Alberta produces $10 million a year in crude oil and almost as much in natural gas and gas byproducts. And although two-thirds of the province's population lives in the metropolises of Calgary and Edmonton, a strong connection to the wild west endures. One of the greatest celebrations of this heritage is the Calgary Exhibition and Stampede. From amusement park rides to nightly fireworks, chuck-wagon racing to First Nations dances, the diverse aspects of Alberta's heritage are juxtaposed in a 10-day celebration, larger than any other in the country. Ironically, this Wild West event has helped keep First Nations culture alive. During the Stampede, visitors can see traditional teepees, taste bannock, and experience the Grass Dance, a ritual based partly on the hunting techniques of centuries ago.

ABOVE: Built for the 1988 Winter Olympics, Calgary's Saddledome was designed to look like the curve of a saddle. The 18,000-seat facility boasts the world's largest cable-suspended concrete roof and is home to the Calgary Flames hockey team.

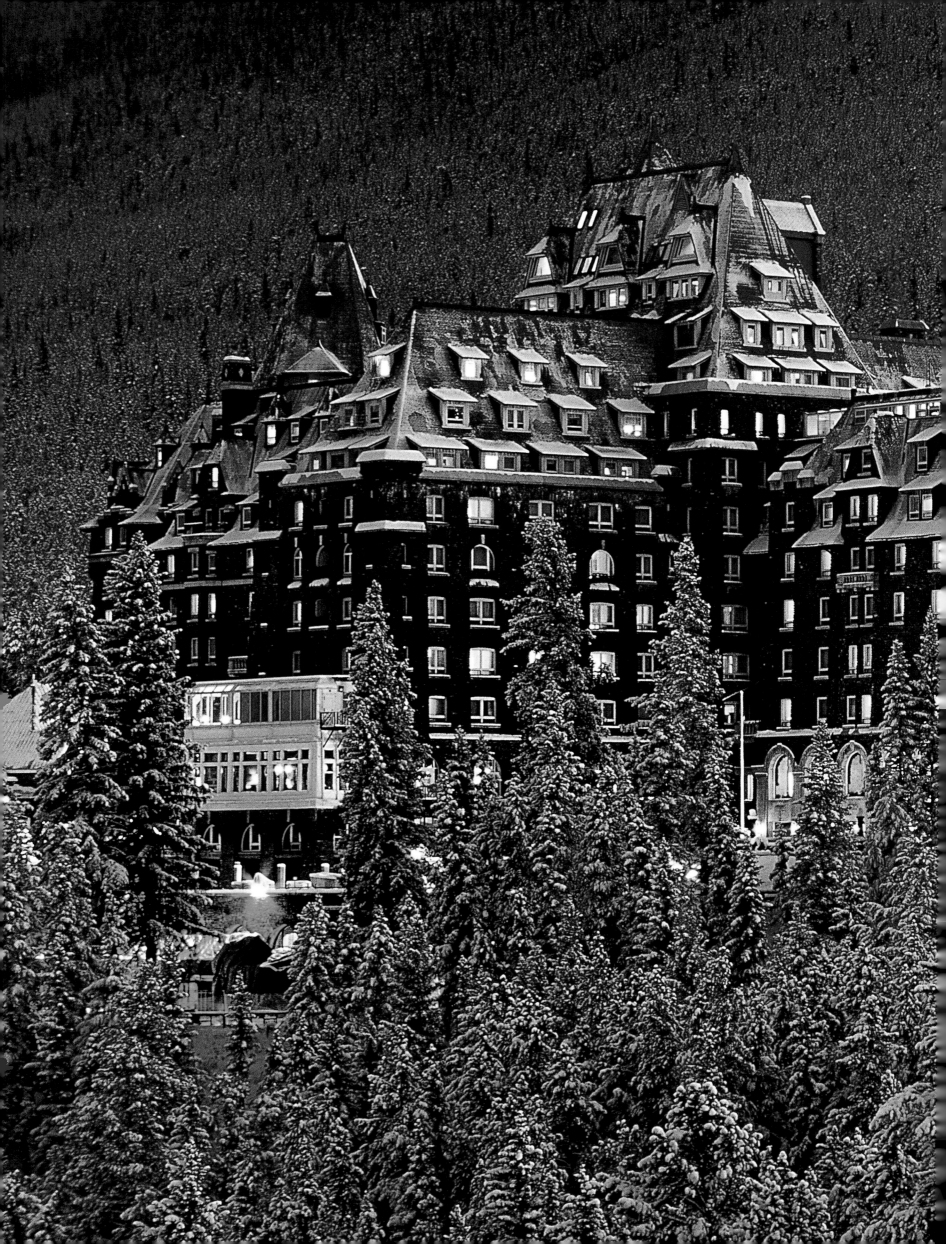

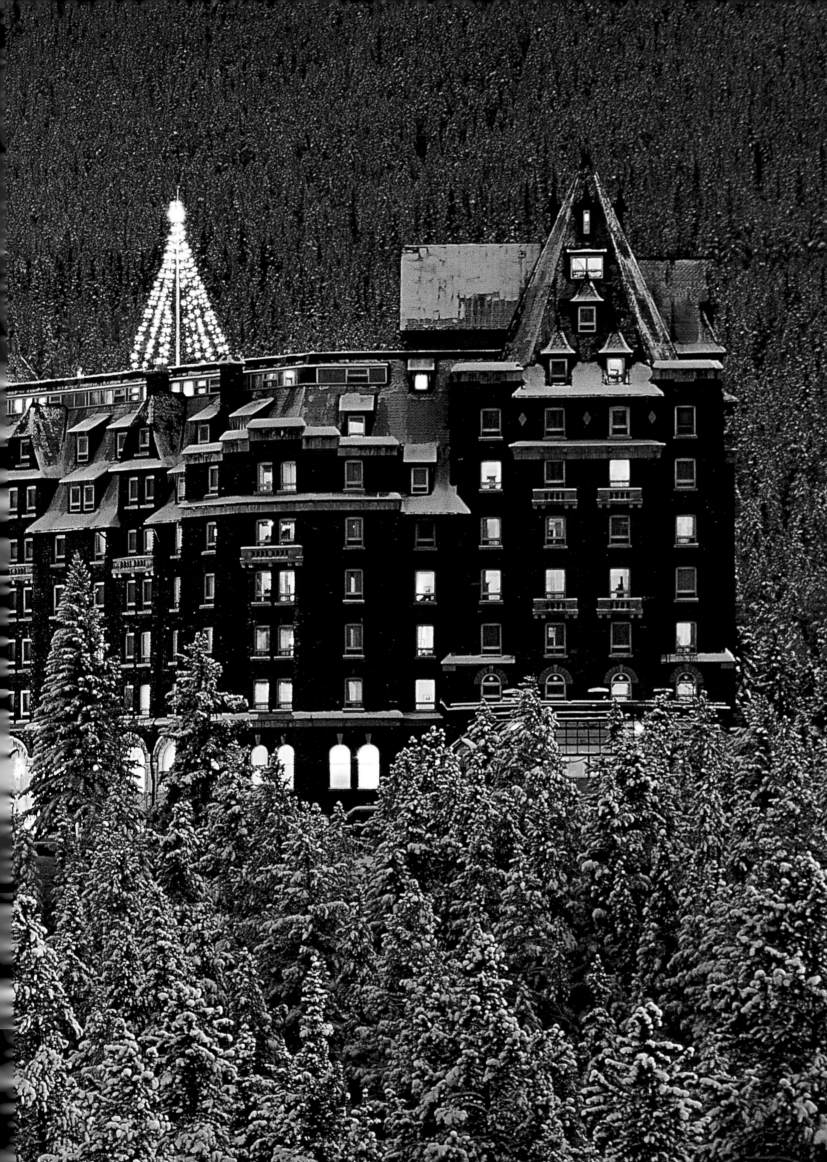

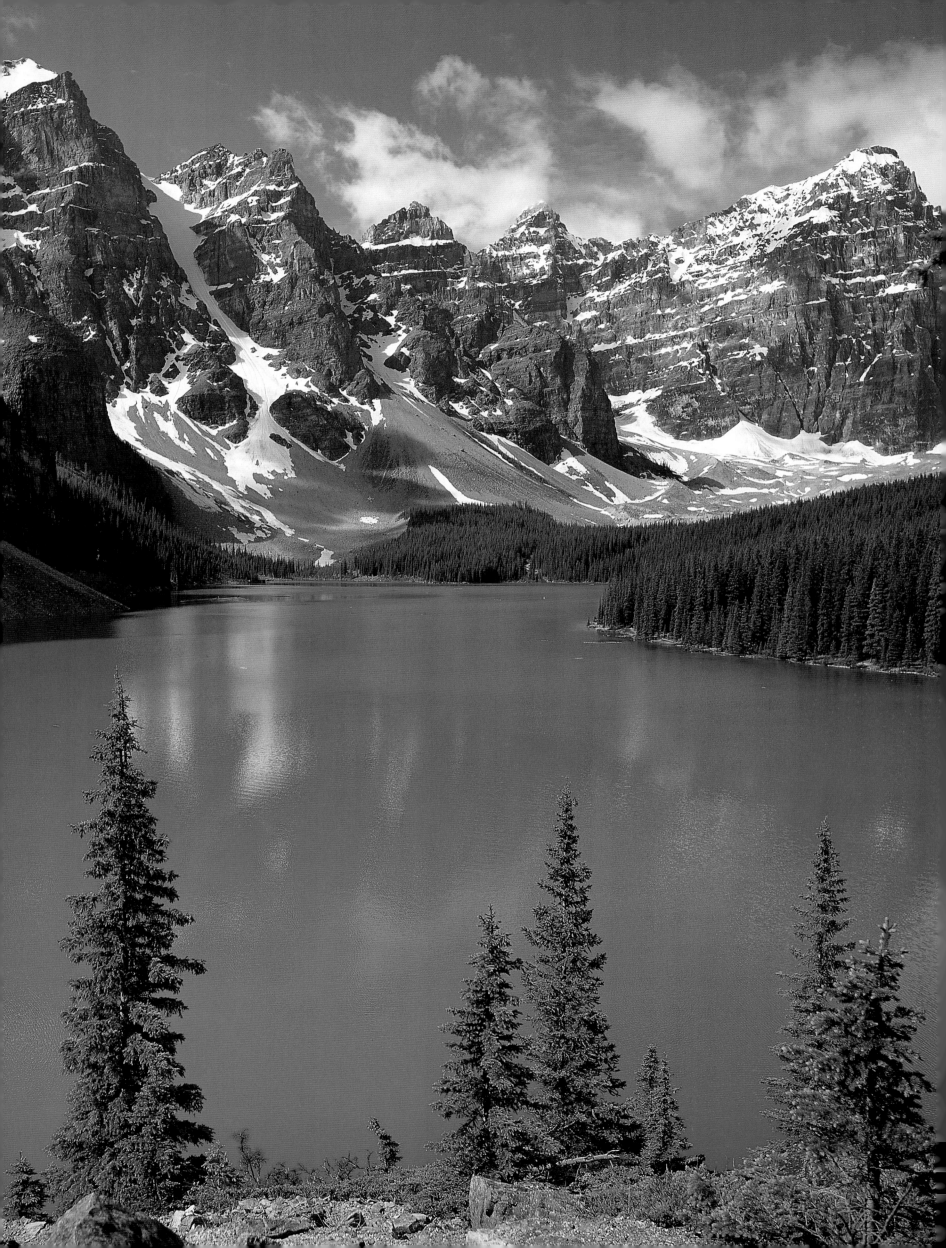

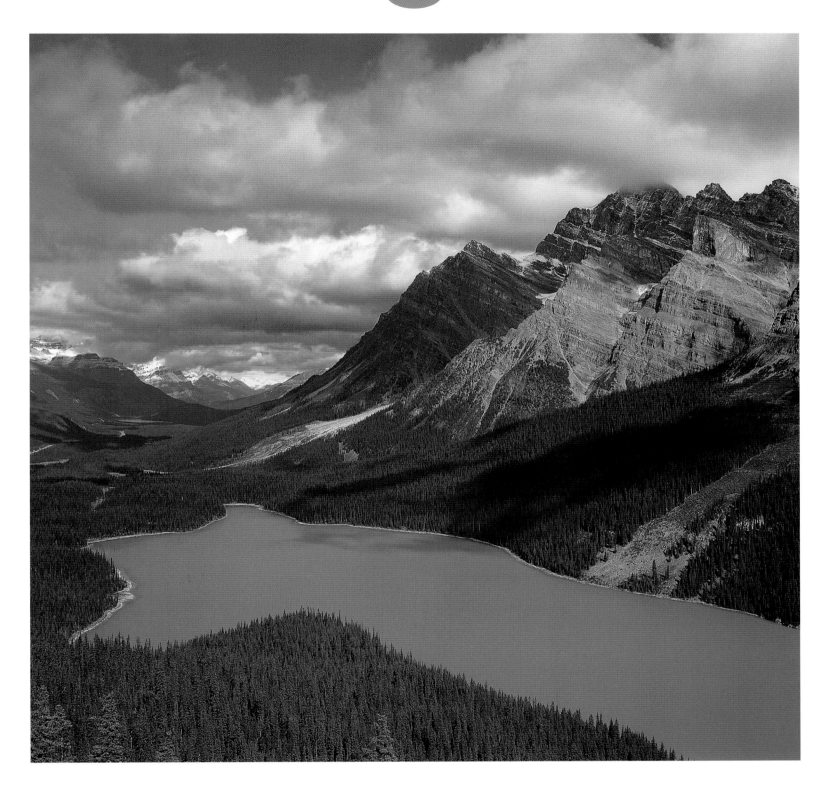

LEFT: Explorer Walter Wilcox named Moraine Lake in 1893, believing the debris at one end of the lake was a moraine left by a glacier. Geologists now believe it is the remains of a rock slide from the peak above.

ABOVE: Peyto Lake was a favourite camping site of Bill Peyto, a British-born outfitter whose knowledge of the Rockies made him one of the area's most respected guides.

PREVIOUS PAGES: Founded in 1885, Banff is the oldest national park in Canada and the second oldest in North America, after Yellowstone. Built to offer a panoramic view of the park, the Banff Springs Hotel was completed in 1888. At the time, it was the largest hotel in the world.

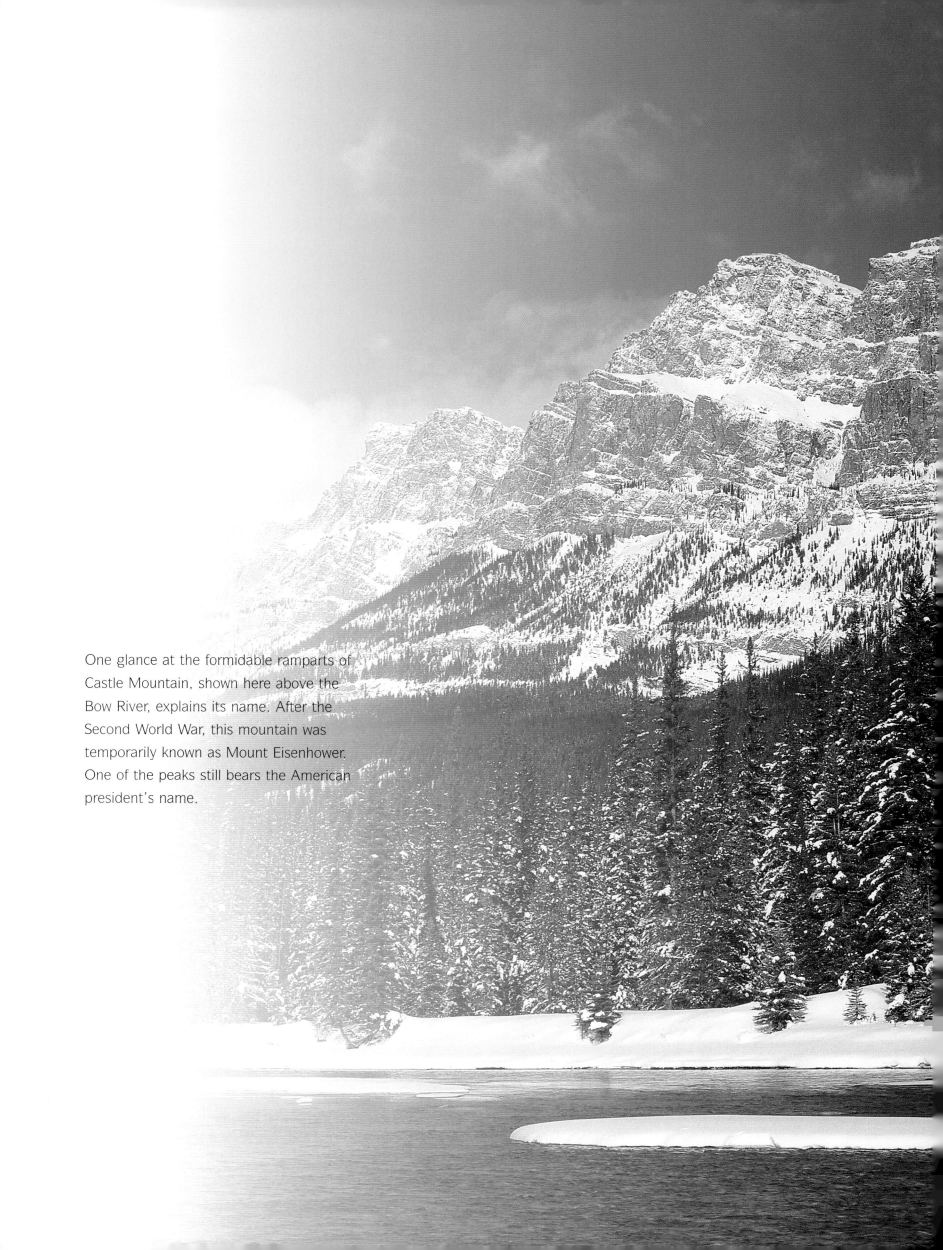

One glance at the formidable ramparts of
Castle Mountain, shown here above the
Bow River, explains its name. After the
Second World War, this mountain was
temporarily known as Mount Eisenhower.
One of the peaks still bears the American
president's name.

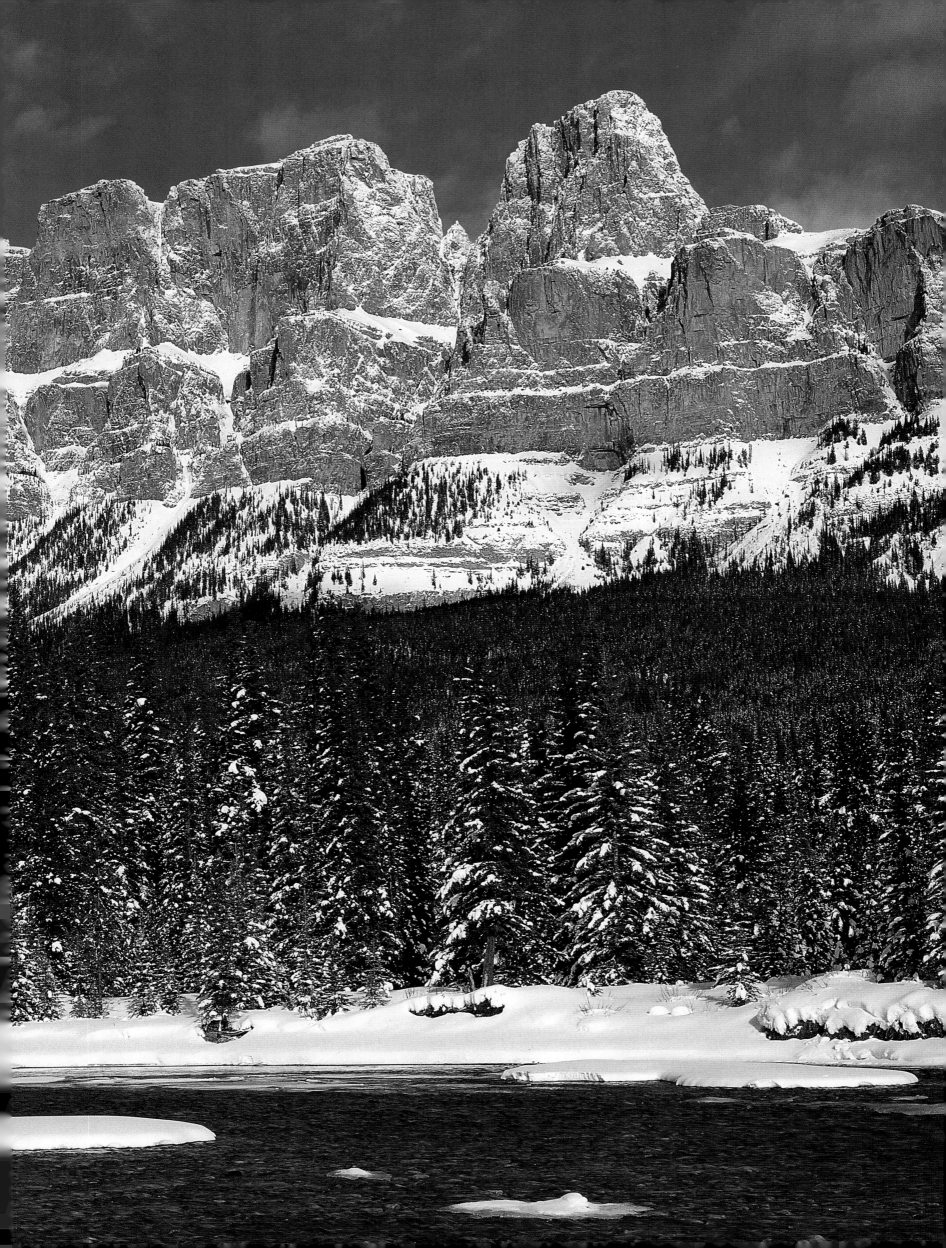

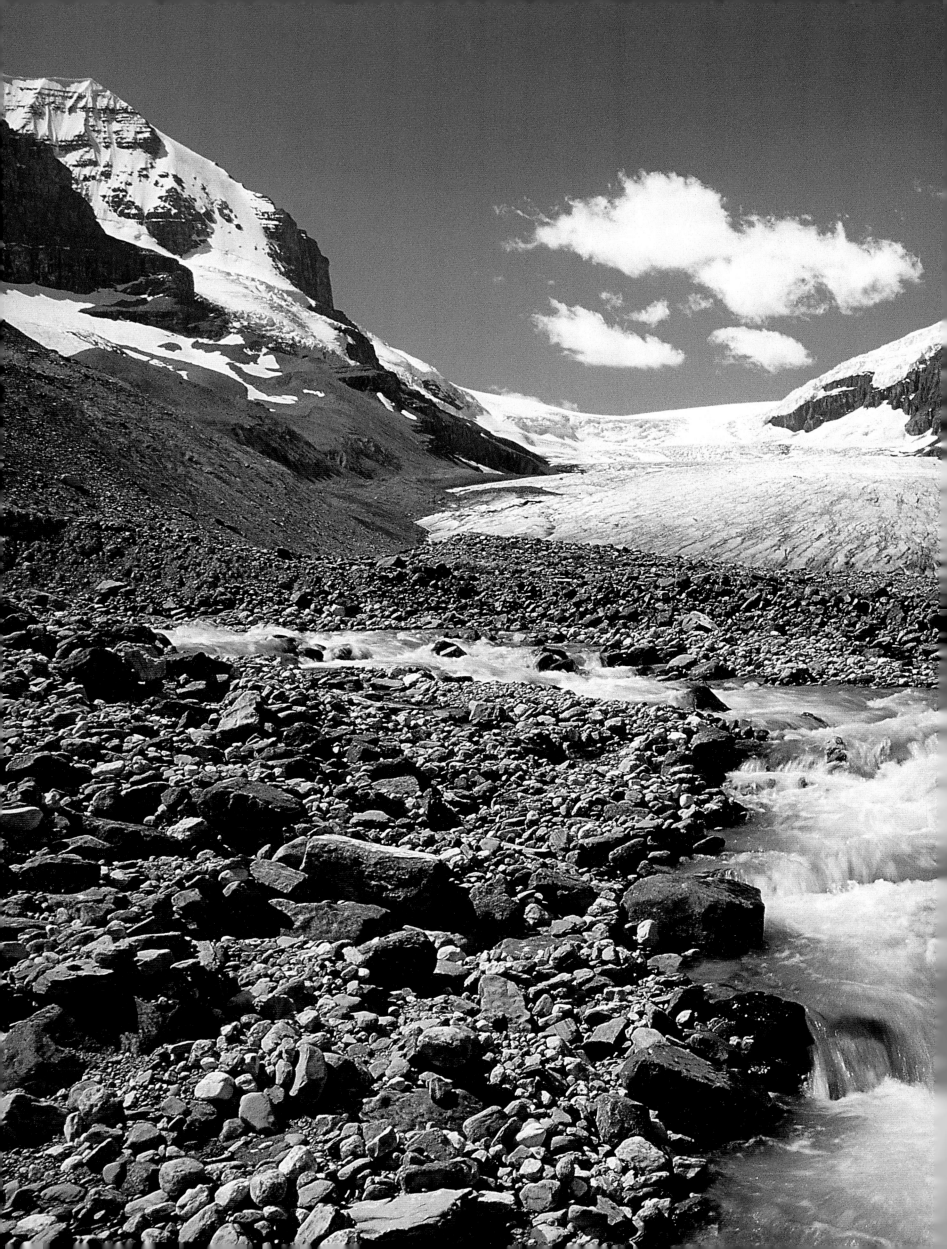

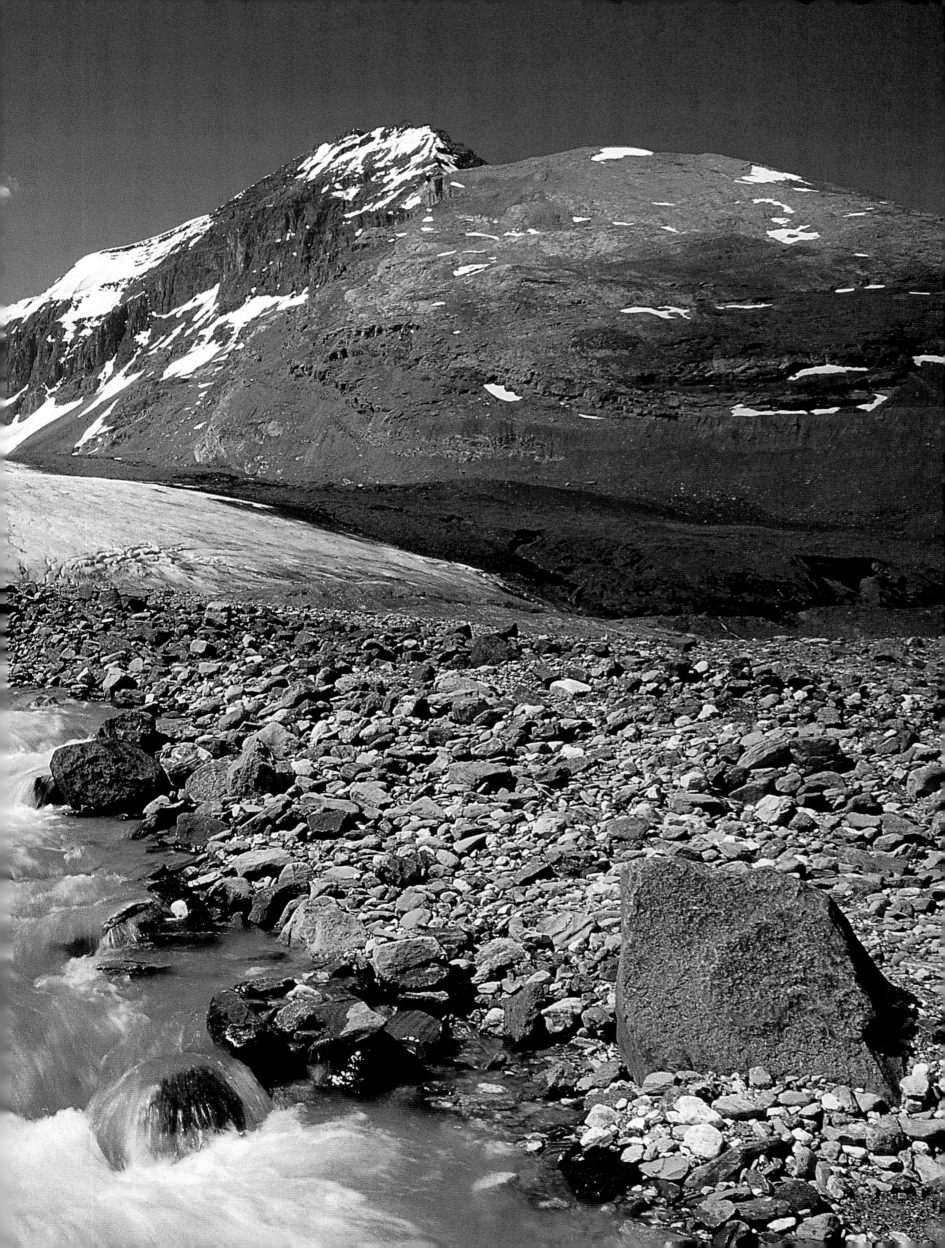

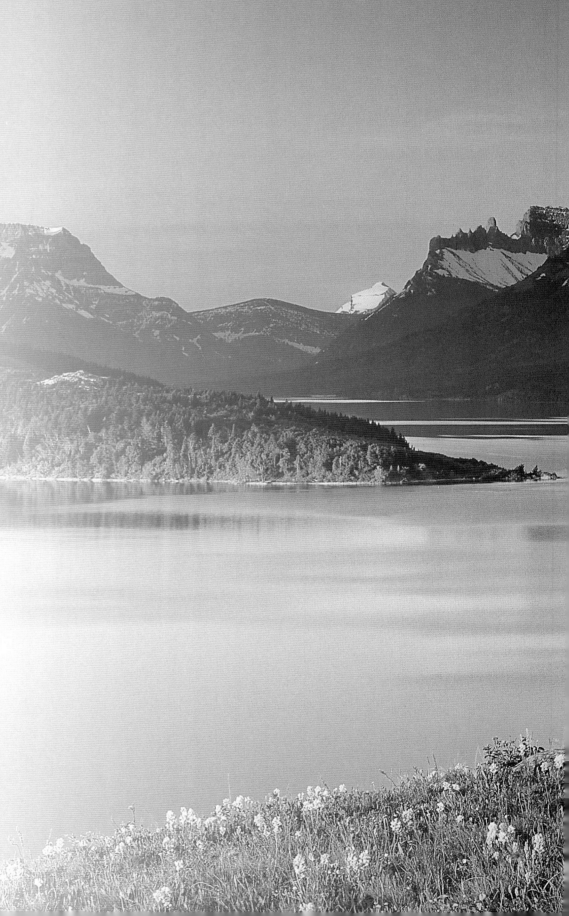

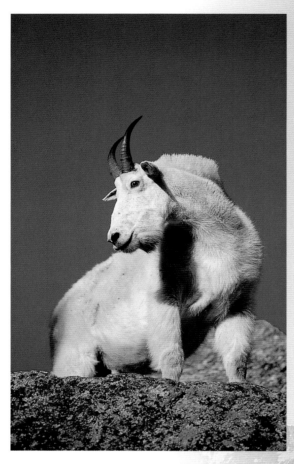

ABOVE: A mountain goat's narrow body allows it to walk tiny ledges. Its rubbery hooves cling to the rough stone, and its sharp eyes help it accurately gauge heights and distances. These adaptations to climbing allow the animal to graze high in the alpine.

RIGHT: Built by the American company Great Northern Railroad to serve its passengers, the Prince of Wales Hotel is the largest wood-framed building in Alberta. The hotel lies within the Waterton-Glacier International Peace Park. Created in 1932 between Alberta and Montana, this was the first park of its kind in the world.

PREVIOUS PAGES: The Columbia Icefield between Mount Columbia and Mount Athabasca is up to 365 metres (1200 feet) deep. The largest icefield south of the Arctic Circle, it includes about 30 glaciers.

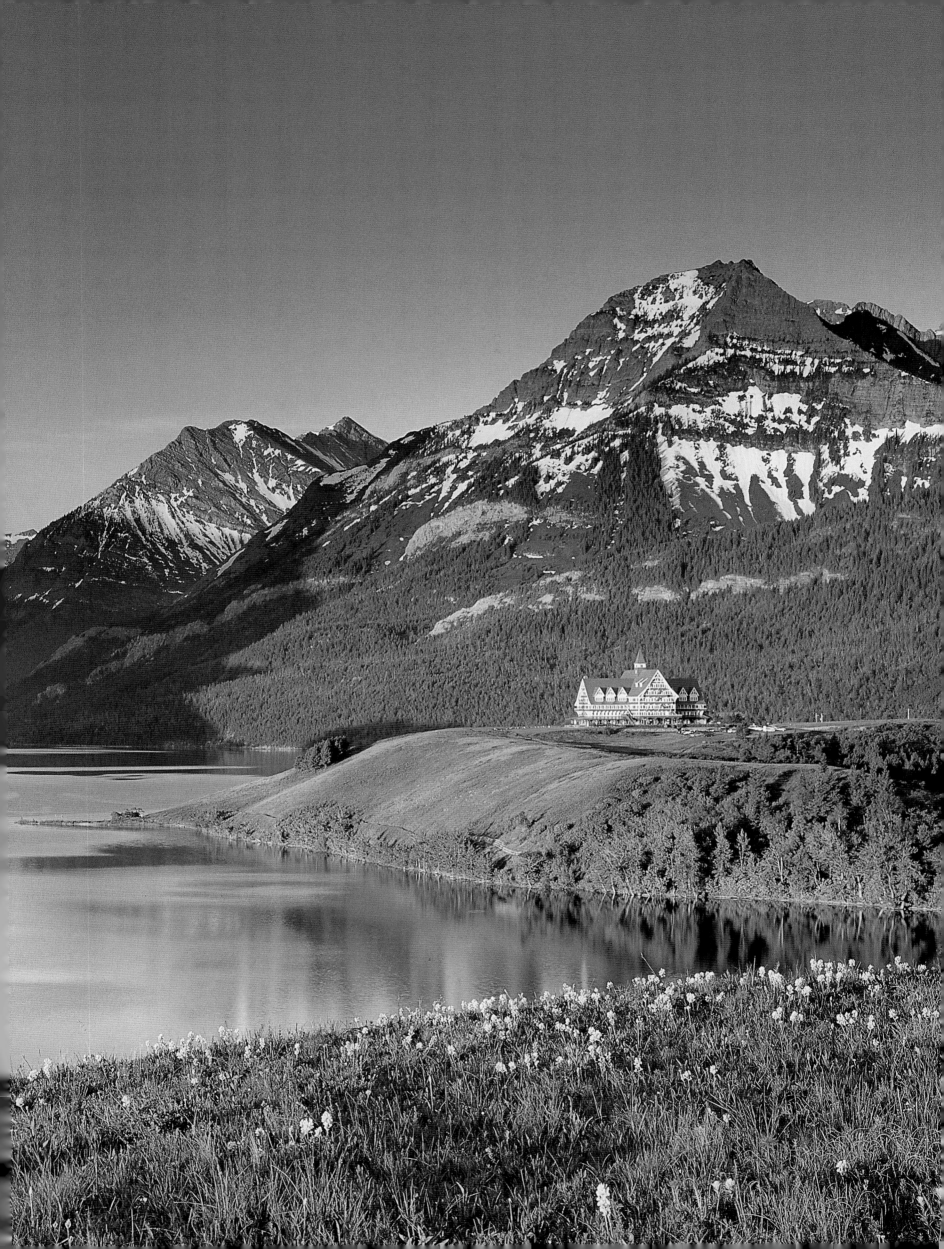

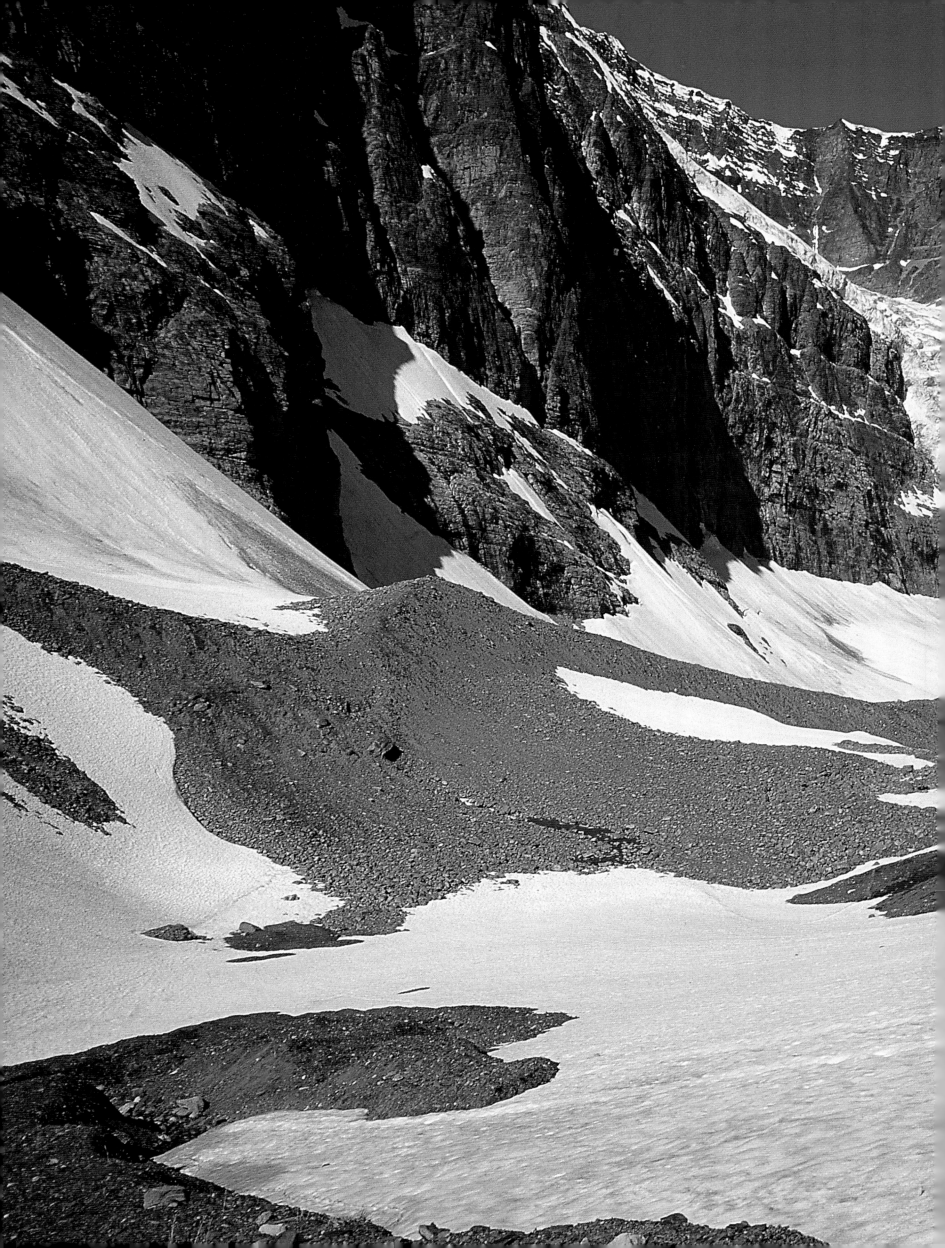

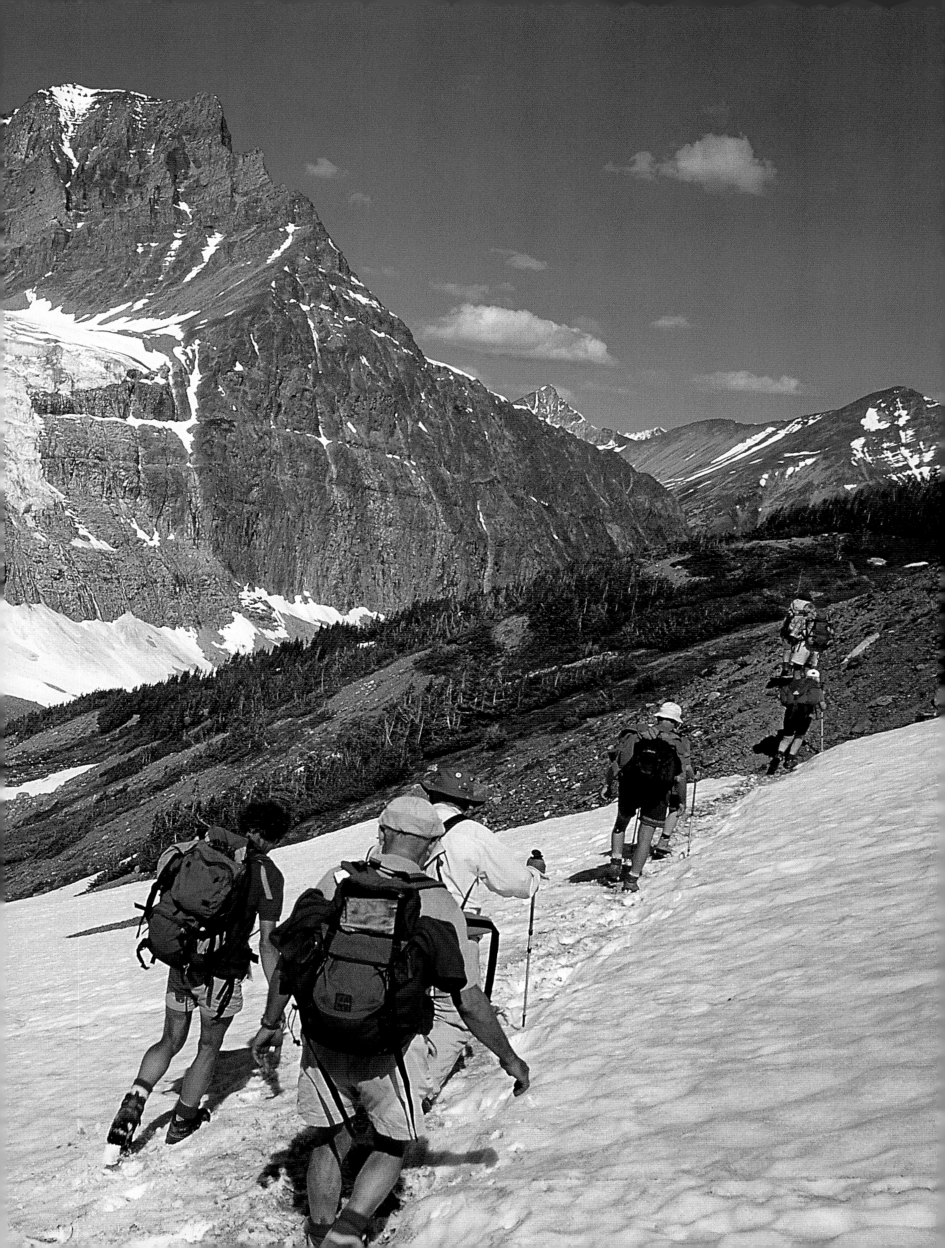

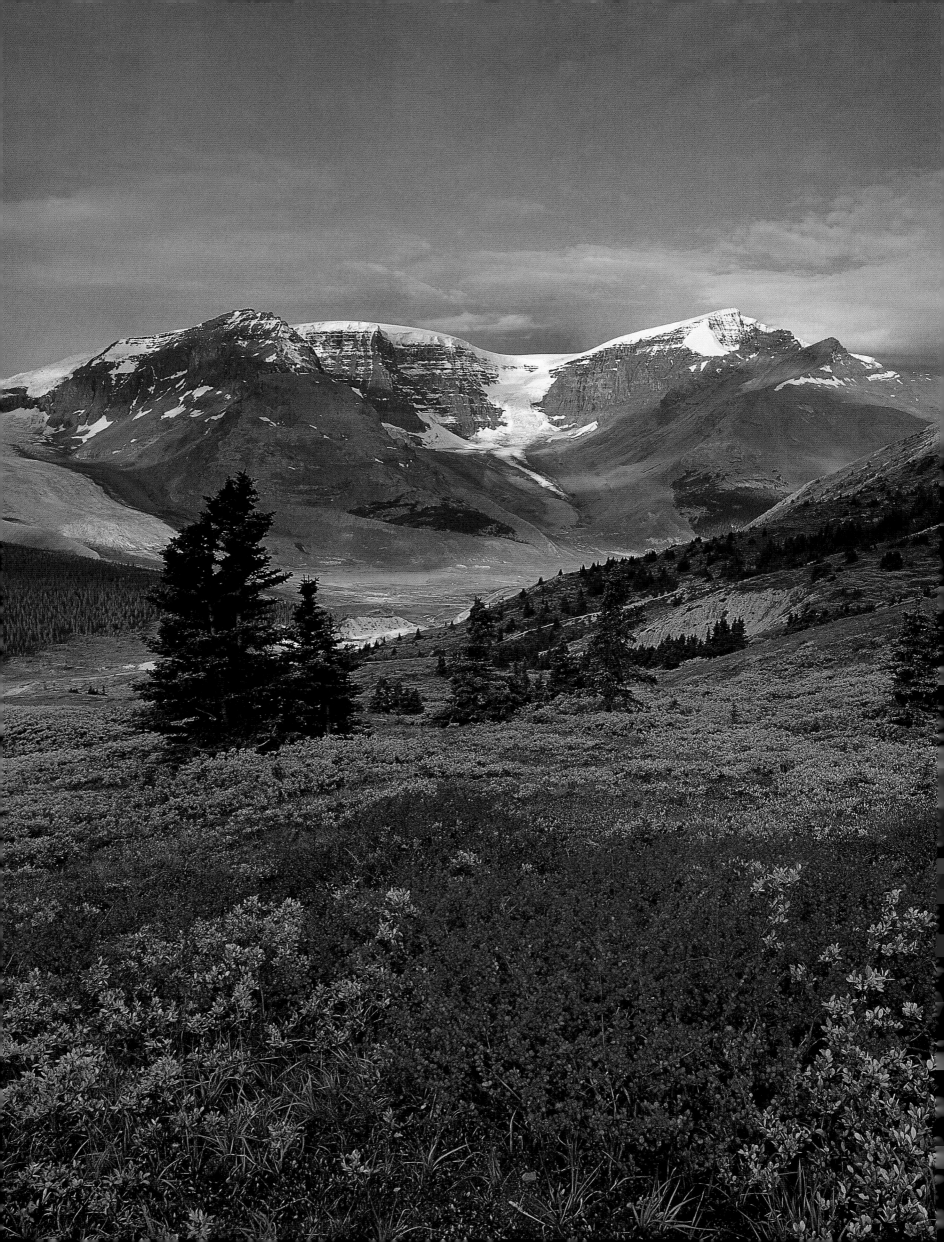

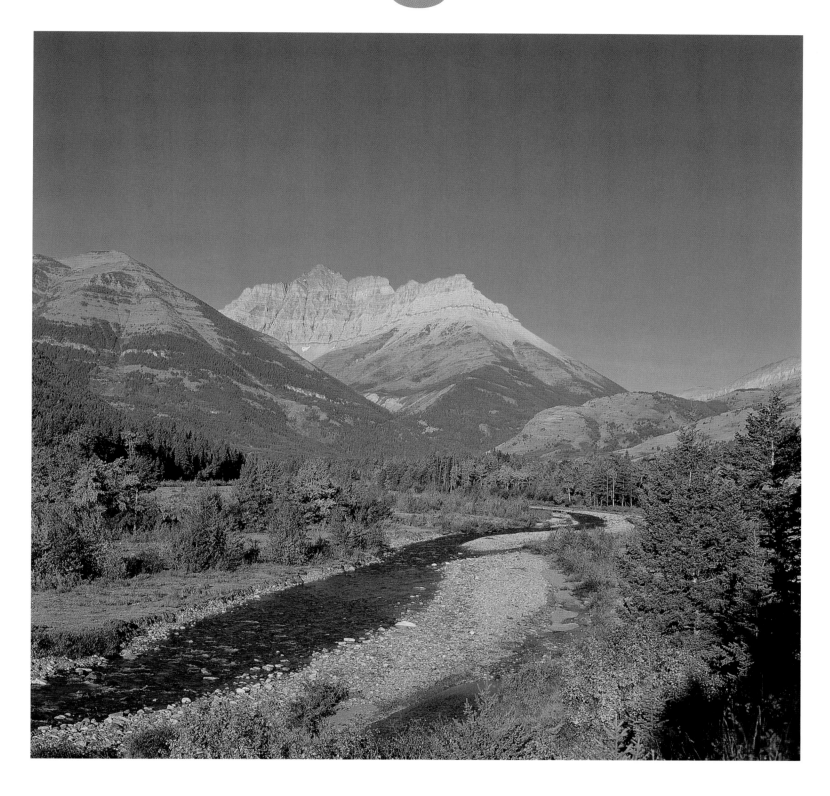

LEFT: Wilcox Pass is named for Walter Wilcox, a Yale College student, photographer, and amateur geologist who explored the Rockies in the late 19th century. Wilcox was one of the first non-Natives to see Moraine Lake, the Valley of the Ten Peaks, Paradise Valley, and many other natural wonders of the range.

ABOVE: Created as a recreational area by the Alberta government in 1977, Kananaskis Country includes several distinct ecosystems, from aspen groves and dry grasslands to rugged foothills and alpine peaks. The 4250-square-kilometre (1640-square-mile) preserve also includes three provincial parks: Peter Lougheed, Bow Valley, and Bragg Creek.

PREVIOUS PAGES: A guide leads adventurous climbers over the surface of a glacier in Jasper National Park. Similar expeditions have been departing since the early 1900s, when the Canadian Pacific Railway established the park to draw passengers to the Rockies.

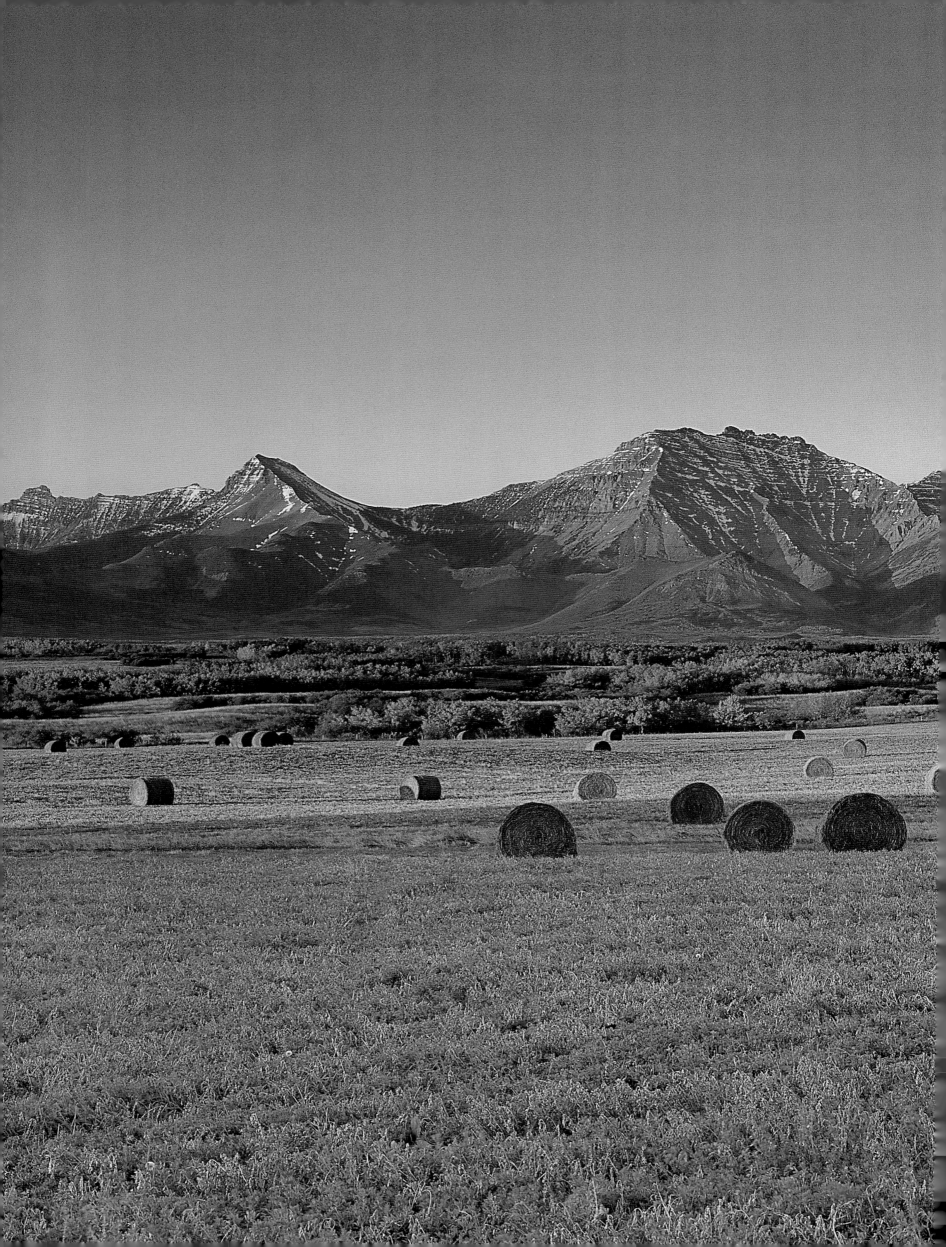

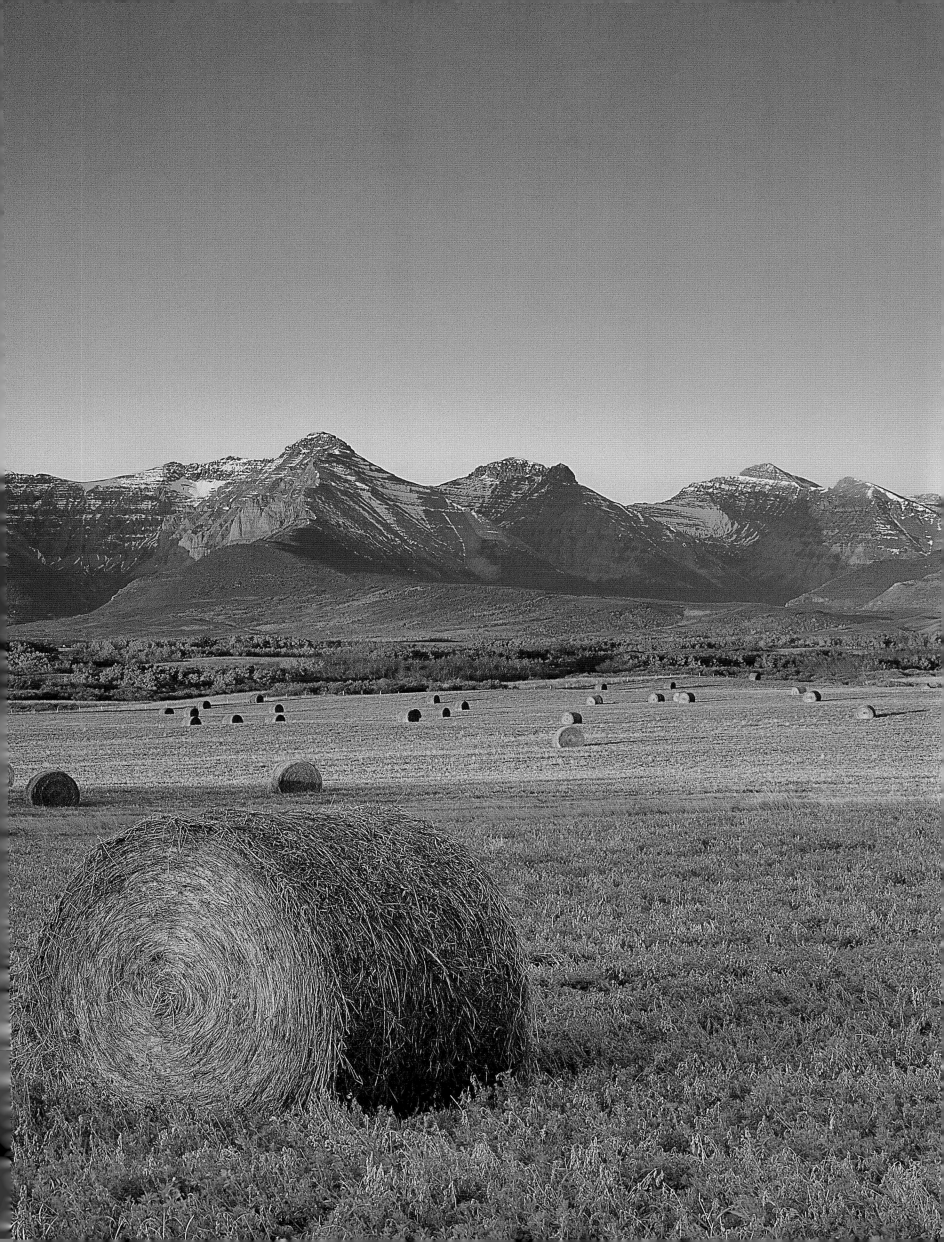

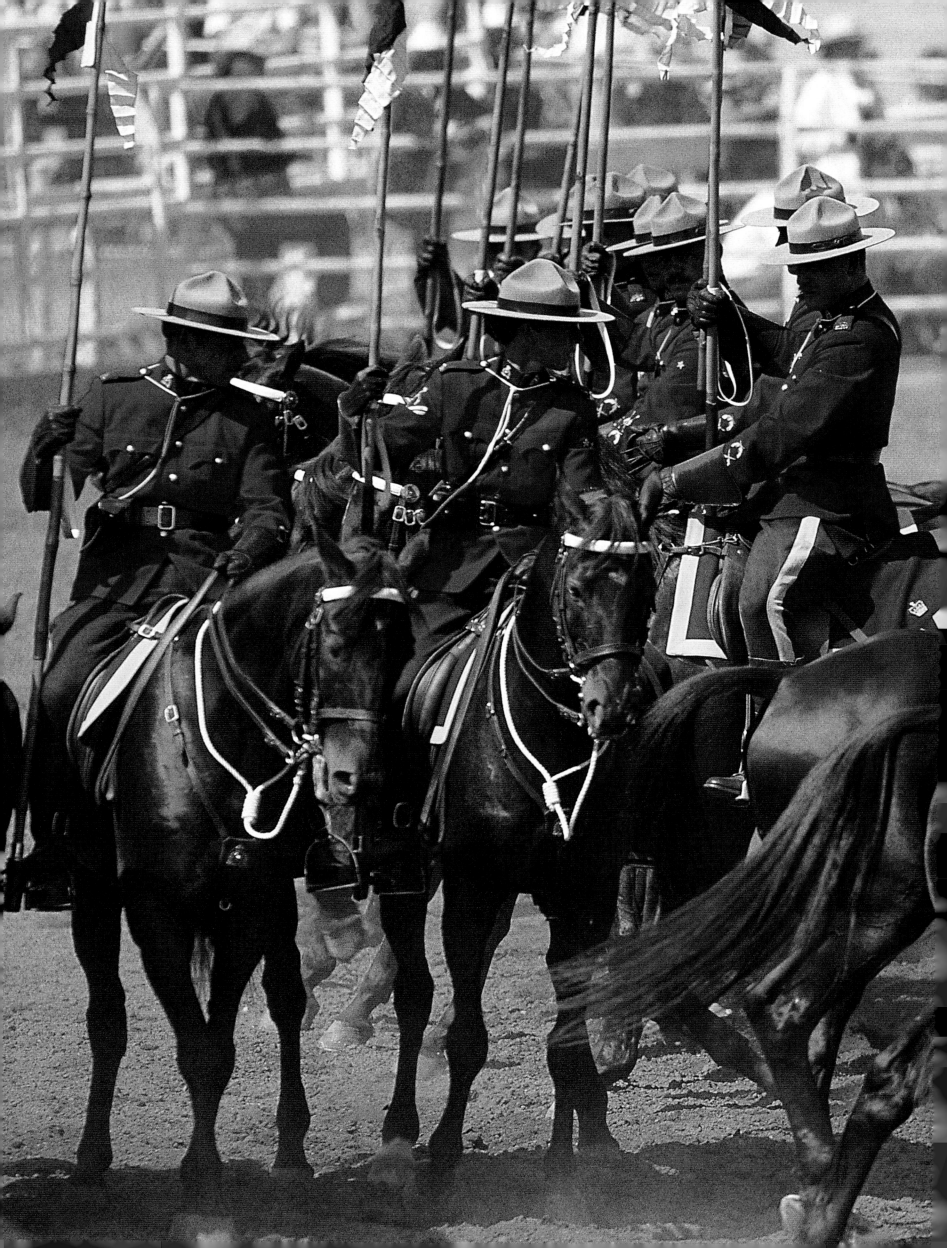

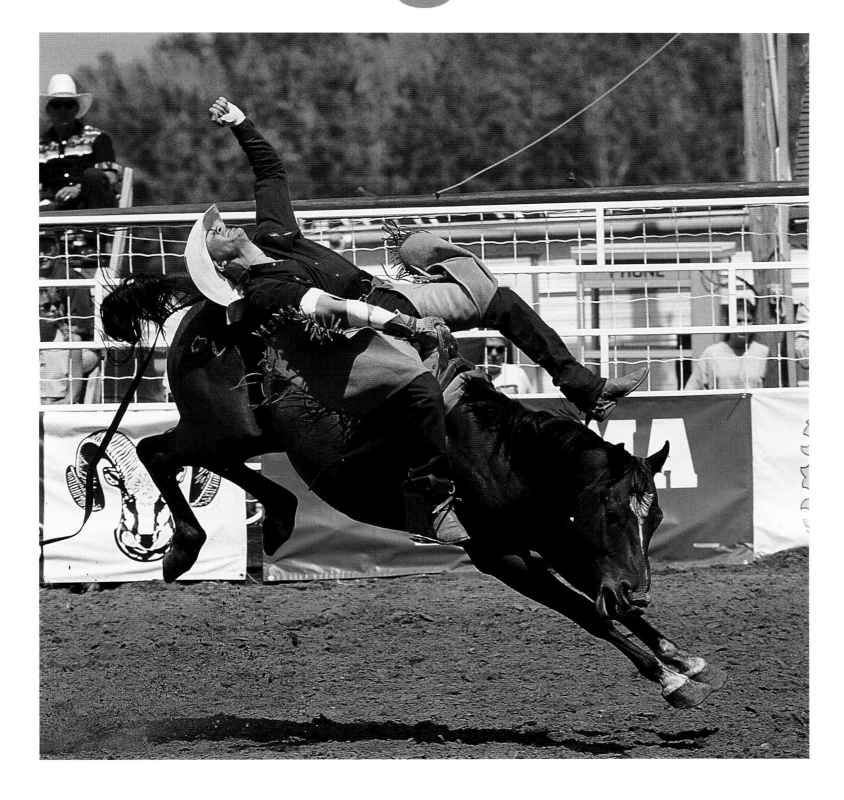

LEFT: The Royal Canadian Mounted Police Musical Ride entertains as part of the festivities at the Calgary Stampede. An adaptation of 19th-century practice drills, the musical ride is performed around the country by specially trained RCMP officers.

ABOVE: The Calgary Exhibition and Stampede is the largest annual event in Canada. The July festivities include a 10-day rodeo, a parade, games, exhibits, and shows — events which draw 100,000 people a day to Stampede Park.

PREVIOUS PAGES: Alberta, Saskatchewan, and Manitoba encompass about 80 percent of the nation's farmland, producing the vast majority of Canada's wheat, barley, rye, oats, and canola.

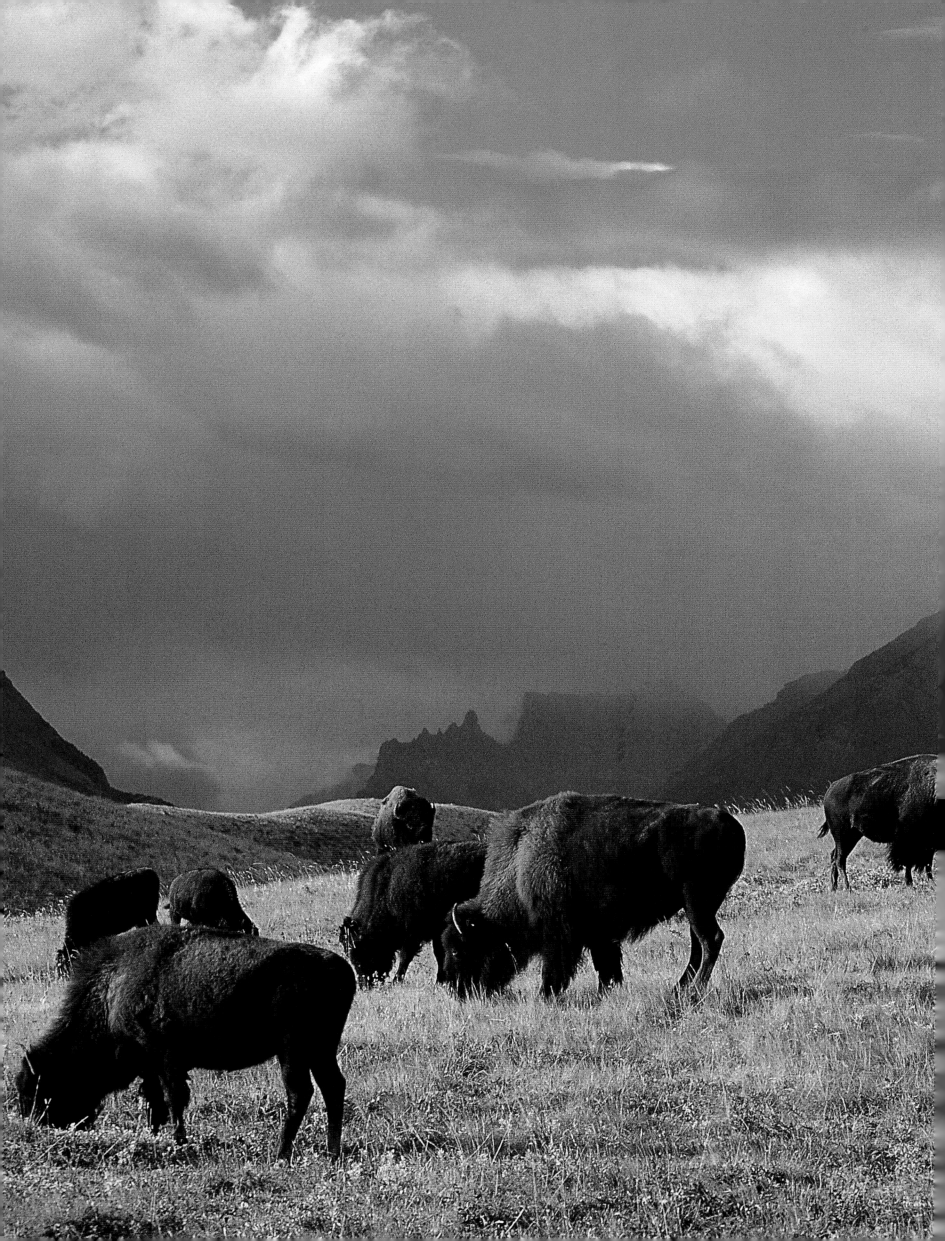

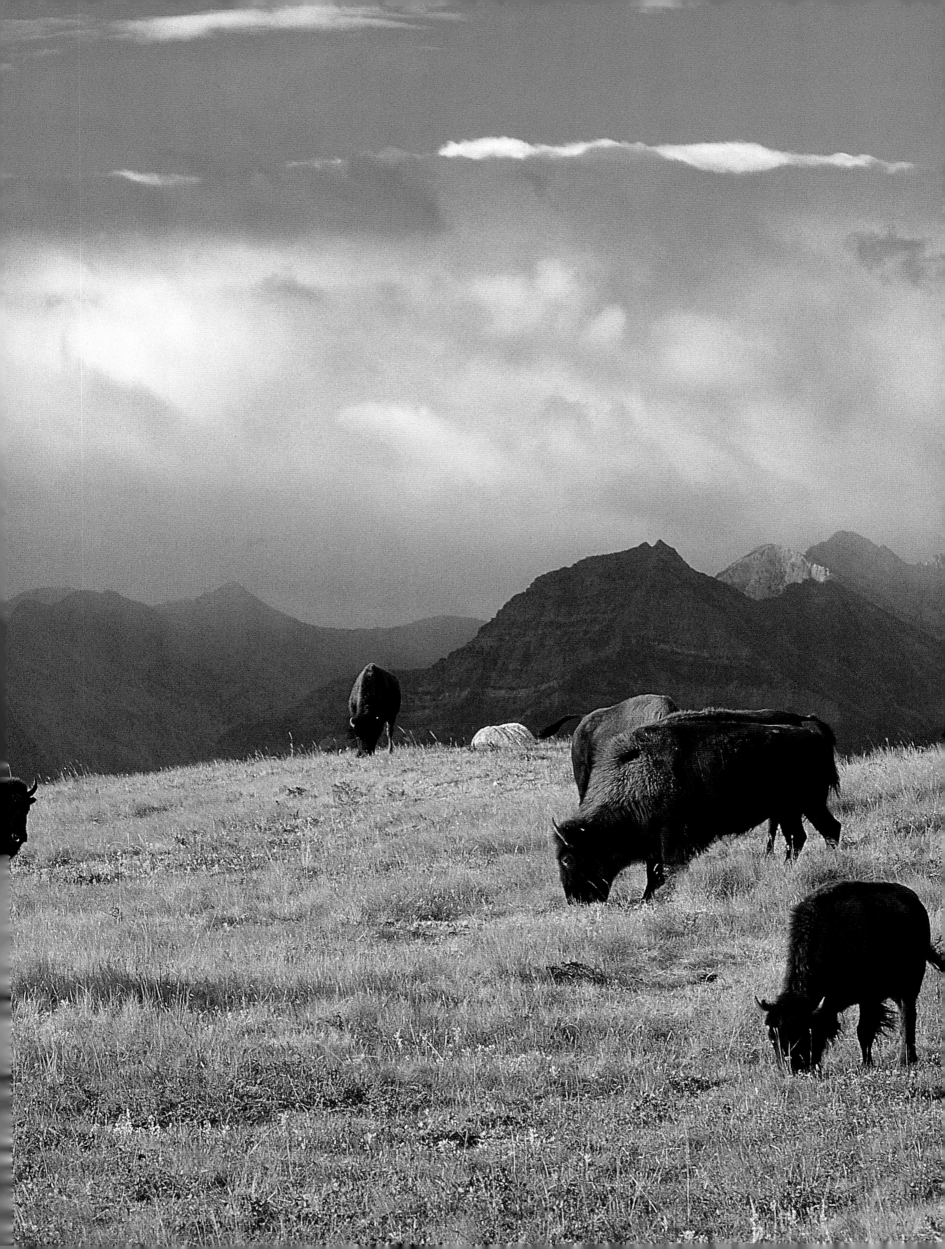

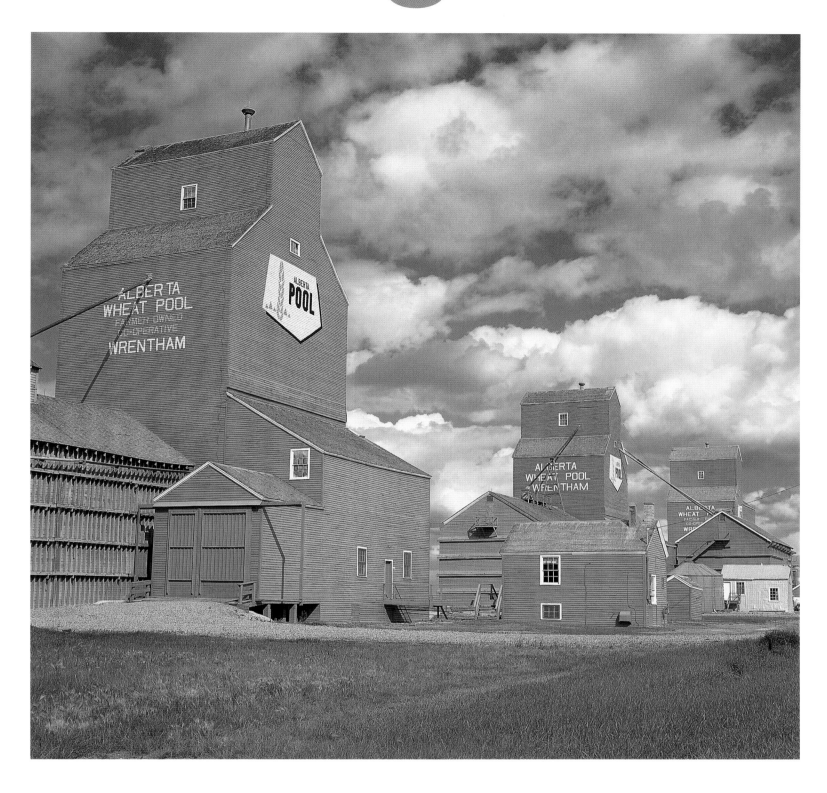

LEFT: This hayfield near Rollyview is one of more than 59,000 farms in Alberta. A total of 20 million hectares (50 million acres) of land is dedicated to agriculture in the province.

ABOVE: The rail lines that first brought settlers to Alberta are still a vital part of the province, connecting the vast agricultural lands to their urban markets.

PREVIOUS PAGES: Herds of bison once again roam Alberta's grasslands in areas set aside as a wildlife preserve, after a close brush with extinction in the late 1800s. One of the main threats to the animal today is the dwindling prairie, as agriculture and urban areas envelop more land.

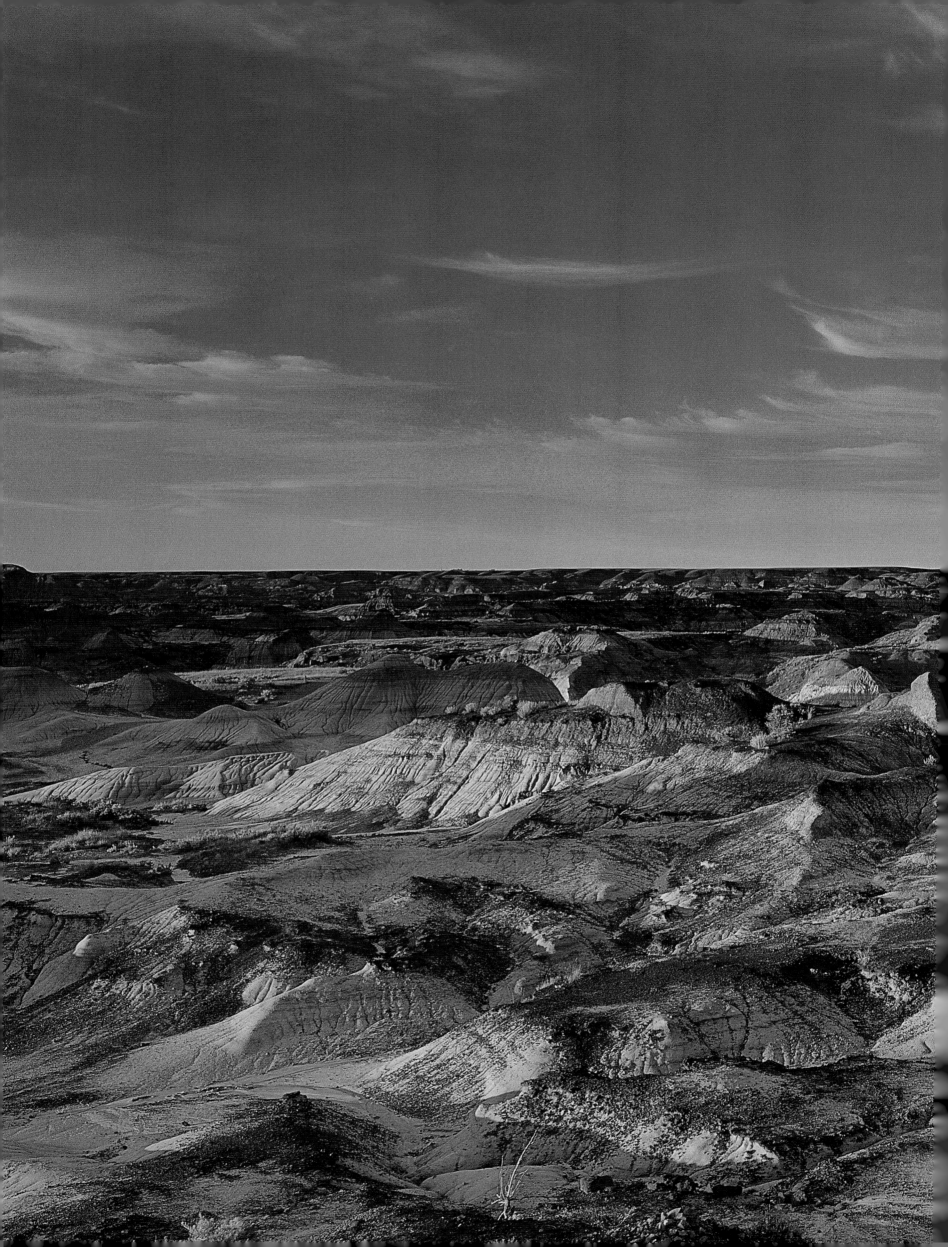

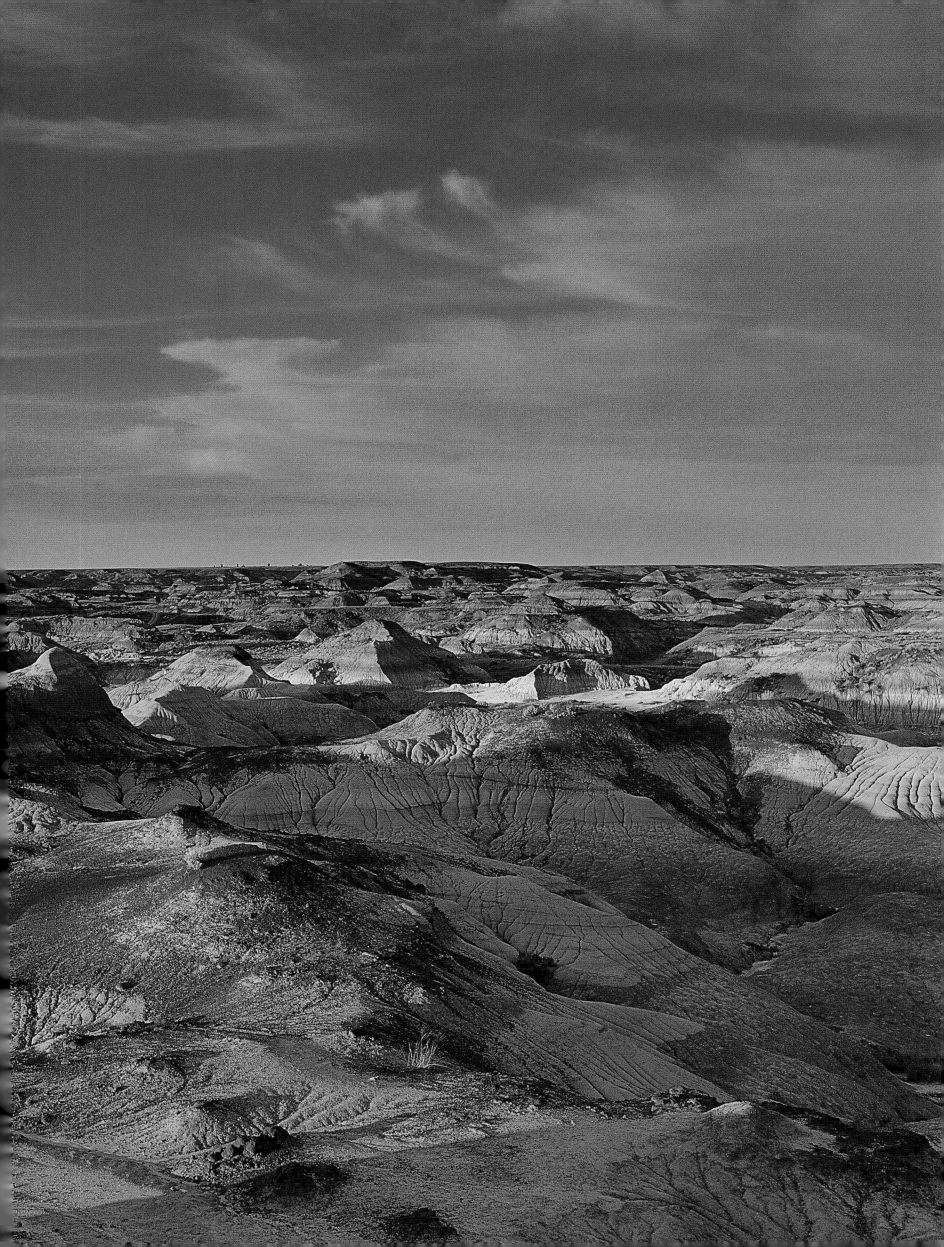

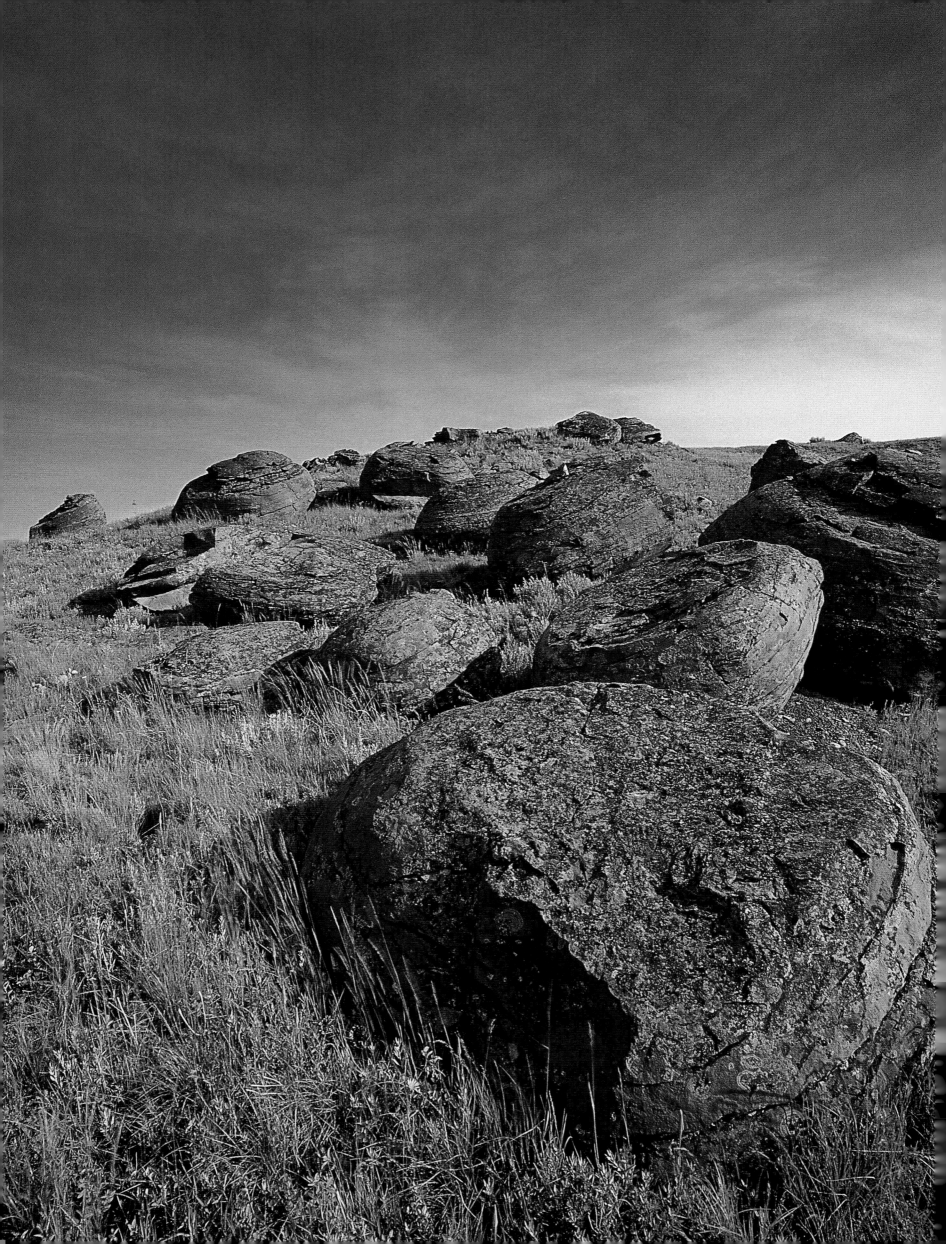

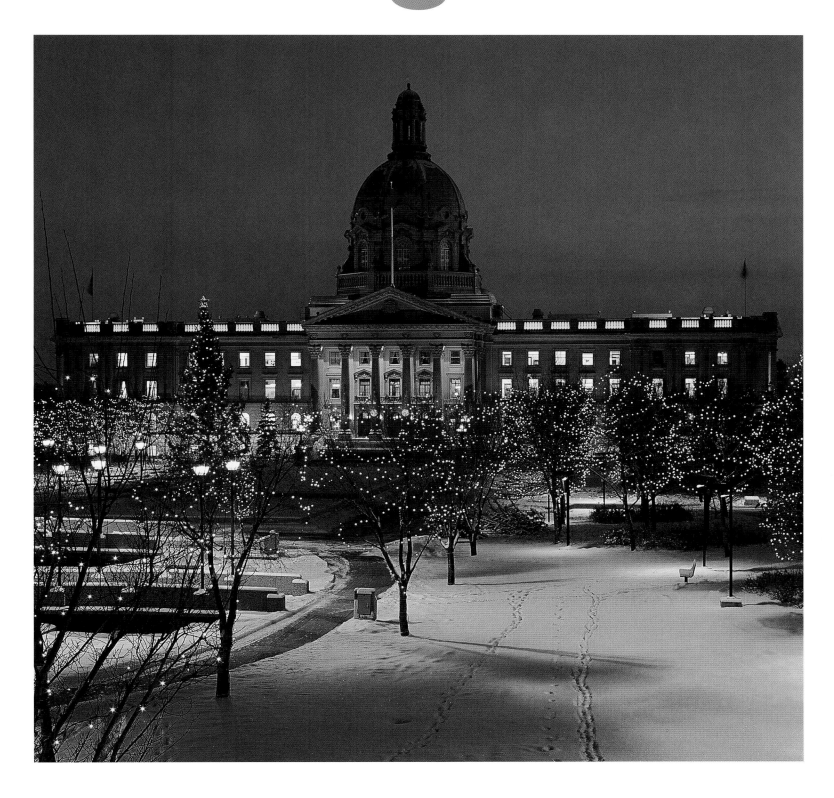

LEFT: These sandstone boulders are slowly emerging from the earth, as the soil around them is blown away. They are part of the Red Rock Coulee Natural Area, just south of Seven Persons.

ABOVE: The Legislative Buildings were completed in 1912 on the site of Edmonton's original fur-trading posts. Fort Augustus was built in the 1700s by the North West Company to capitalize on the area's high populations of beaver and muskrat. The Hudson's Bay Company built Fort Edmonton nearby in 1795.

PREVIOUS PAGES: Dinosaurs roamed these badlands 75 million years ago. Archeologists have unearthed the bones of more than 30 species — 17 percent of the world's known dinosaur species — in Dinosaur Provincial Park. The skeletons share the earth with crocodile and clam fossils, signs of the once lush climate.

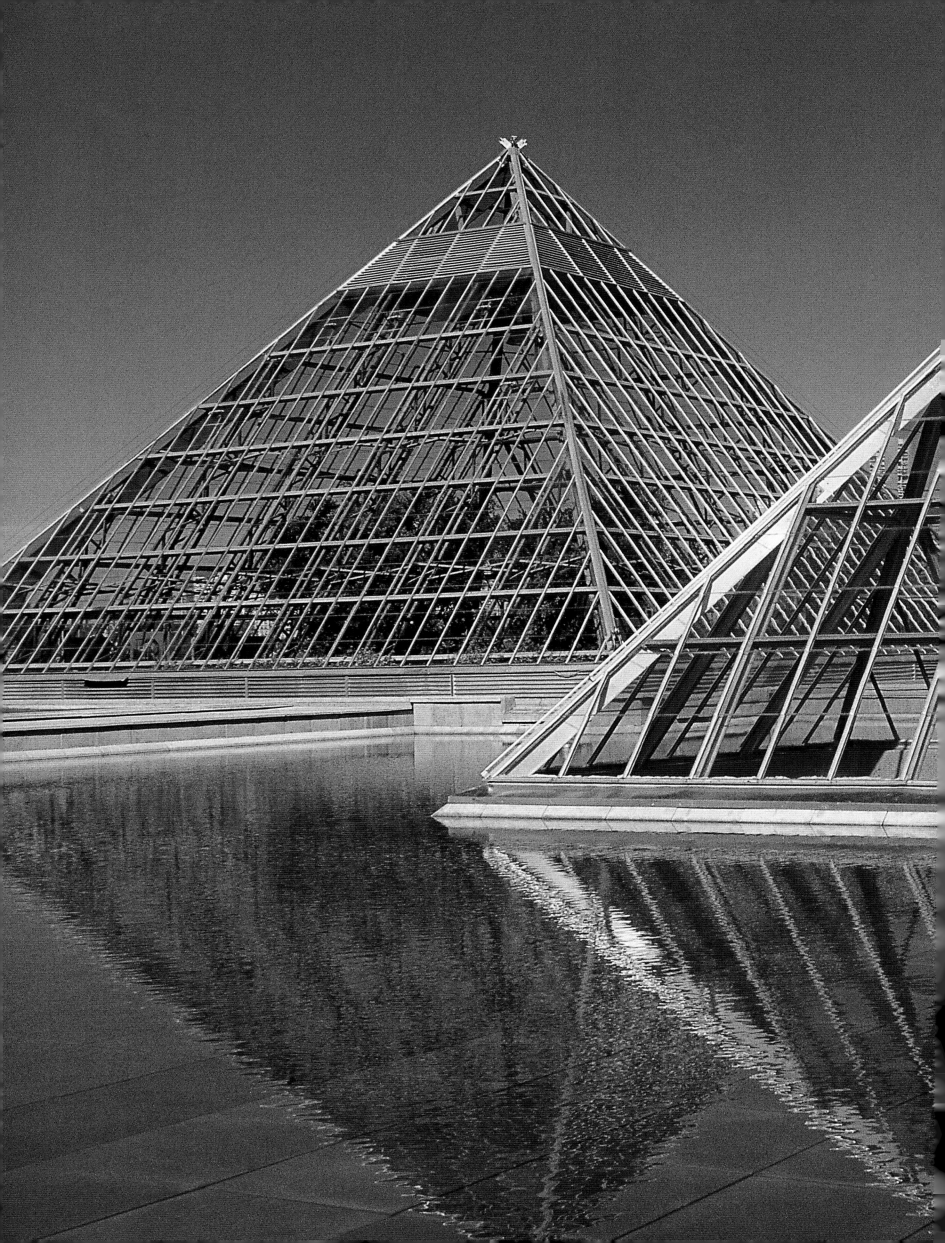

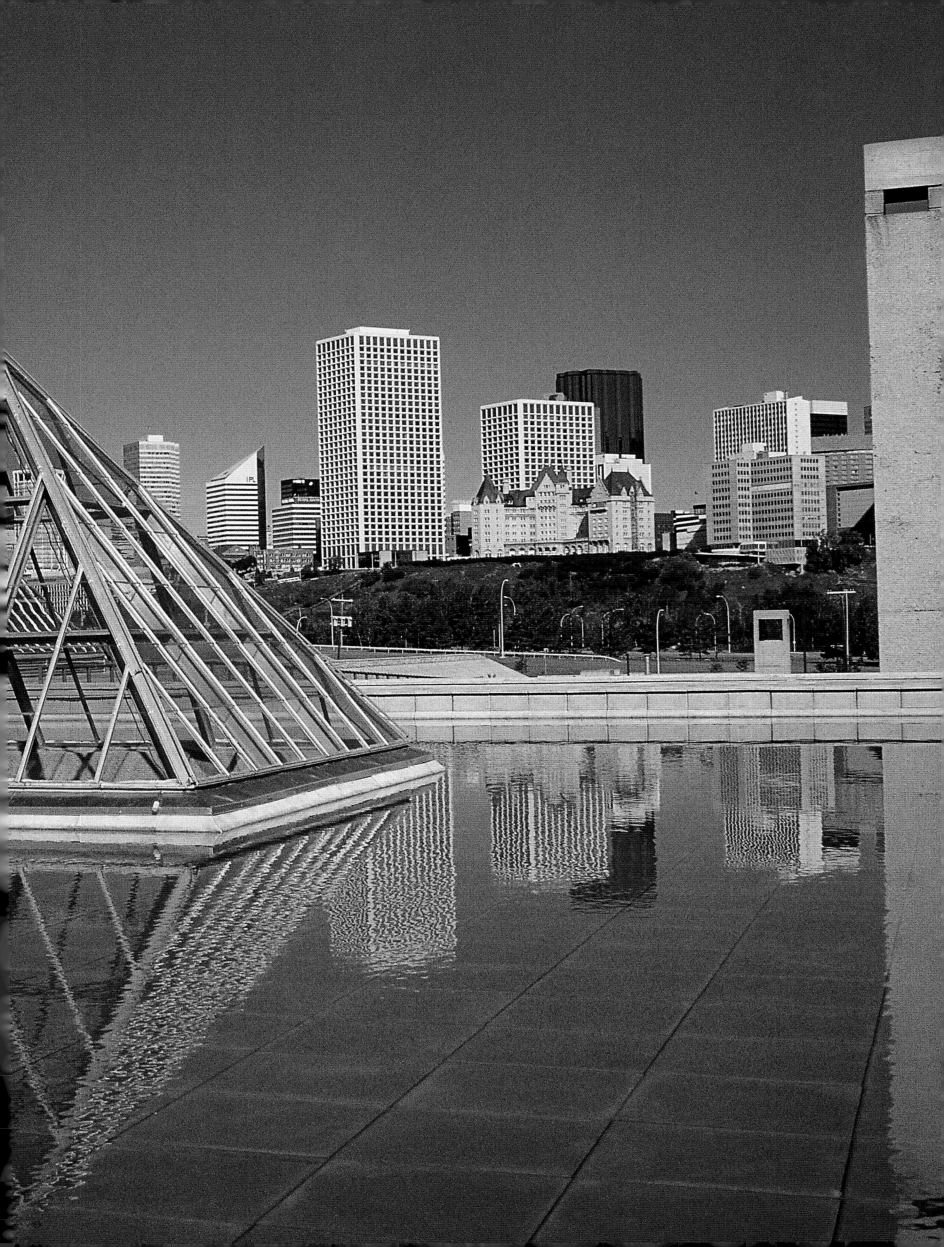

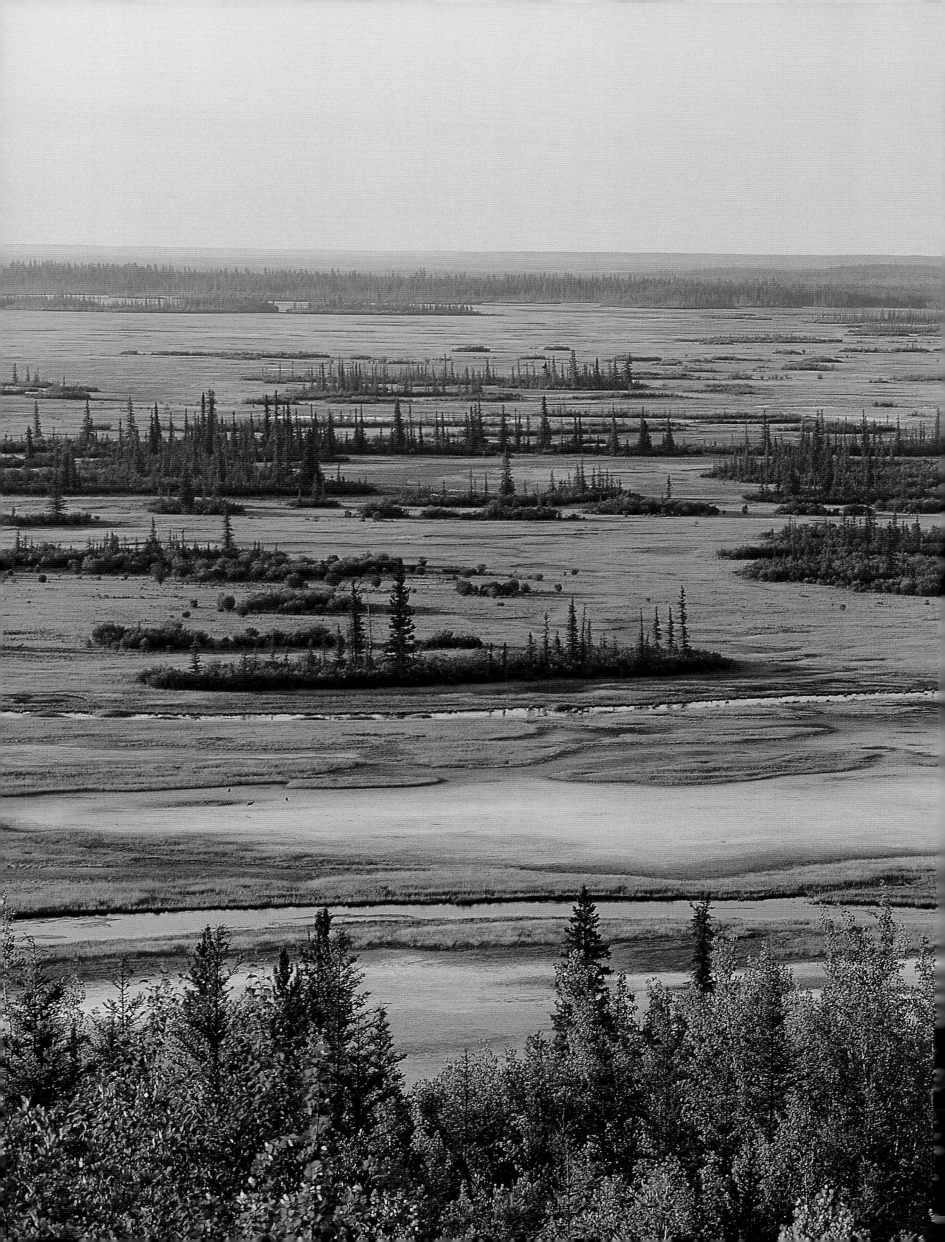

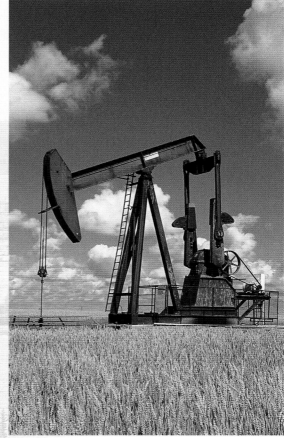

ABOVE: Crude oil, heavy oil, and oil sands have been unearthed throughout the province, beginning with the 1914 discovery in the Turner Valley. In the 1970s, the seemingly unending resources created more millionaires than at any other time in Canadian history.

LEFT: Wood Buffalo National Park extends from Alberta into the Northwest Territories. It's one of the largest national preserves in the world, second only to a park in Greenland. The world's largest bison herd roams the park, while the rare whooping crane nests in the wetlands.

PREVIOUS PAGES: Three of the unique pyramid-style greenhouses of Edmonton's Muttart Conservatory replicate tropical, temperate, and arid climates. The fourth hosts changing exhibits of flora from around the world.

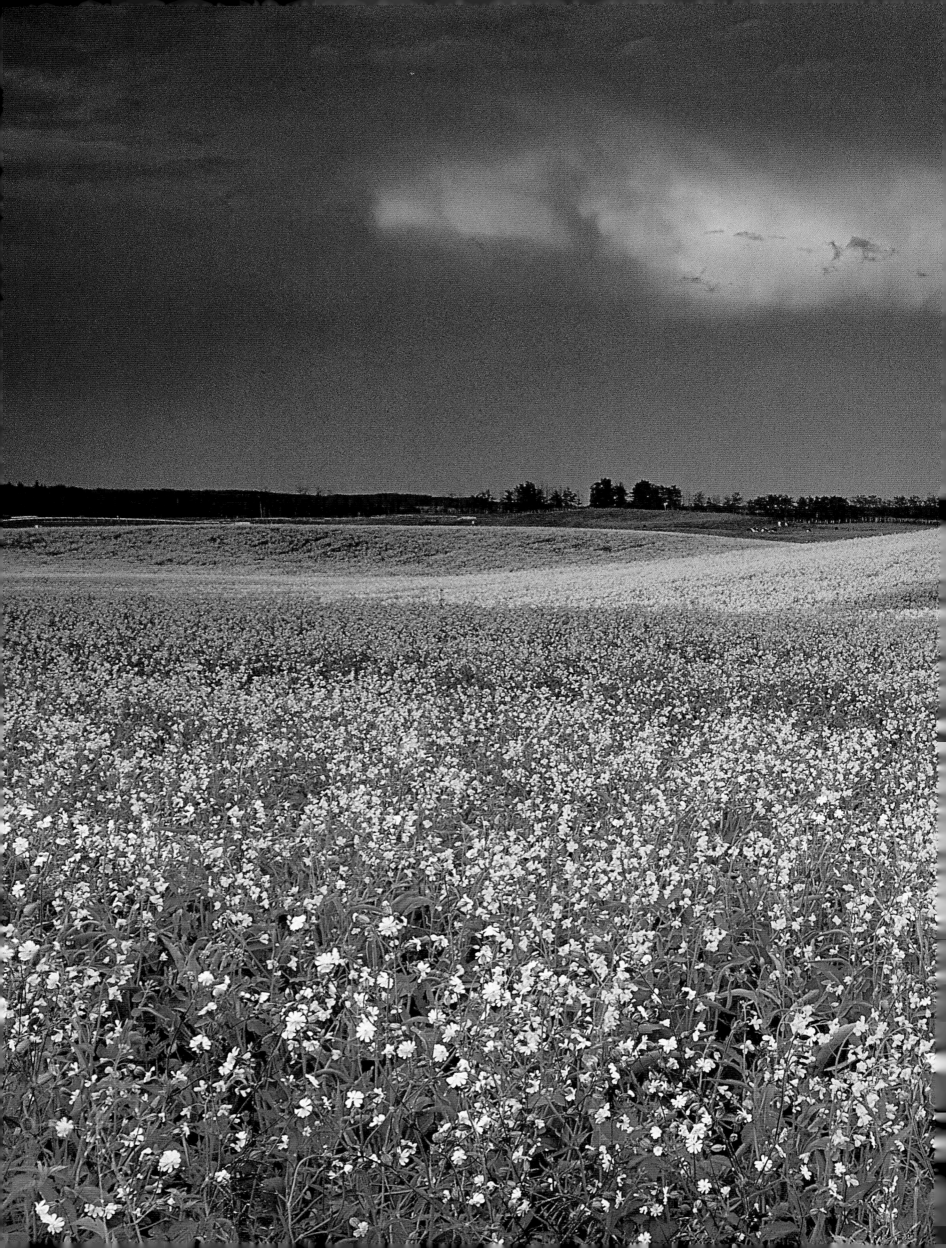

In the 1920s, Canada's national park system was a fledgling organization struggling to attract visitors and support. But when J.C. Campbell, the parks department's director of publicity, stumbled across a unique lecturer in Quebec, he was sure his marketing problems were solved. The lecturer was Grey Owl, and he spoke about conservation issues with the help of two pet beavers, Jelly Roll and Rawhide. Campbell suggested that the government install Grey Owl and the beavers in a national park, creating a natural draw for visitors.

The government agreed, and after a brief stint in Manitoba's Riding Mountain National Park, Grey Owl settled into a cabin on Ajawaan Lake in Saskatchewan's Prince Albert National Park. His pets moved in as well, constructing a beaver lodge half outside and half inside the cabin.

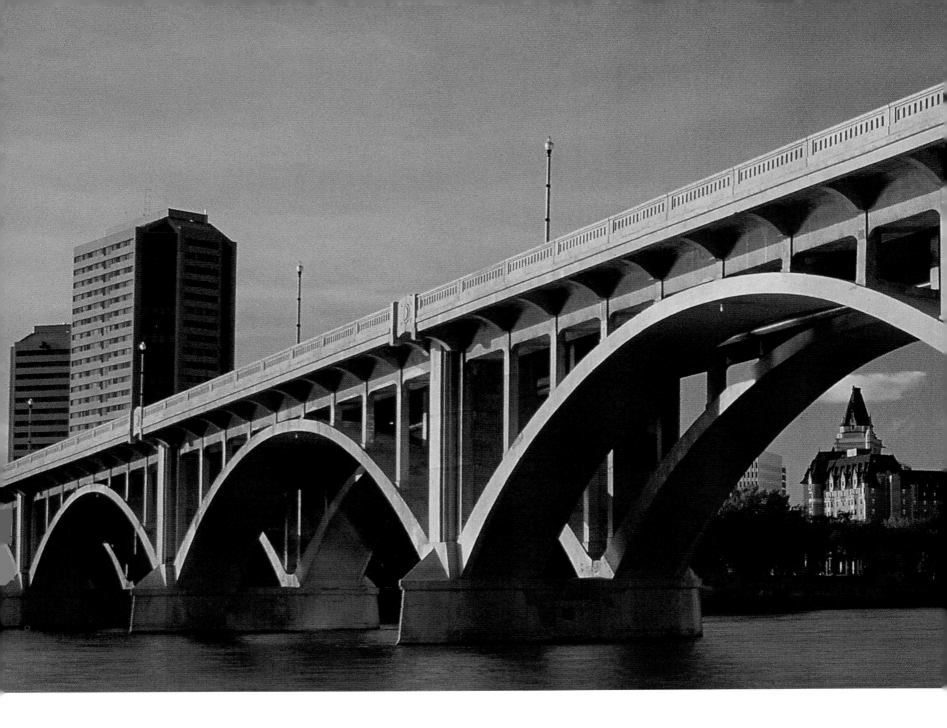

For the next seven years, Grey Owl spoke to park visitors about the threatened status of the beaver and the importance of nature. Costumed in beaded leather and an eagle-feather headdress, he travelled to Britain to promote his writings, including *Pilgrims of the Wild* and the children's story *Sajo and the Beaver People*. By 1936, 600 people a year were visiting his cabin in the woods, and tents had to be erected to hold his fan mail. What his fans didn't know, however, was that Grey Owl was a construct of his own imagination.

In his stories, Grey Owl told of his birth in Mexico to a Scottish father and an Apache mother, and his childhood in northern Ontario with the Ojibway people. In reality, he was born Archibald Stansfield Belaney in Hastings, England — a fact discovered shortly after his death in 1938. Belaney had travelled to Canada from England in 1906 and worked as a clerk, guide, mail carrier, forest ranger, and trapper, learning more and more about the ways of the Ojibway people. In 1920, he took the name Grey Owl and began to speak about issues of conservation.

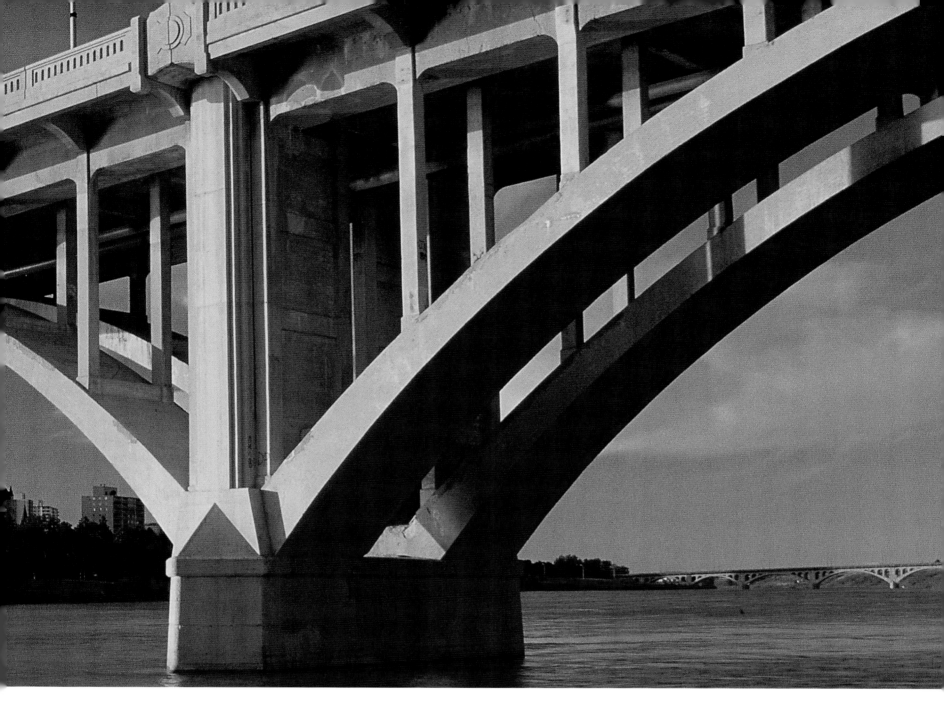

When the parks department discovered the truth, they immediately set out to inform Grey Owl's followers. The beaver restoration project at Ajawaan Lake was abandoned, and reply letters to fans explained the misconceptions. Despite the department's efforts, however, Grey Owl's legend continued to grow. The story of his identity seemed only to add to his allure. Today, he is seen as one of the first proponents of the conservation movement in Canada.

The park he helped to make famous is now one of more than 35 national parks and reserves in Canada, the largest encompassing over 44,000 square kilometres (17,000 square miles). Saskatchewan's own park system protects an additional 34 areas, ranging from wilderness preserves where large tracts of pristine land provide habitat for wildlife, to parks of historical and cultural significance. And like the legend of Grey Owl, the movement towards responsible management of the land in Saskatchewan and Canada continues to grow.

ABOVE: Saskatoon is often called the "City of Bridges," with seven spans across the South Saskatchewan River. Broadway Bridge links the historic Broadway Avenue, the city's oldest shopping district, with downtown.

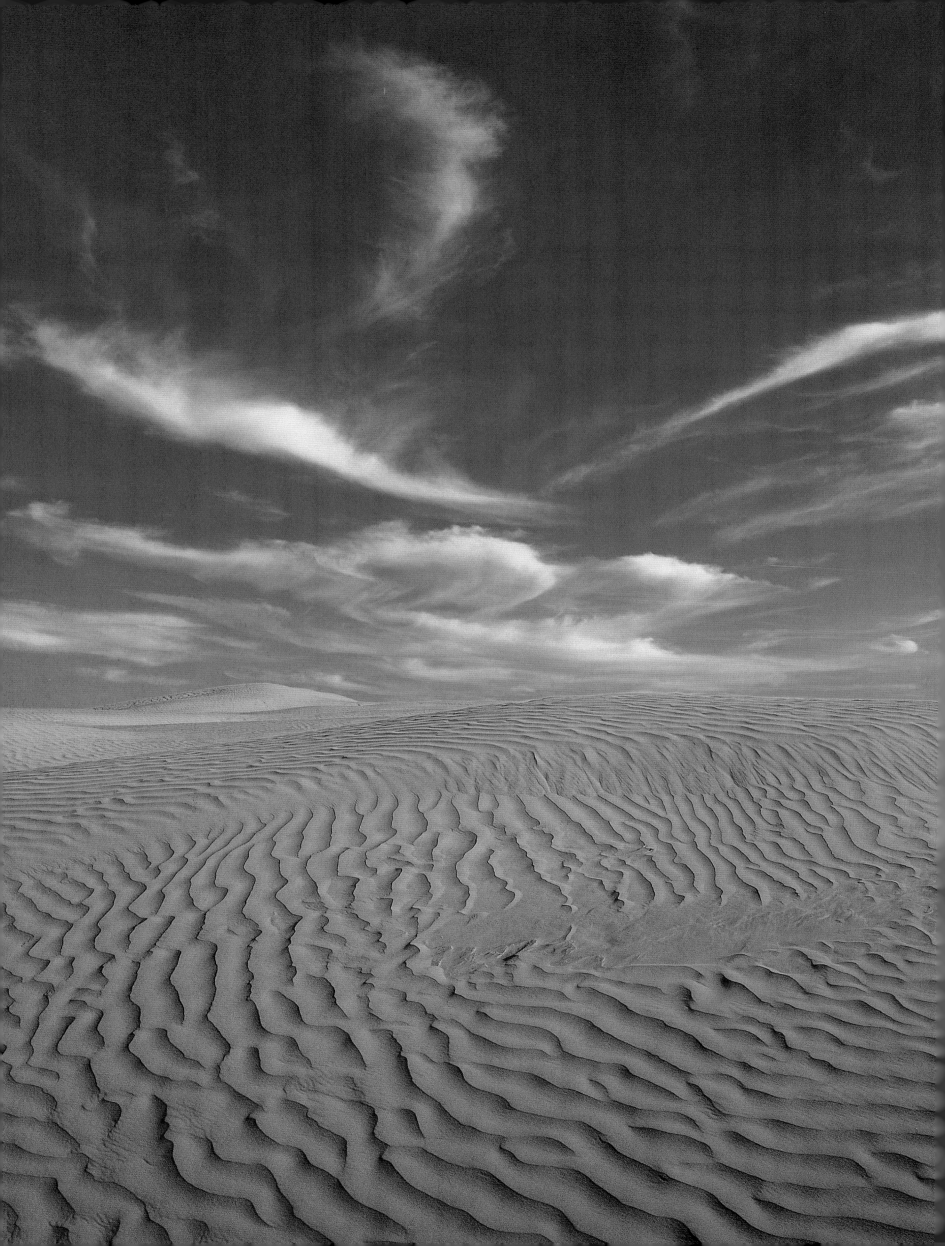

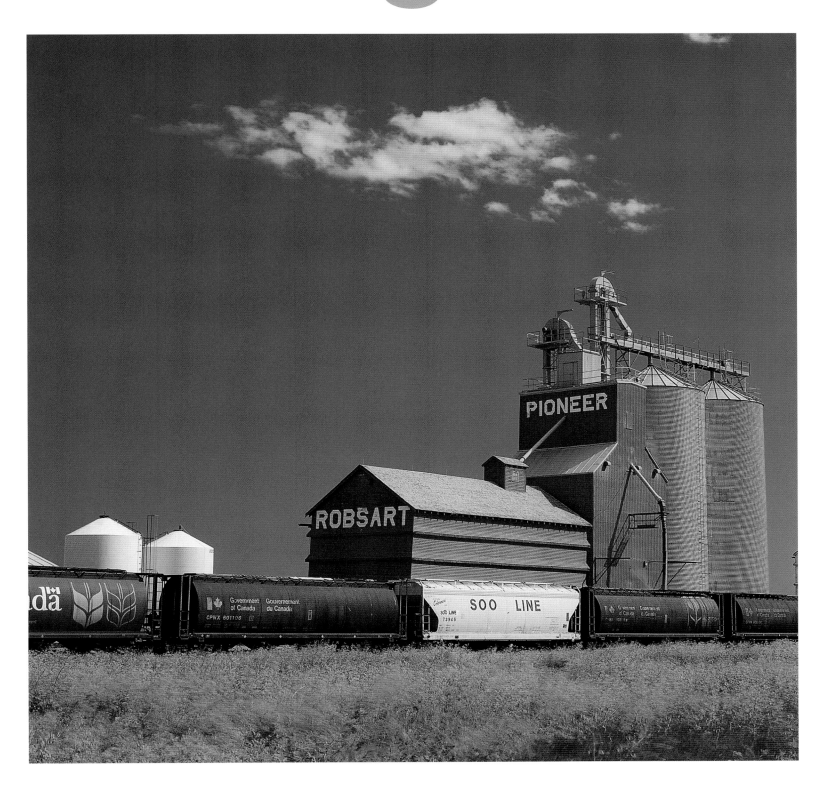

LEFT: The Great Sandhills, swept bare by the wind, span 1900 square kilometres (730 square miles) between Maple Creek, Leader, and Webb. They are the largest connecting dunes in the prairies, and home to coyotes and deer as well as bird and reptile species.

ABOVE: Wheat, the staple of Saskatchewan's economy, is not indigenous to North America. Brought by settlers from Europe, the first wheat was planted in western Canada in 1754 in the Carrot River Valley. Saskatchewan now grows about $2 billion worth of the crop each year.

OVERLEAF: Canada's population exploded from just over five million in 1901 to more than seven million in 1911. Many of the new immigrants flocked to Saskatchewan, lured by free land and Prime Minister Wilfrid Laurier's promise that the 20th century belonged to Canada.

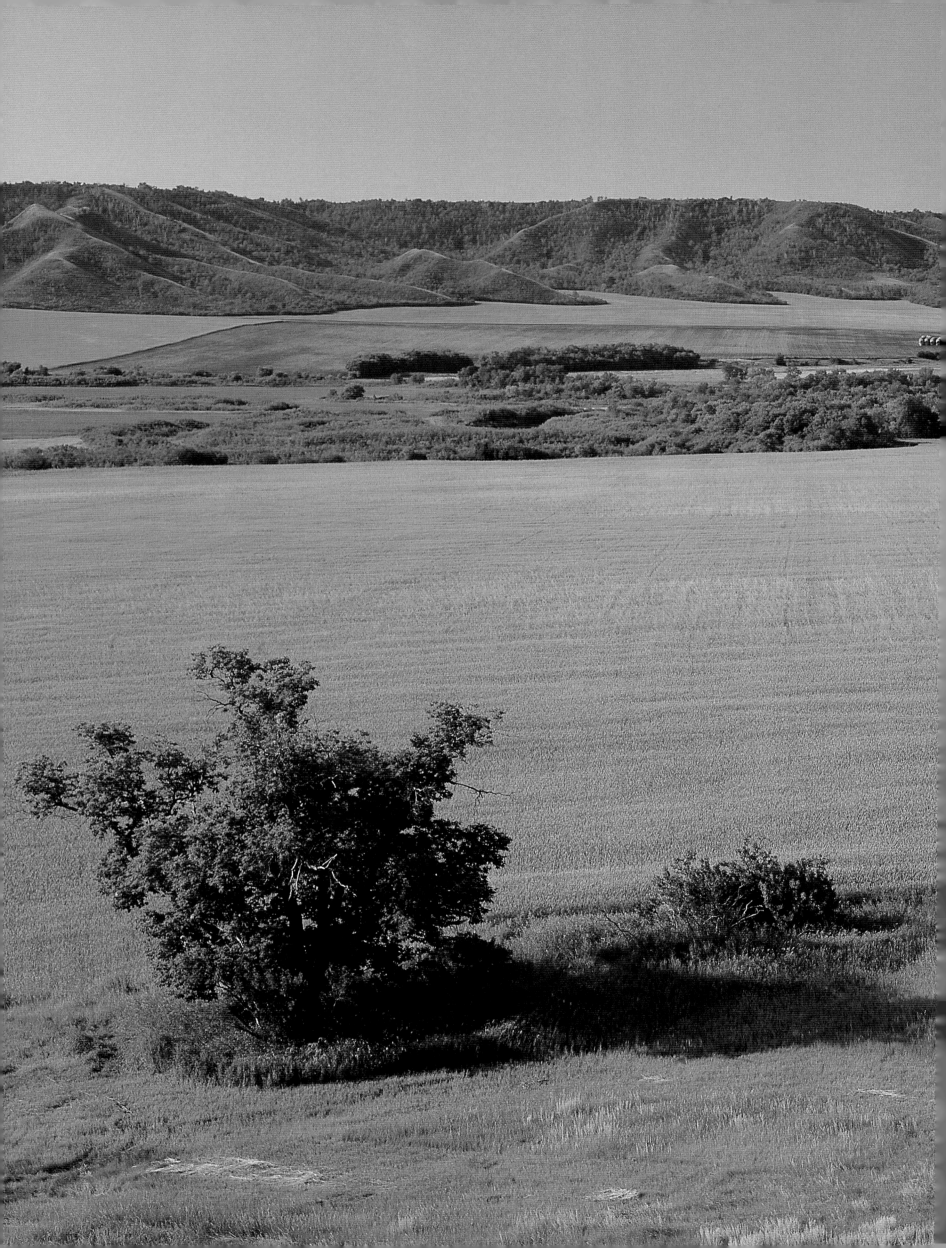

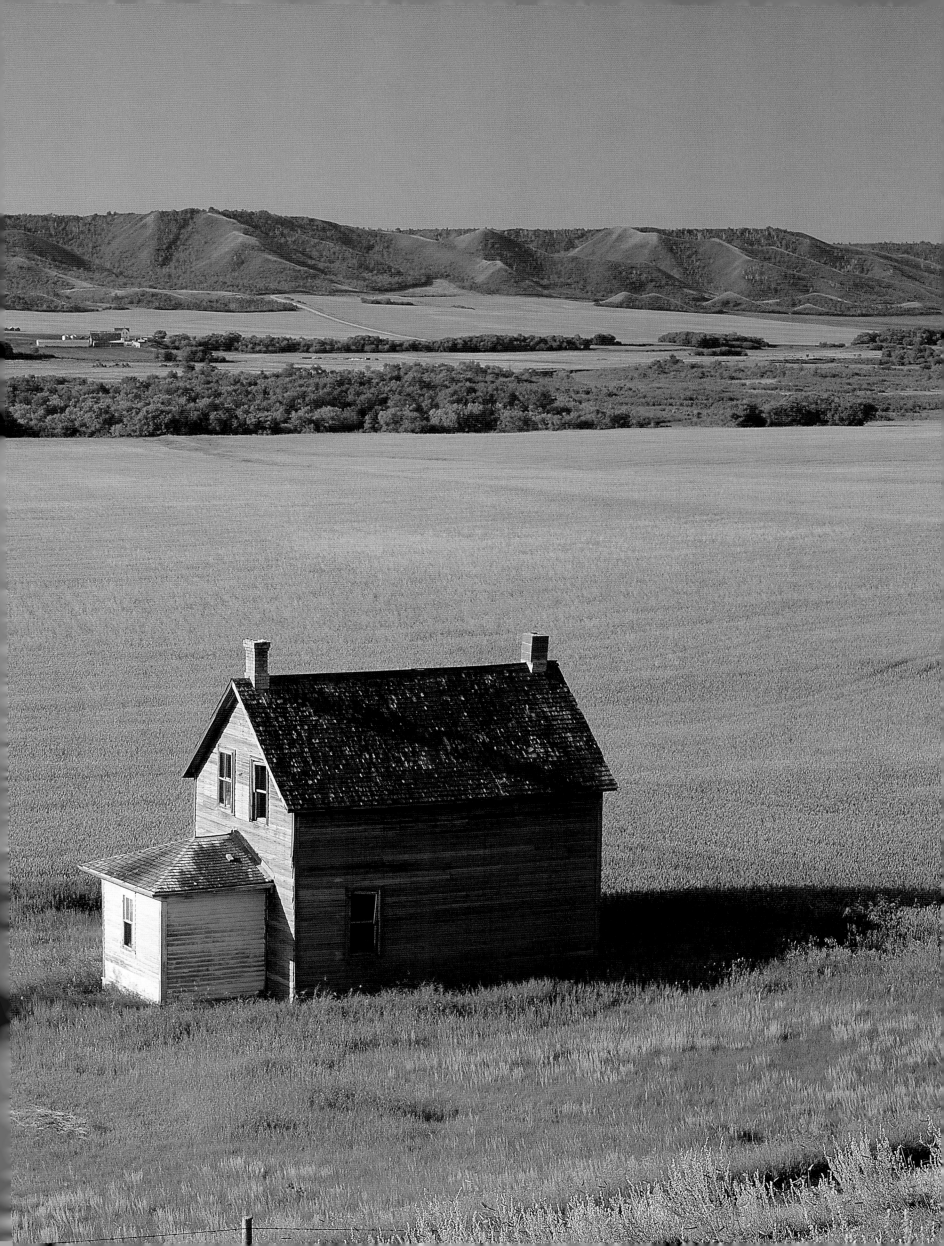

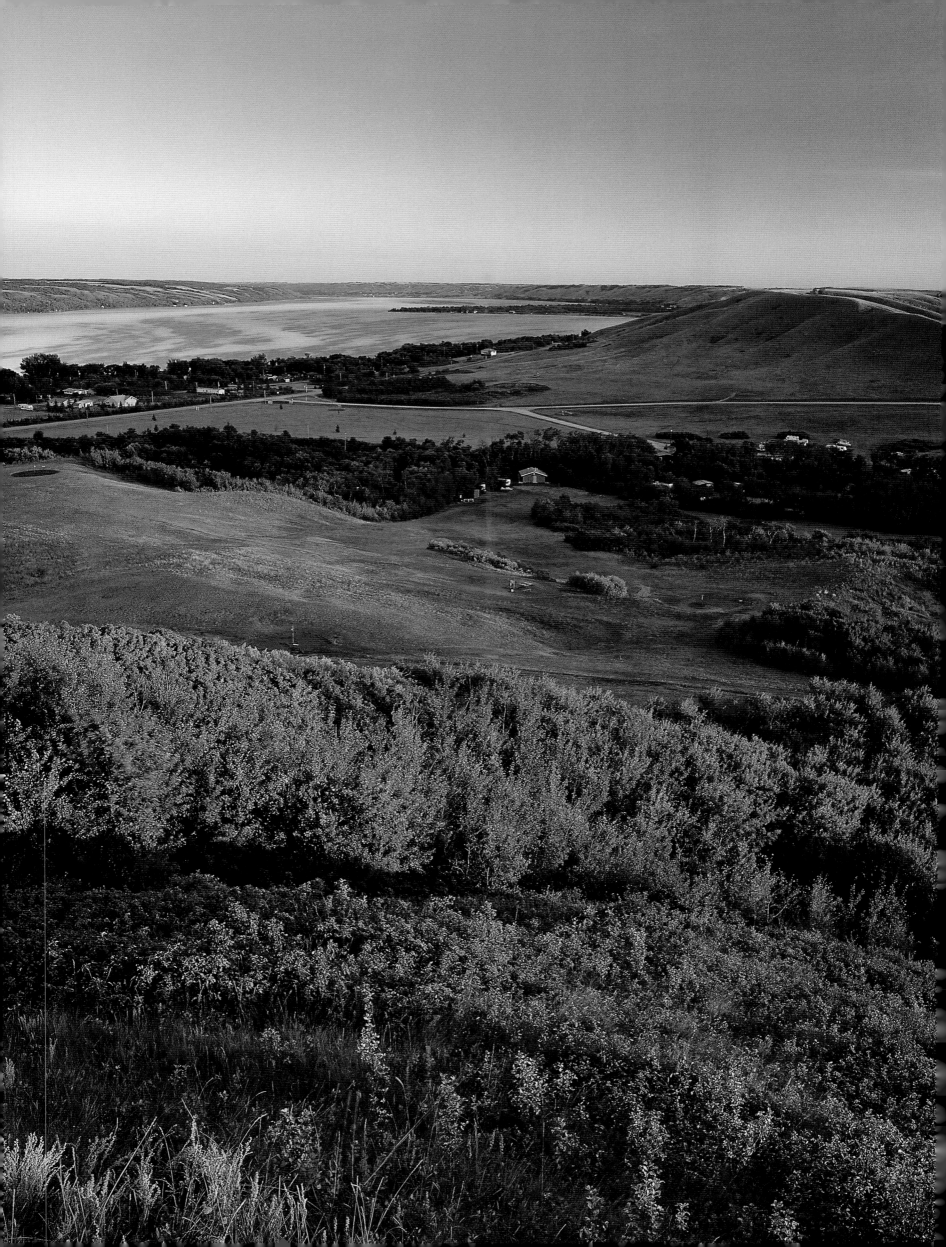

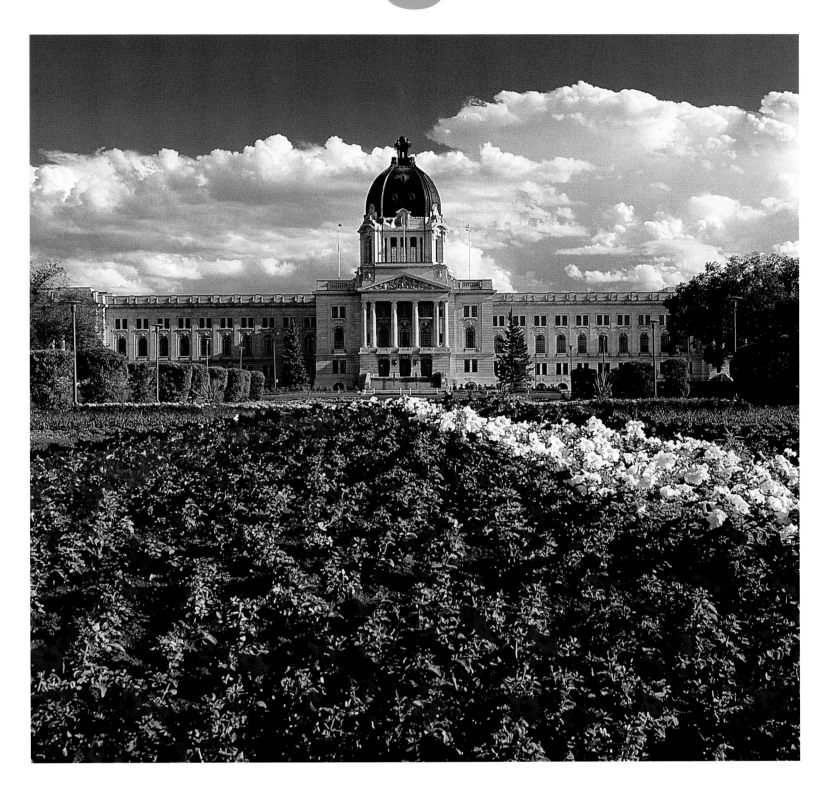

LEFT: According to Métis legend, a young man once heard echoes in the Qu'Appelle Valley calling his true love's name. *Qu'Appelle* means "who calls?"

ABOVE: Regina was a small trading community and North-West Mounted Police fort until the building of the Canadian Pacific Railway in the late 1800s. Prime Minister Sir John A. Macdonald asked the CPR to select a new capital for the region, and Regina was chosen.

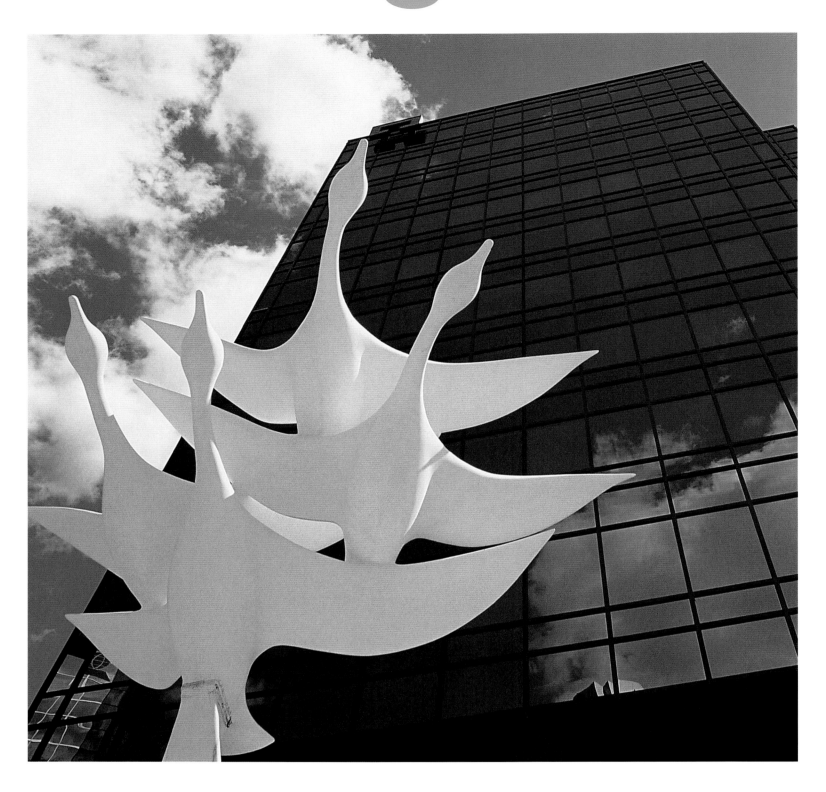

ABOVE: *Western Spirit*, a sculpture of four Canada geese carved by Dow Reid, stands outside Regina's Canada Trust Building.

RIGHT: Saskatoon was founded by members of a Methodist temperance group in 1883. In 1900, just over 100 people lived there. It is now Saskatchewan's largest city, with a population of 200,000.

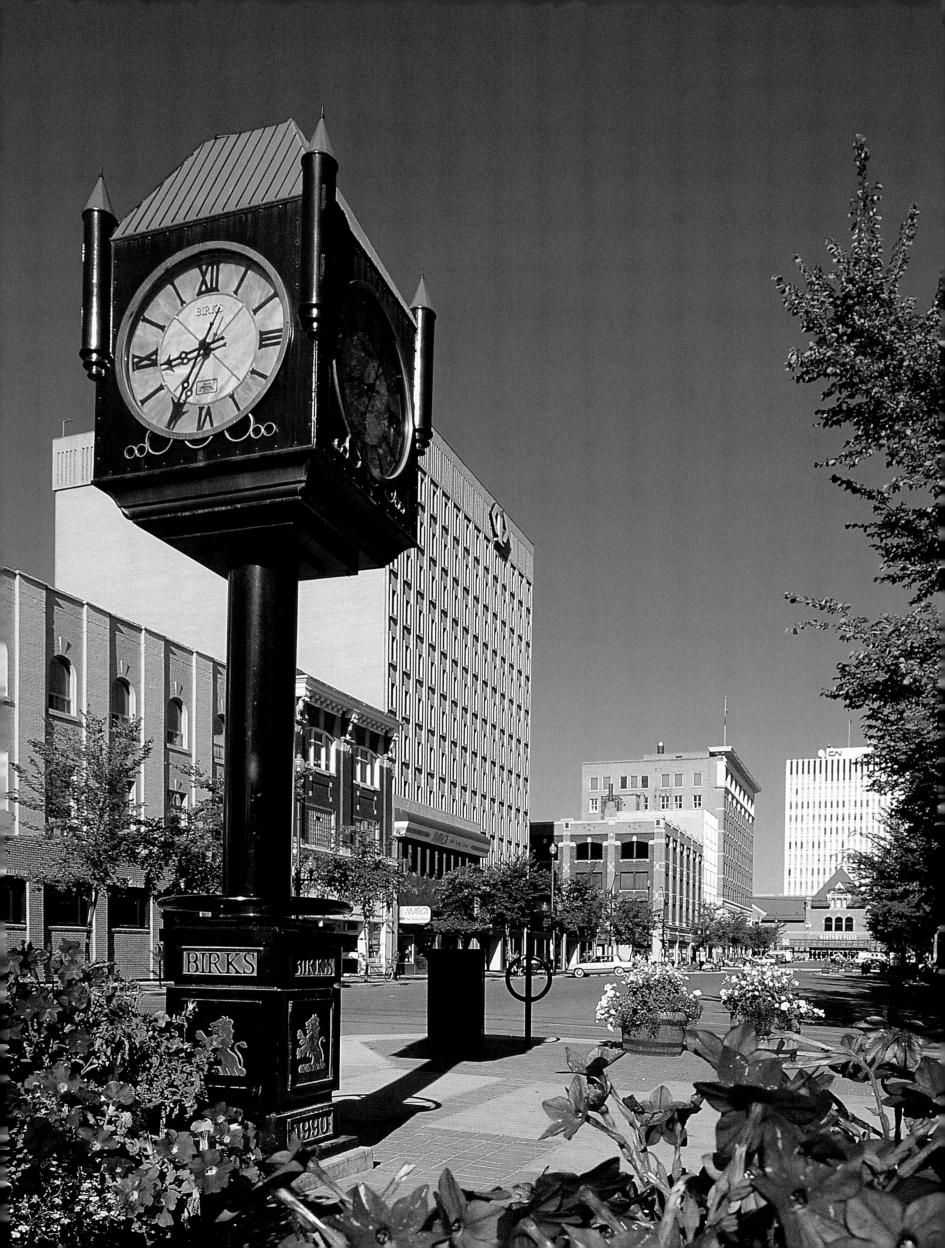

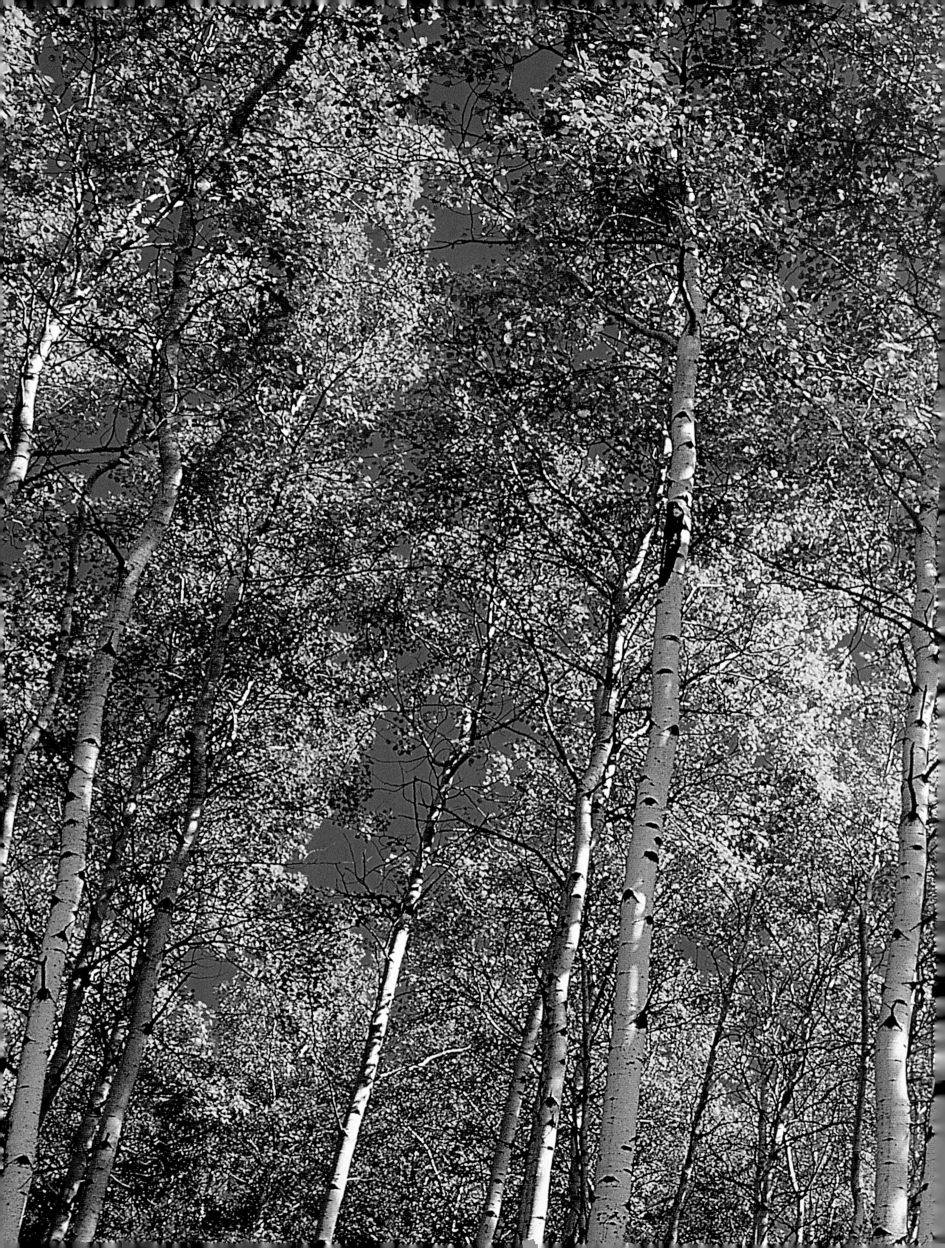

ABOVE: In the 1690s, Hudson's Bay Company employee Henry Kelsey was the first European to explore Saskatchewan. Today, much of the province remains sparsely populated, a web of farmland, northern wetlands and the Great Sandhill region of the far south.

LEFT: The aspen groves of central Saskatchewan slowly give way to thick northern forests in Prince Albert National Park. These woods and the park's many lakes are home to a diversity of wildlife, from wolves and caribou to pelicans and ospreys.

OVERLEAF: There are more than 100,000 lakes scattered throughout the province, along with several major river systems — the North and South Saskatchewan, the Assiniboine, and the Churchill. The Cree name for Saskatchewan, *Kisiskatchewan*, means "the river that flows swiftly."

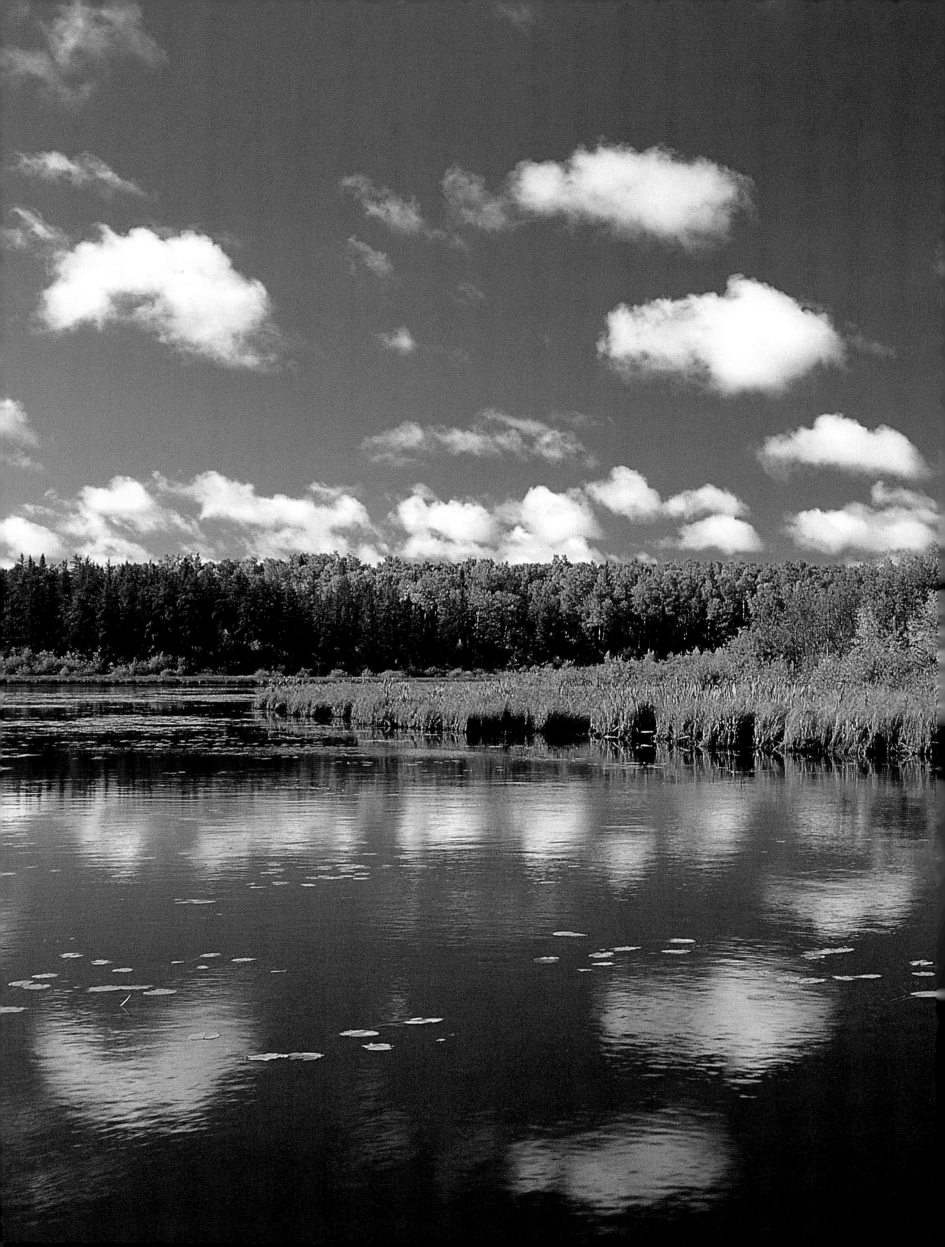

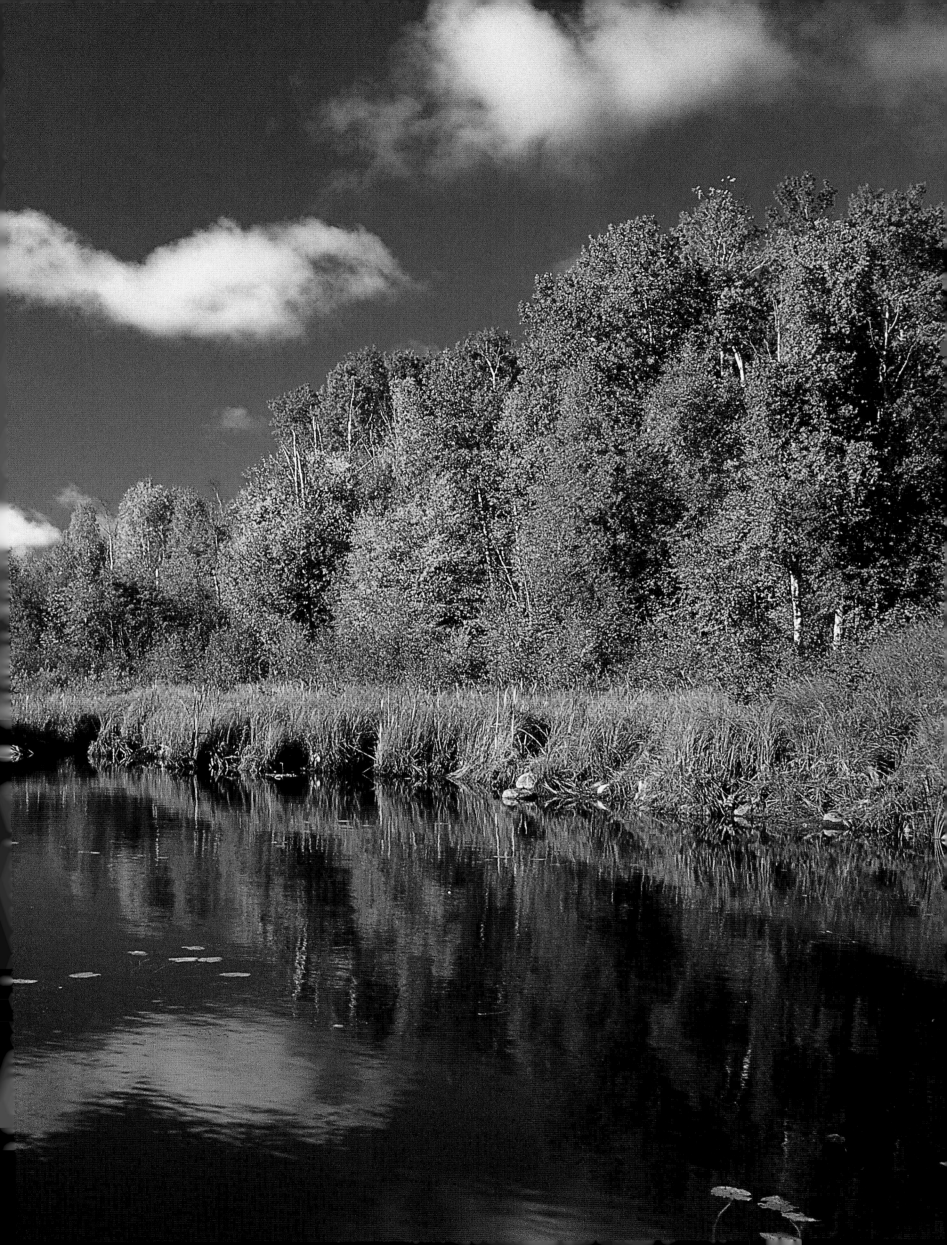

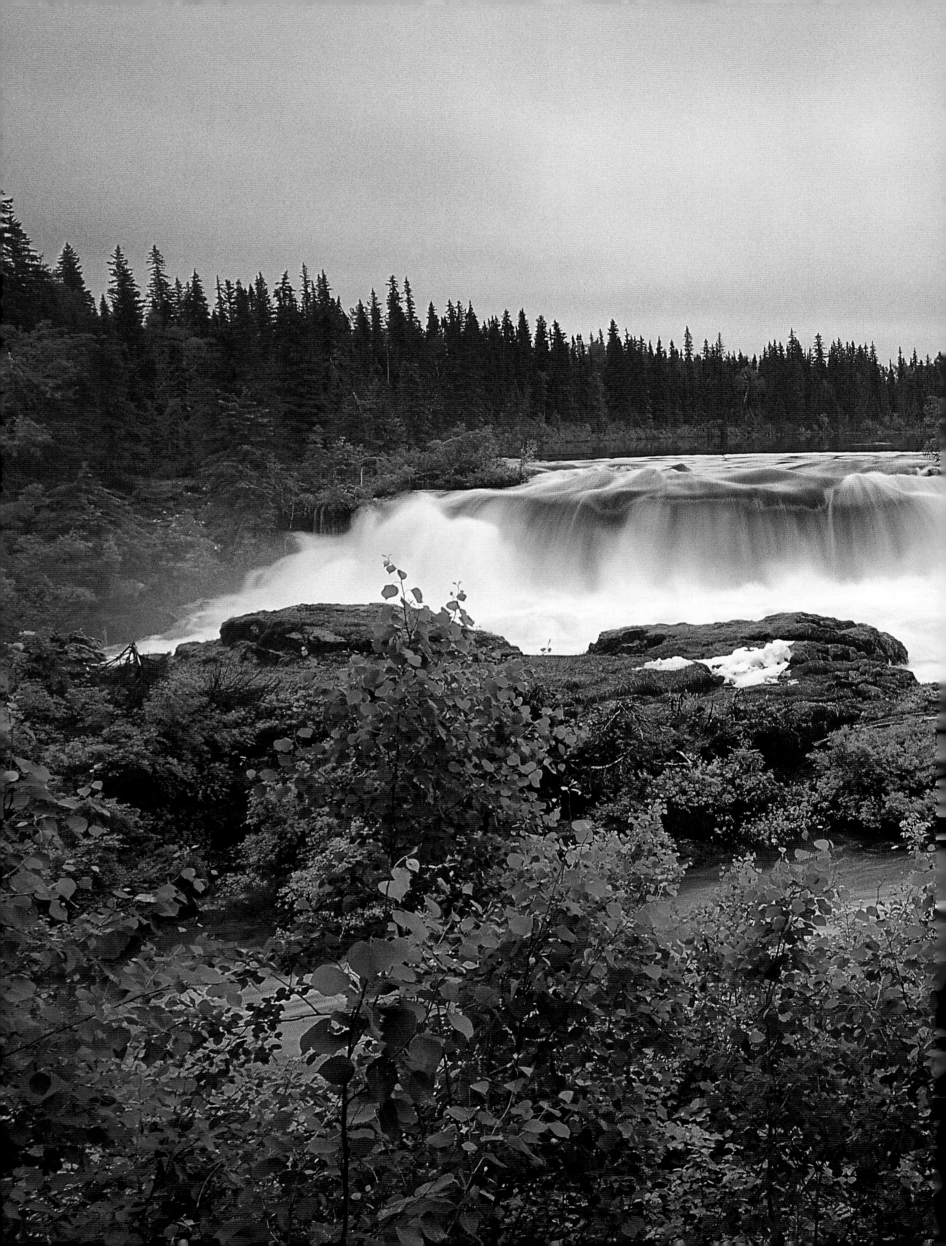

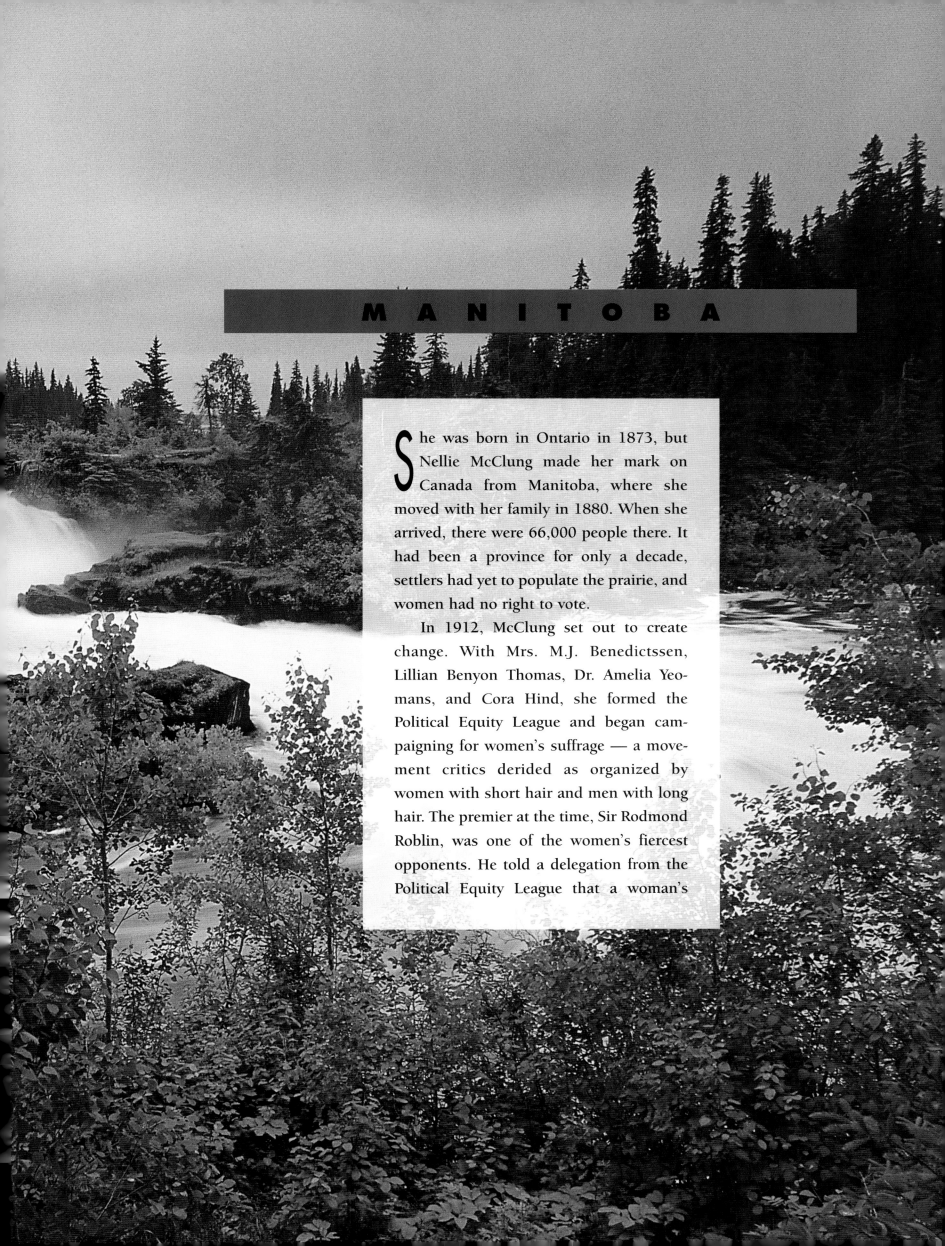

MANITOBA

She was born in Ontario in 1873, but Nellie McClung made her mark on Canada from Manitoba, where she moved with her family in 1880. When she arrived, there were 66,000 people there. It had been a province for only a decade, settlers had yet to populate the prairie, and women had no right to vote.

In 1912, McClung set out to create change. With Mrs. M.J. Benedictssen, Lillian Benyon Thomas, Dr. Amelia Yeomans, and Cora Hind, she formed the Political Equity League and began campaigning for women's suffrage — a movement critics derided as organized by women with short hair and men with long hair. The premier at the time, Sir Rodmond Roblin, was one of the women's fiercest opponents. He told a delegation from the Political Equity League that a woman's

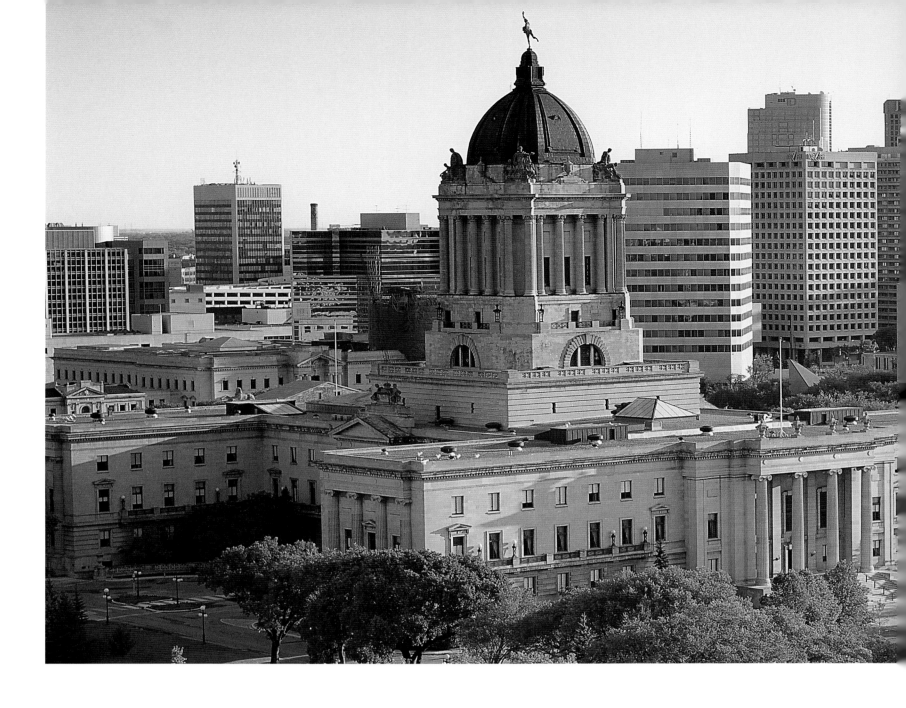

PREVIOUS PAGES: Pisew Falls on the Grass River are the highest accessible falls in Manitoba. Eighteenth-century explorer and Hudson's Bay Company employee Samuel Hearne once travelled this river.

place was in the home, caring for her children and performing her wifely duties.

His response galvanized the league into action, and on January 28, 1914, the curtains opened at Winnipeg's Walker Theatre on a performance called "How the Vote Was Won." Starring McClung as premier, the satire involved a group of men requesting enfranchisement. McClung's response: "You are beautiful, cultured men, who I am sure make good homes, and you should stay there." The play directed a scathing hit at the government, and earned instant success in the local media.

The leader of Manitoba's opposition, T.C. Norris, was slightly more receptive to the women's views than Roblin was. Norris promised that should they collect a petition of 40,000 signatures, he would bring their concerns before parliament. He no doubt expected 40,000 signatures to be an impossible task, but the petition was produced, with even more signatures than needed. The bill enfranchising women was passed on January 28, 1916. Women in Manitoba became the first in the nation to

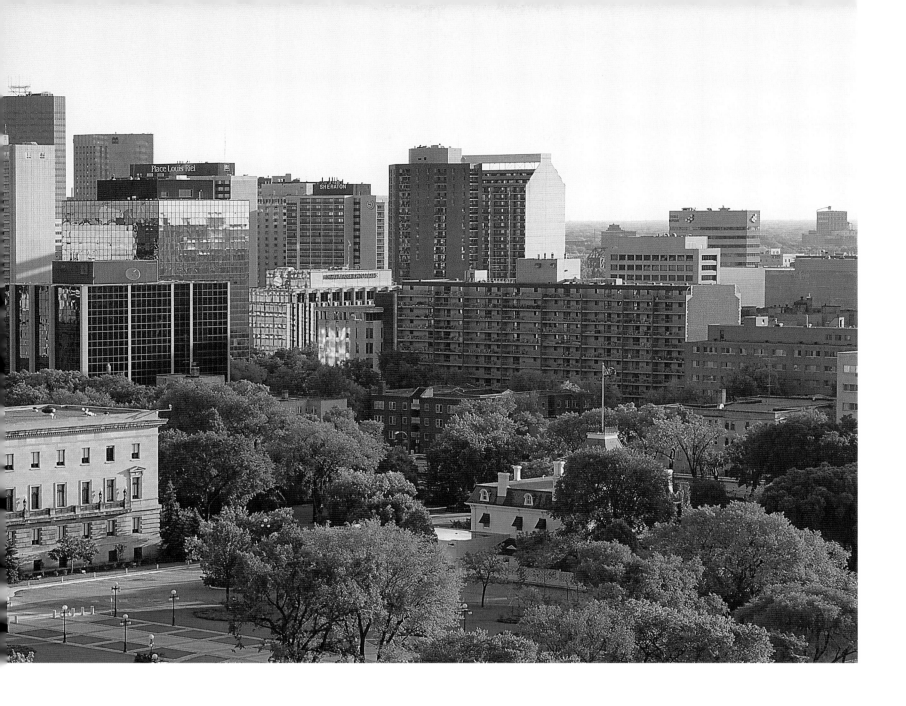

earn the right to vote in provincial elections and hold political office.

Nellie McClung was not the first Manitoban to change the course of Canadian history, or the last. Her predecessors included Louis Riel, who led the rebellion of the Métis against the fledgling Canadian government in 1869 and 1870. Her followers included the soldiers of World War II. More than 65,000 Manitoba residents enlisted, from a total provincial population of 500,000. In Winnipeg, three men from the same street were honoured with the Victoria Cross.

Manitoba continues to be a thriving centre for thoughts and ideas. Novelists Margaret Laurence and Gabrielle Roy are natives of the province, as well as sculptor Leo Mol and artist Jackson Beardy. The Winnipeg Folk Festival, held for more than two decades, offers residents and visitors the opportunity to hear local musicians and those from around the world, while the Fringe Festival each July brings new and avant garde performers to centre stage. Canadians can easily see the work of Nellie McClung at the polls, but Manitoba residents also see her legacy in the thriving culture of their province.

ABOVE: The rare Tyndall stone and neoclassical style of Winnipeg's Legislative Building is studied by architects around the world. Completed in 1919, this is now one of Canada's most valued buildings.

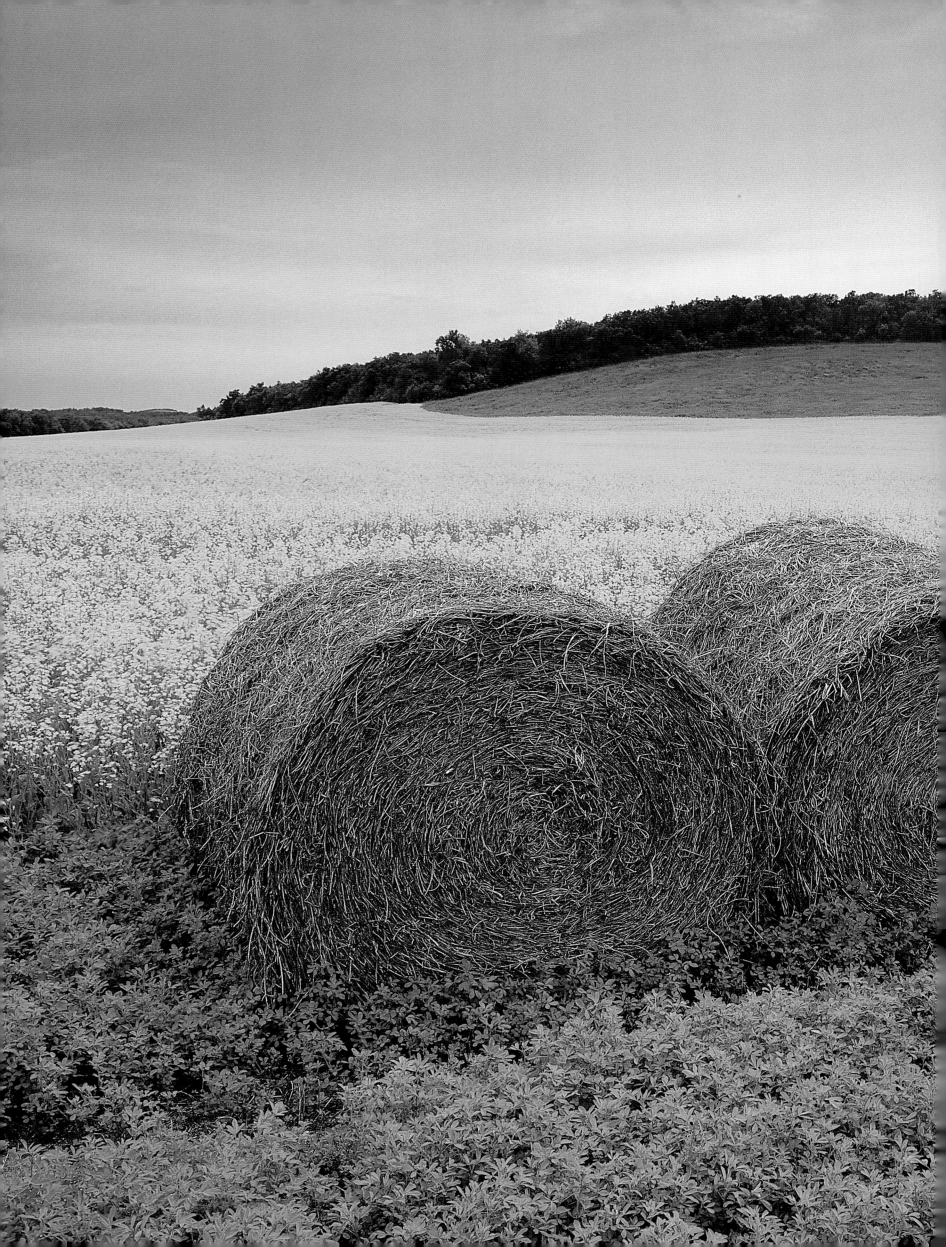

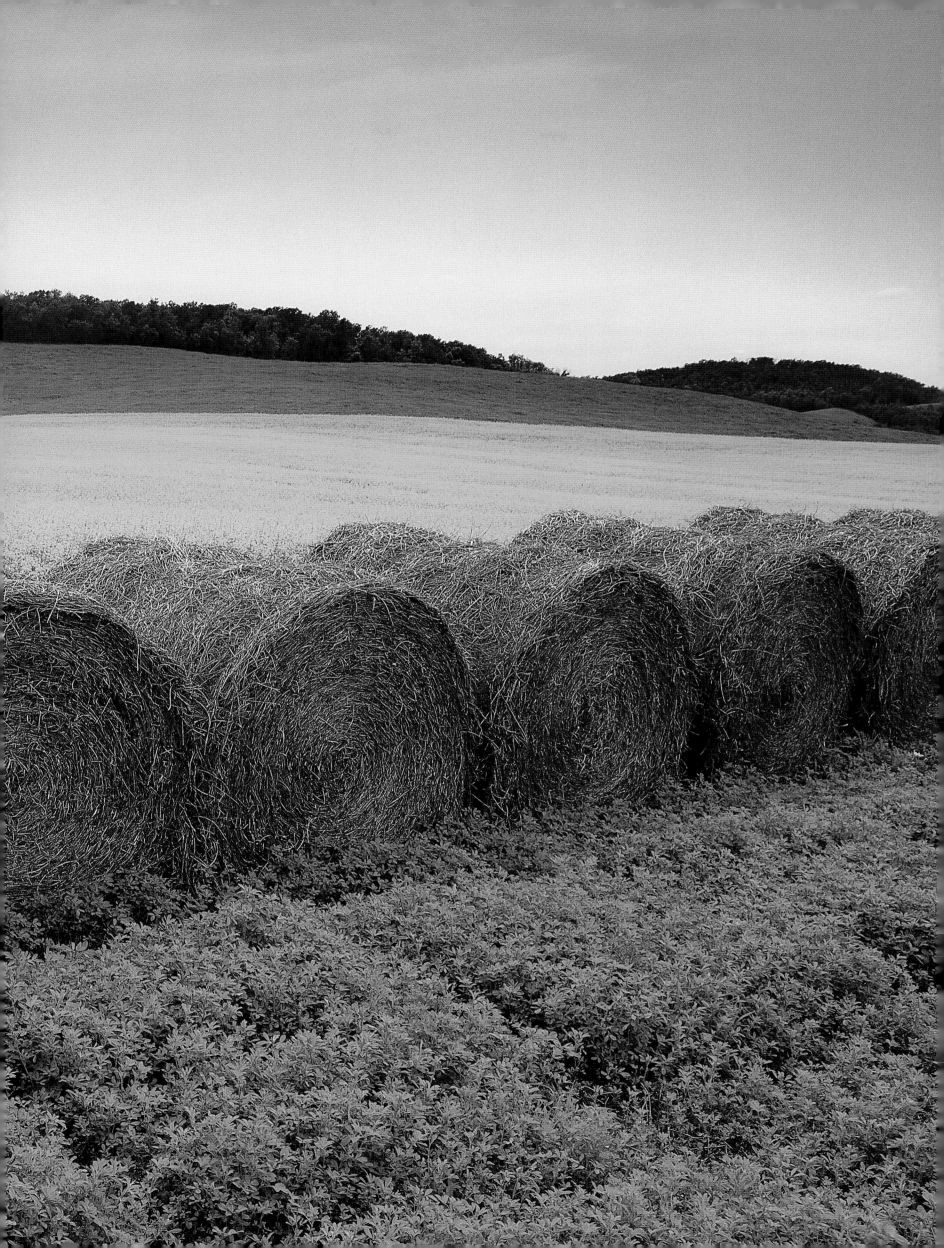

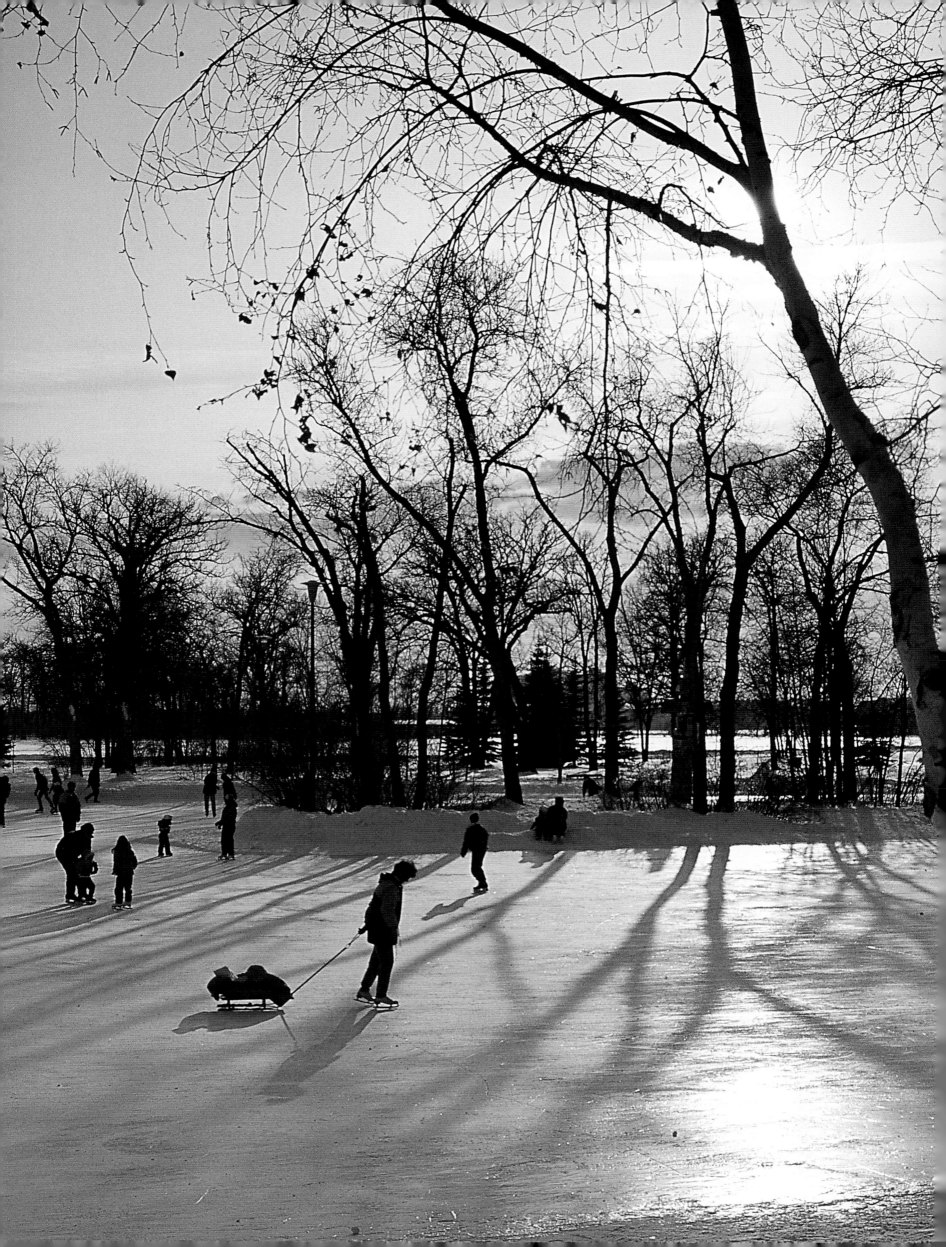

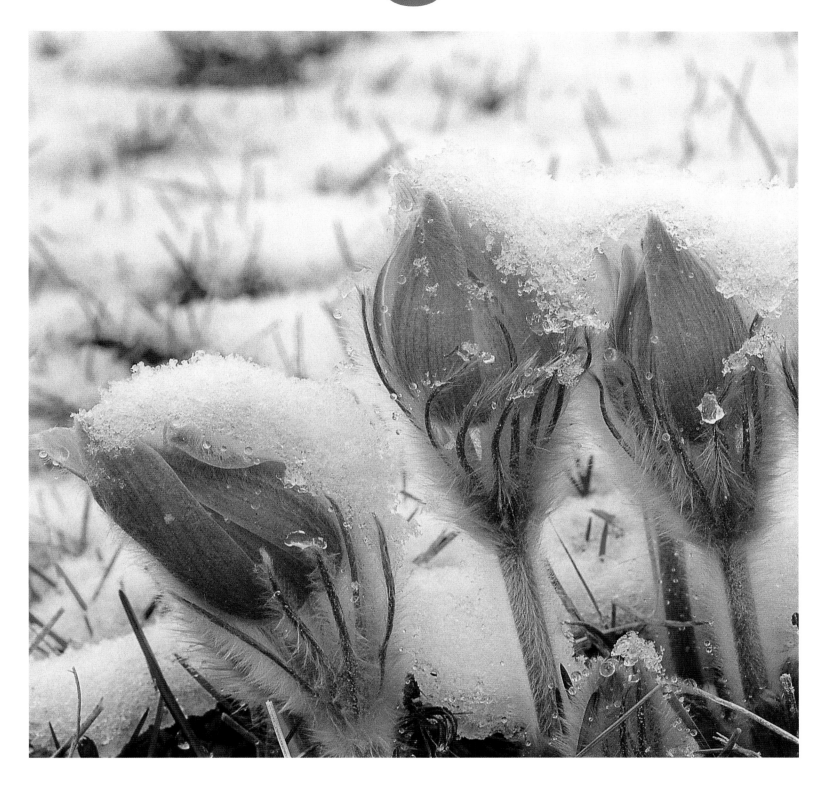

LEFT: Almost half the population of Manitoba lives in Winnipeg. The city boomed in the 1880s with the arrival of the railway, and still plays a major role in the Prairies as a commercial and cultural centre.

ABOVE: Manitoba's official flower, the prairie crocus, often appears before the last of the snow has melted in the spring. It is one of hundreds of wildflowers that flourish in the tall grass prairie.

PREVIOUS PAGES: Hay, alfalfa, and canola fields create geometric patterns in the farmland near Holland. More than 25,000 farms checker the province, contributing $2.7 billion to Manitoba's economy annually.

ABOVE: Fine sand beaches alternate with the rocky shoreline of Lake Manitoba.

RIGHT: The Keystone Province earned its nickname for its shape, as well as its position in the east-west centre of Canada and the north-south centre of the continent.

PREVIOUS PAGES: Each year, the Royal Canadian Mint in Winnipeg can make up to three billion coins — enough to provide all of Canada's circulation coins plus currency for about 14 other countries.

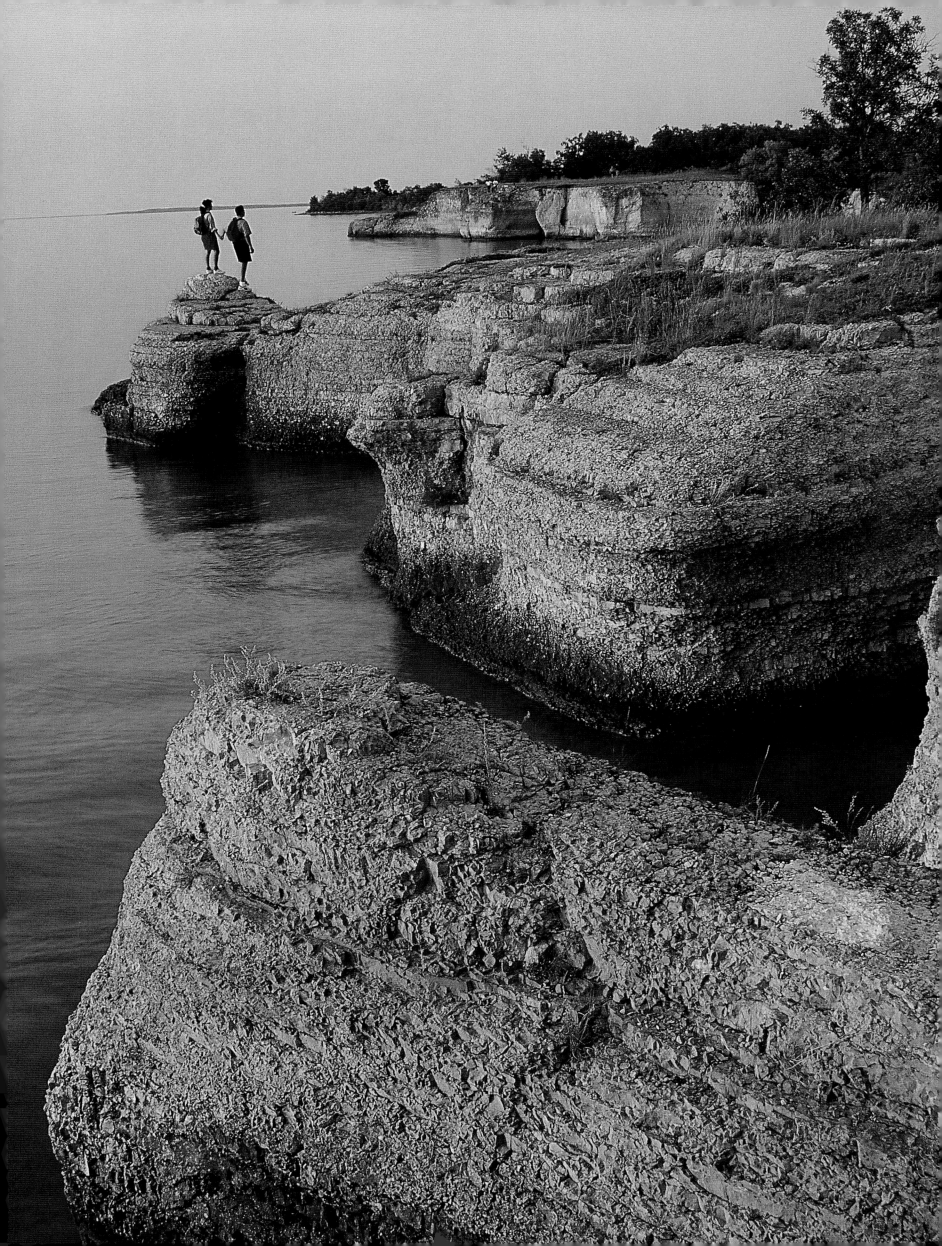

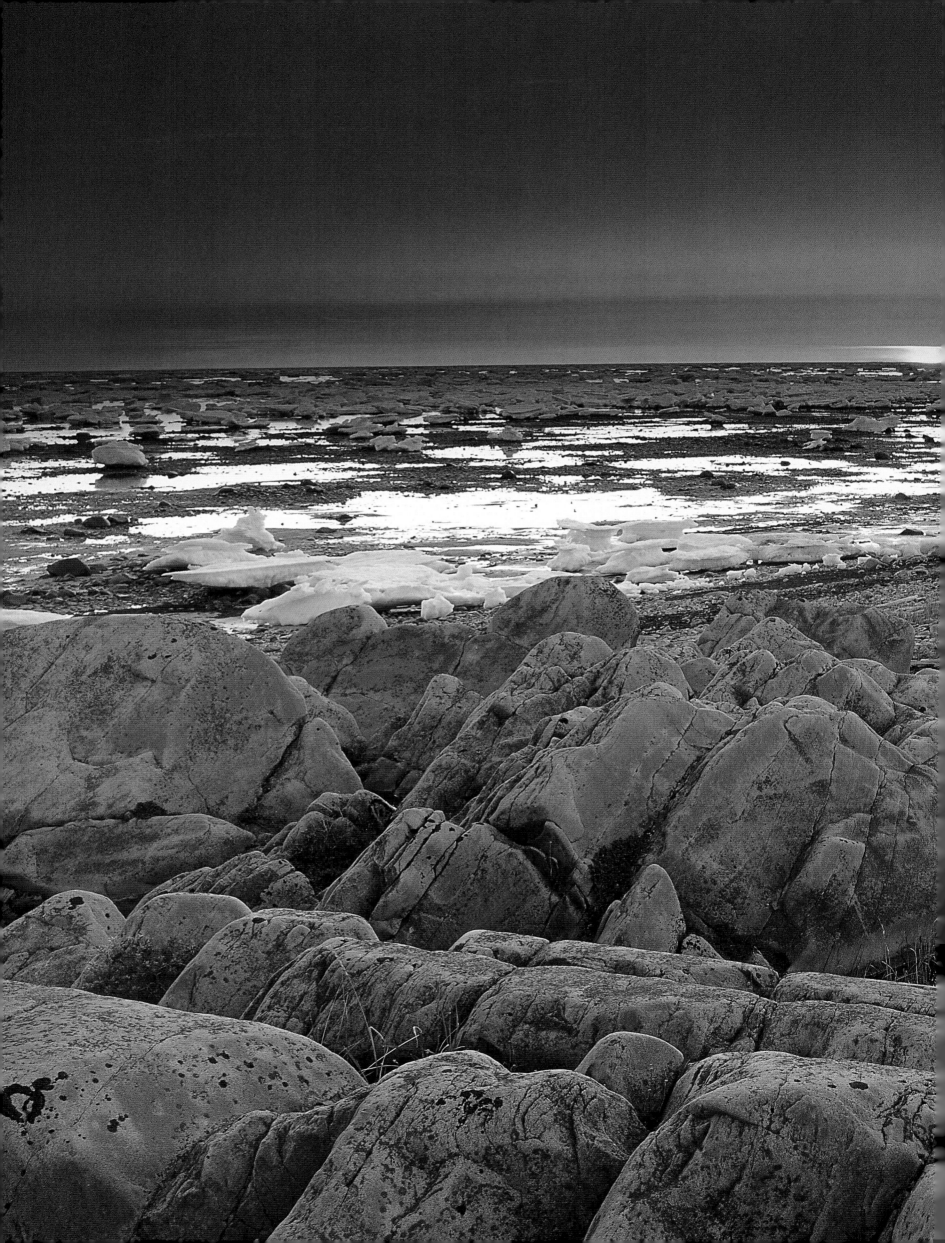

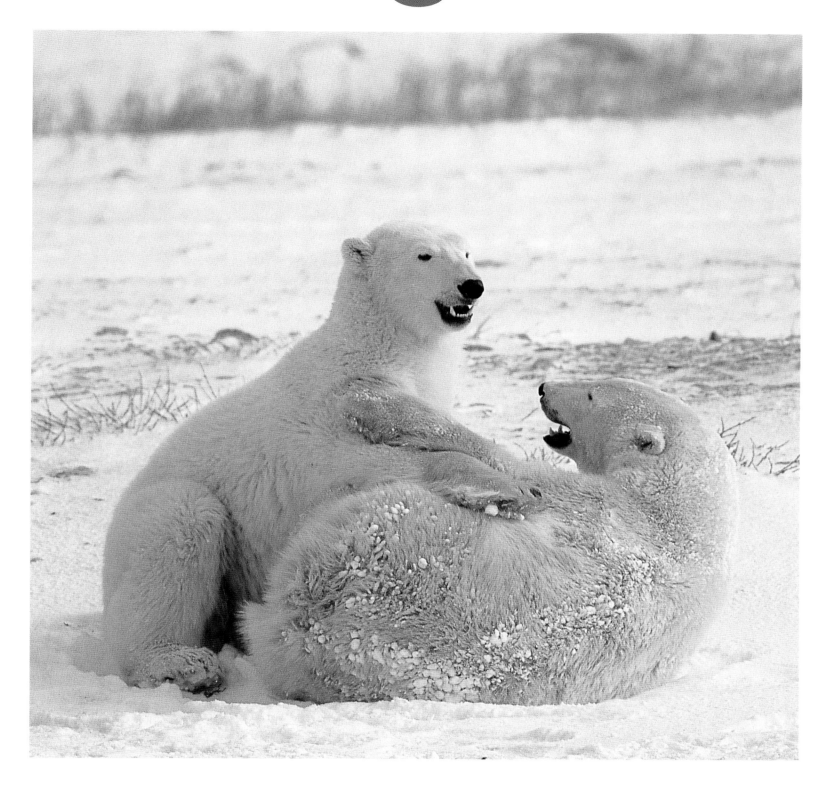

LEFT: The land along the Hudson Bay coast is locked in ice for eight months of the year, but it is far from barren. More than 400 plant species grow in the surrounding tundra and almost 200 bird species have been sighted in the area.

ABOVE: Polar bears migrate to the shores of Hudson Bay in the fall, waiting for the winter freeze and access to their hunting grounds on the pack ice. Though they are normally solitary creatures, male polar bears can often be seen playing and wrestling — perhaps passing the time while they wait.

PREVIOUS PAGES: Riding Mountain National Park, home to the world's largest black bears, has been named a Biosphere Reserve by UNESCO. It serves as an international model of how humans and nature can co-exist.

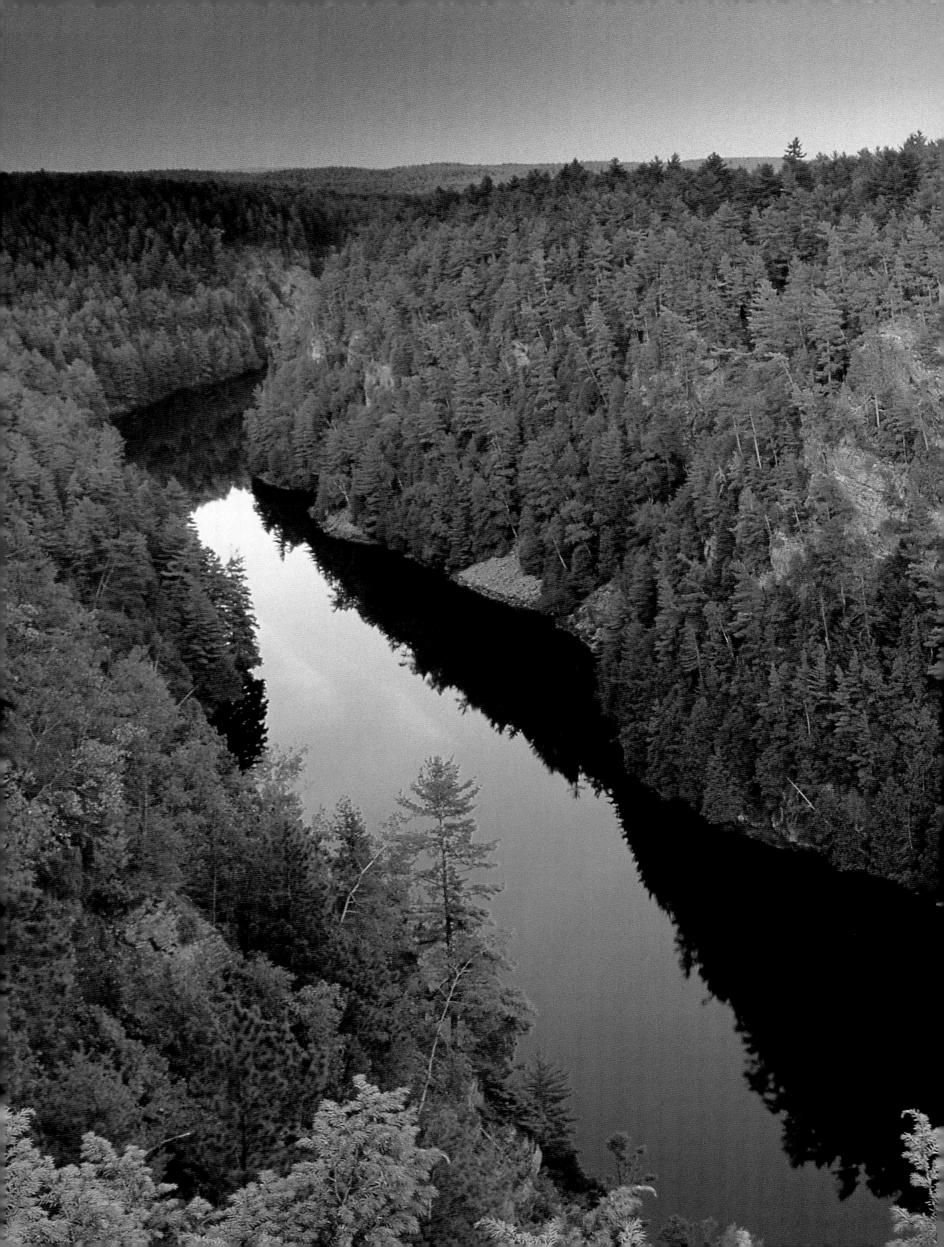

ONTARIO

As the United States gained independence from Britain, thousands who stood behind the British crown flocked to what was then Upper Canada. Among them was a 20-year-old woman destined to become one of the country's most famous heroes.

American soldiers arrived at the door of Laura and James Secord in June 1813, demanding food and lodging. The War of 1812 between the British and the Americans was at its height. The Americans had invaded from Detroit in July of that year and burned the British fort at York the following April. Laura had no choice but to allow the soldiers into her home.

As Laura served and cleaned up after the feasting and drinking soldiers, they began to boast of how they would attack the British at Beaver Dams, taking them by

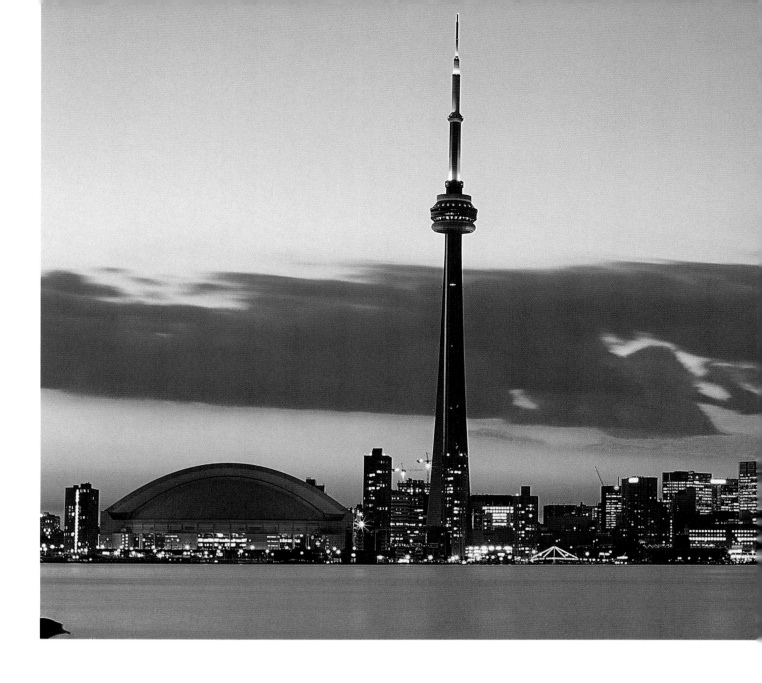

surprise and gaining control of the Niagara Peninsula. Laura overheard their talk and knew that Lieutenant FitzGibbon, commander of the fort at Beaver Dams, must be warned. Because her husband had been wounded at the Battle of Queenston Heights, she set off alone before dawn, avoiding the main roads and travelling a 20-kilometre (12-mile) route from her home. Those who betrayed the American forces faced death by firing squad, and local legend tells that she took a cow and a milk bucket as disguise.

Though challenged by a gruelling route and the dangers of travelling alone, she arrived safely at the British camp with her warning. Only two days later, the British forces ambushed the American soldiers, ending their attack.

This adventure may have changed the course of Canadian history, but in the two centuries since, the province has undergone transformations that Laura Secord and her contemporaries never could have foreseen. What in 1812 was a colony of farmers and small merchants is now a province populated by more than 11 million people. Only about 20 percent continue to live in rural areas. More than three-quarters live in

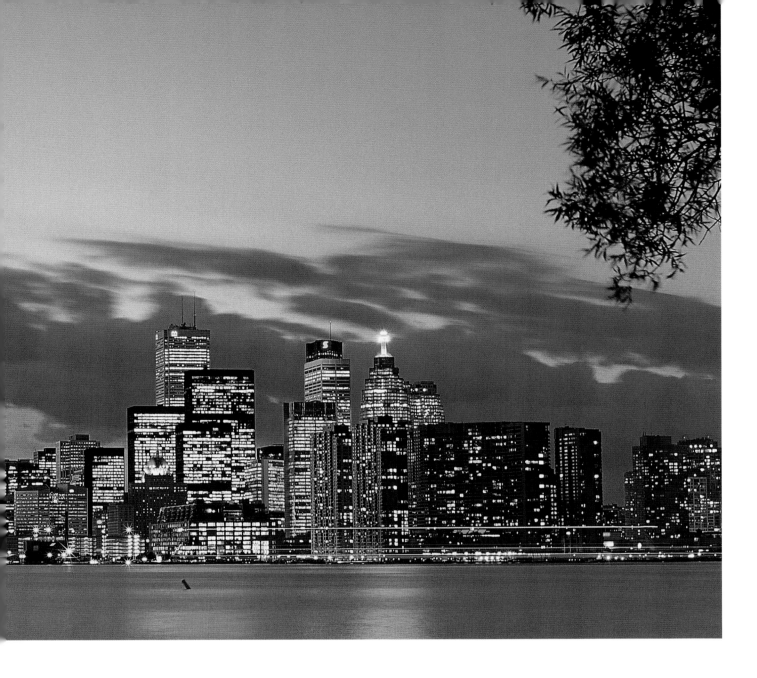

towns and cities, especially Toronto and the surrounding areas of Peel, York, Halton, and Durham.

The Loyalists who came to Canada in the 1800s were followed by immigrants from around the world. A walk through Toronto today might lead past Asian import stores, Persian bakeries, and Mediterranean restaurants. Though English and French remain predominant, there are more than 60 languages spoken in the province, including Chinese, Italian, German, Portuguese, Indo-Iranian, Greek, Polish, Spanish, Dutch, and Ukrainian. And as more than 100,000 immigrants arrive in the province each year, more new customs and ideas follow. There are also two major First Nation languages, Algonquian and Ojibway, spoken in the province.

More than any other province, Ontario is a mosaic of peoples and customs. And those who arrive here find a history based on the achievements of immigrants—including the hair-raising journey of a 19th-century Loyalist, without whose efforts the province of Ontario might easily have become one of the newly created United States.

ABOVE: Toronto is a thriving blend of high finance, modern architecture, cosmopolitan streets, and cultural performances. Downtown, the modern curves of the new city hall rise just across from the stone grandeur of the old, while historic, vine-clad neighbourhoods contrast with the energy of the waterfront.

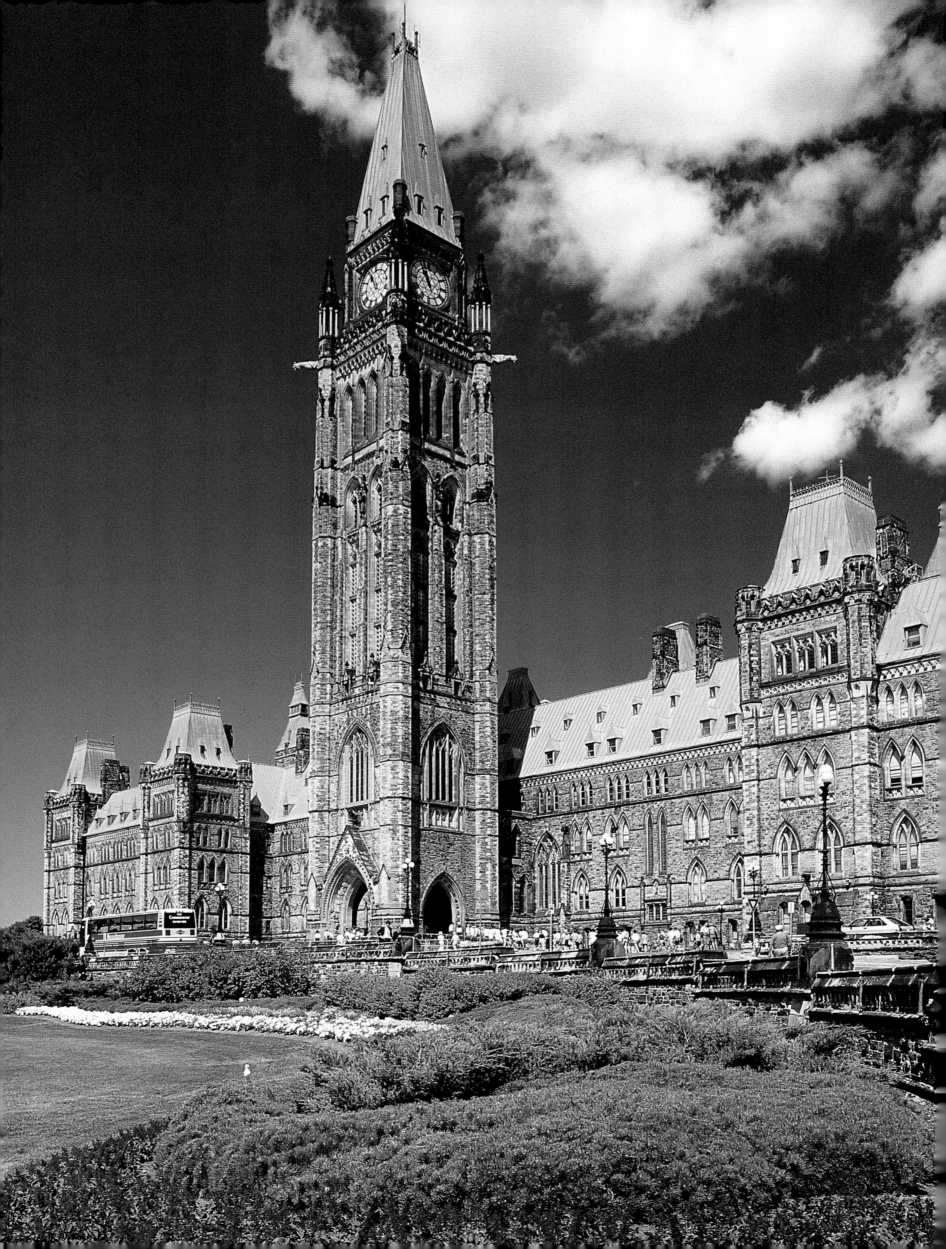

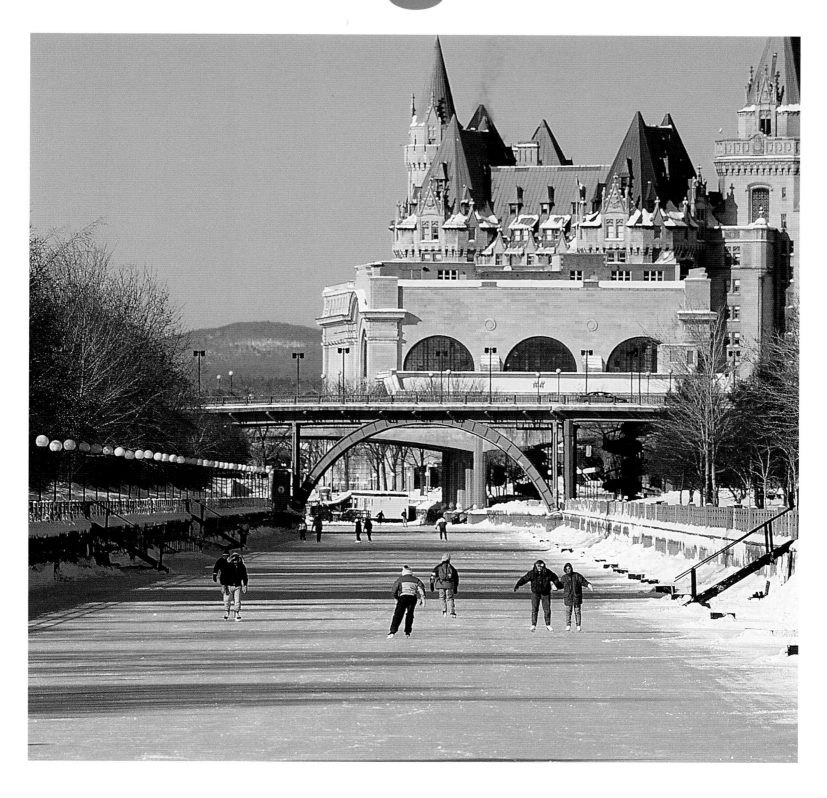

LEFT: When Thomas Fuller and Chilion Jones designed Canada's Parliament Buildings in 1859, the Gothic revival–style arches were lined with eye-catching red sandstone. When the structure was rebuilt after a fire in 1916, architects followed a similar but less colourful style.

ABOVE: Built after the War of 1812 in case of future attacks by the U.S., the Rideau Canal has never been used for military purposes. In winter an eight-kilometre (five-mile) stretch of the canal in Ottawa is transformed into the world's longest skating rink.

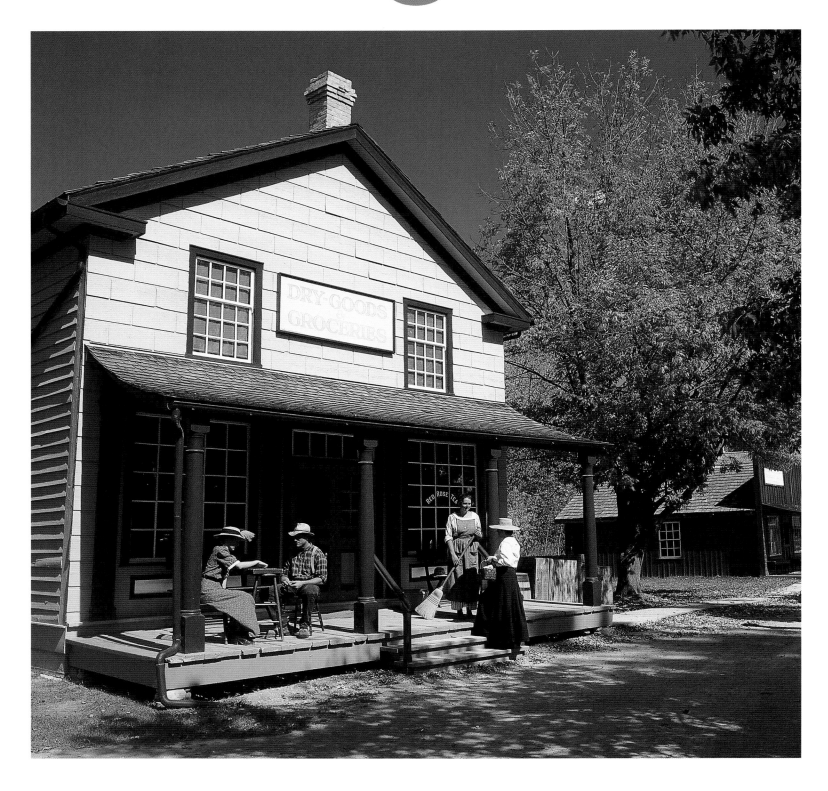

ABOVE: Each year, costumed staff members at Doon Heritage Crossroads welcome 40,000 visitors, including thousands of schoolchildren, and sweep them back to 1914 in Waterloo County. The tiny village and two working farms demonstrate what daily life was like in the past.

RIGHT: More than 1800 islands dot the St. Lawrence River between Canada and the United States, some only a few metres across and others large enough for a dock and waterfront home.

OVERLEAF: Southern Ontario supports a strong agriculture industry, from this farmland near Waterloo to the lush orchards and vineyards of the Niagara Peninsula. Dairy and poultry farms are also common in the province.

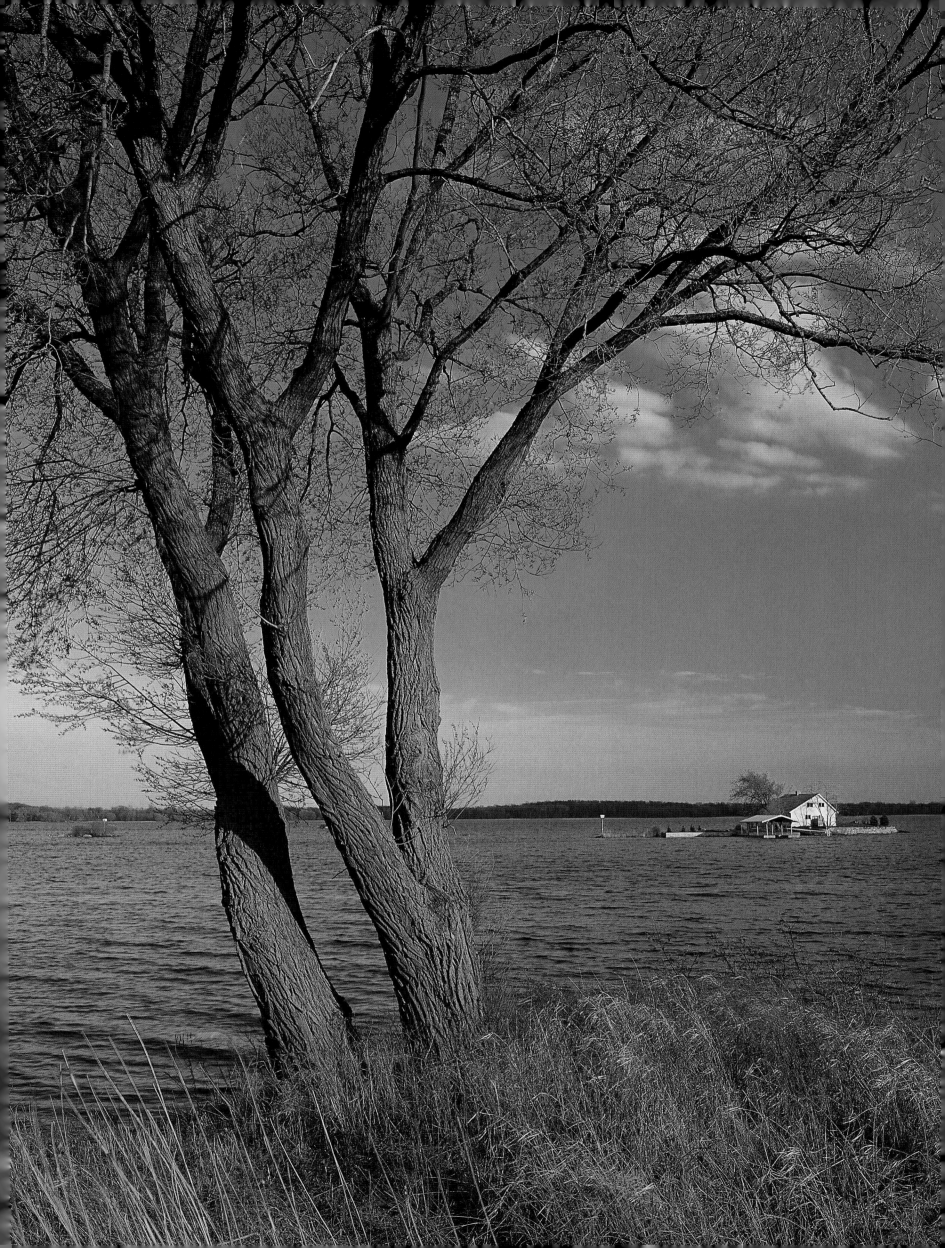

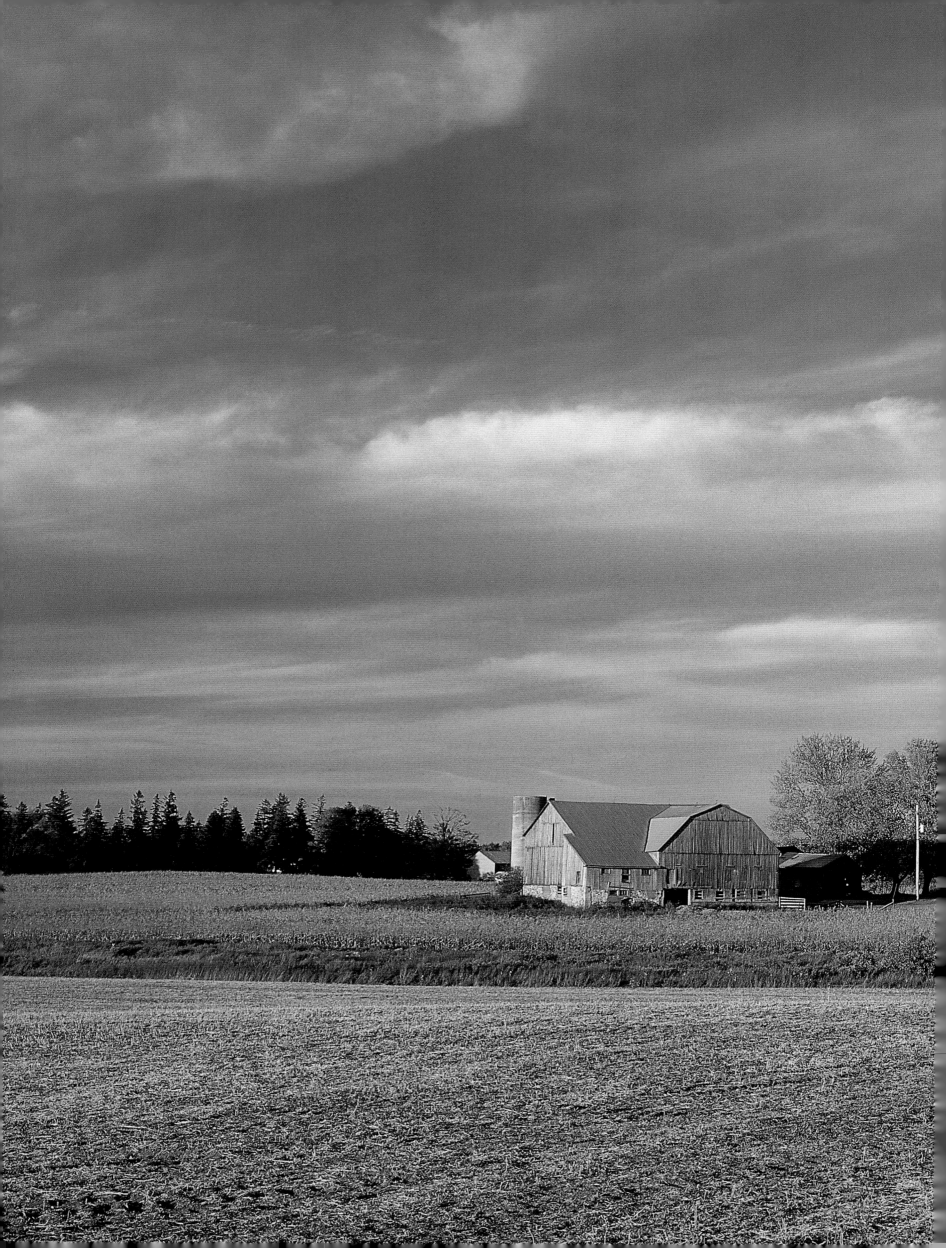

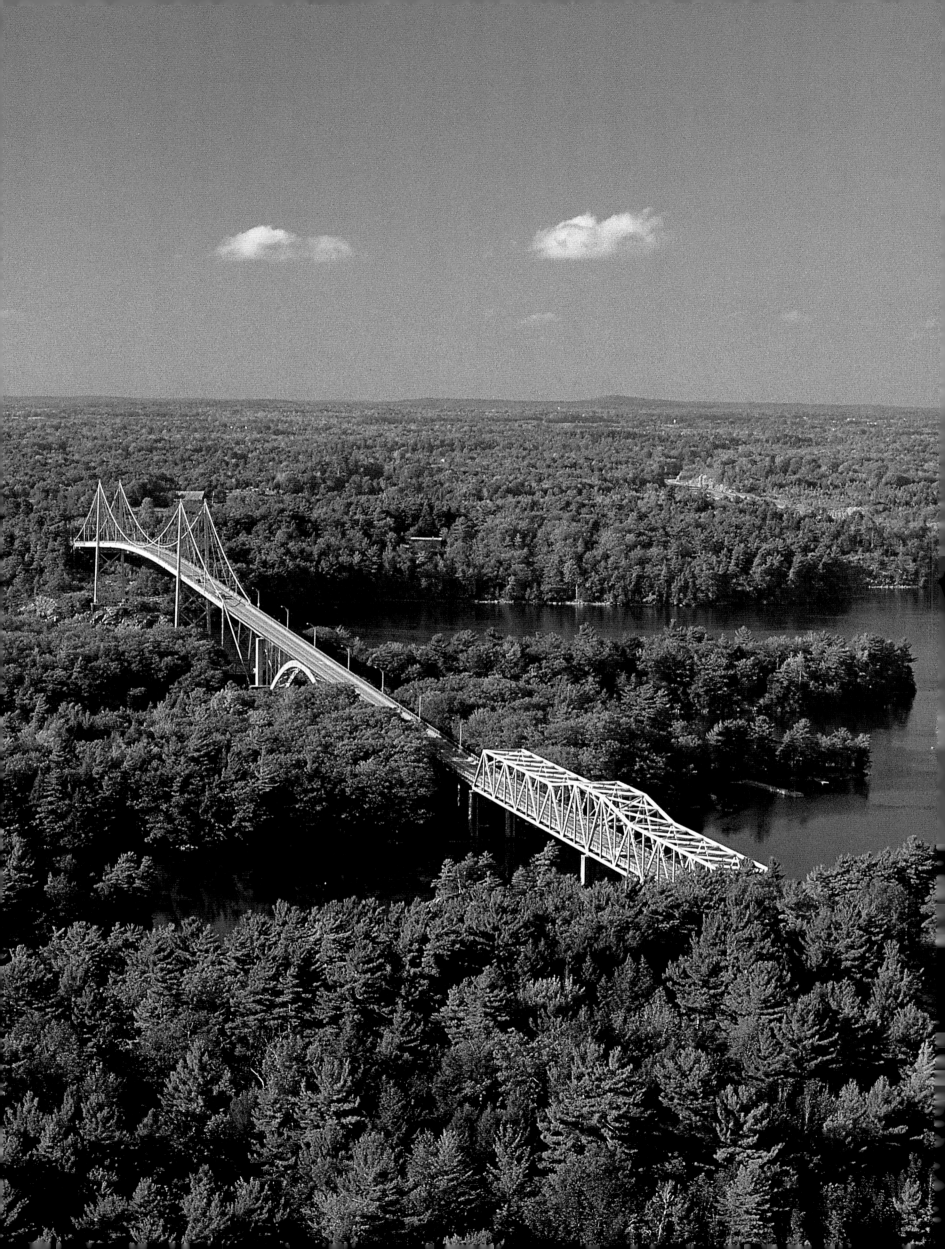

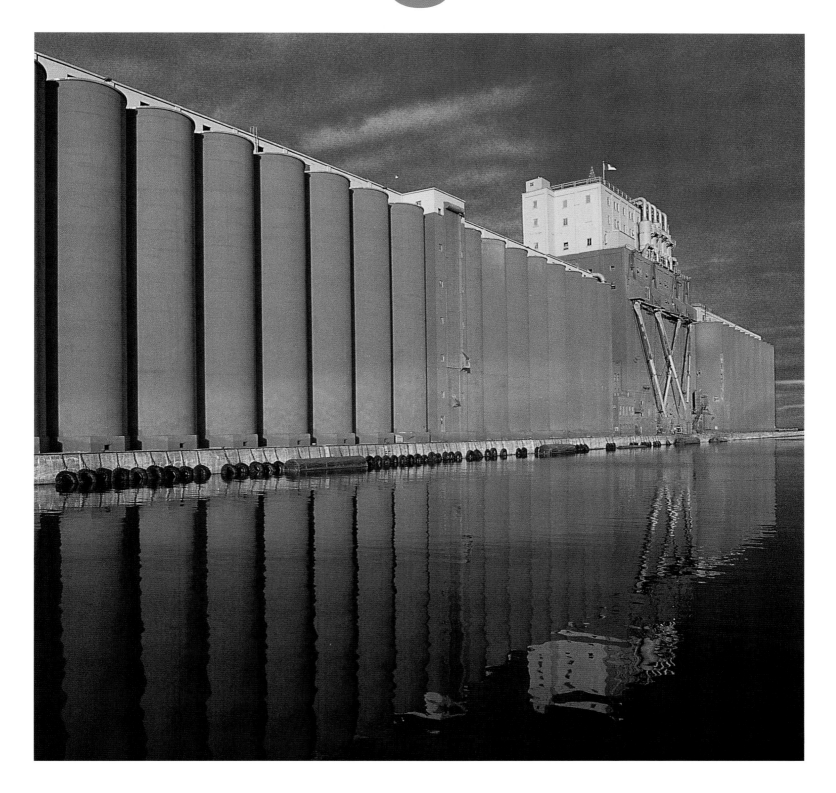

LEFT: St. Lawrence Islands National Park is Canada's smallest national preserve. It protects 19 islands — totalling nine square kilometres (3^1/$_2$ square miles)—in the region known as the Thousand Islands.

ABOVE: Grain elevators line Lake Superior at the port city of Thunder Bay. The grain gathered here is shipped down the Great Lakes for export to countries around the world, including Italy, France, Russia, and the United States.

OVERLEAF: Pie Island is one of the eye-catching mesas in the Thunder Bay area. Formed by ancient volcanic activity, the island is capped by hard rock about 90 metres (295 feet) thick, helping to protect the softer sediment underneath from erosion.

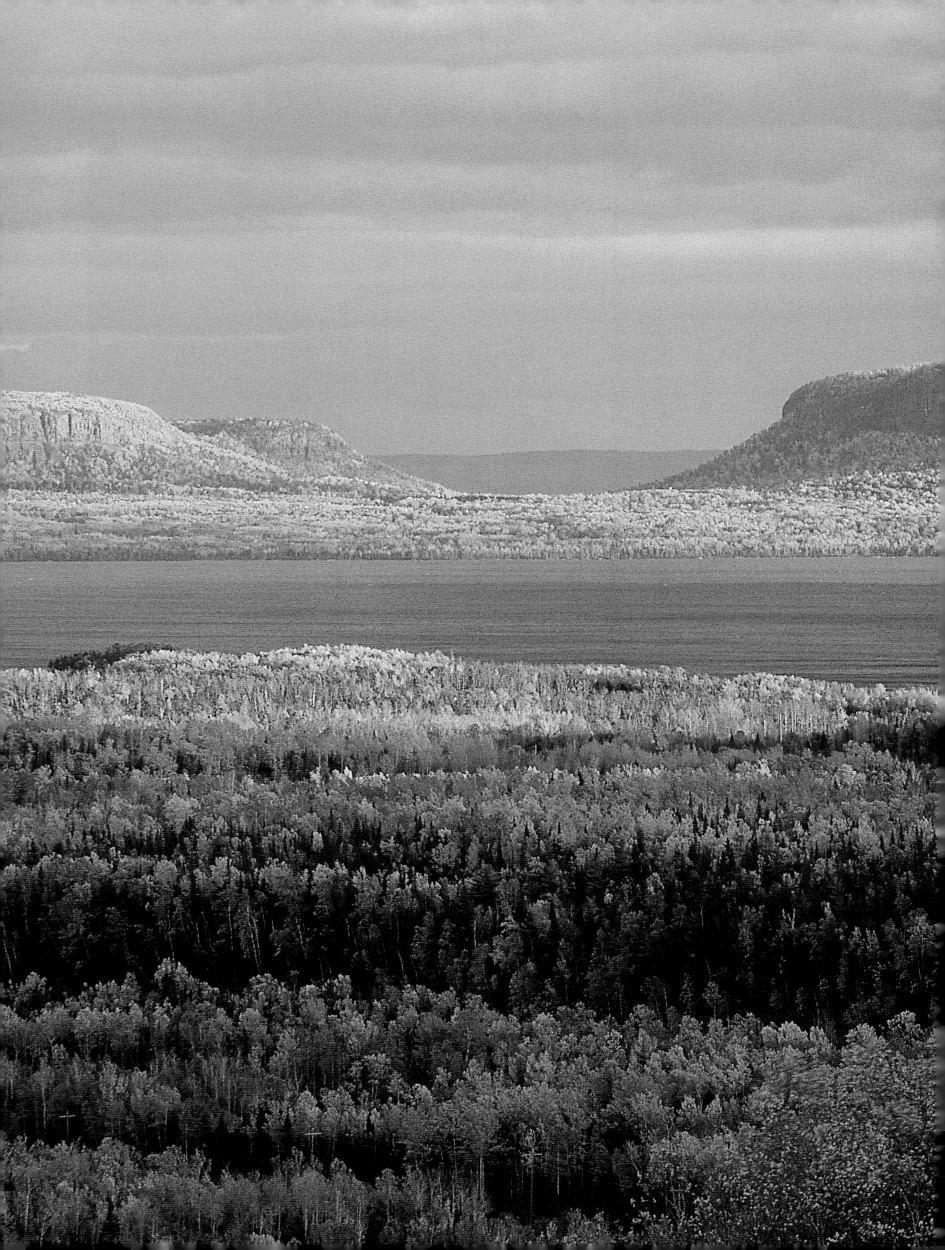

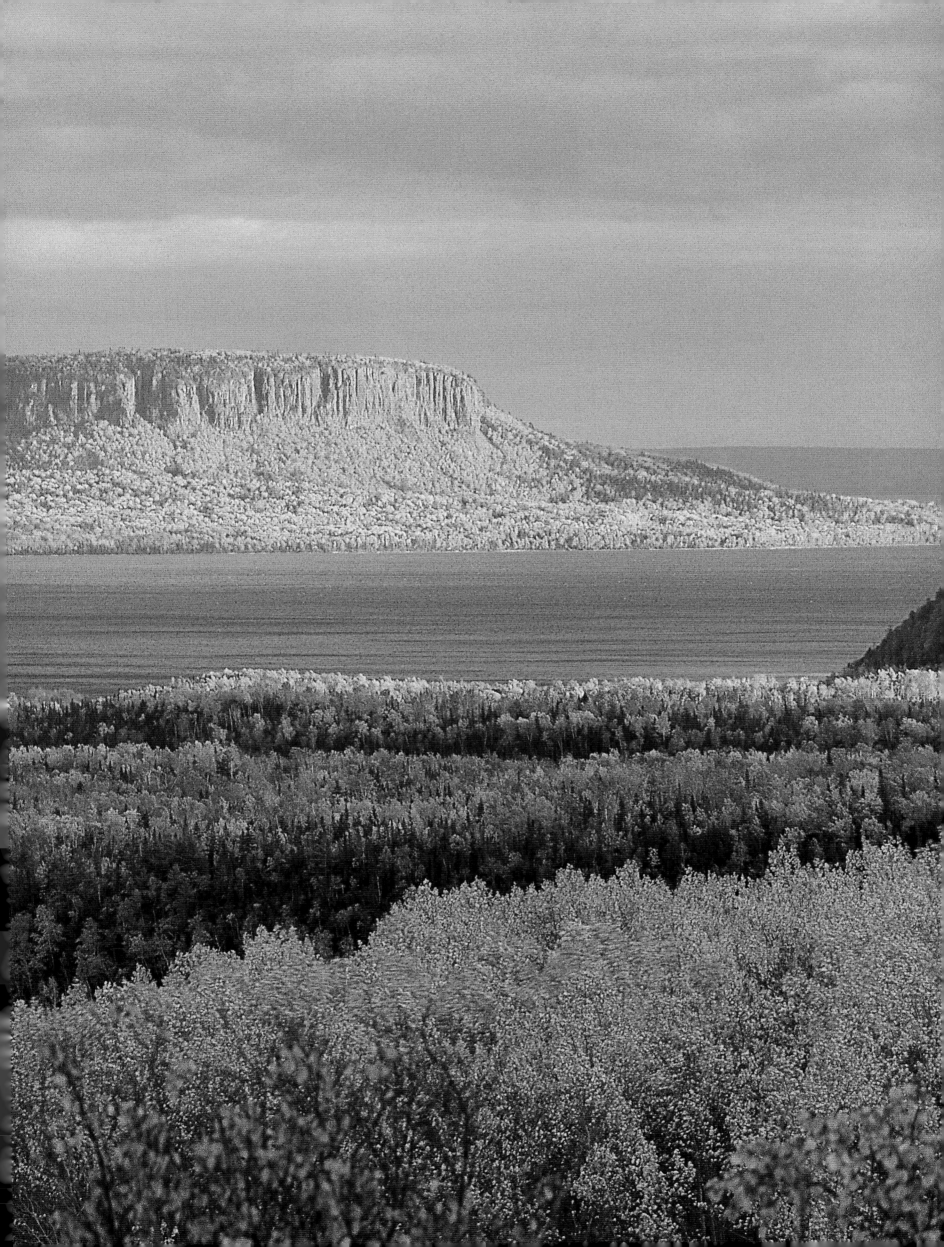

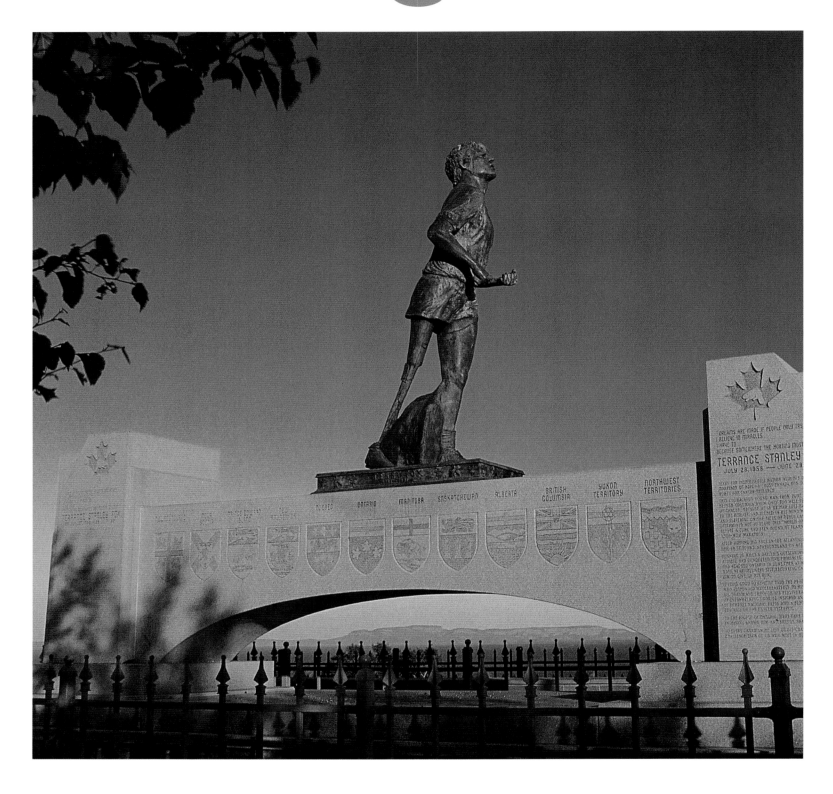

ABOVE: In 1980, having lost one leg to cancer, 21-year-old Terry Fox set out to run across Canada to raise money for cancer research. Just outside Thunder Bay, the disease forced him to abandon his journey. Fox died in 1981, but monuments and commemorative runs across Canada honour his memory.

RIGHT: Stretching for 28,700 square kilometres (11,080 square miles) in Canada and 53,400 square kilometres (20,600 square miles) in the United States, Lake Superior is Canada's largest lake and has the largest surface area of any lake in the world.

OVERLEAF: Together, the five Great Lakes—Superior, Michigan, Huron, Erie, and Ontario—hold 20 percent of the world's fresh water. Bruce Peninsula National Park, above the waters of Lake Huron, protects the ancient rock of the Niagara Escarpment. Fathom Five National Marine Park protects the waters below.

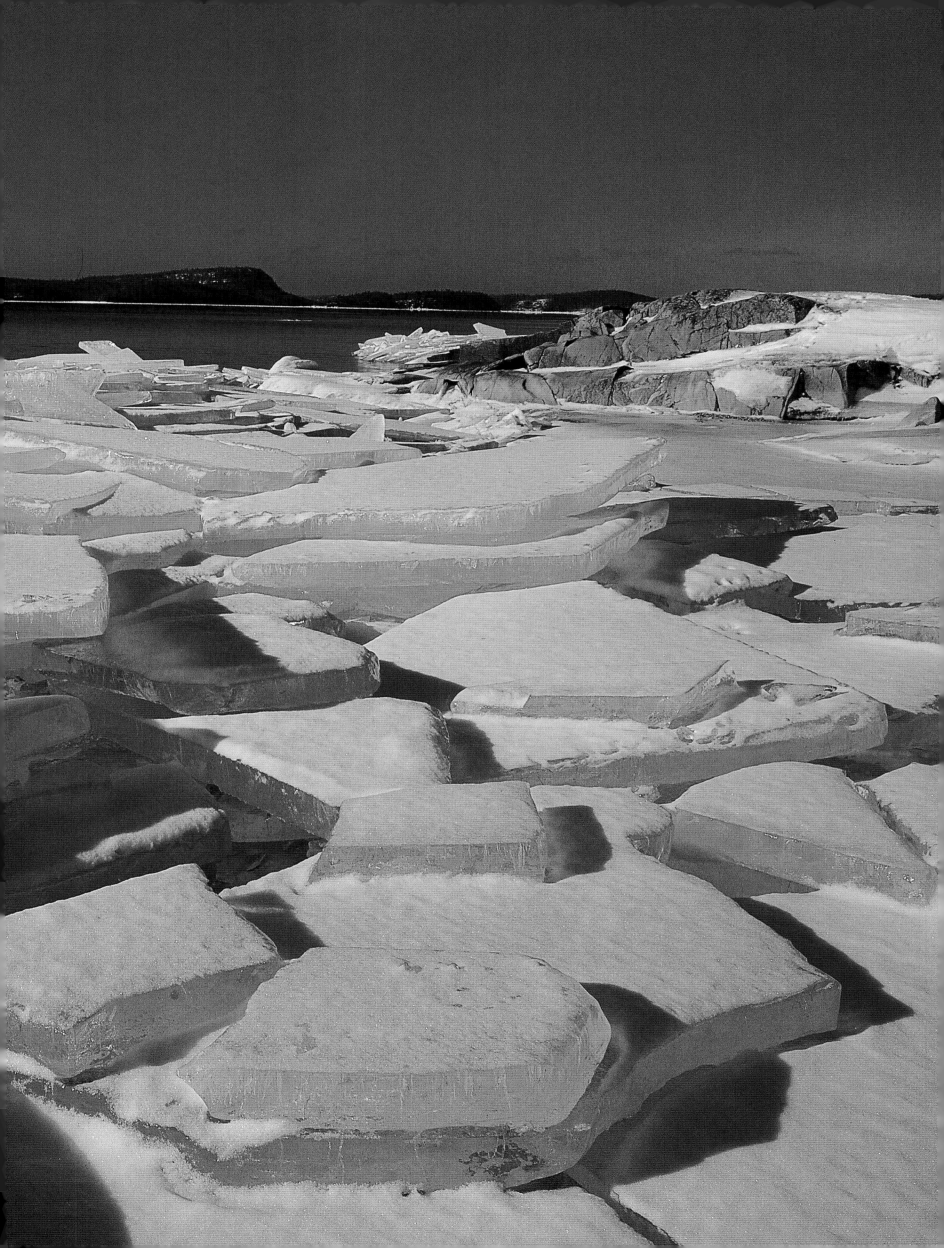

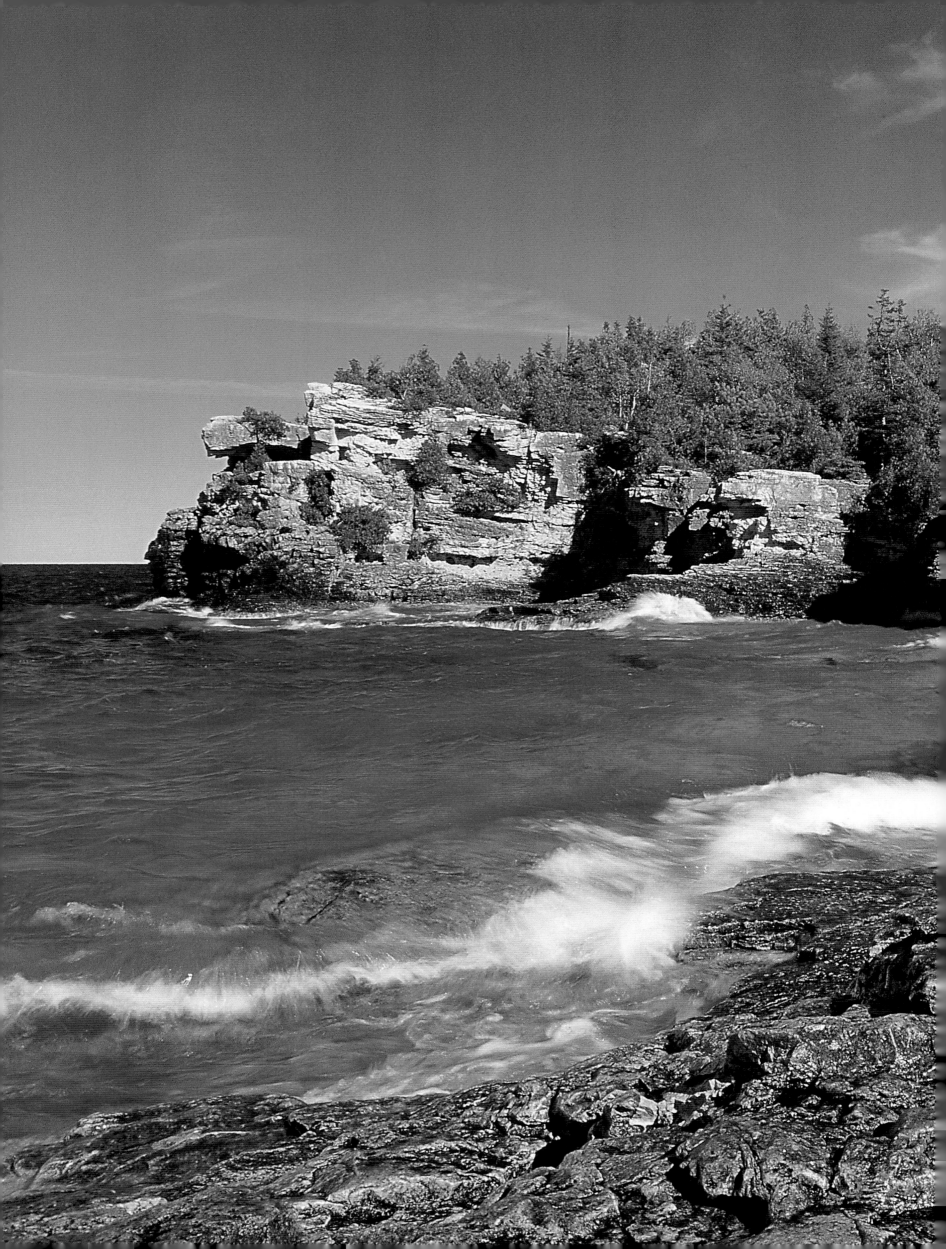

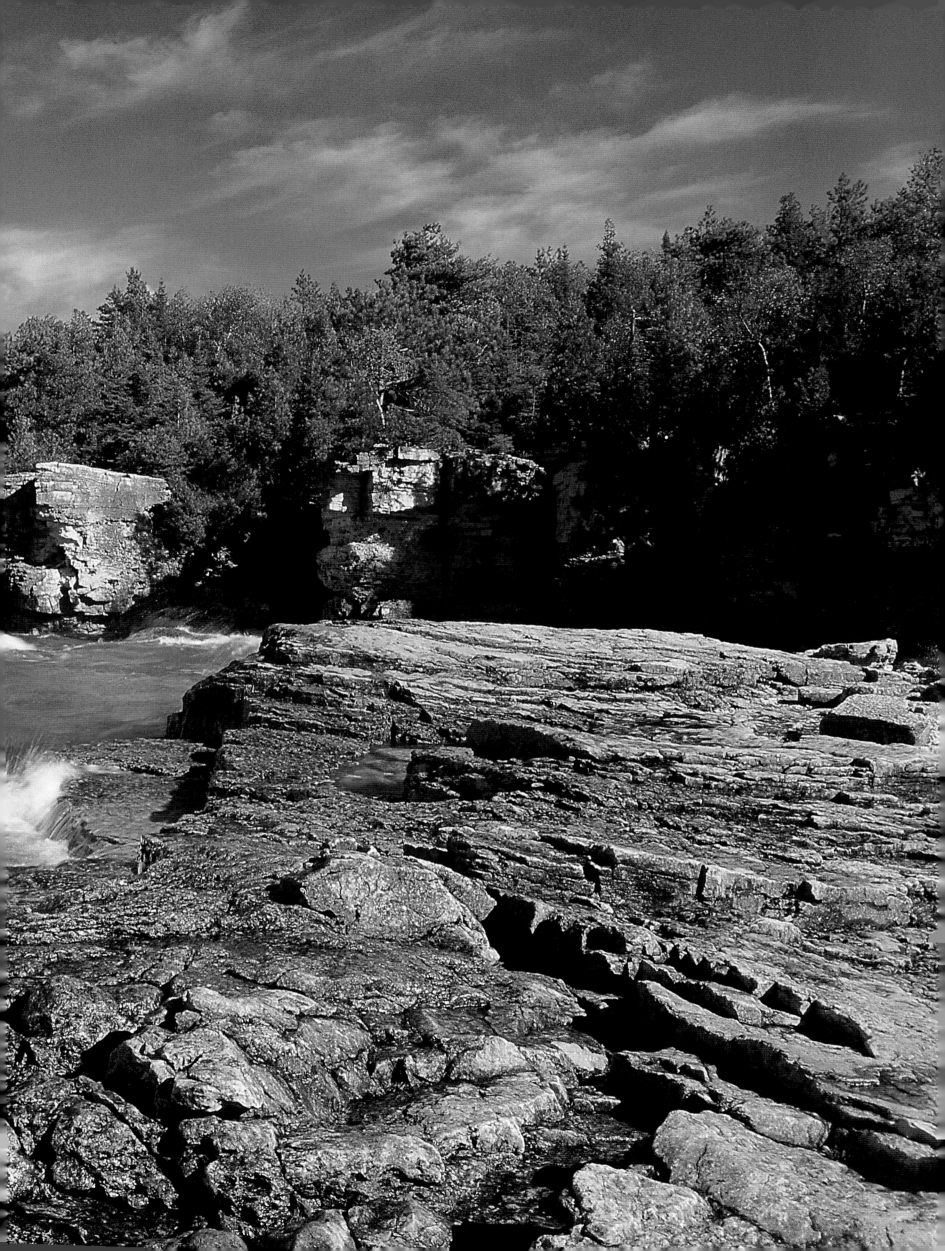

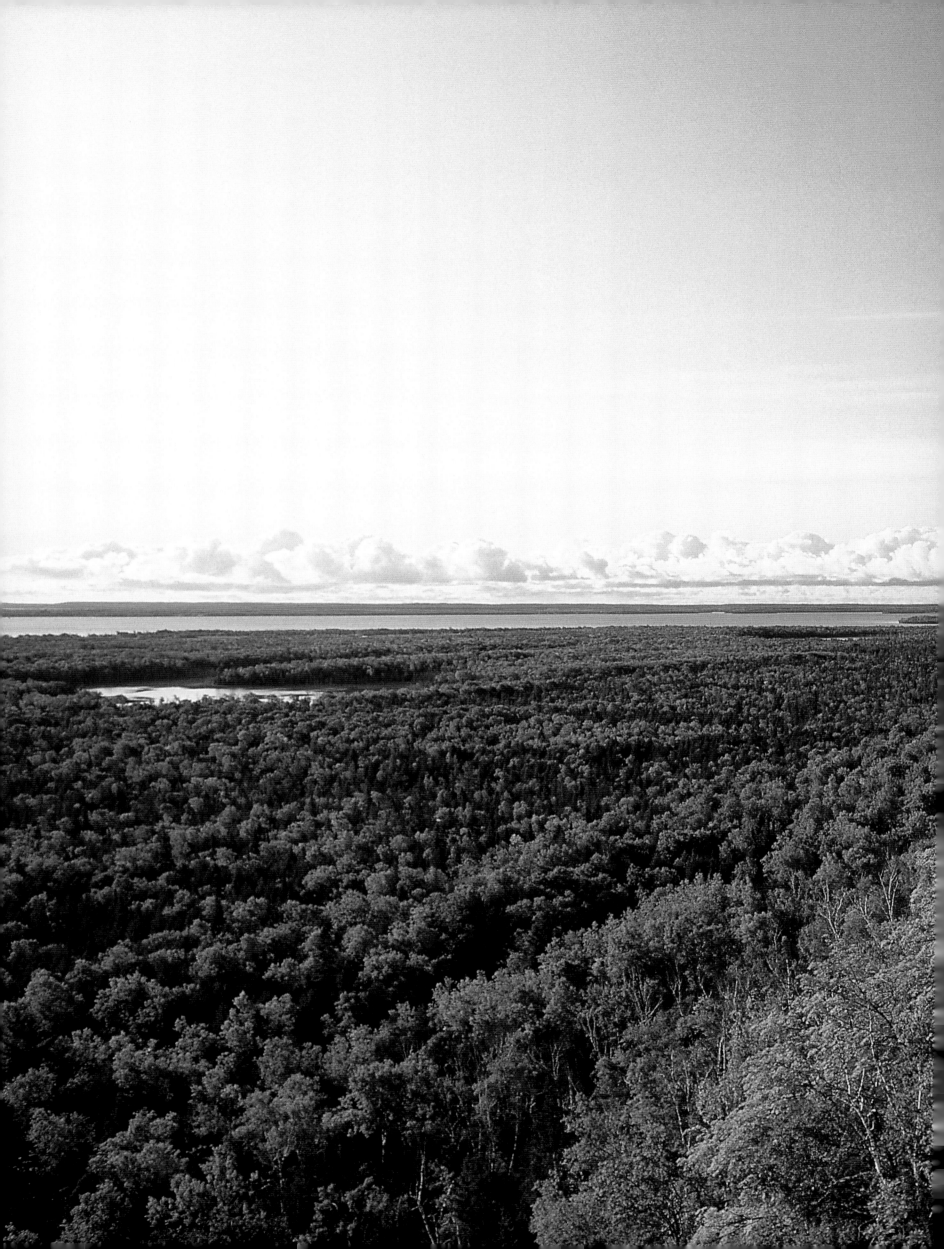

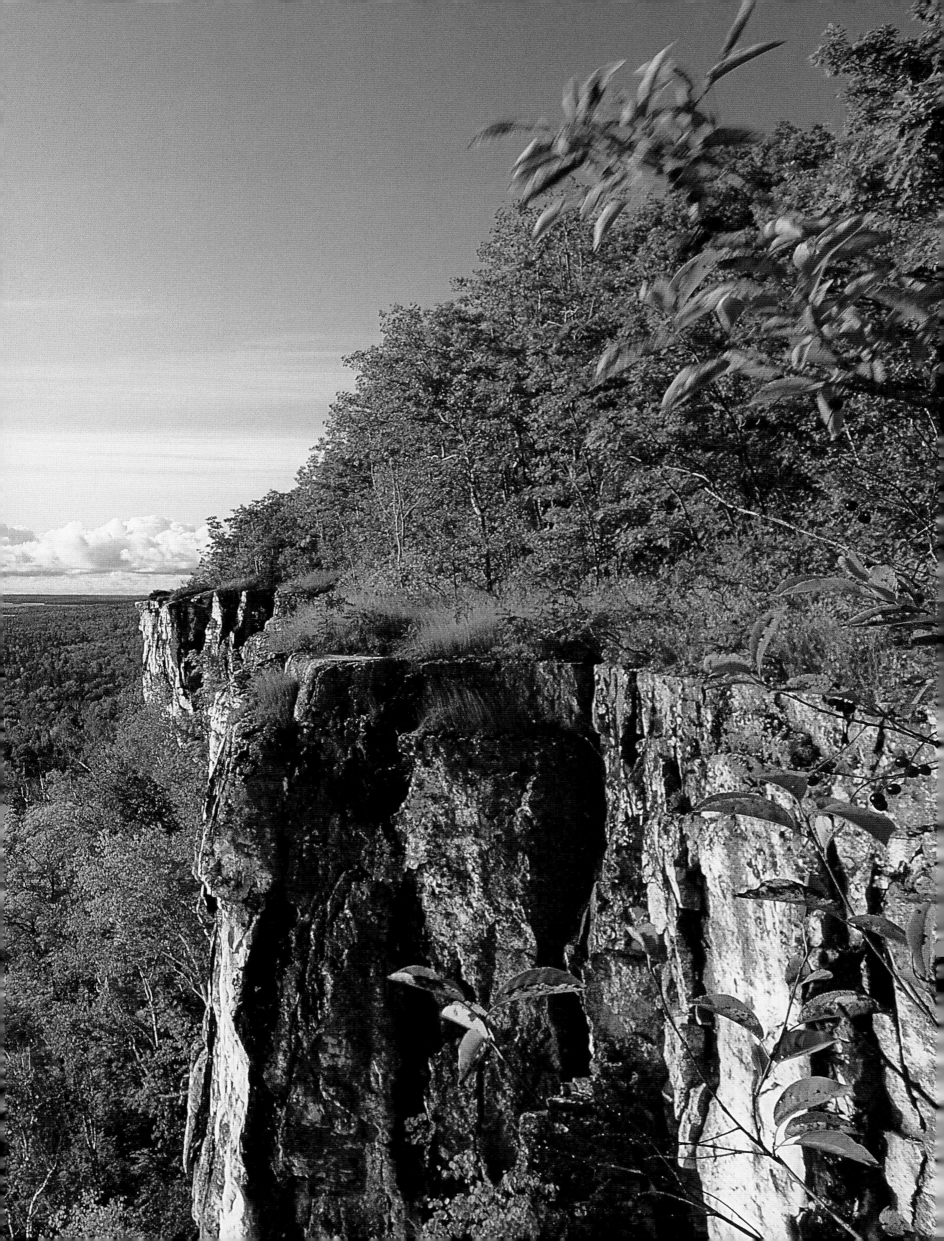

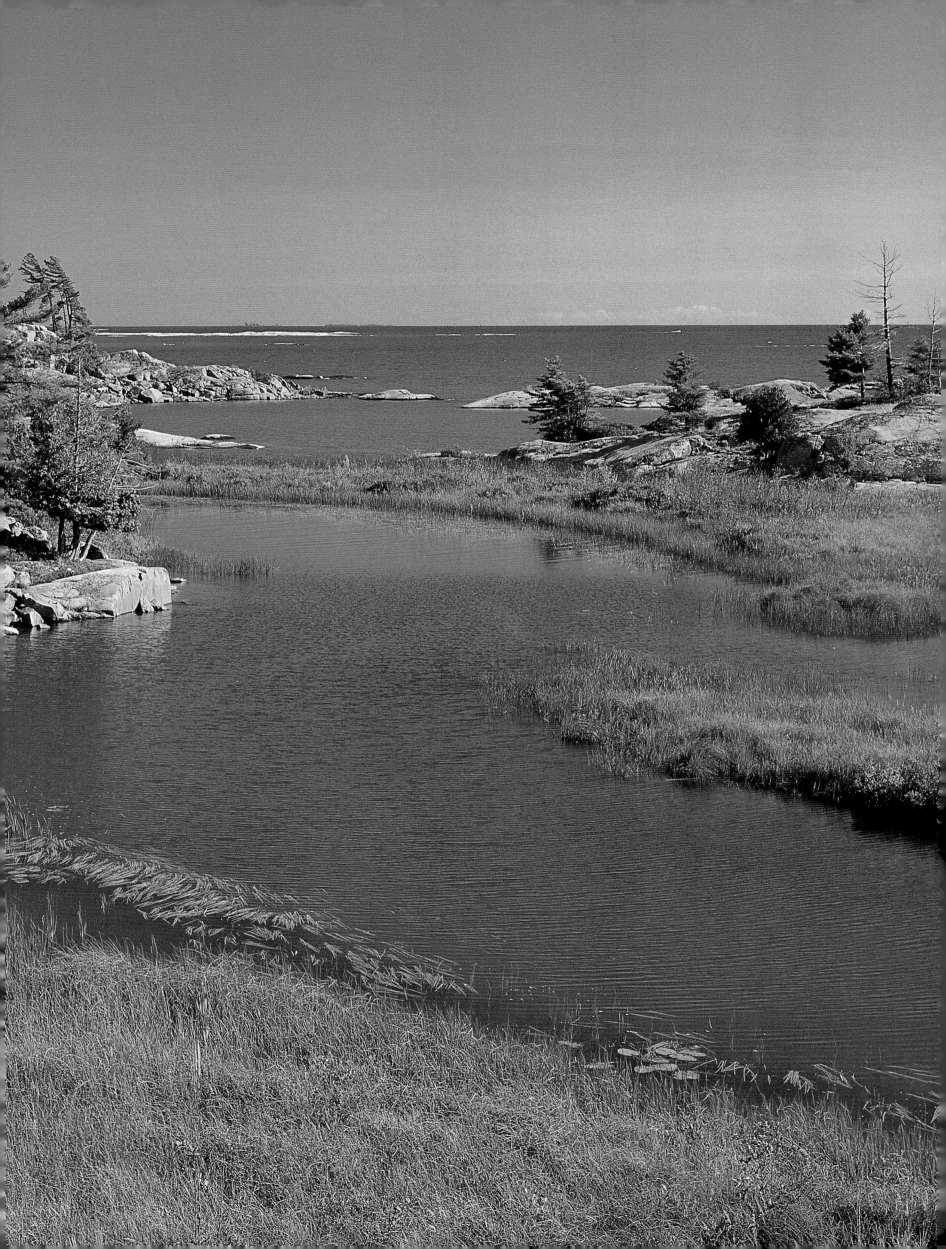

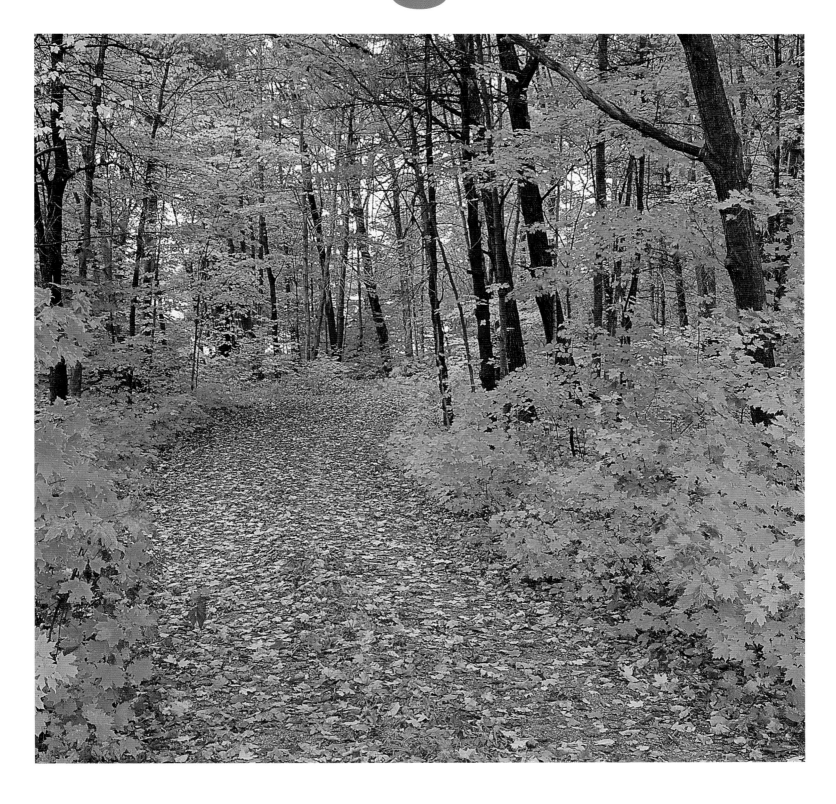

LEFT: The Chickanishing River flows into Lake Huron's Georgian Bay, considered one of the most beautiful spots on the shores of the Great Lakes. This was one of the first areas of the lakes to be explored by Europeans — Samuel de Champlain toured the bay in 1615.

ABOVE: A path winds through fall colours near Gravenhurst. A historic town a few hours' drive north of Toronto, Gravenhurst is the gateway to the Muskoka Lakes region of cottages and parks.

PREVIOUS PAGES: According to a First Nations legend, the Great Spirit first created life on Manitoulin Island — the largest freshwater island in the world. This is a favourite destination for outdoor enthusiasts, who hike the Cup and Saucer Trail through thick forest and past intriguing rock formations.

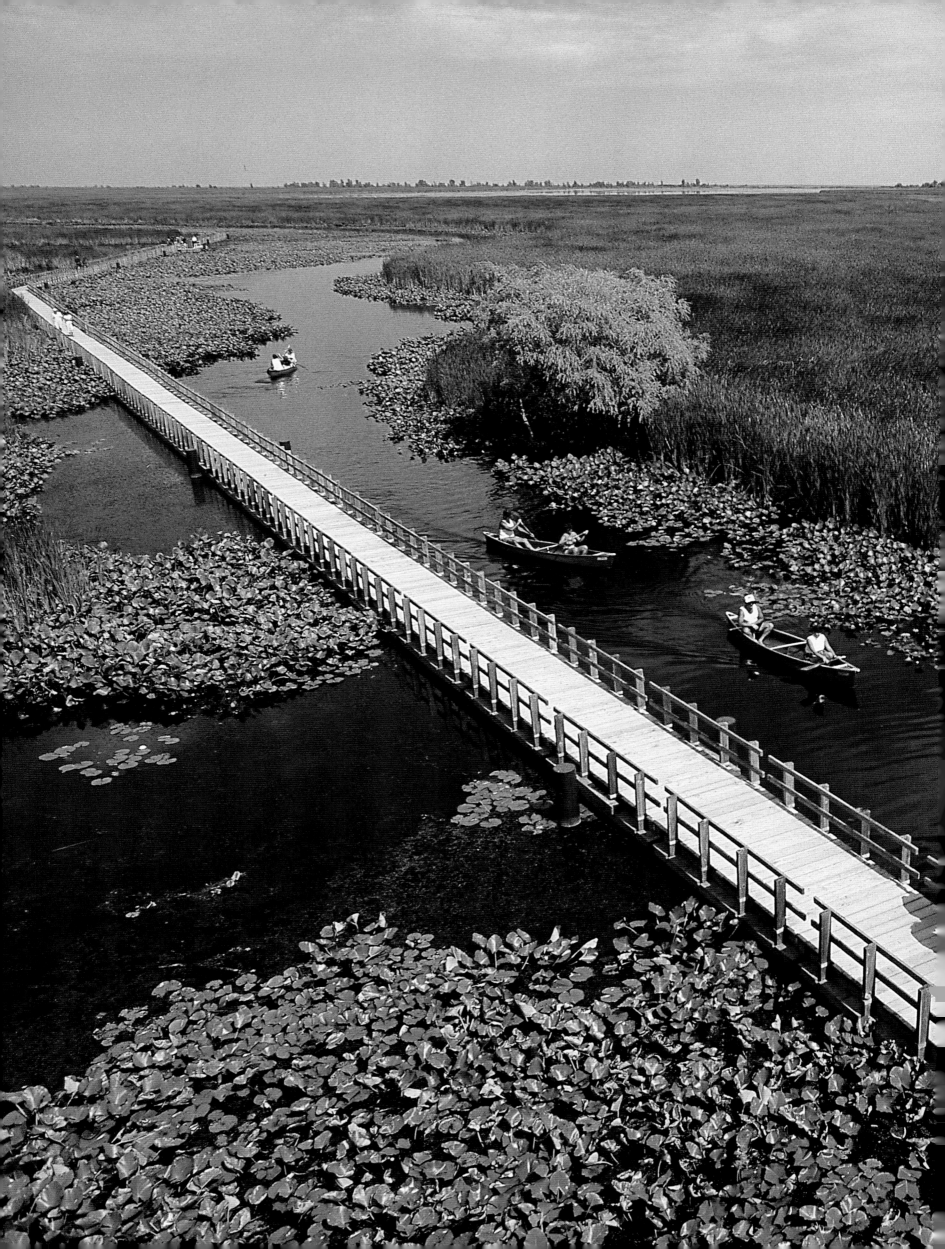

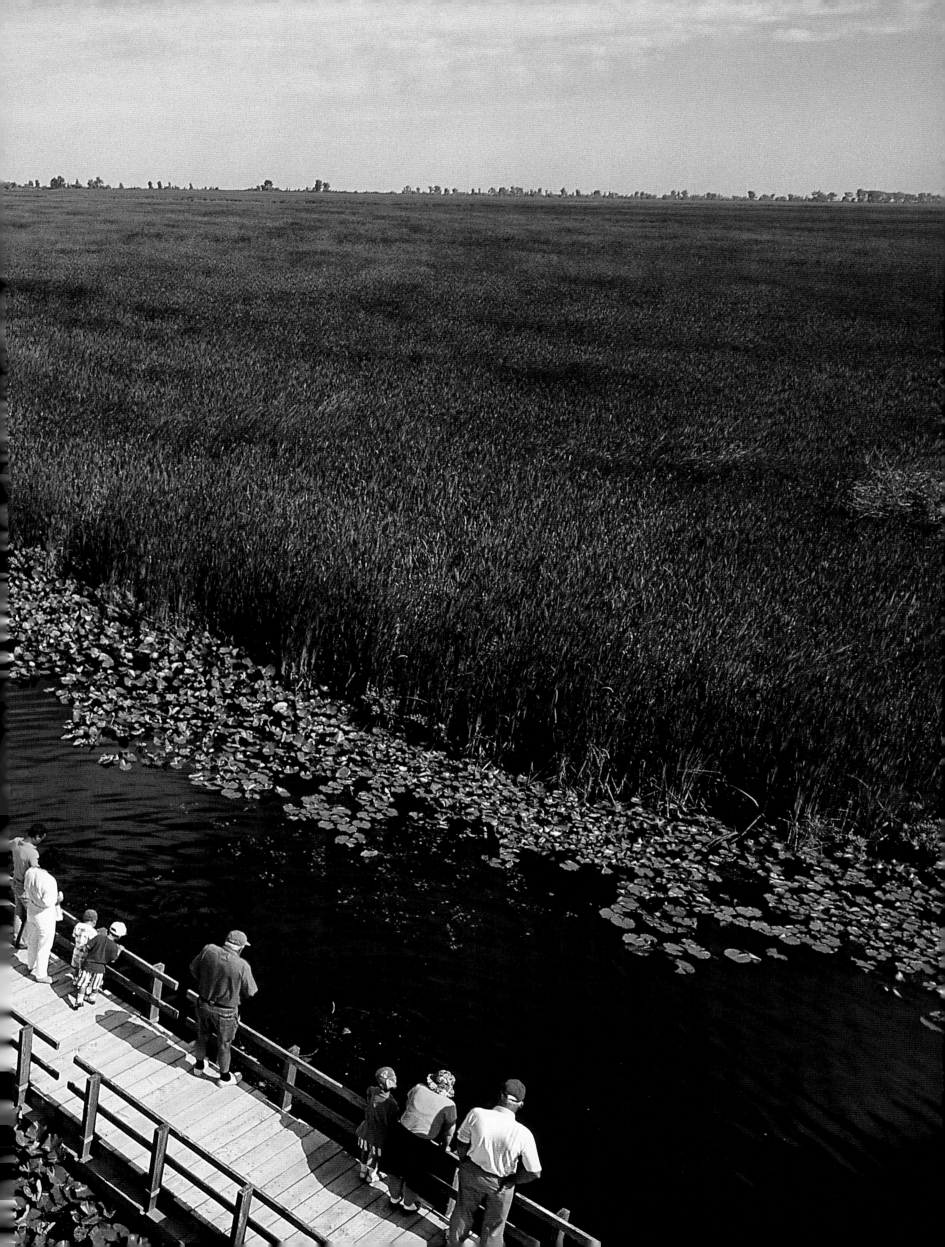

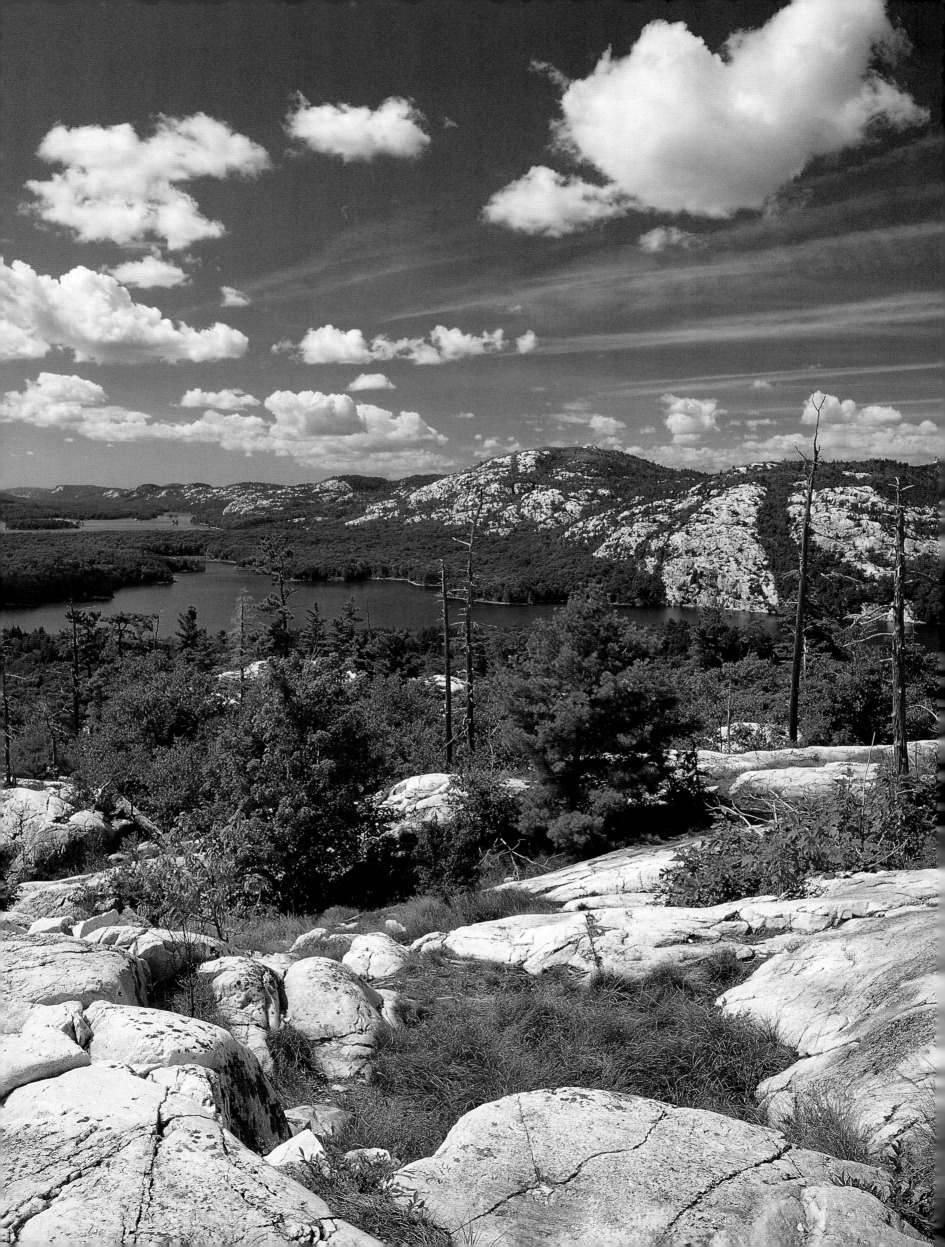

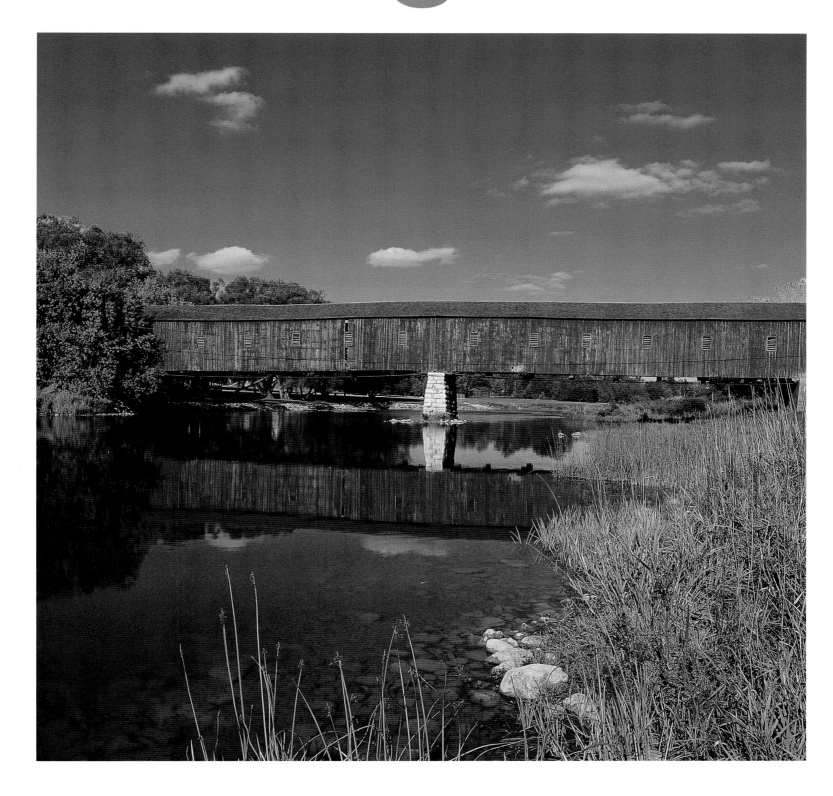

LEFT: Known as the crown jewel of Ontario's provincial park system, Killarney Provincial Park protects spectacular scenery at the western edge of Georgian Bay. The park is accessible by foot or canoe.

ABOVE: A horse-drawn carriage, a dimly lit spot...it's easy to guess how Ontario's last covered bridge earned the name "Kissing Bridge." This 60-metre (200-foot) span was built in 1881 in West Montrose.

PREVIOUS PAGES: At Canada's southernmost tip, Point Pelee is at the same latitude as northern California. Thousands of birds stop here on their annual migrations, and they're joined each fall by flights of monarch butterflies.

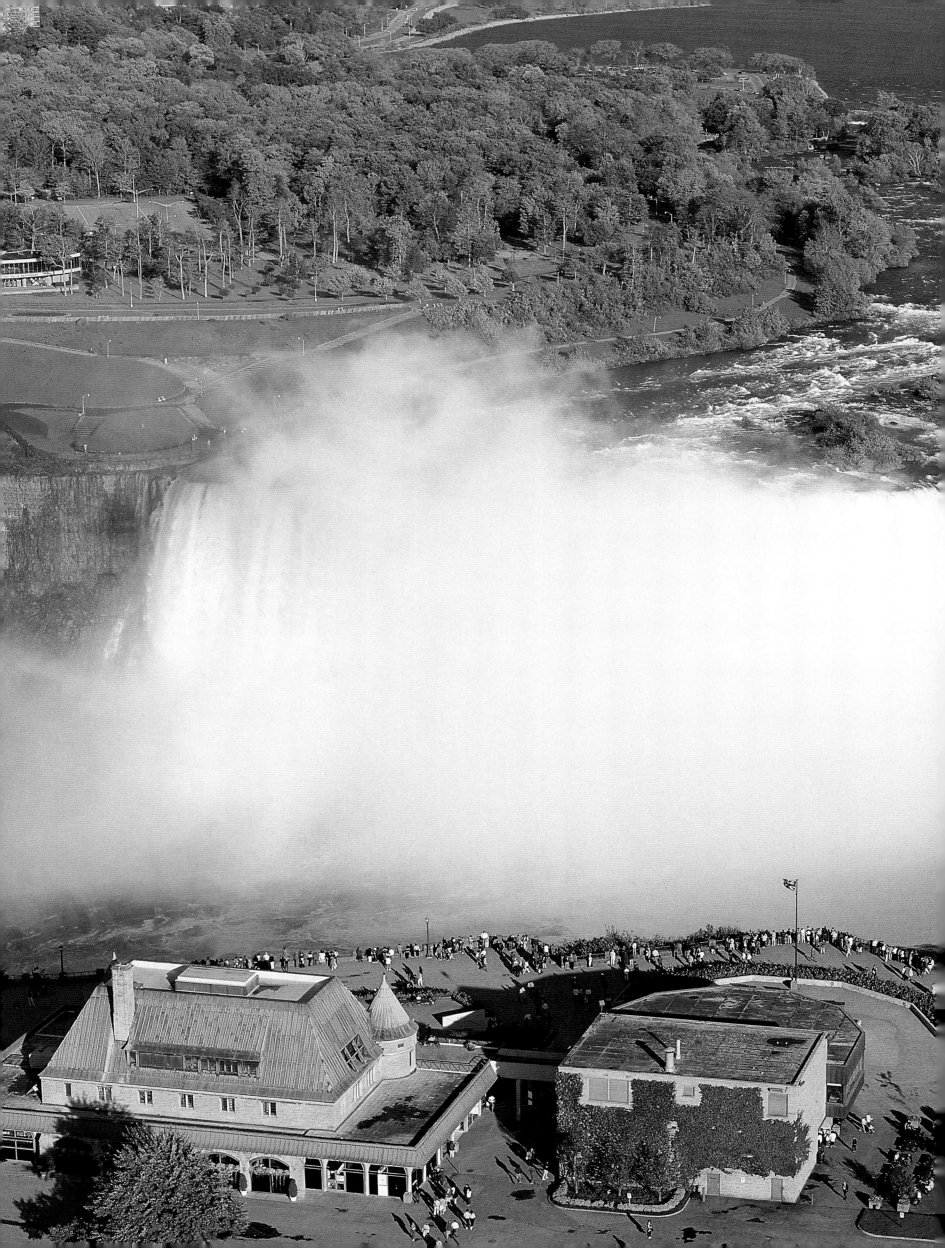

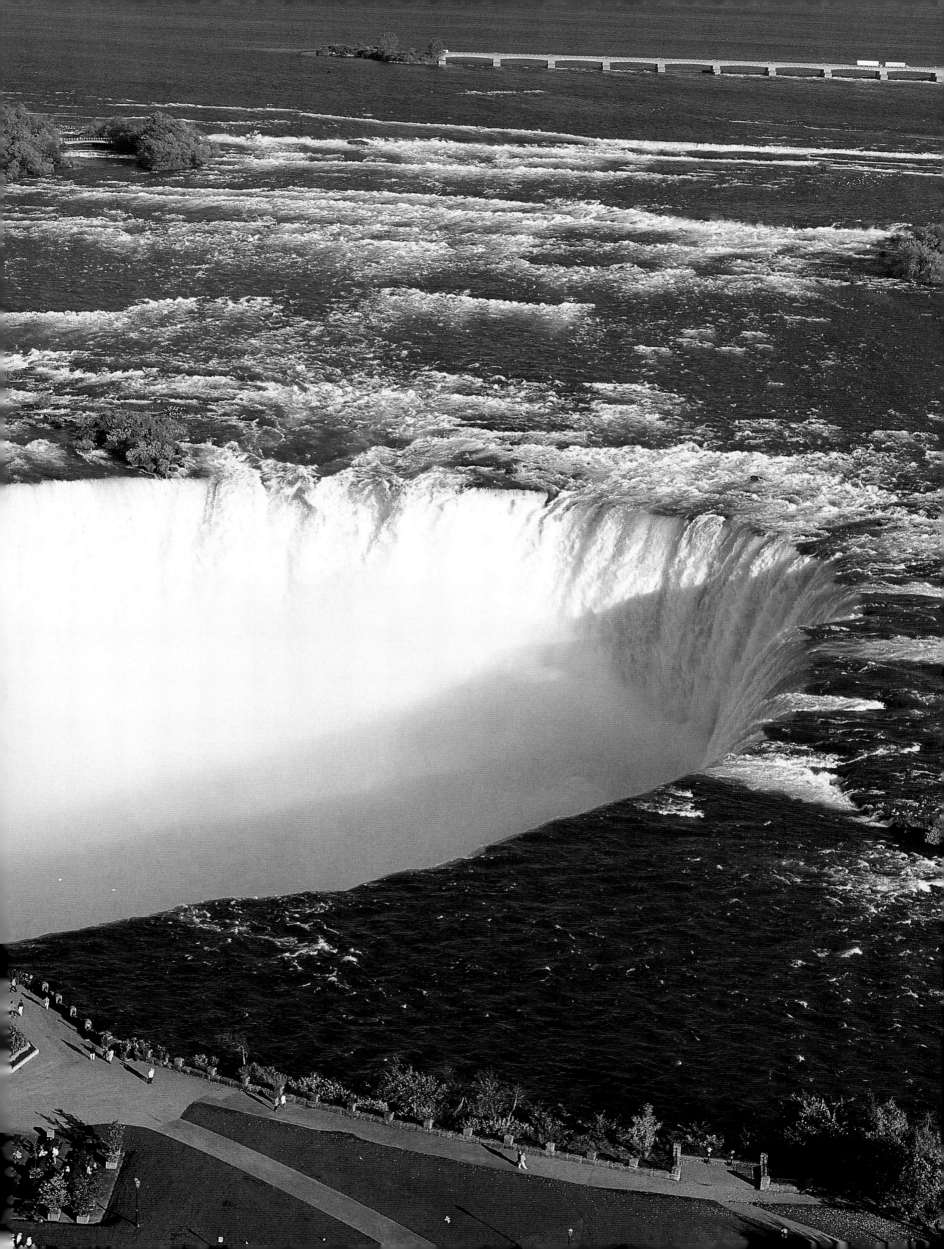

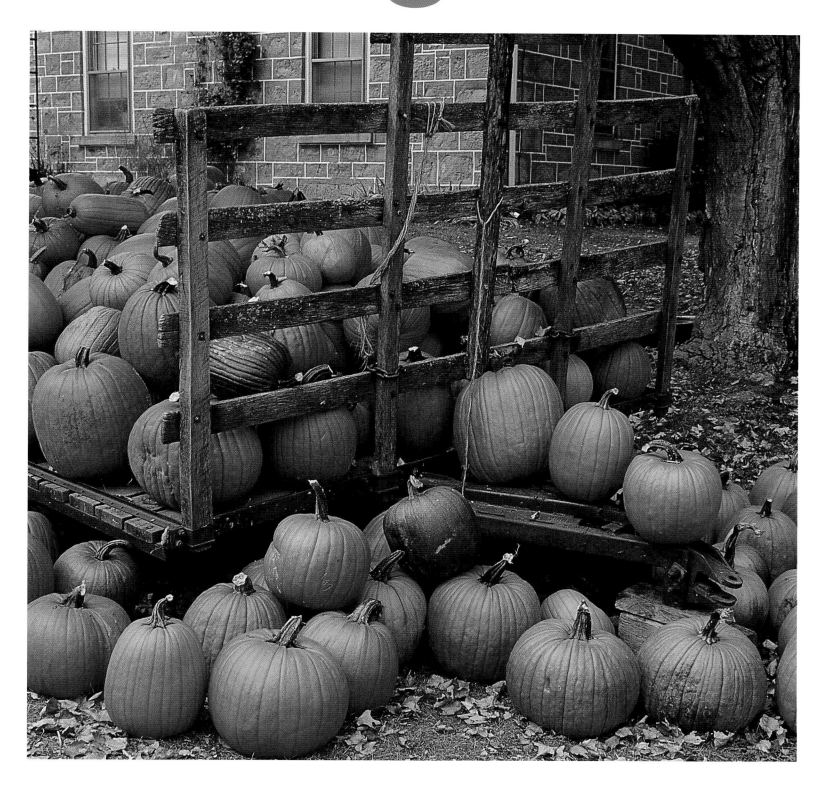

LEFT: The 19th-century village of Niagara-on-the-Lake is home to the Shaw Festival, an annual event dedicated to the works of George Bernard Shaw and the plays, musicals, and mimes of his contemporaries.

ABOVE: Pumpkins are piled in a display near Puslinch, a reminder of the fall season. Farmers in Ontario produce more than 200 horticultural products, from pumpkins and berries to corn and apples.

PREVIOUS PAGES: The seventh natural wonder of the world, Niagara Falls attracts more than 12 million visitors annually. So much water cascades over the falls that the cliff edge erodes at a rate of three centimetres (1.2 inches) per year.

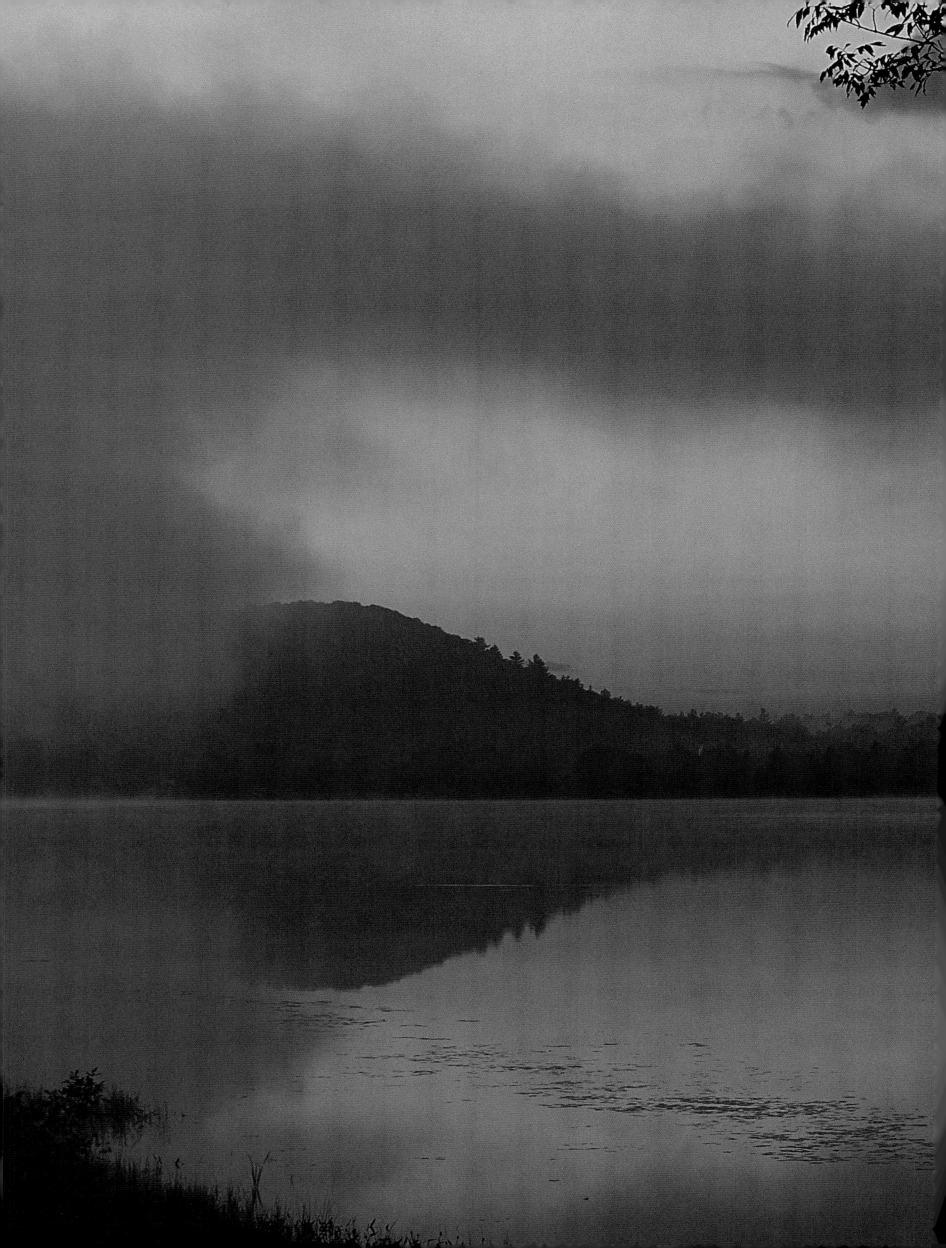

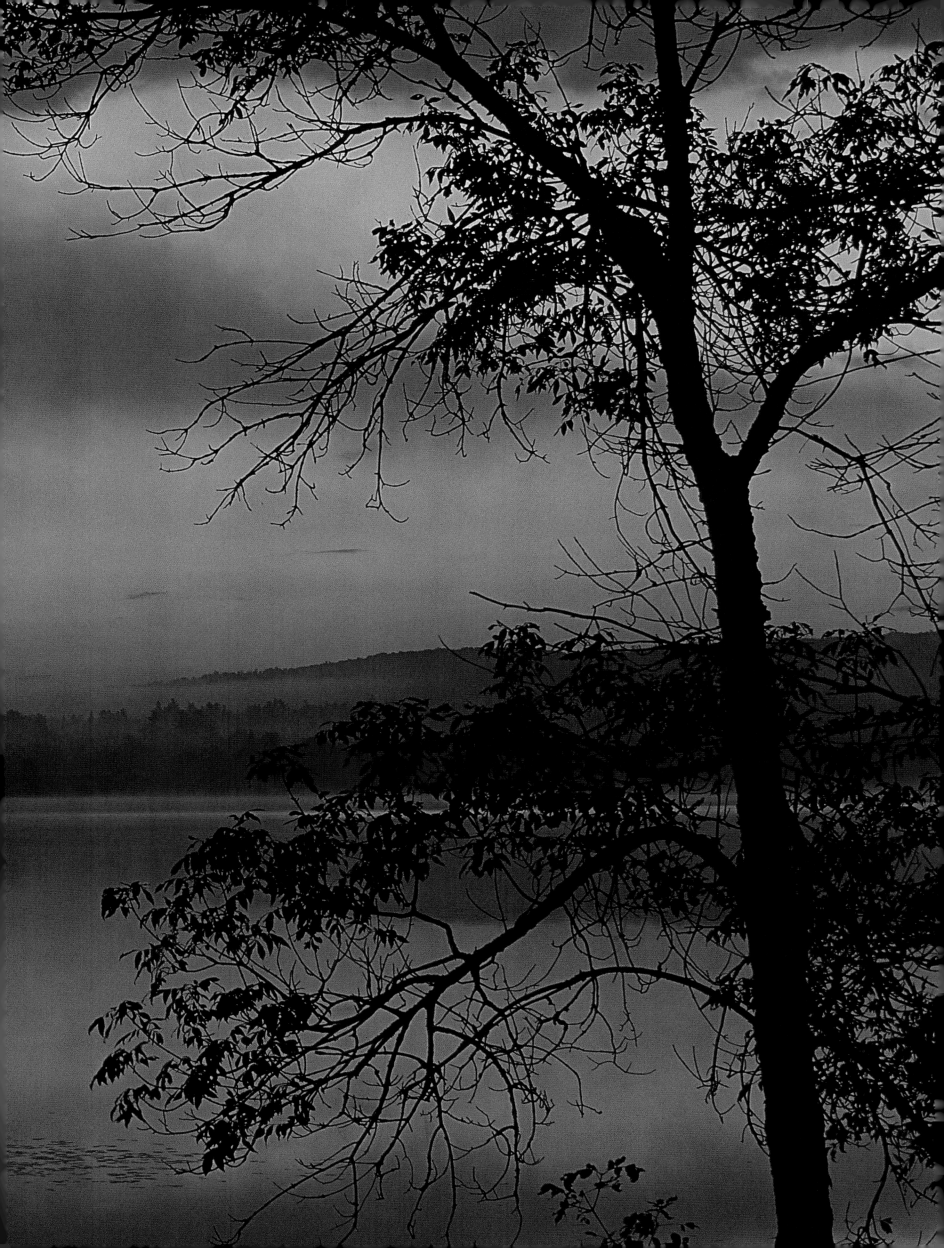

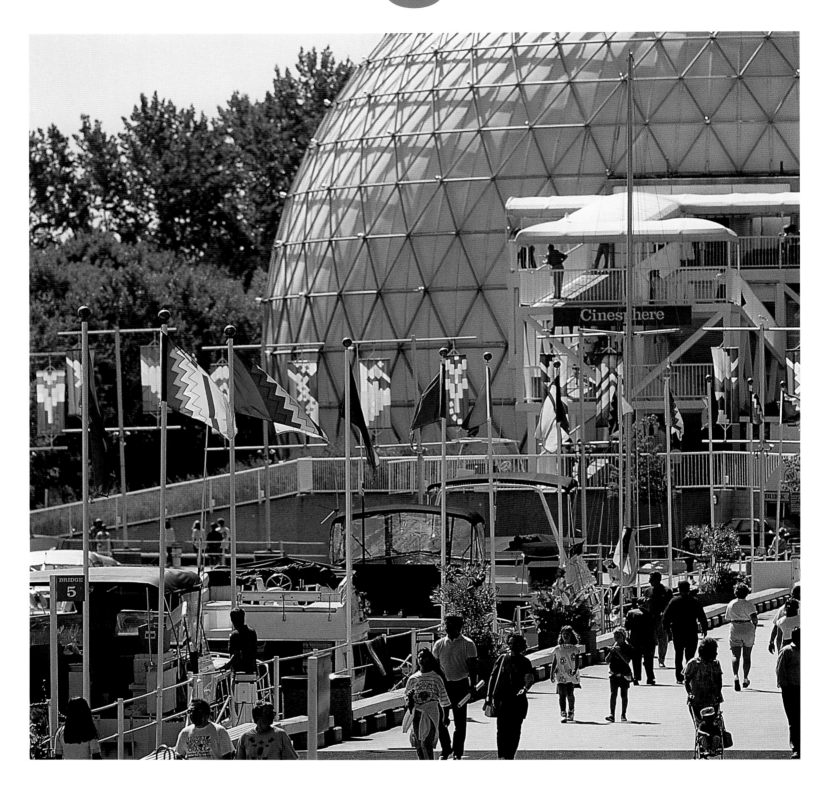

ABOVE: Ontario Place is built on three artificial islands along Toronto's waterfront. Scores of visitors flock to the entertainment complex to enjoy a variety of activities and stroll along the docks on summer afternoons.

RIGHT: After an international competition, Toronto selected the design of Finnish architect Viljo Revell for City Hall, built in 1965. From the air, the complex looks like an eye flanked by two curved eyelids.

PREVIOUS PAGES: Dawn lights the waters of North Pine Lake in the Haliburton Highlands, south of Algonquin Provincial Park.

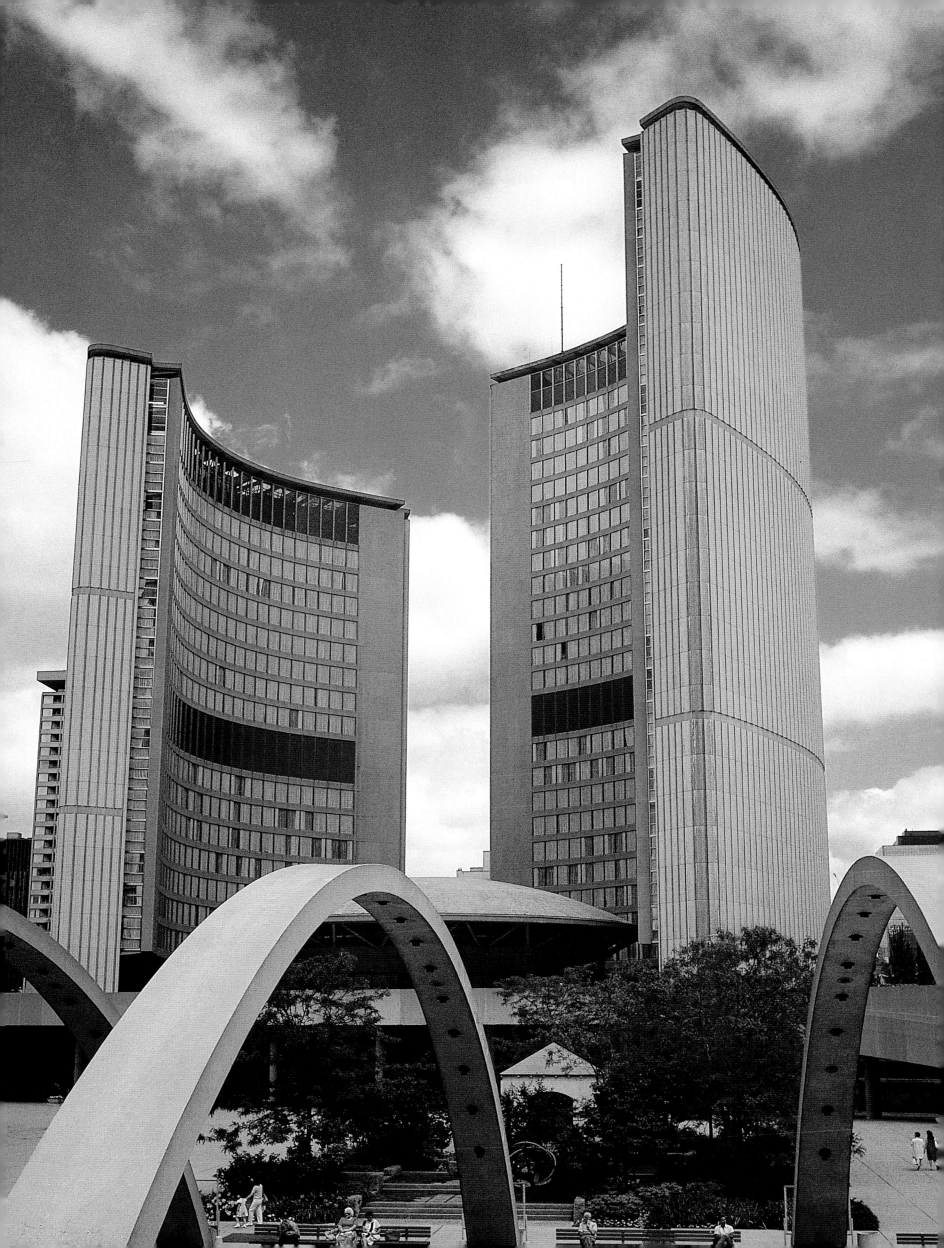

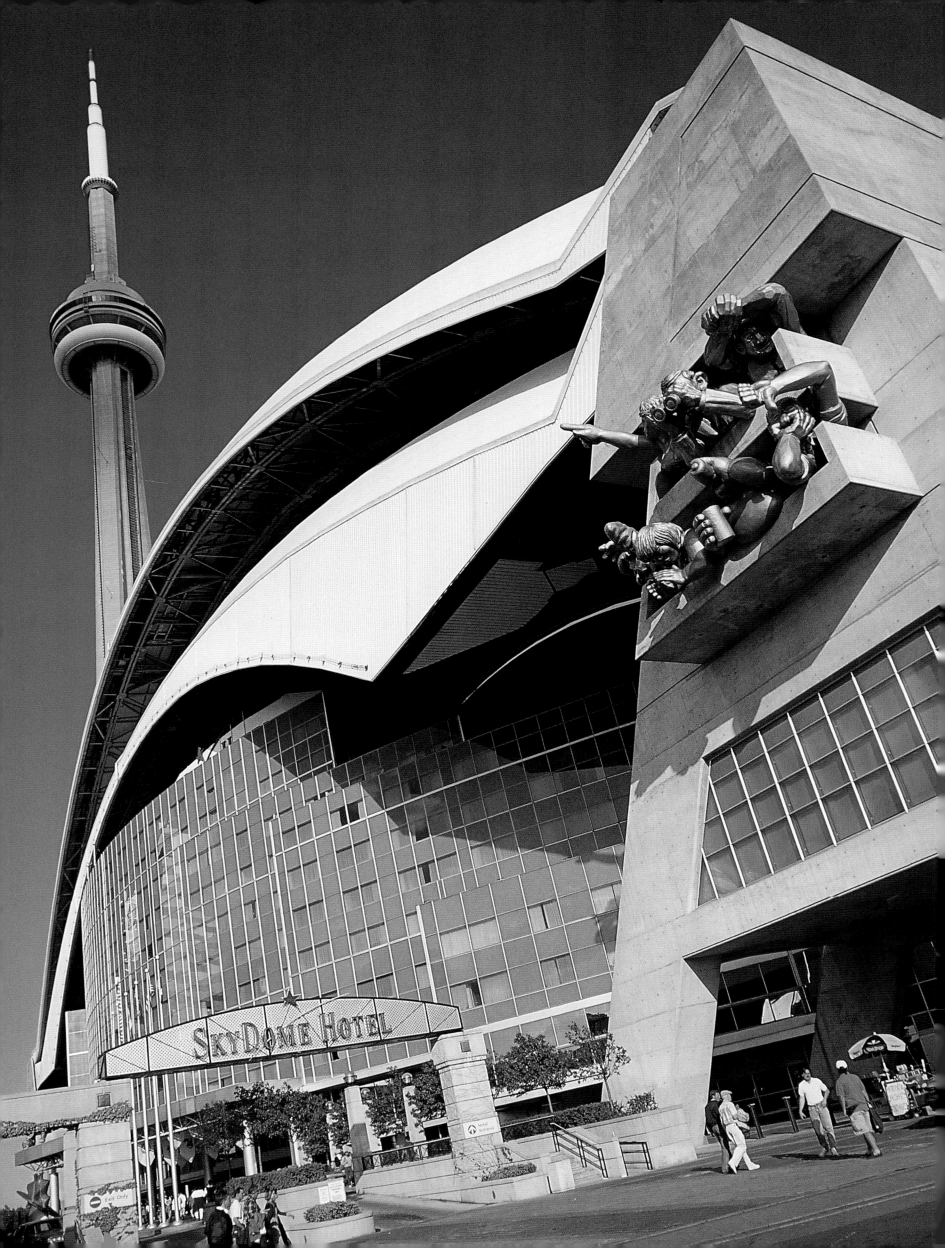

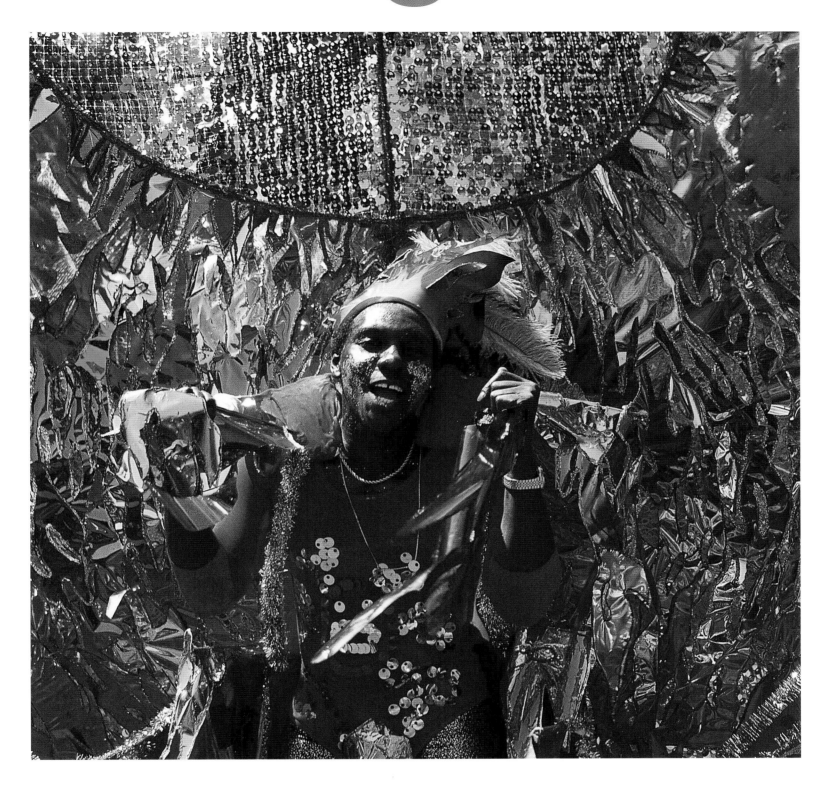

LEFT: Built in 1989, the 52,000-seat SkyDome was the first sports dome in the world to have a fully retractable roof. It hosts Blue Jays baseball, Argonauts football, and Raptors basketball games.

ABOVE: Caribana is a West Indian festival modelled after Trinidad's Carnival, a celebration of freedom from slavery. Held each summer, Caribana's most popular event is the parade, when thousands of participants in extravagant costumes join a procession so long that it takes several hours to pass.

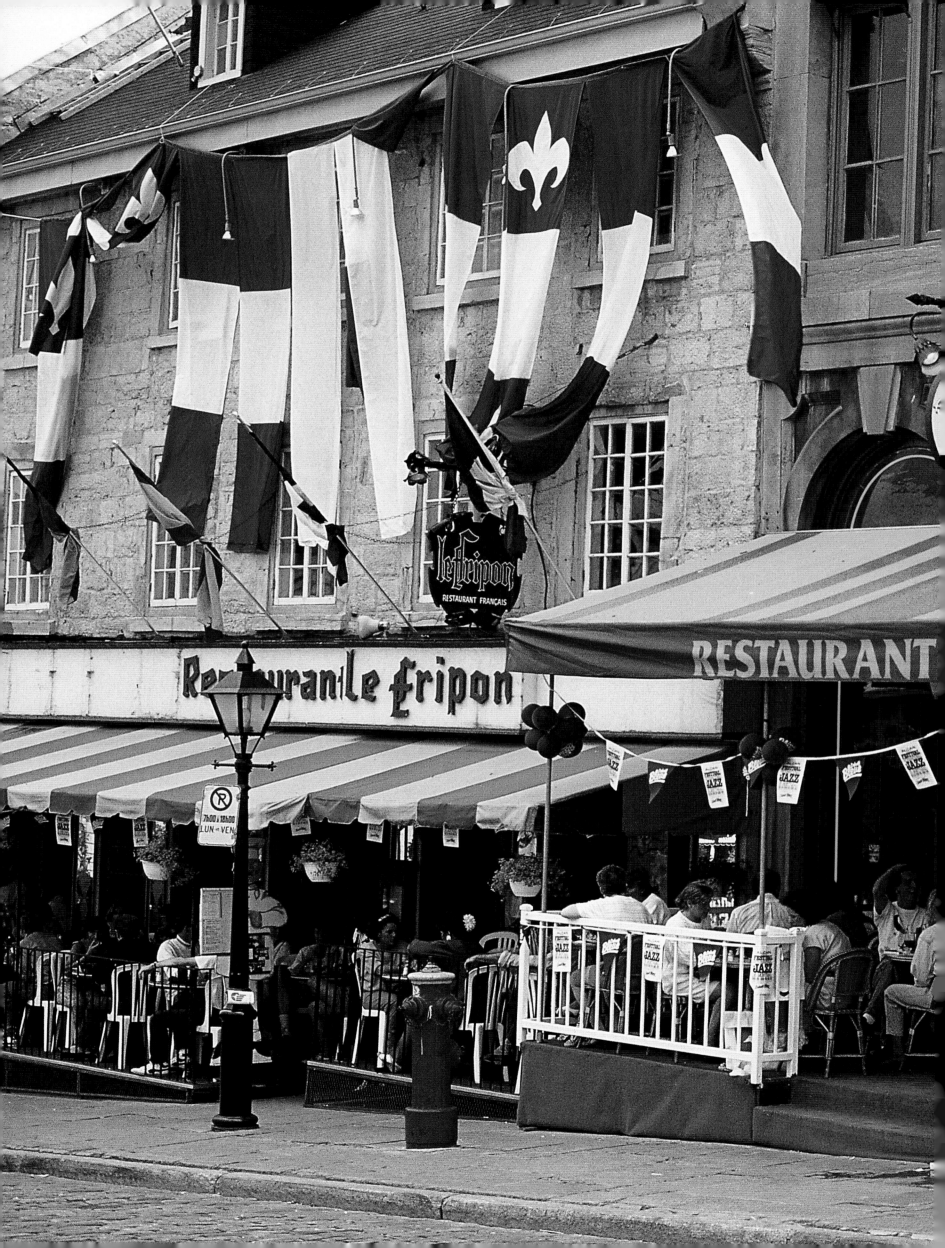

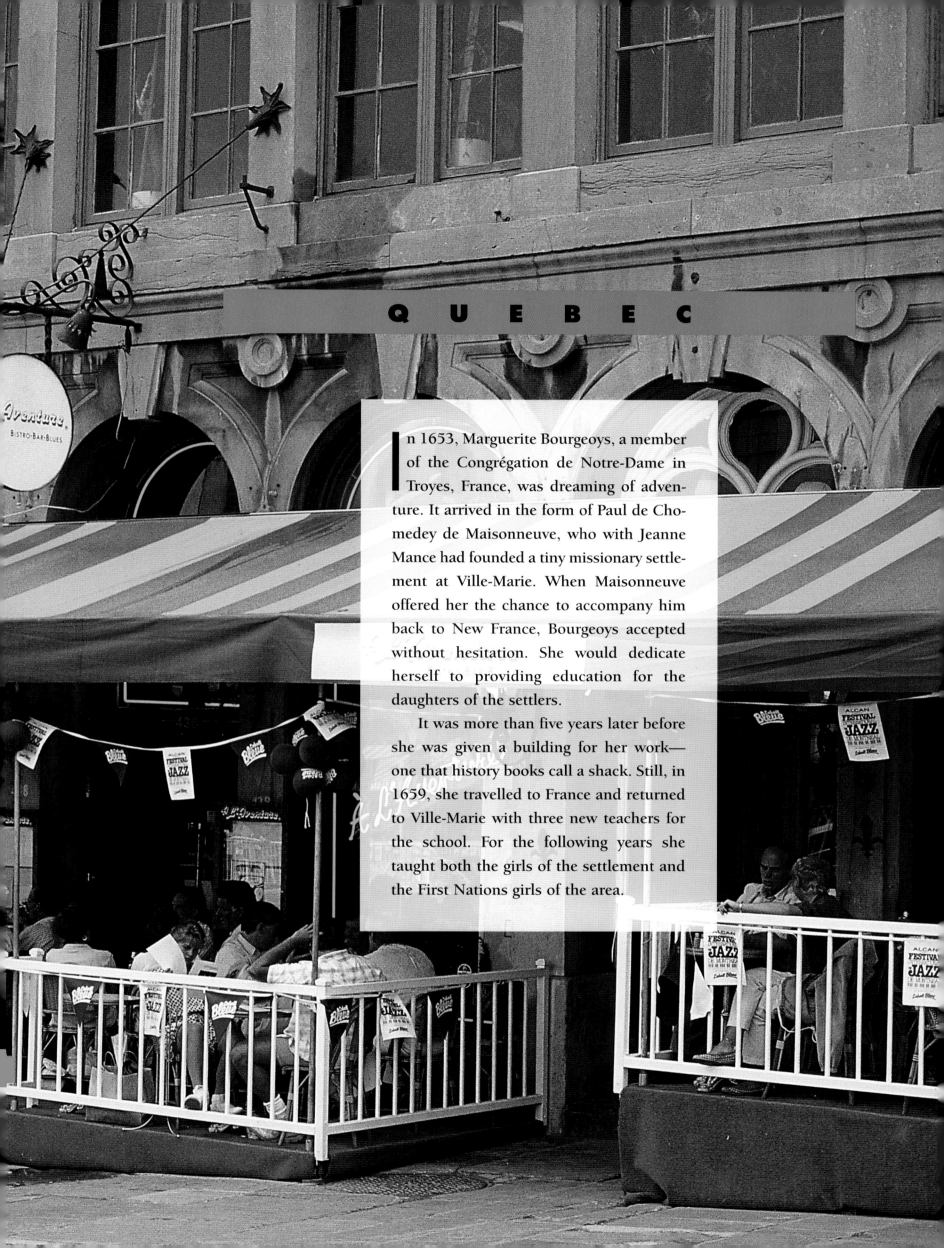

QUEBEC

In 1653, Marguerite Bourgeoys, a member of the Congrégation de Notre-Dame in Troyes, France, was dreaming of adventure. It arrived in the form of Paul de Chomedey de Maisonneuve, who with Jeanne Mance had founded a tiny missionary settlement at Ville-Marie. When Maisonneuve offered her the chance to accompany him back to New France, Bourgeoys accepted without hesitation. She would dedicate herself to providing education for the daughters of the settlers.

It was more than five years later before she was given a building for her work—one that history books call a shack. Still, in 1659, she travelled to France and returned to Ville-Marie with three new teachers for the school. For the following years she taught both the girls of the settlement and the First Nations girls of the area.

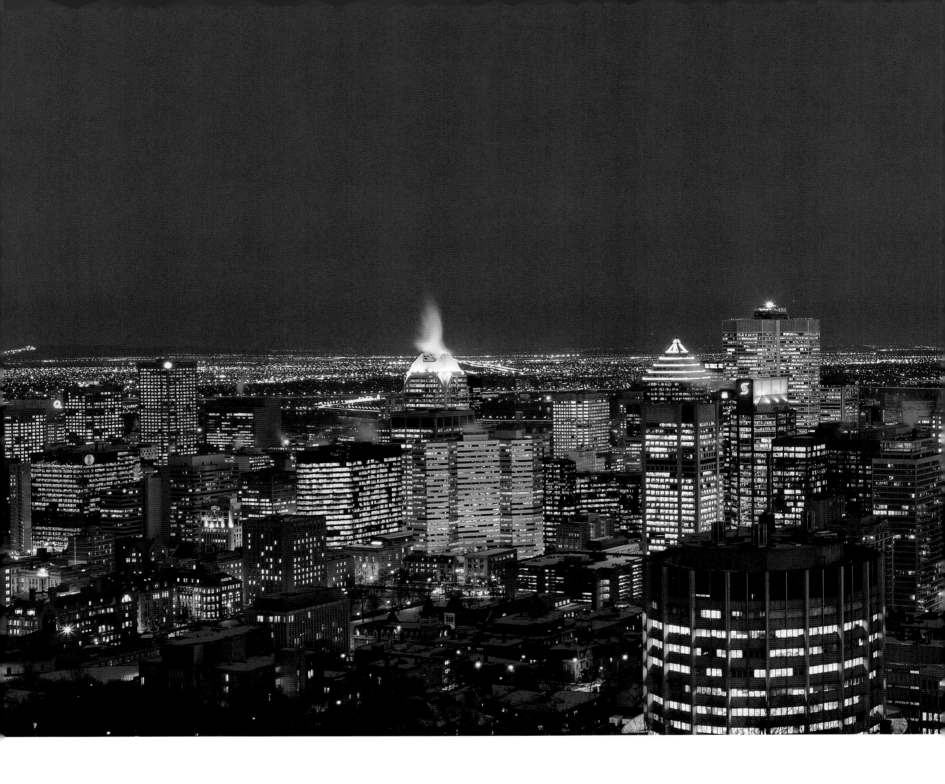

It also fell to Bourgeoys to welcome the *filles du Roi*, or "daughters
of the King," orphans and young women brought to the growing colony
to become the wives of merchants and fur traders. In 1667, impressed
by her work, Bishop Laval endorsed the teachers of Ville-Marie and gave
them permission to open schools throughout New France, wherever
they were needed.

The young colony where Bourgeoys found adventure had turbulent
times to come. There would be Iroquois attacks and smallpox epidemics,
war with Britain and the birth of a new country. Yet the culture of her
time survived and prospered and the fur traders and settlers she passed
on the streets of Ville-Marie helped form what would become the
province of Quebec.

Quebec extends for 1,540,680 square kilometres (594,900 square
miles). It is the largest province in Canada, nearly seven times larger

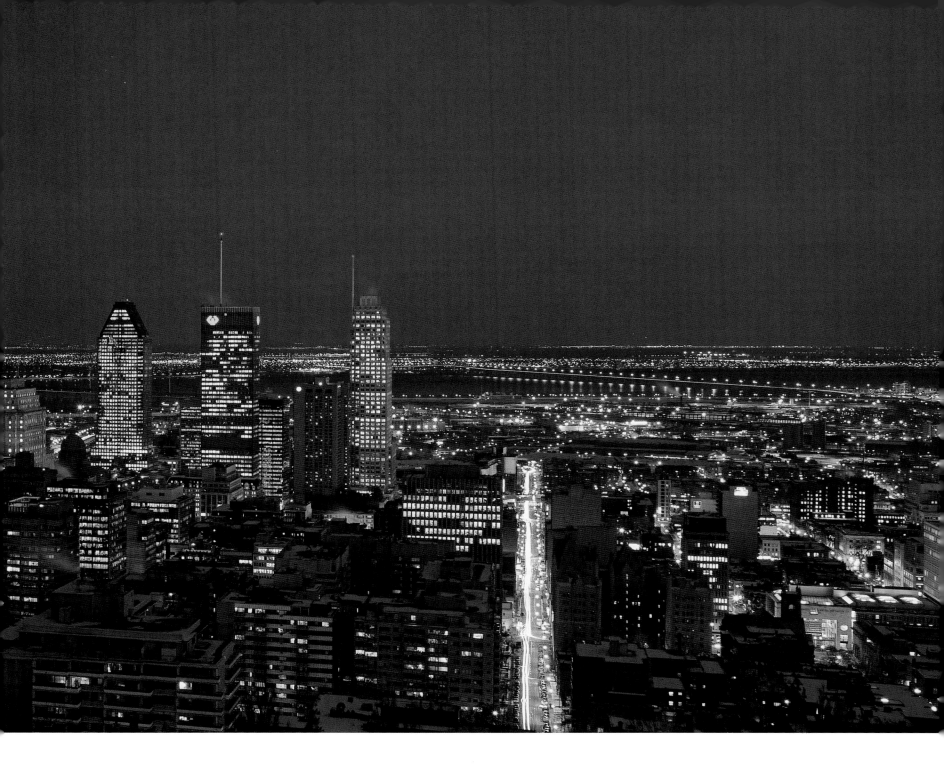

than the U.K. and three times the size of France. Within its boundaries, between the shores of Hudson Bay and the banks of the St. Lawrence River, there are three main regions: the Appalachian Highlands, a series of rolling mountain ranges reaching south to the Gaspé Peninsula; the massive Canadian Shield; and the St. Lawrence Lowlands, an expanse of flat, rich land that spreads from the banks of the river. About 90 percent of Quebec's population still lives in this region, which includes the thriving metropolis of Montreal, once the site of Ville-Marie.

In Quebec schools today, pupils learn of the province's first teacher, Marguerite Bourgeoys. They learn of her classes in the first school, her shepherding of the filles du Roi, and of her sainthood. She was canonized in 1982, and a plaque in her honour in Troyes calls her the founder of education in Montreal and an apostle of French culture in Canada.

ABOVE: Just over one million people live in the city of Montreal. About two million more live in the surrounding areas. The island itself measures 32 kilometres (20 miles) at its longest point and is about 16 kilometres (10 miles) wide.

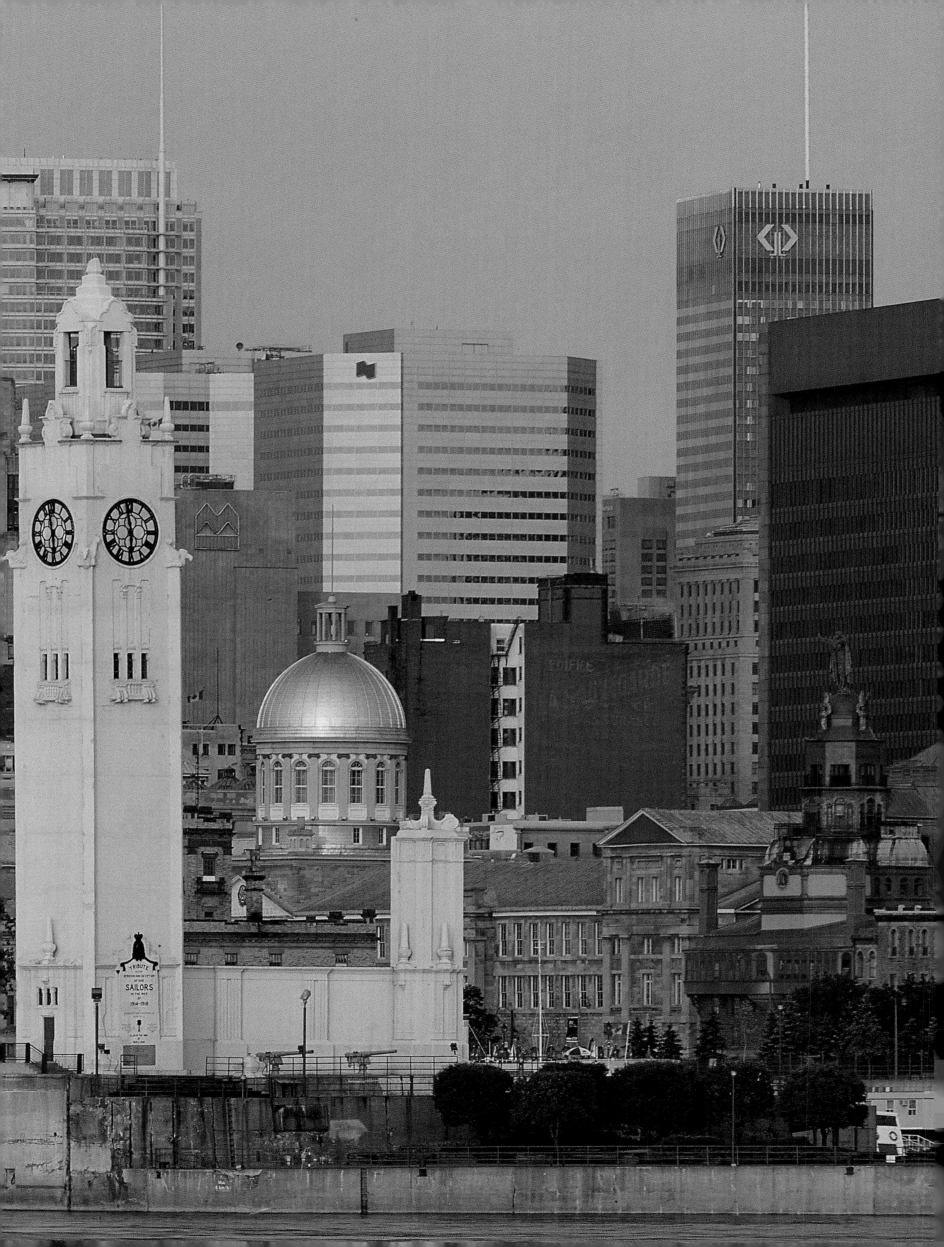

LEFT: For more than 300 years, activity in Montreal was focused along the St. Lawrence River in what is now Old Montreal. In the early 1900s, businesses began to move closer to Mount Royal, towards the city's present downtown. Old Montreal was the site of a massive restoration effort in the 1960s.

ABOVE: There are 28 municipalities on the island of Montreal, and the neighbourhoods of each have a slightly different character.

ABOVE: Historic buildings and traditional architecture line the streets in the Petit Hameau district of Saint Jovite. This picturesque town is a gateway to the outdoor attractions of Mont Tremblant Provincial Park and the Laurentian Mountains.

RIGHT: Gatineau Provincial Park protects 36,000 hectares (89,000 acres) and more than 100 bird species in Quebec's Gatineau Hills. Though within the province of Quebec, the preserve is only a 20-minute drive from downtown Ottawa, and a favourite camping and hiking retreat for many city residents.

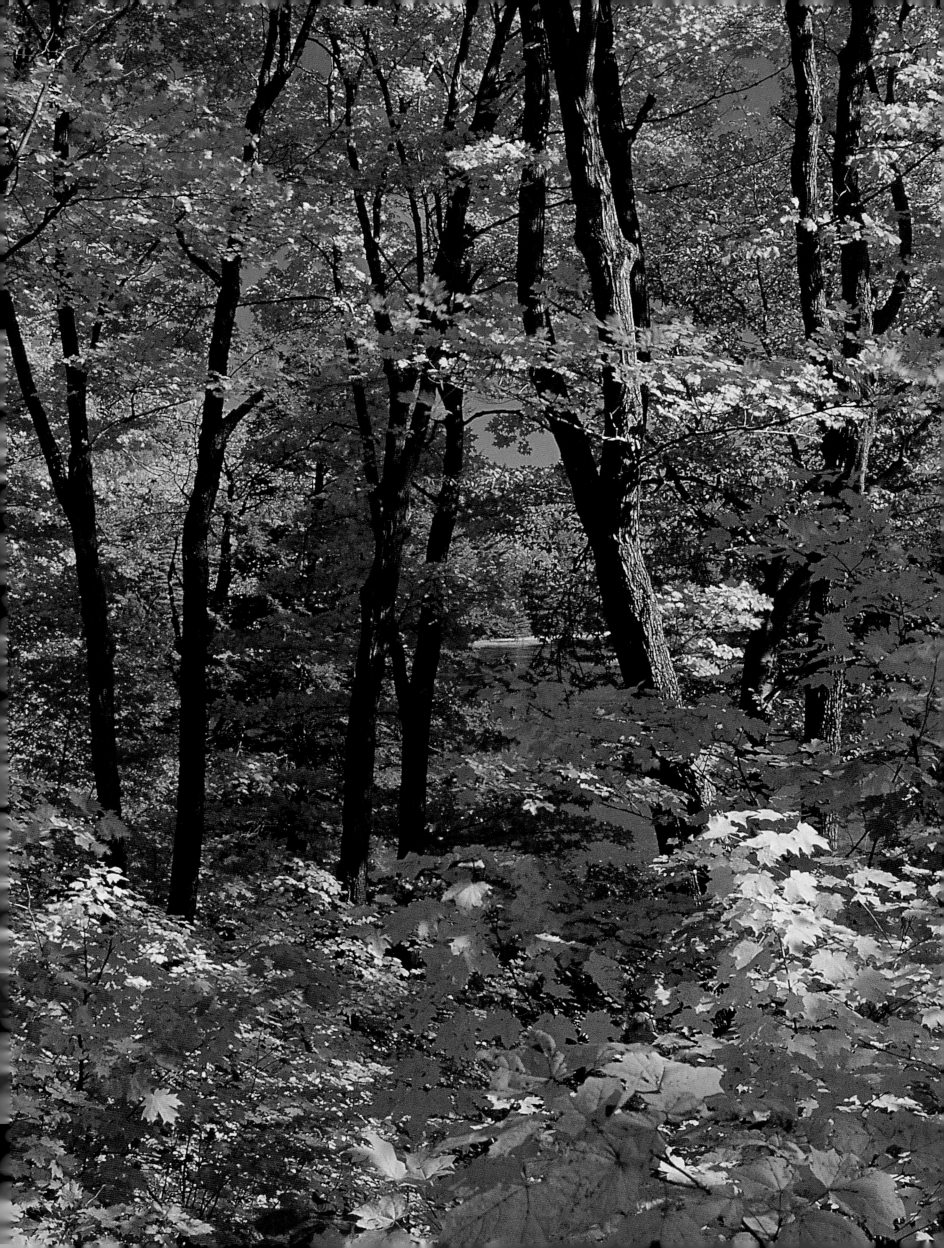

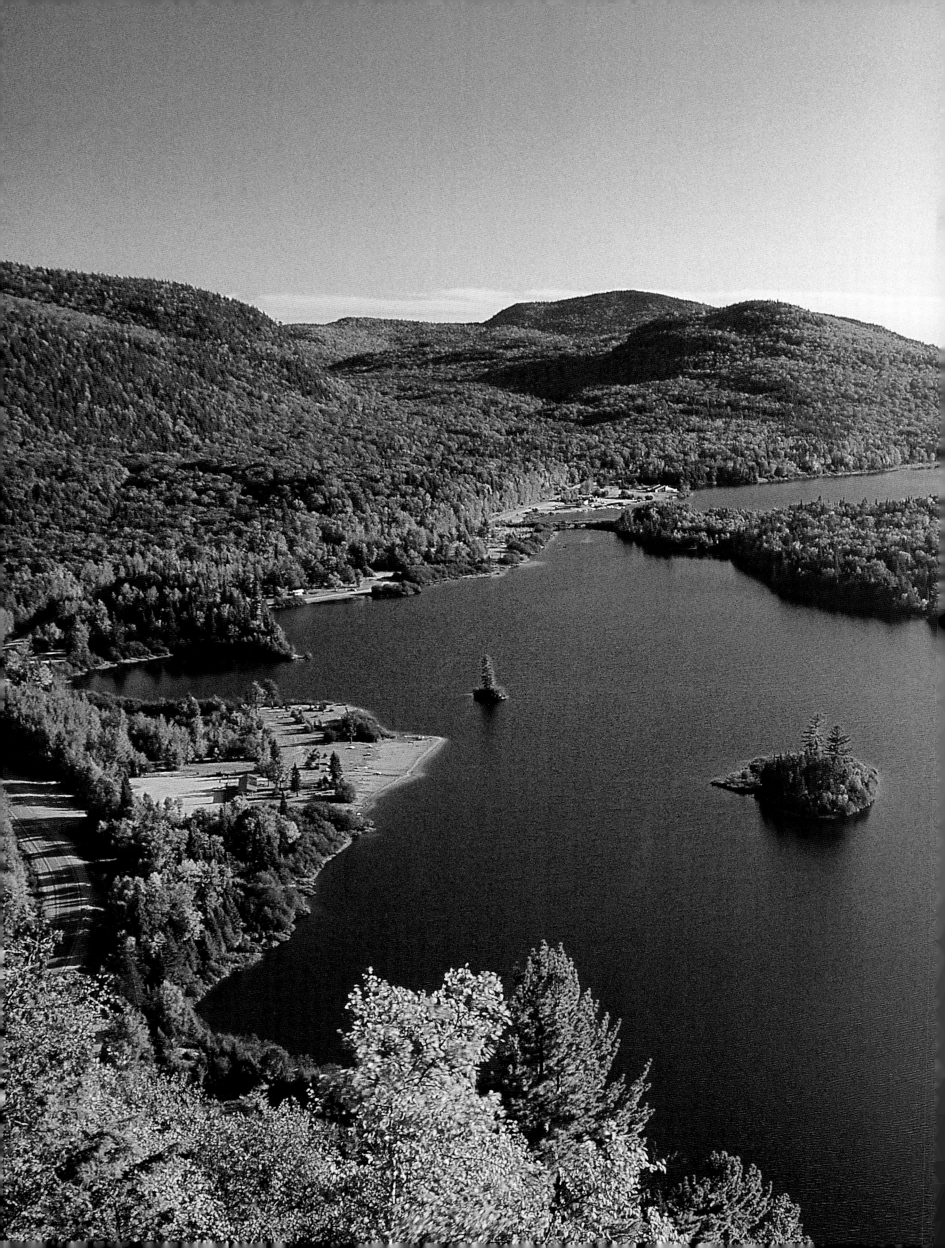

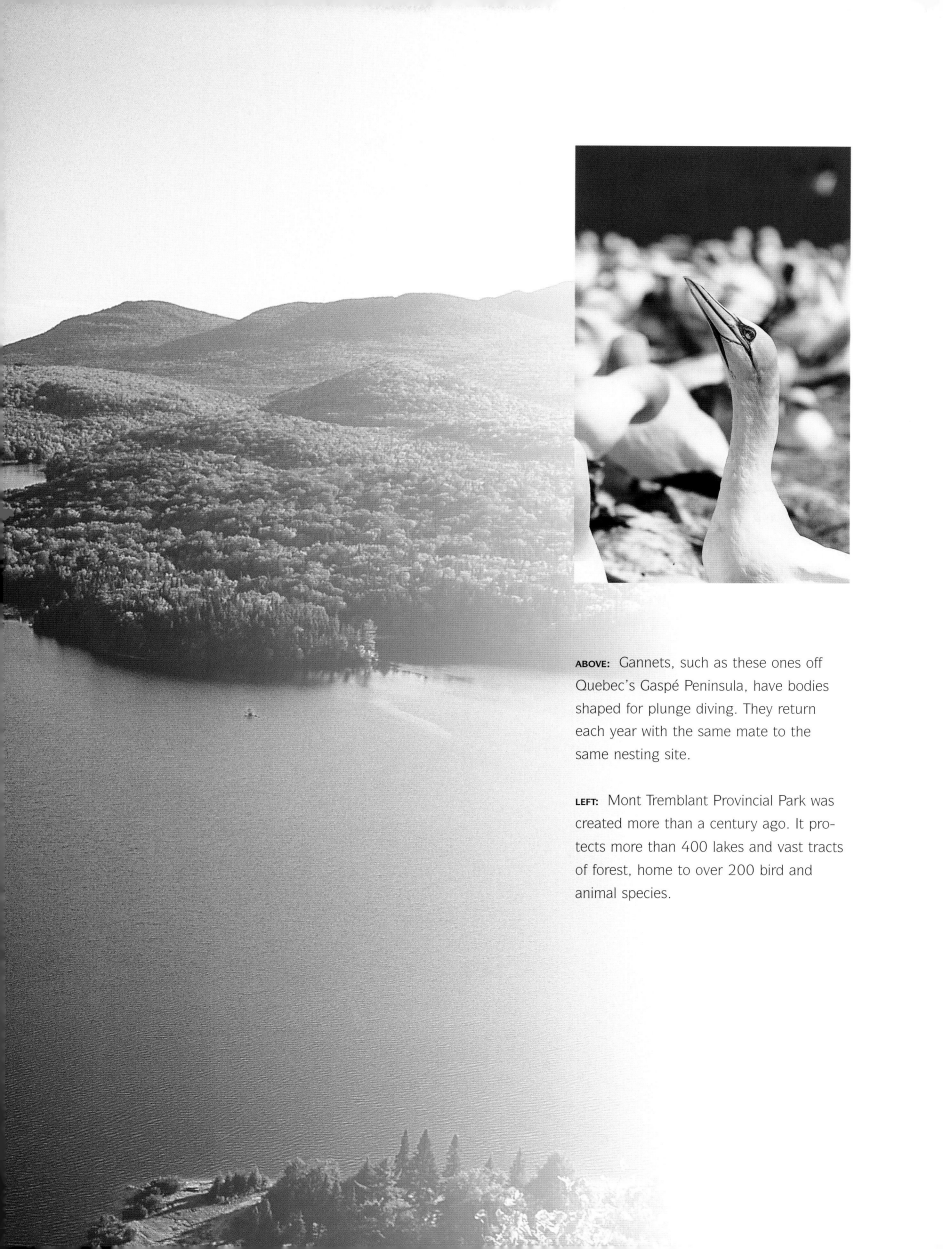

ABOVE: Gannets, such as these ones off Quebec's Gaspé Peninsula, have bodies shaped for plunge diving. They return each year with the same mate to the same nesting site.

LEFT: Mont Tremblant Provincial Park was created more than a century ago. It protects more than 400 lakes and vast tracts of forest, home to over 200 bird and animal species.

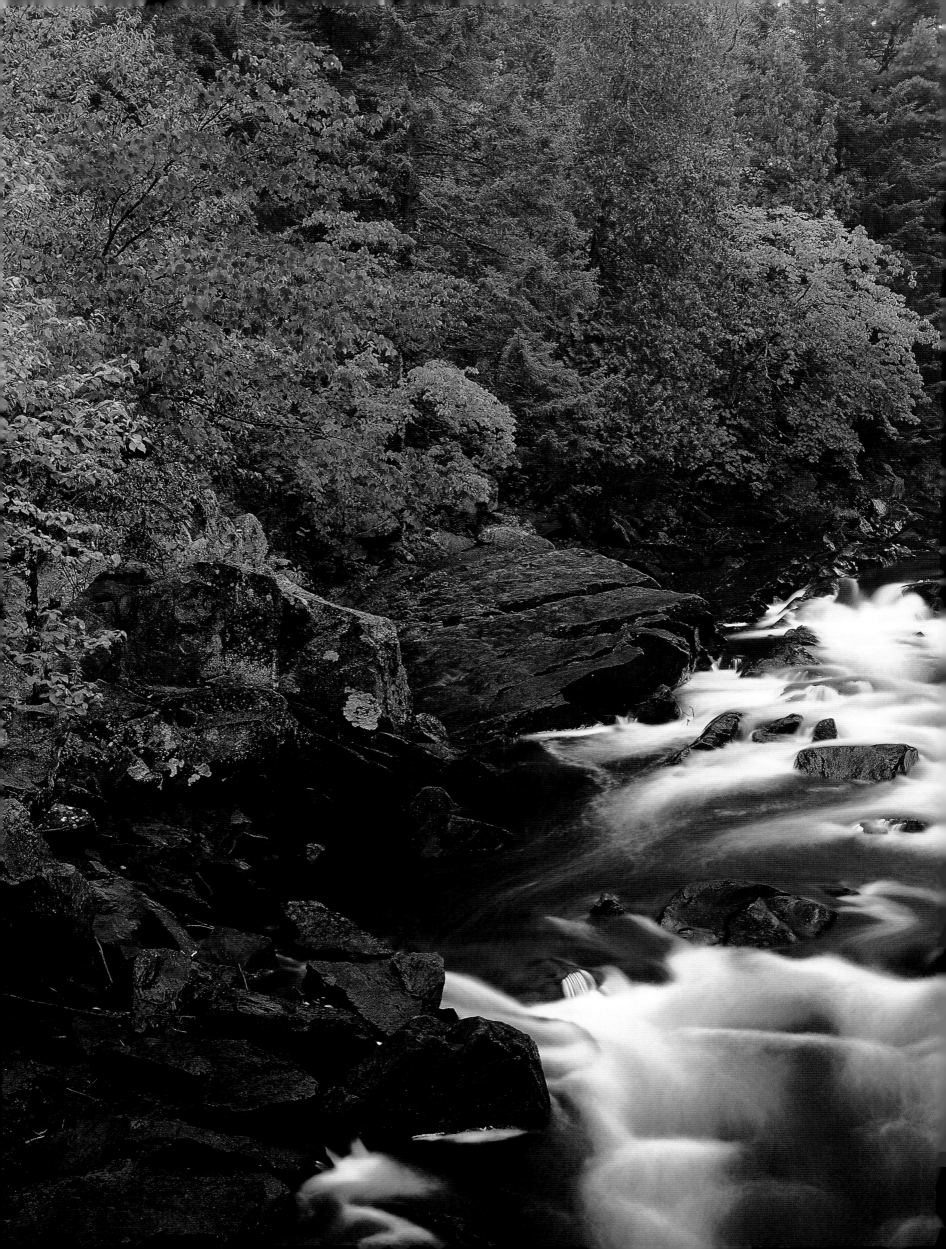

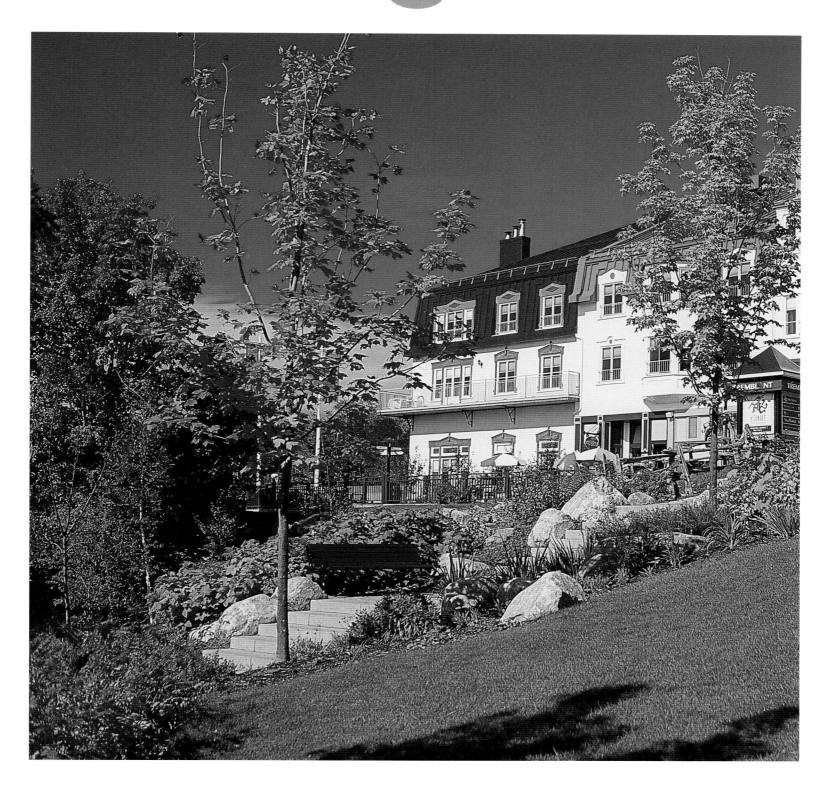

LEFT: Riviere du Diable in Mont Tremblant Provincial Park is one of about a million lakes and rivers in the province. Together, these waterways comprise a fresh water network of 180,000 square kilometres (69,500 square miles), ranging from quiet wetlands to the mighty St. Lawrence.

ABOVE: Soaring more than 900 metres (3,000 feet) high, Mont Tremblant is Quebec's premier ski resort. In the summer, visitors enjoy golf courses, cycling trails, parks, and beaches in the area.

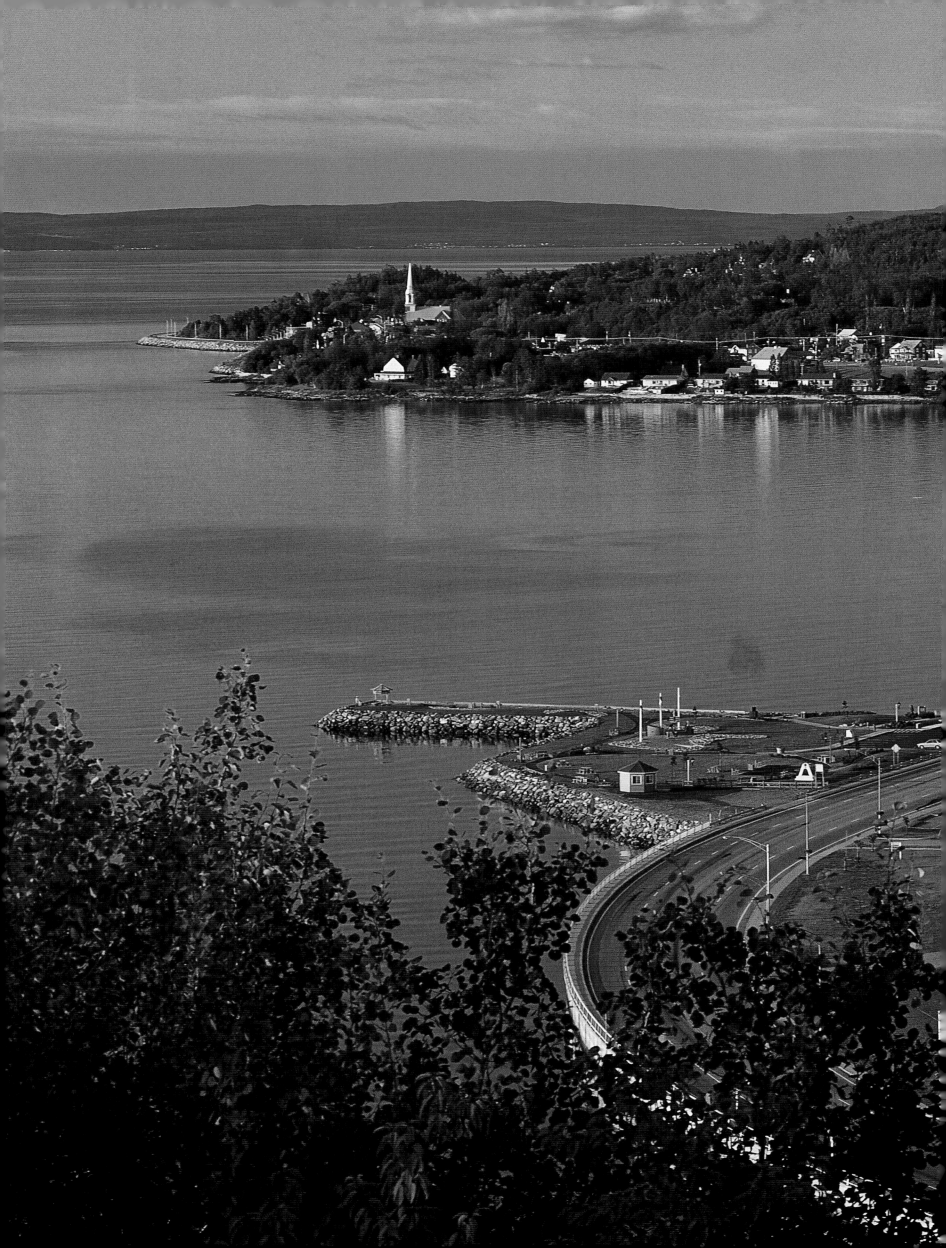

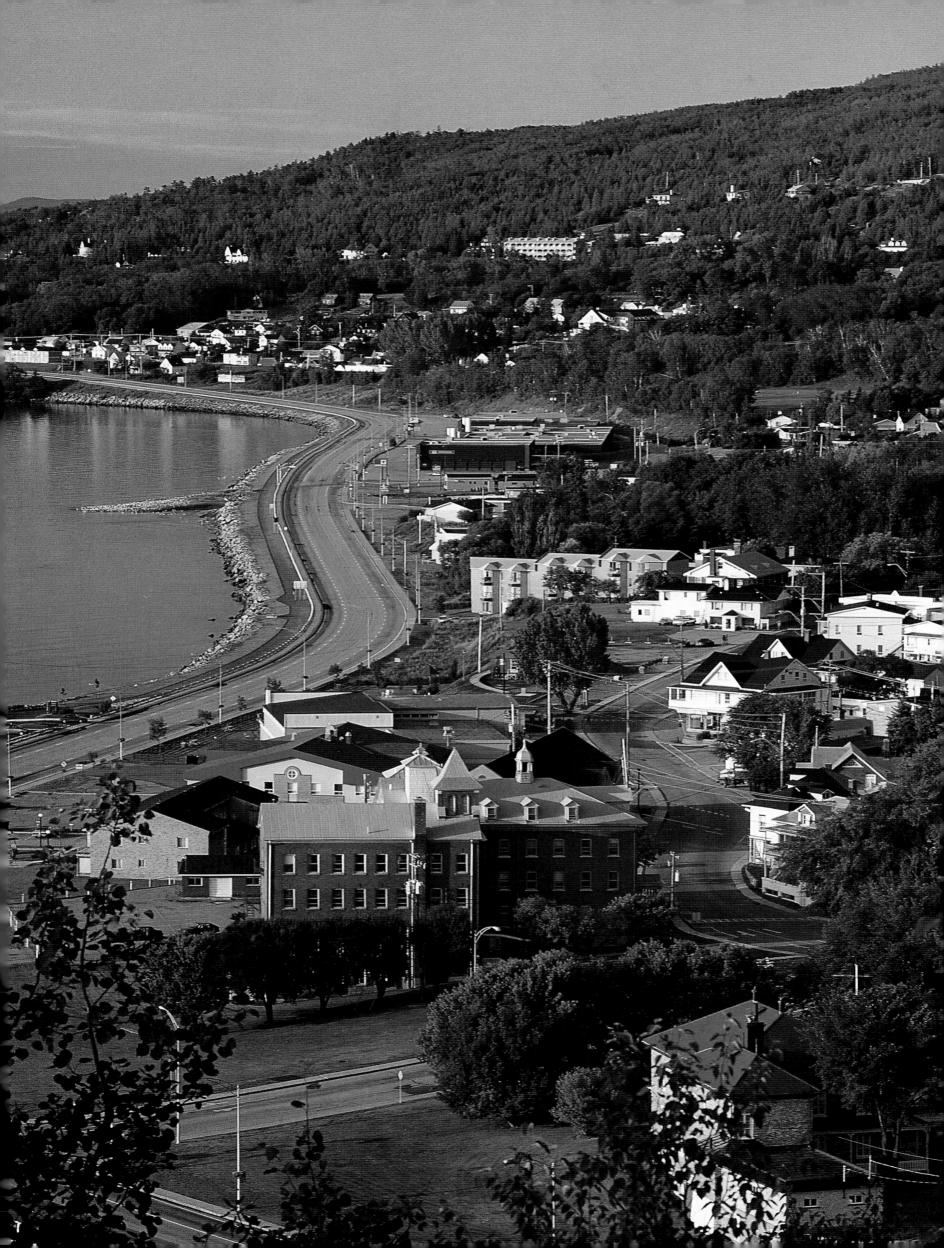

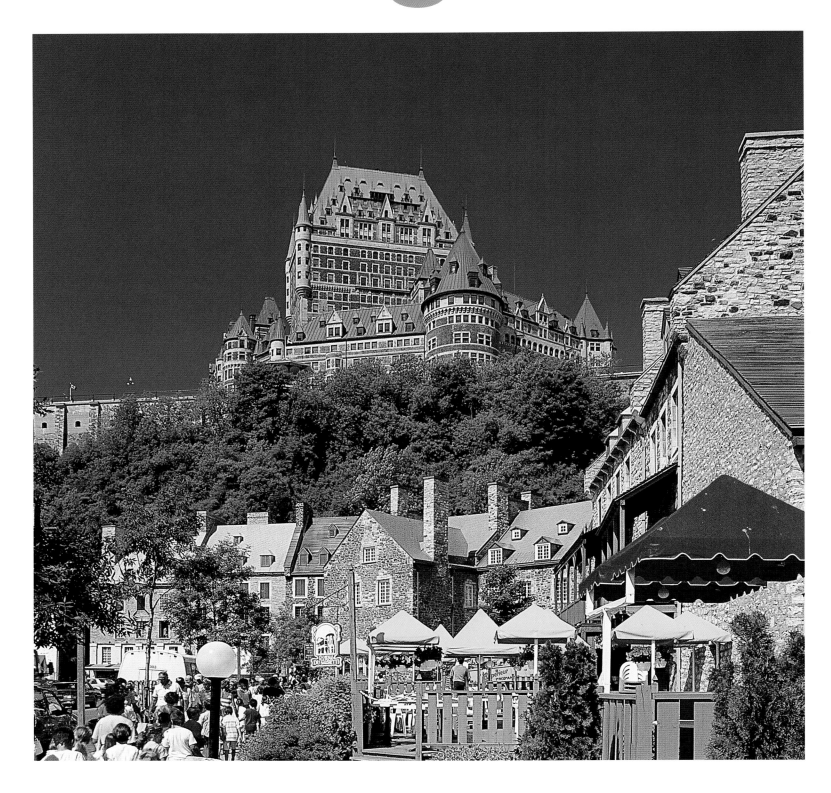

ABOVE: Built by the Canadian Pacific Railway, Chateau Frontenac overlooks the narrow lanes of Quebec's historic old city and the waters of the St. Lawrence.

RIGHT: In 1985, UNESCO named the historic portions of Quebec City the continent's first world heritage site. The oldest quarter, the Haute-Ville, is the only walled city remaining in North America. Many of the stone buildings were built in the 17th and 18th centuries.

PREVIOUS PAGES: La Malbaie, along-side the St. Lawrence in Quebec's Charlevoix Region, was named by Samuel de Champlain when he spent a night here in 1608. Not realizing that the bay was inaccessible at high tide, Champlain was trapped here until the water level returned. According to local legend, he exclaimed, "Ah la malle bayes!"

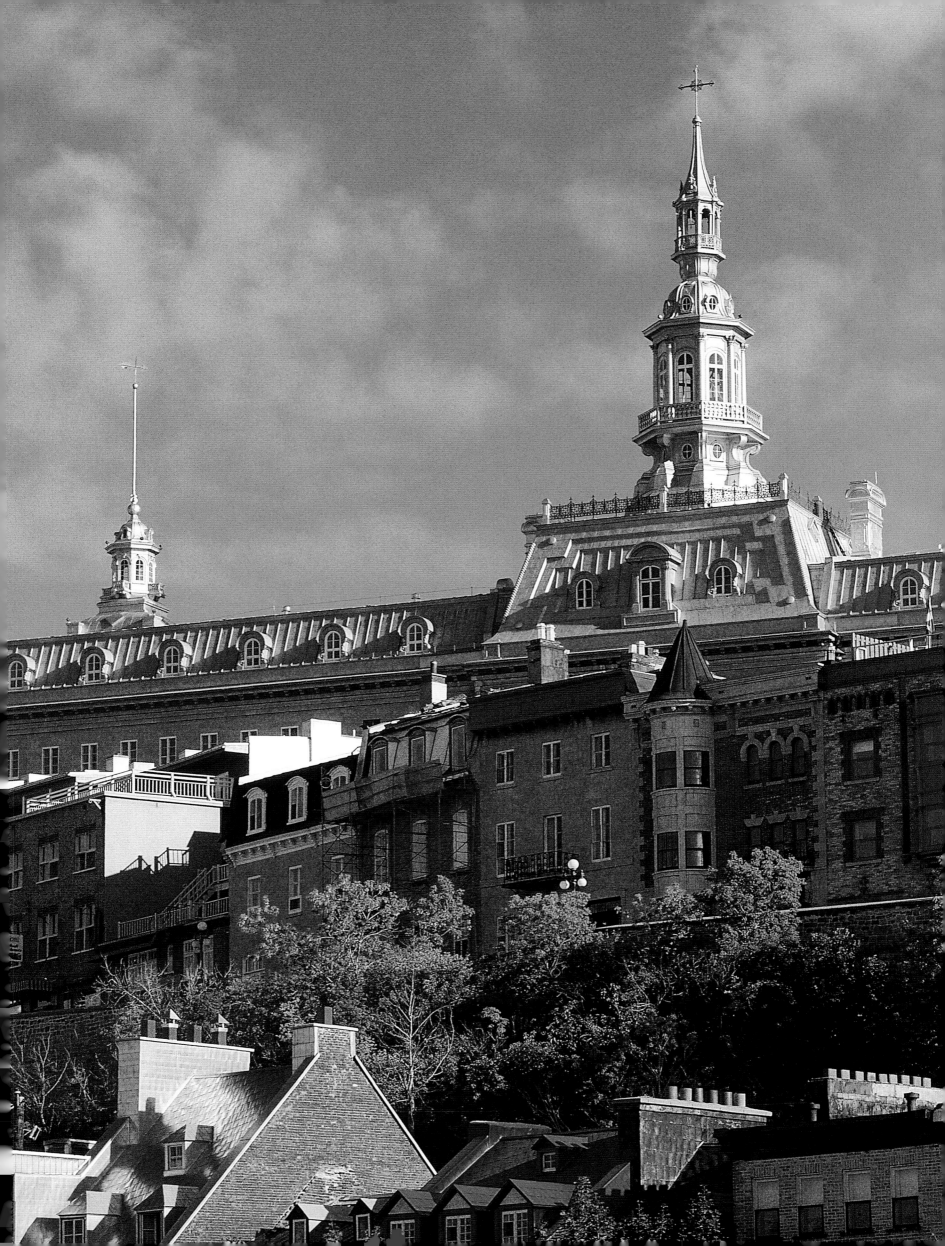

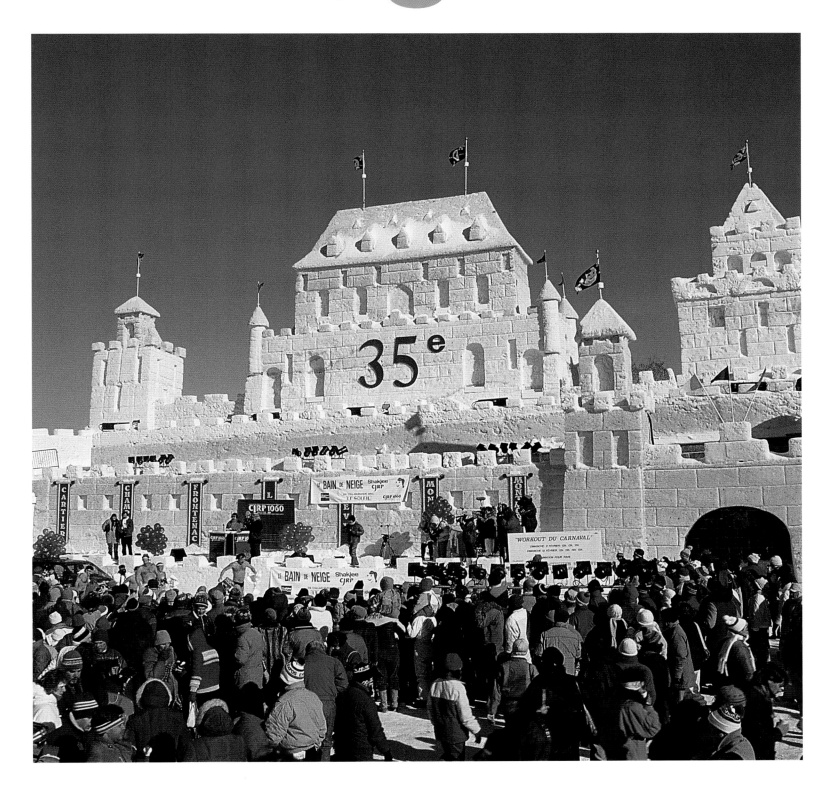

LEFT: Agriculture is one of Quebec's leading industries. In fact, farmers raise 40 percent of Canada's dairy cows within the province.

ABOVE: The Quebec Winter Carnival brings the streets of Quebec City to life each February with events that include snow sculpting contests, a parade, a soapbox derby, and children's sports.

OVERLEAF: Pierced Rock, or Rocher Percé, is 88 metres (290 feet) high and stretches for 400 metres (1300 feet) along the shore of Quebec's Gaspé Peninsula. At low tide, an exposed sandbar allows visitors to walk to the rock and discover the ancient fossils embedded in the limestone.

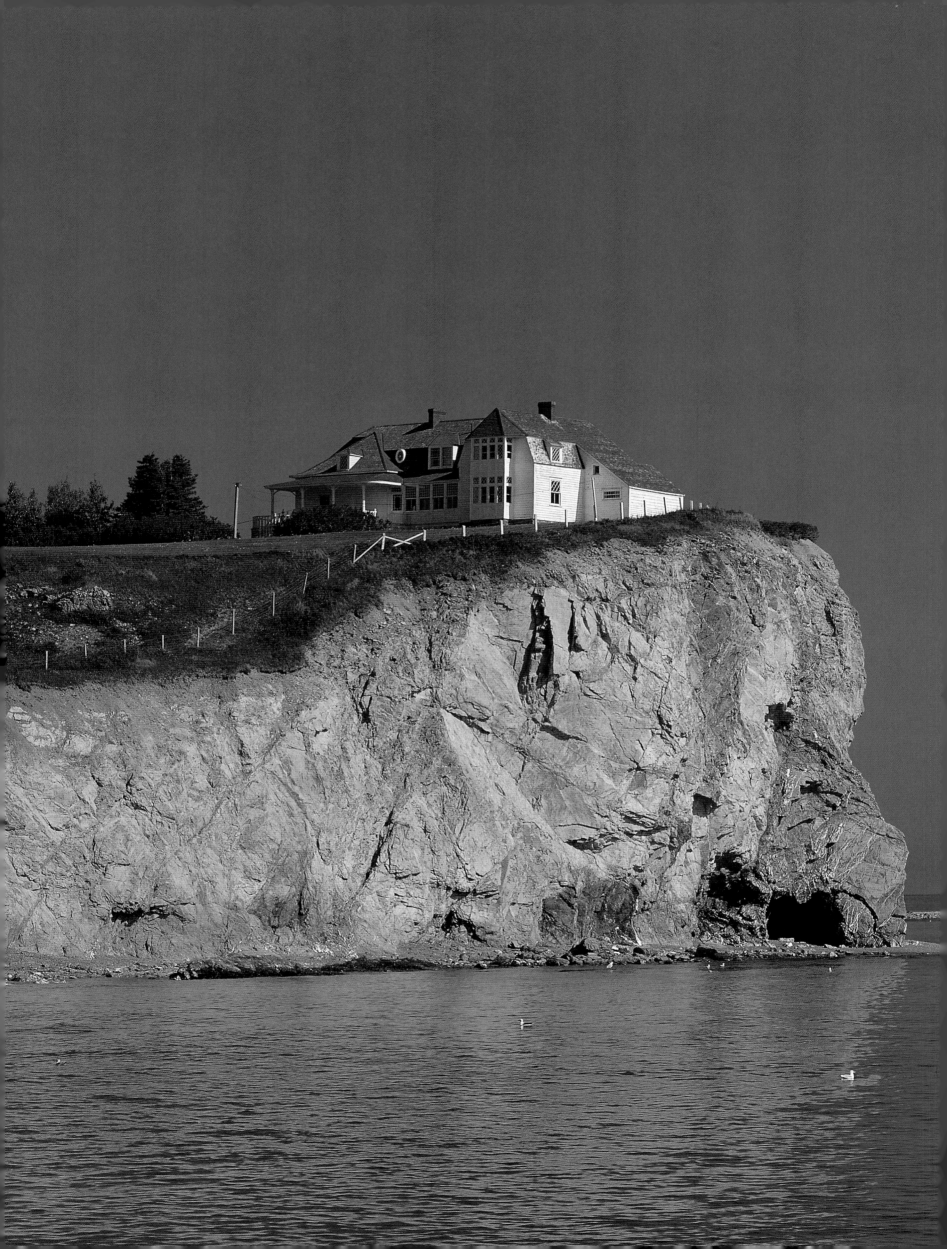

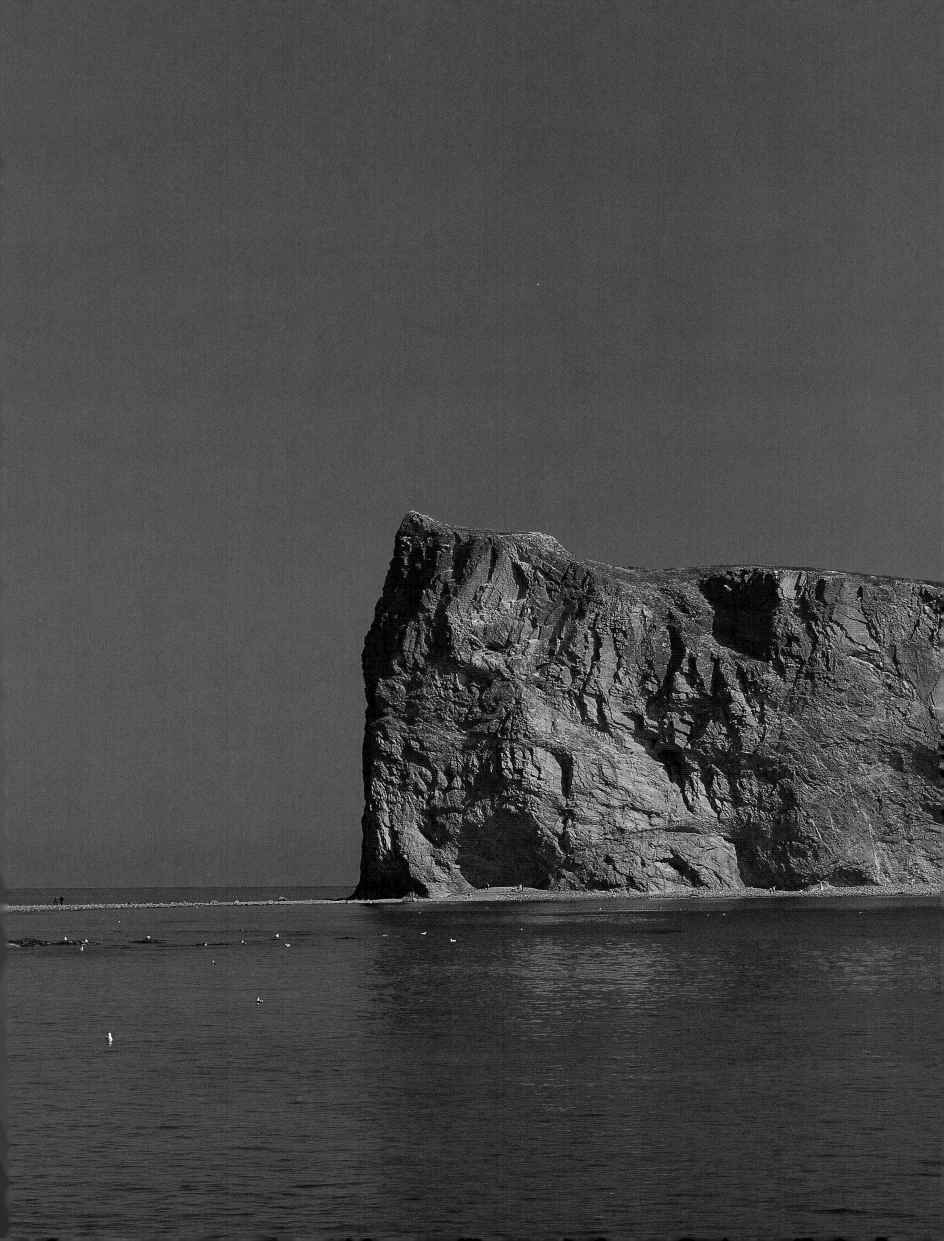

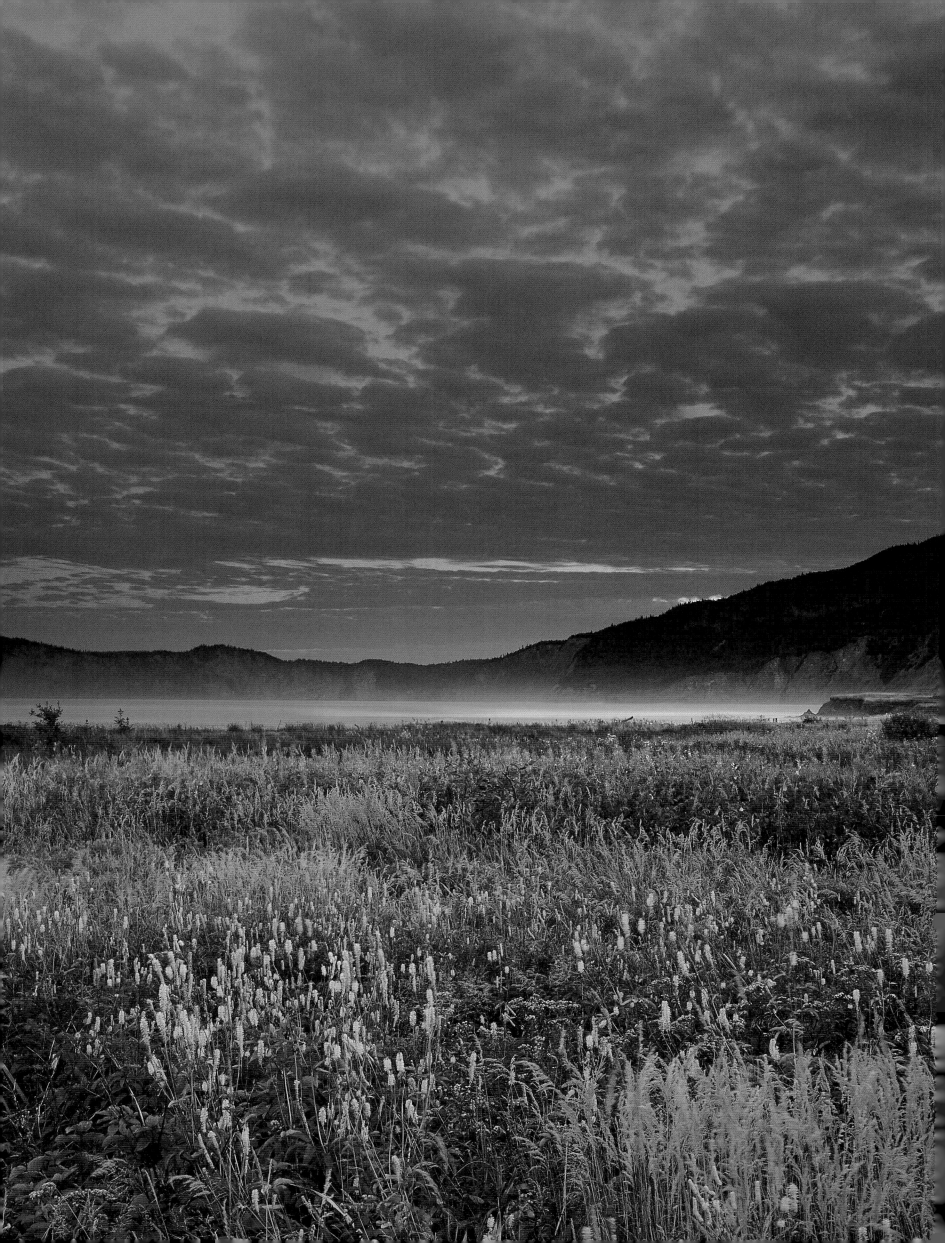

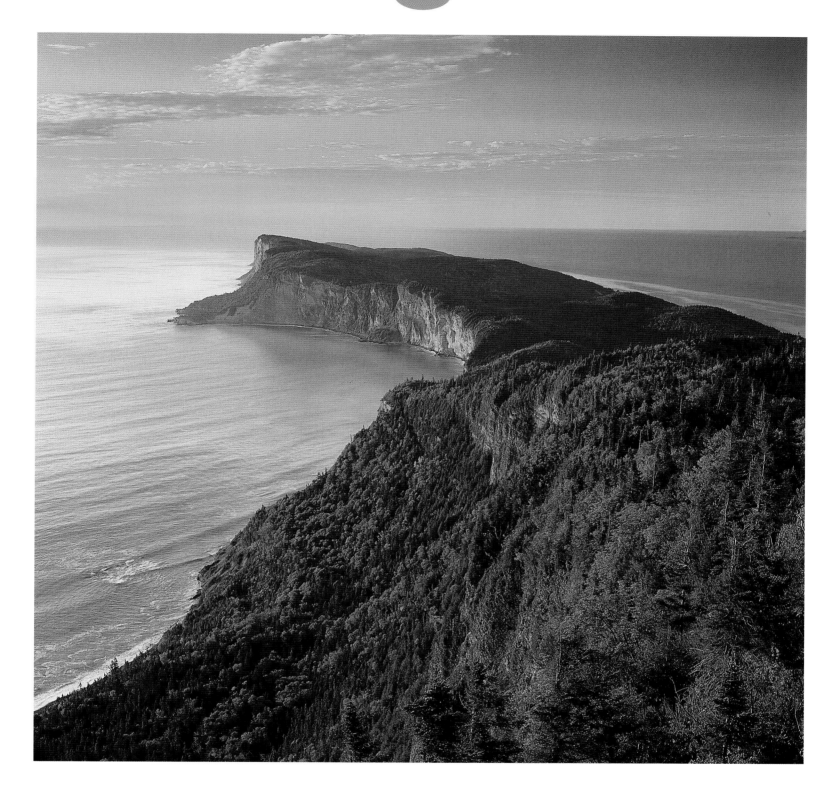

LEFT: The interpretive theme at Quebec's Forillon National Park is "Harmony between Man, Land and Sea." First Nations used this area as a fishing base for thousands of years, and French farmers and fishers lived here until the park's development in 1970.

ABOVE: Forillon National Park protects the stunning landscape of the Gaspé Peninsula, 244 square kilometres (94 square miles) of rugged cliffs and mountains.

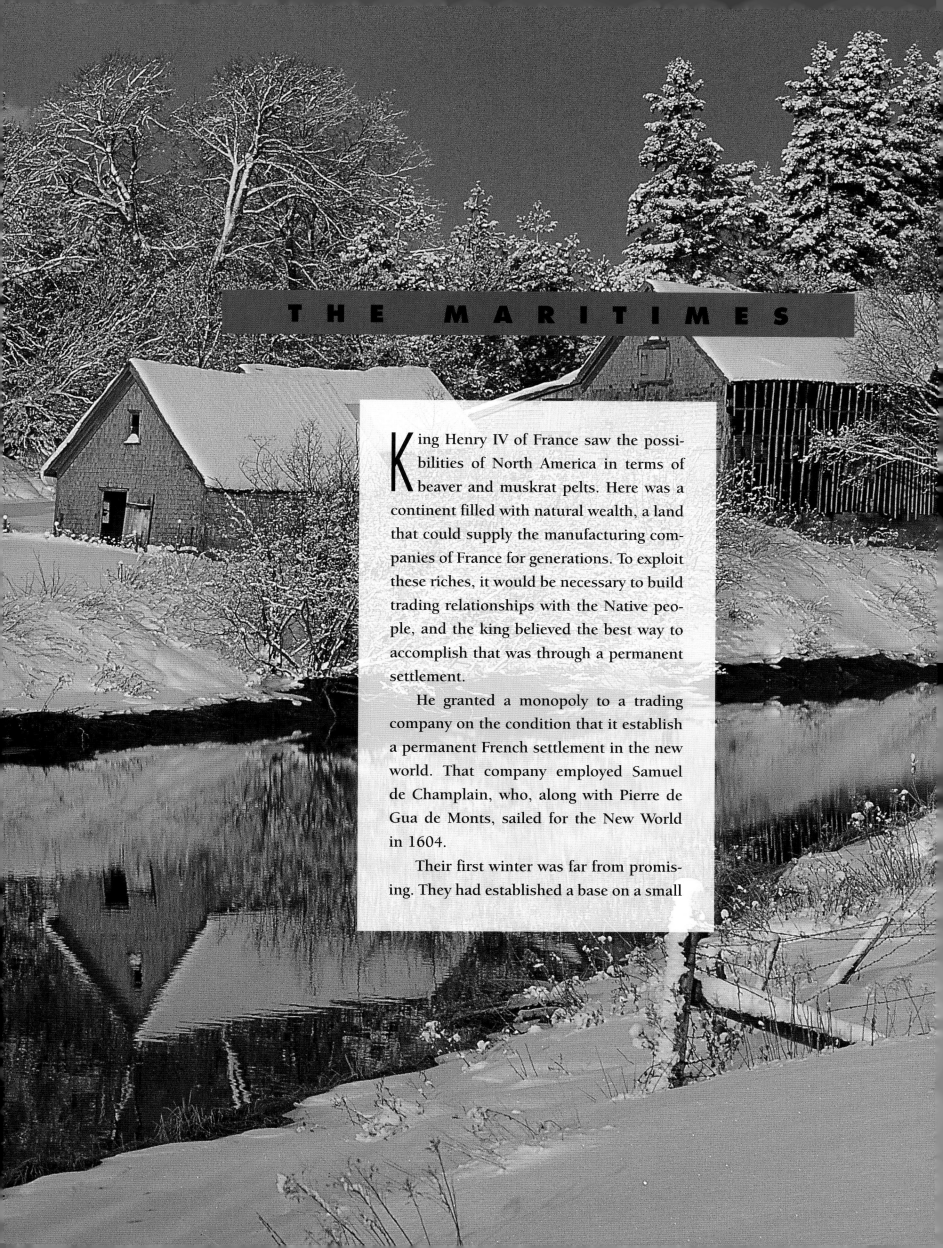

King Henry IV of France saw the possibilities of North America in terms of beaver and muskrat pelts. Here was a continent filled with natural wealth, a land that could supply the manufacturing companies of France for generations. To exploit these riches, it would be necessary to build trading relationships with the Native people, and the king believed the best way to accomplish that was through a permanent settlement.

He granted a monopoly to a trading company on the condition that it establish a permanent French settlement in the new world. That company employed Samuel de Champlain, who, along with Pierre de Gua de Monts, sailed for the New World in 1604.

Their first winter was far from promising. They had established a base on a small

island off what is now the coast of Maine. Beset by starvation and scurvy, more than half the settlers died in the first winter. In spring, they abandoned the island and planned a new settlement across the Bay of Fundy. Port Royal was a mere cluster of wood-framed buildings around a central courtyard, but it was surrounded by the fertile land of the Annapolis Basin in present-day Nova Scotia. Able to establish crops, the Acadian settlers were this time successful, and Port Royal is considered the first permanent European settlement on the continent.

Myriad influences shaped the growth of Canada's Maritime provinces. As their names attest, their founders were not all French. Nova Scotia — "New Scotland" — was named in 1621 by landholder Sir William Alexander. Prince Edward Island was named to honour the father of Queen Victoria, and New Brunswick's title was chosen for King George III, descendant of the House of Brunswick.

The Acadians thrived in the Maritimes, but many were forced to leave when they refused to pledge allegiance to Britain. The Loyalists arrived from the new United States, having refused to relinquish their

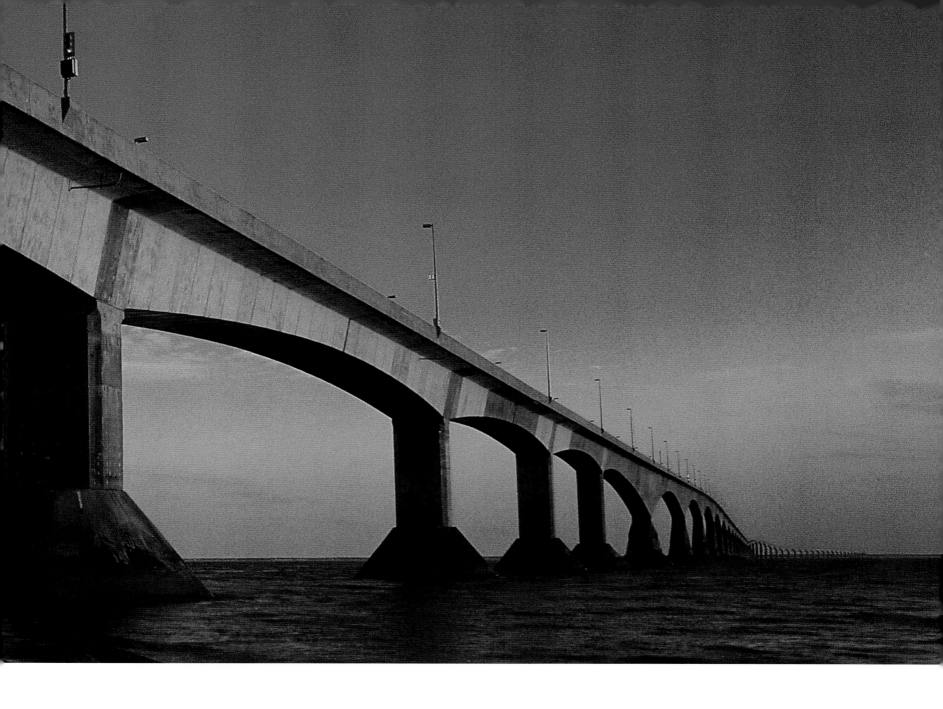

allegiance to Britain. Eventually, immigrants from around the world joined their ranks.

Nova Scotia alone is now home to 920,000 residents and the combination of winding coastline, including more than 3000 islands, and lush river valleys draws thousands of visitors. Workers in Canada's leading fishery harvest $800 million from the sea each year, including lobster, scallops, and crab.

In New Brunswick, more than 60 percent of the population is under the age of 45. More and more, this is a centre for growth, drawing high-tech companies from around the continent to cosmopolitan downtown Fredericton and the lively streets of Saint John.

About 225 kilometres (140 miles) long, Prince Edward Island is Canada's smallest province. The construction of Confederation Bridge from New Brunswick has allowed even more visitors to tour the legendary home of Lucy Maud Montgomery, wander lanes lined with potato fields, or glimpse the shoreline of Prince Edward Island National Park, looking much as it did when the first settlers arrived four centuries ago.

ABOVE: Confederation Bridge stretches 13 kilometres (8 miles) from New Brunswick to Prince Edward Island. Finished in 1997, the construction of the bridge was a massive four-year undertaking. Pillars more than 55 metres (180 feet) high were necessary to support the span.

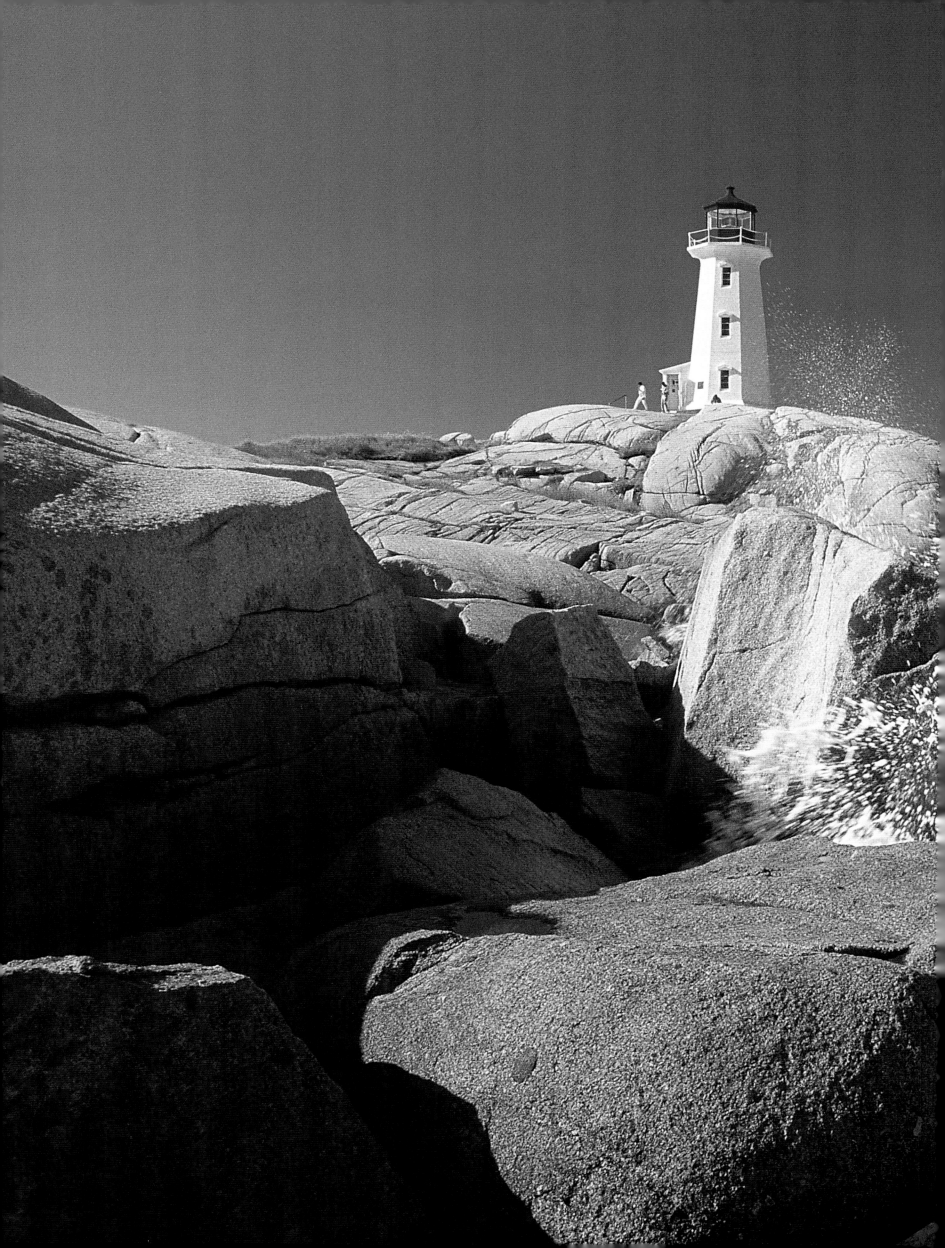

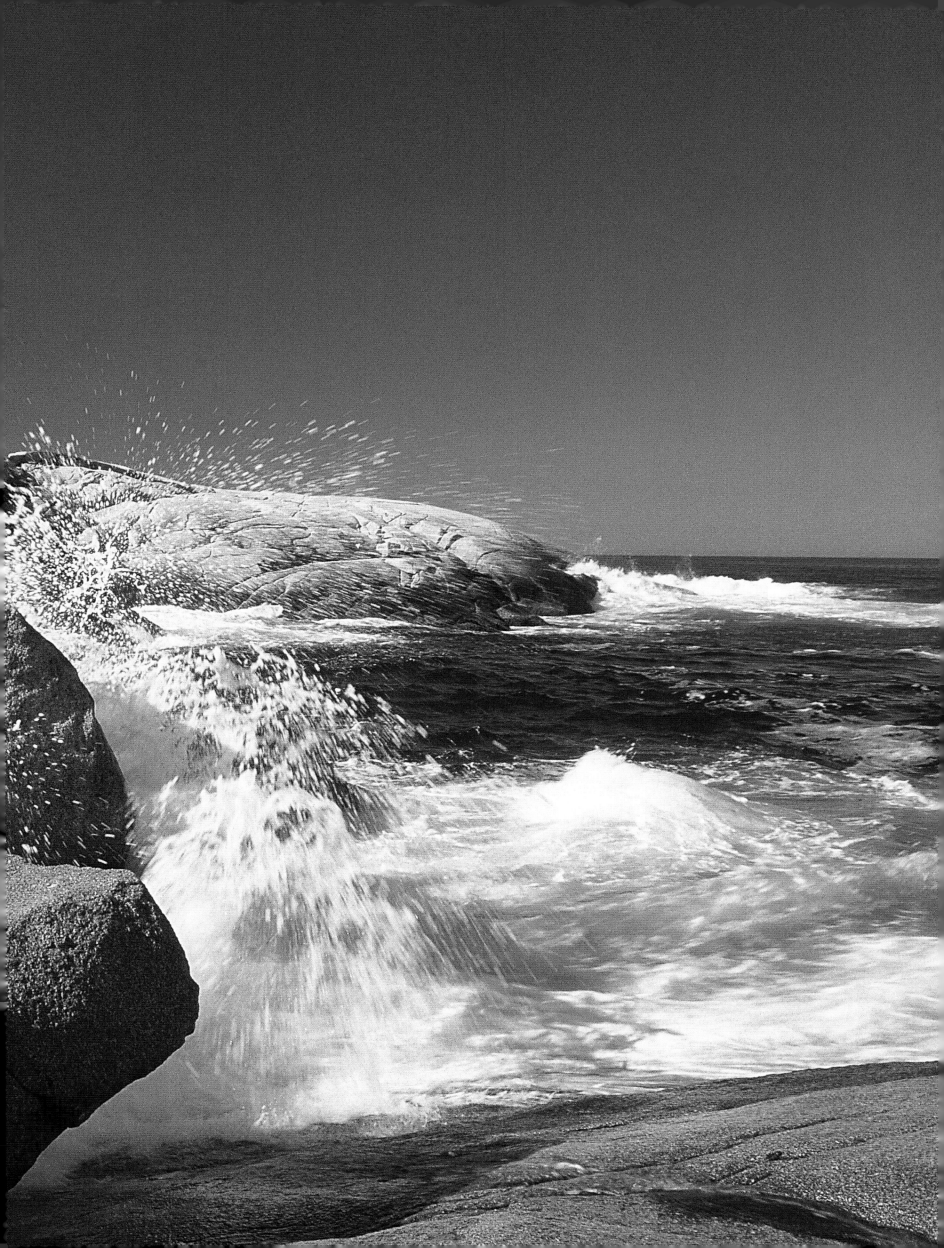

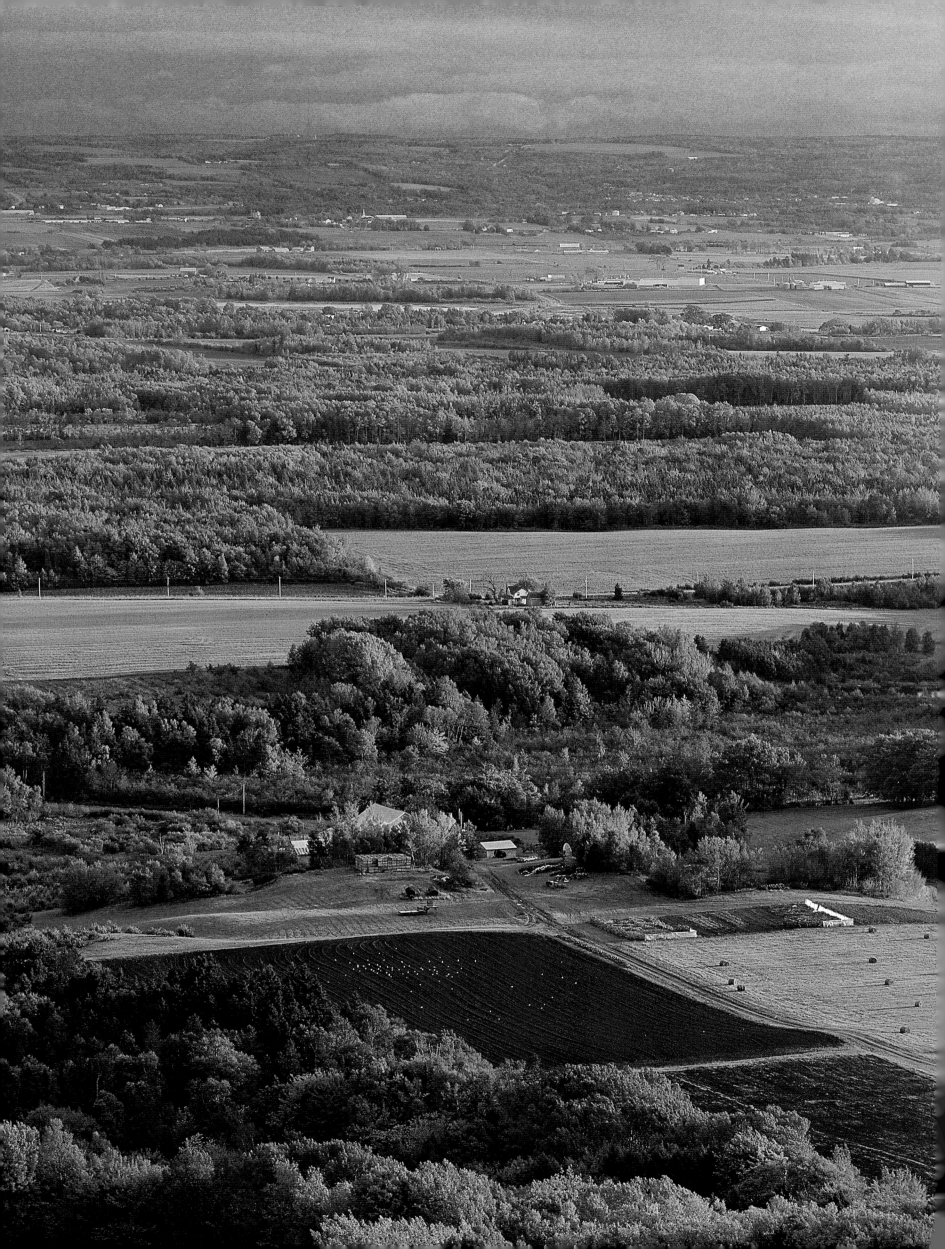

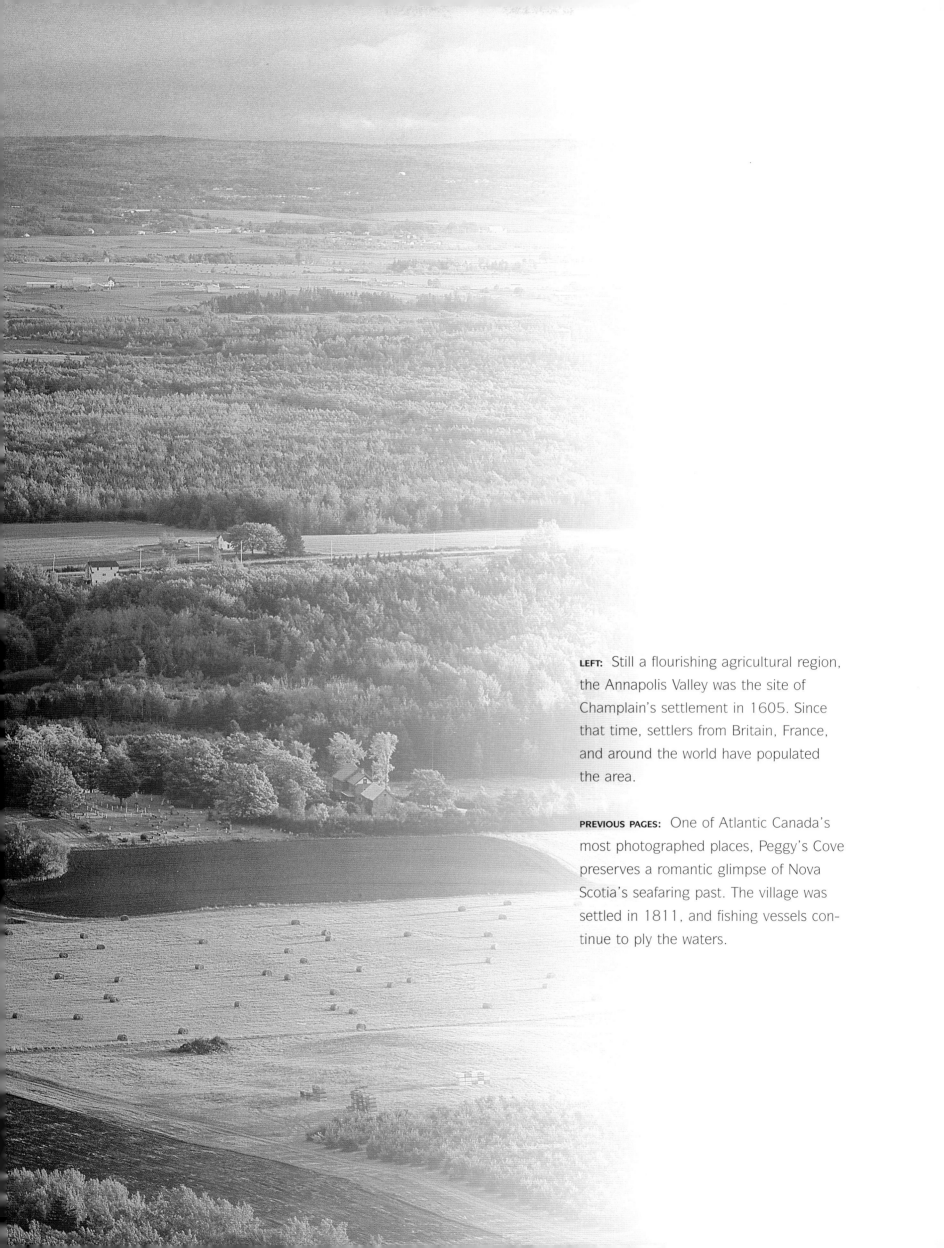

LEFT: Still a flourishing agricultural region, the Annapolis Valley was the site of Champlain's settlement in 1605. Since that time, settlers from Britain, France, and around the world have populated the area.

PREVIOUS PAGES: One of Atlantic Canada's most photographed places, Peggy's Cove preserves a romantic glimpse of Nova Scotia's seafaring past. The village was settled in 1811, and fishing vessels continue to ply the waters.

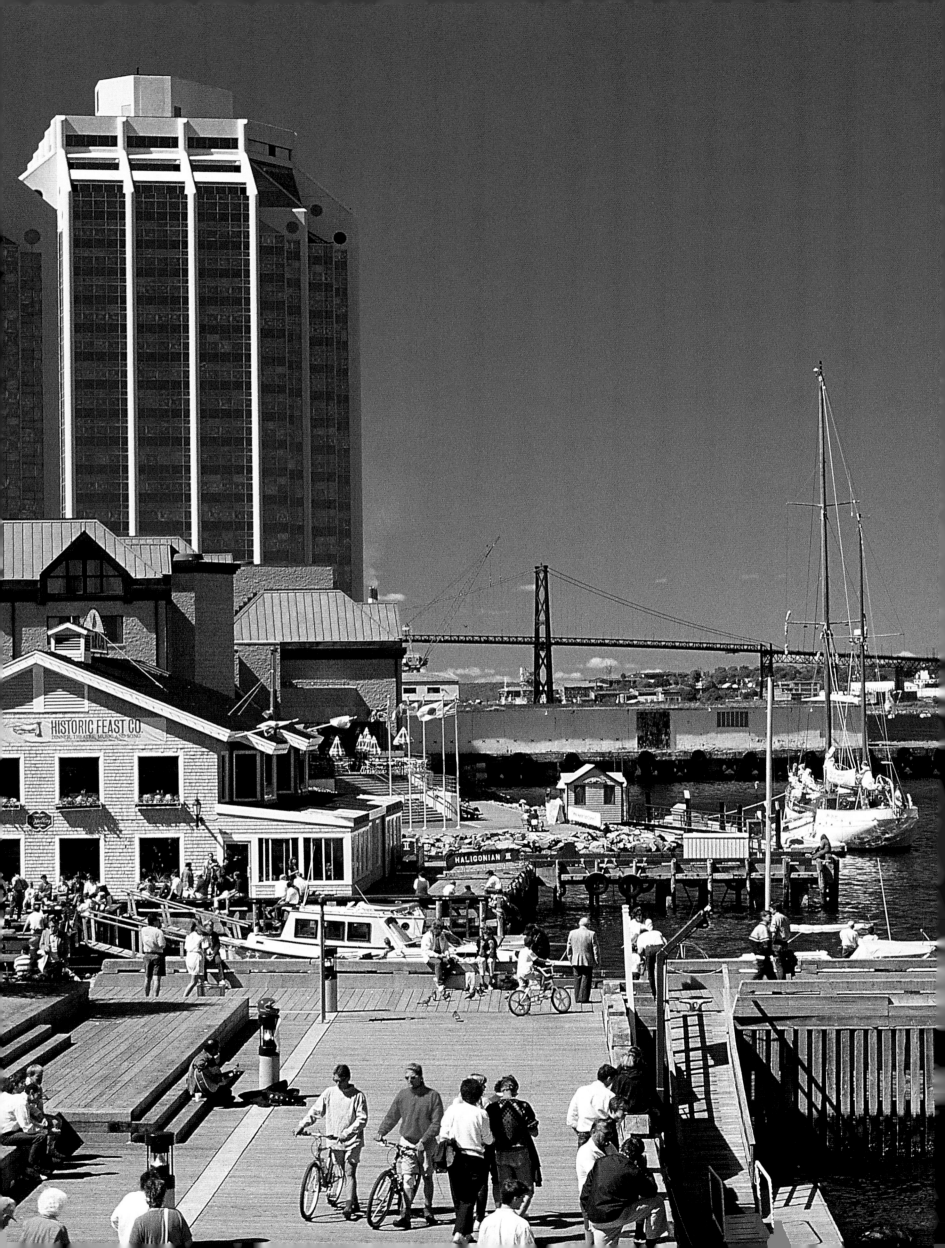

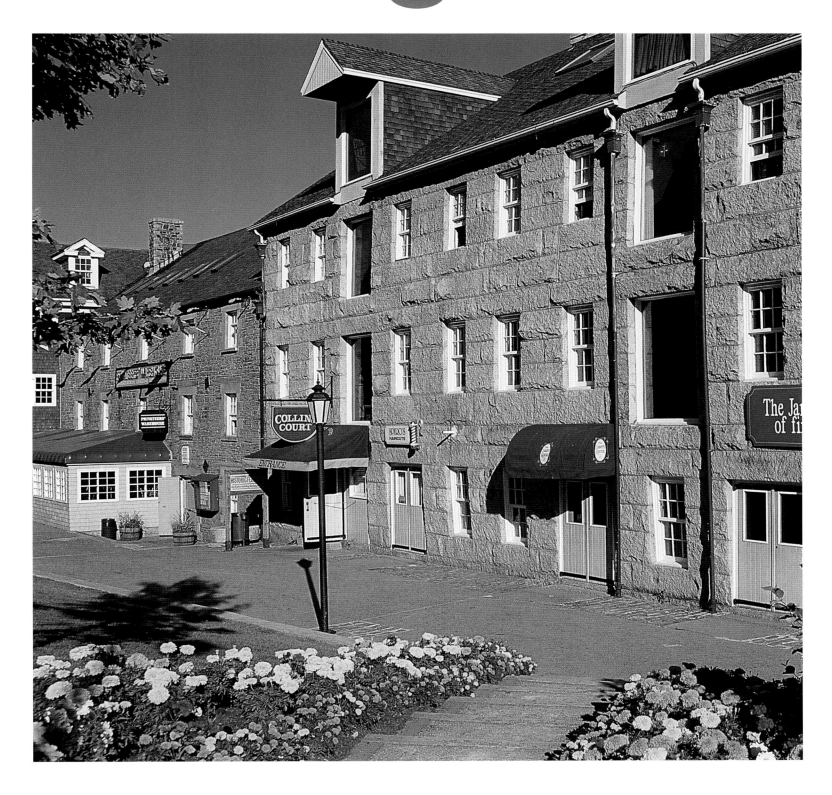

LEFT: The warehouses and shipping offices lining Halifax Harbour were built between 1800 and 1905. Many have been restored and now serve as shops, galleries, and restaurants.

ABOVE: The 19th-century buildings of Halifax's Historic Properties were once the neighbourhood of Enos Collins, local businessman and notorious smuggler. Collins was an important figure in the Halifax Banking Company, which later became the Royal Bank.

OVERLEAF: The jagged cliffs of Cap d'Or divide the Bay of Fundy and the Minas Basin. No part of Nova Scotia is more than 56 kilometres (35 miles) from the sea. Lighthouses, fishing vessels, and docks can be found at almost every village along the coast.

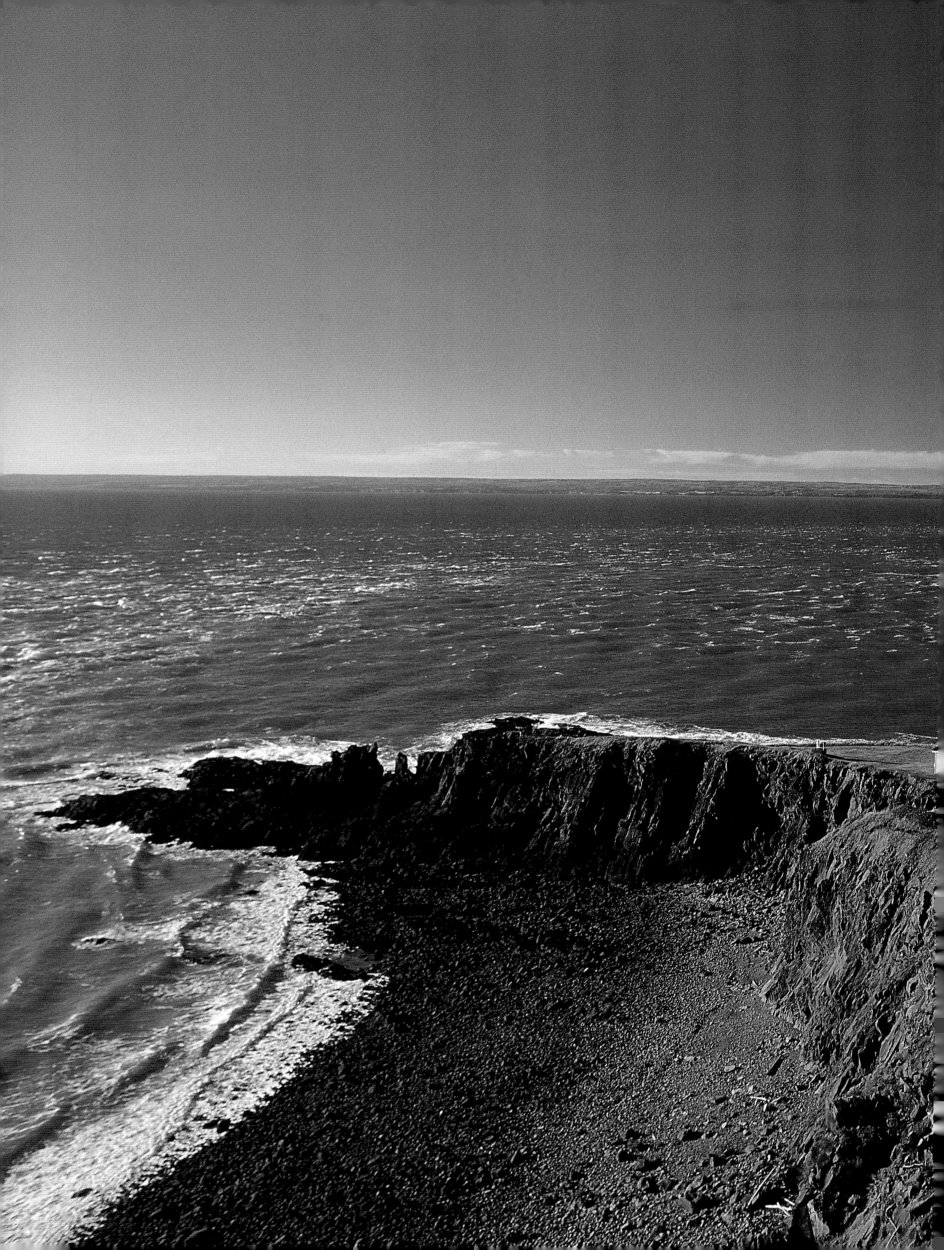

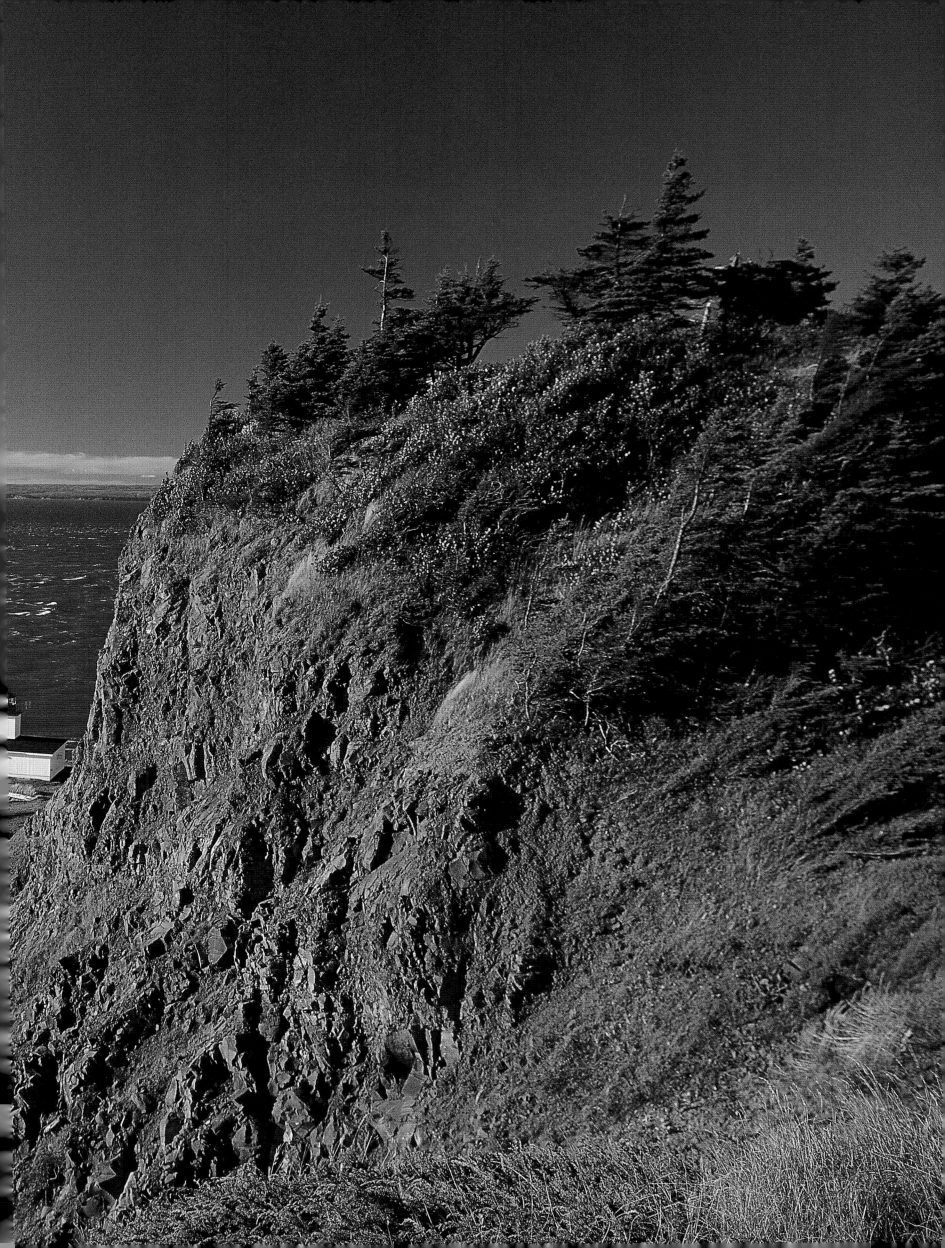

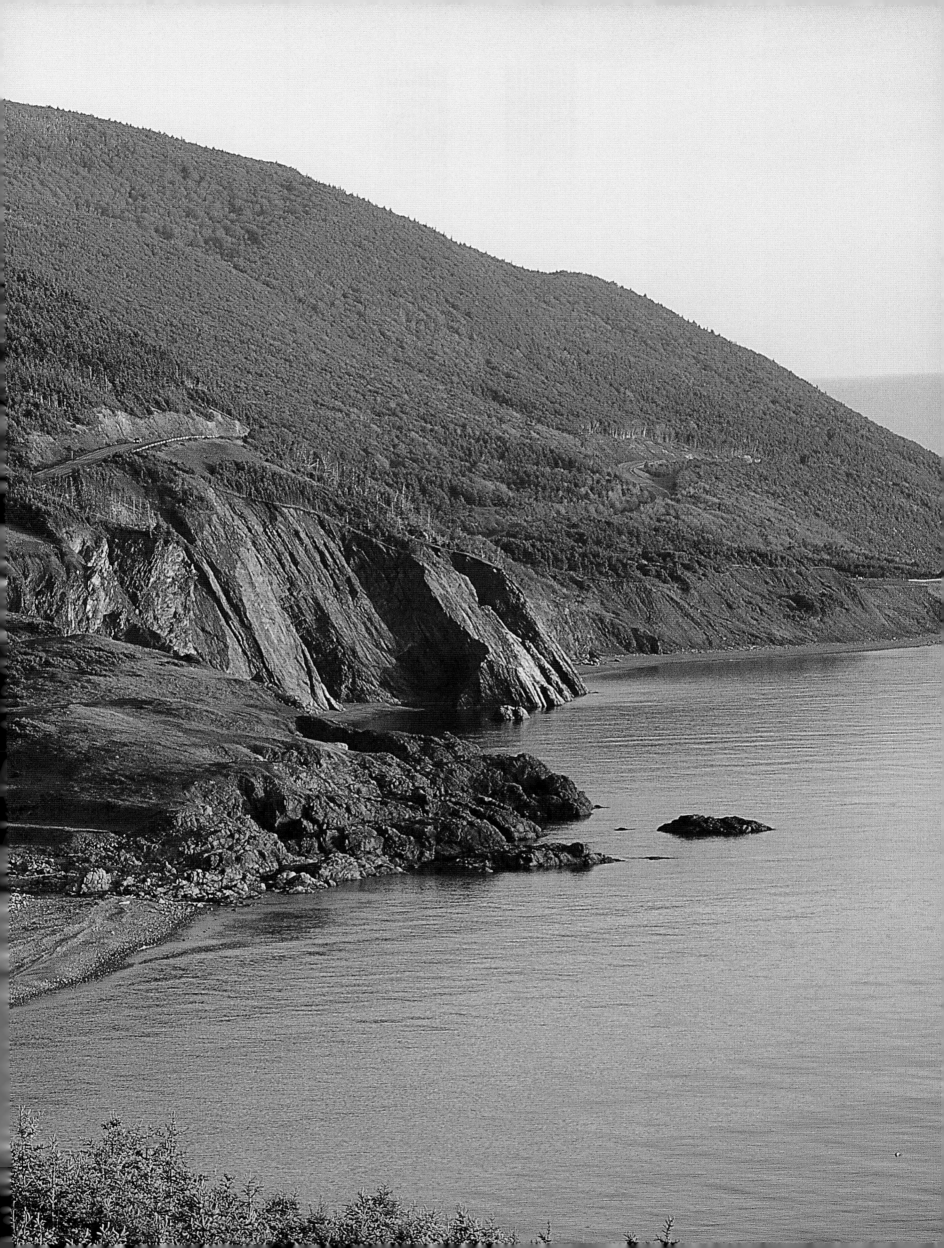

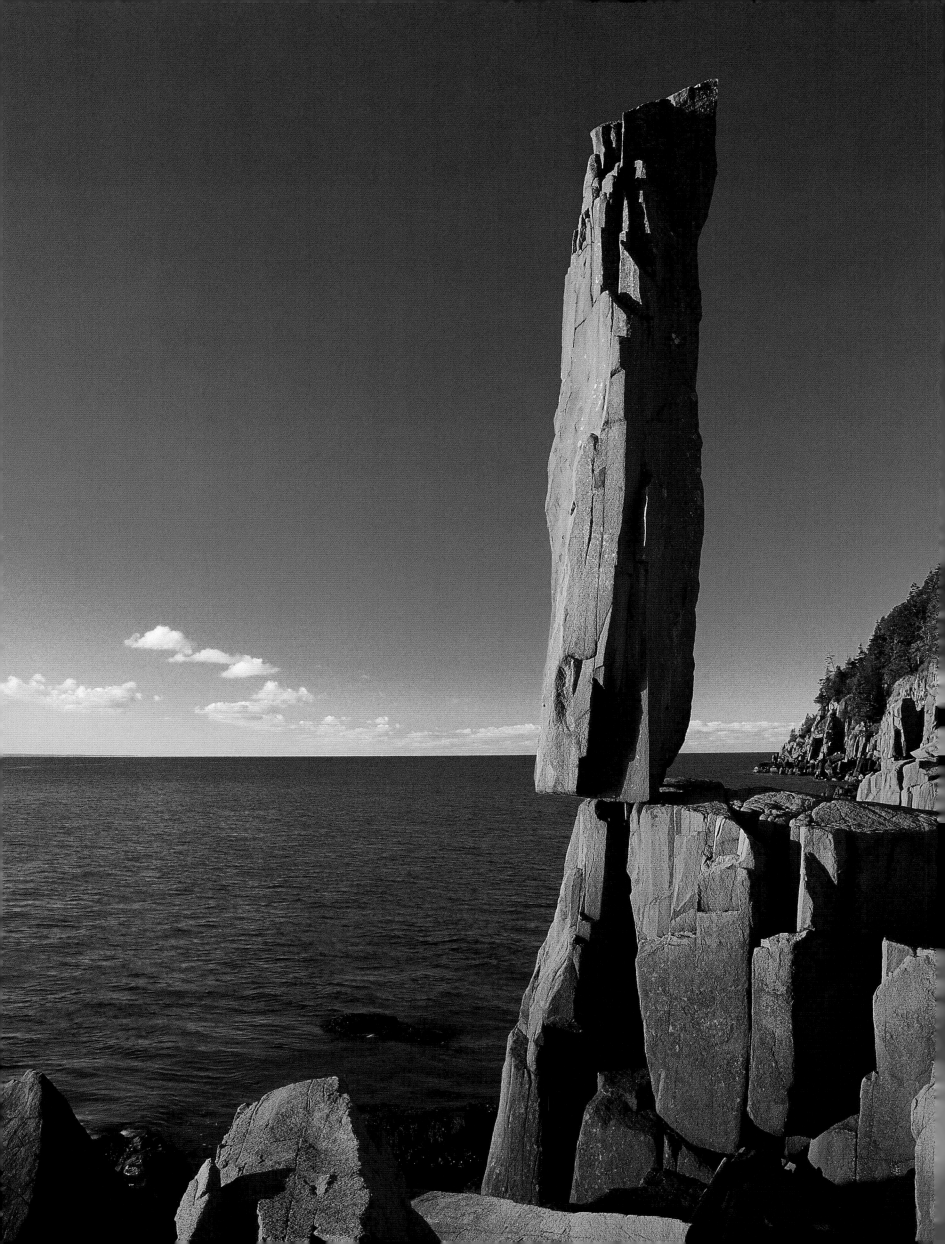

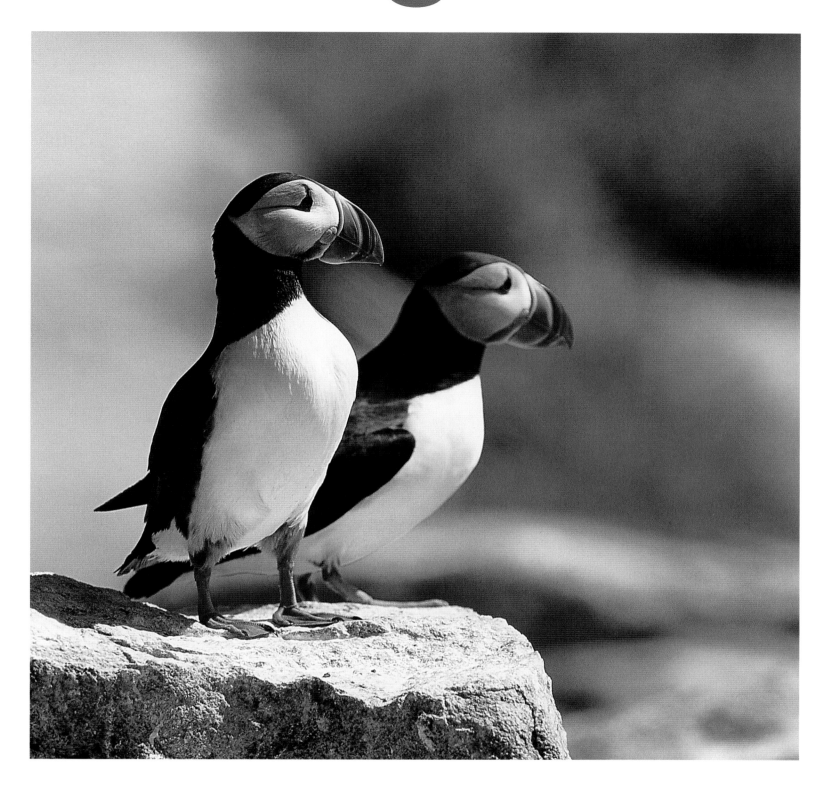

LEFT: Balancing Rock has defied the harshest Atlantic storms and attempts by countless visitors to push it into the sea. Such unique sights are one reason Nova Scotia draws more visitors per year than any other maritime province.

ABOVE: During the breeding period, the puffin's large, bright bill is used to signal to its mate and its neighbours. These birds have found refuge at New Brunswick's Machias Seal Island sanctuary, also home to terns and razorbacks.

PREVIOUS PAGES: One of the most dramatic drives in Canada, 294-kilometre-long (183-mile-long) Cabot Trail winds through Cape Breton Highlands National Park and circles the northern part of the island. Some Cape Breton residents claim that John Cabot landed near here in 1497, though Newfoundlanders disagree.

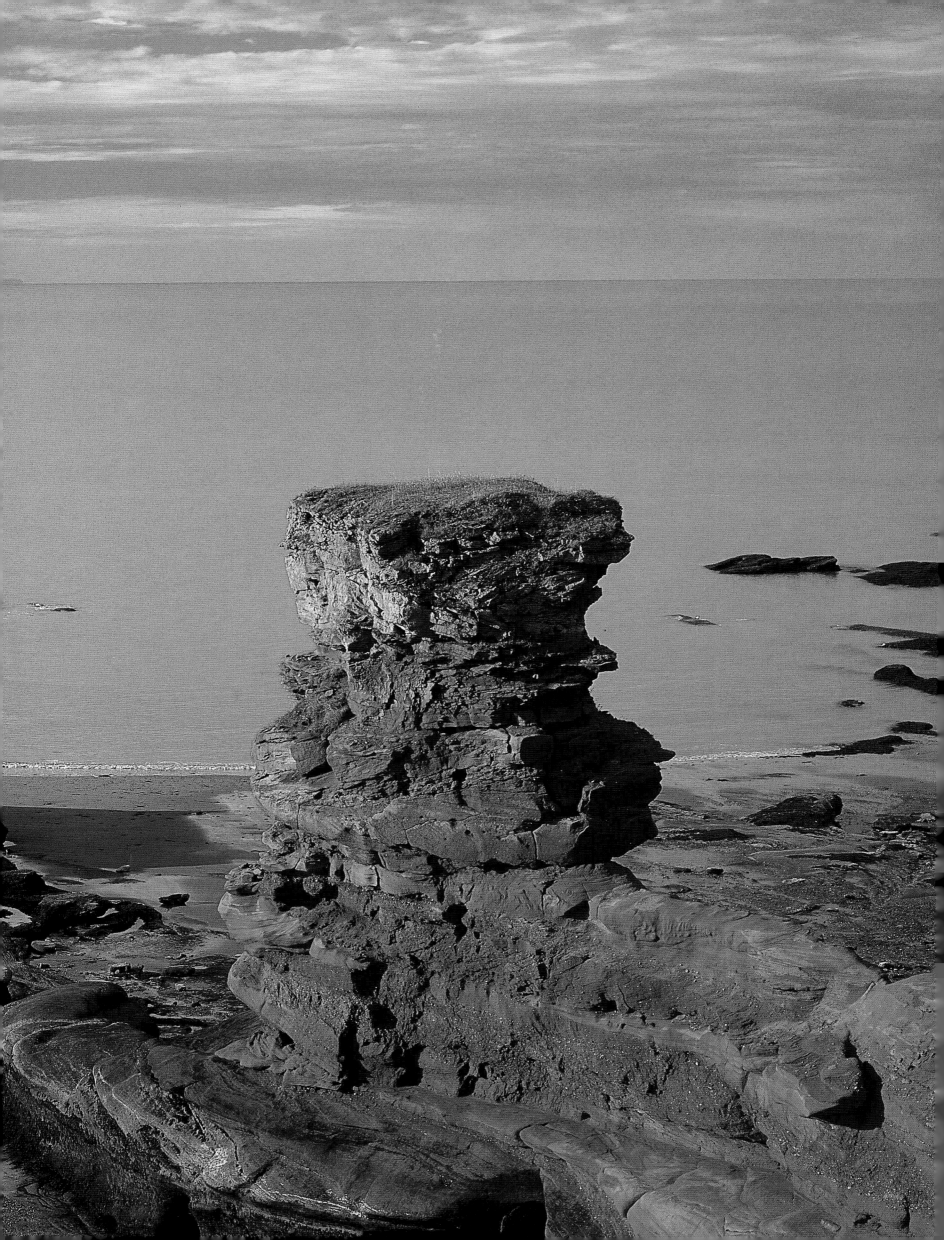

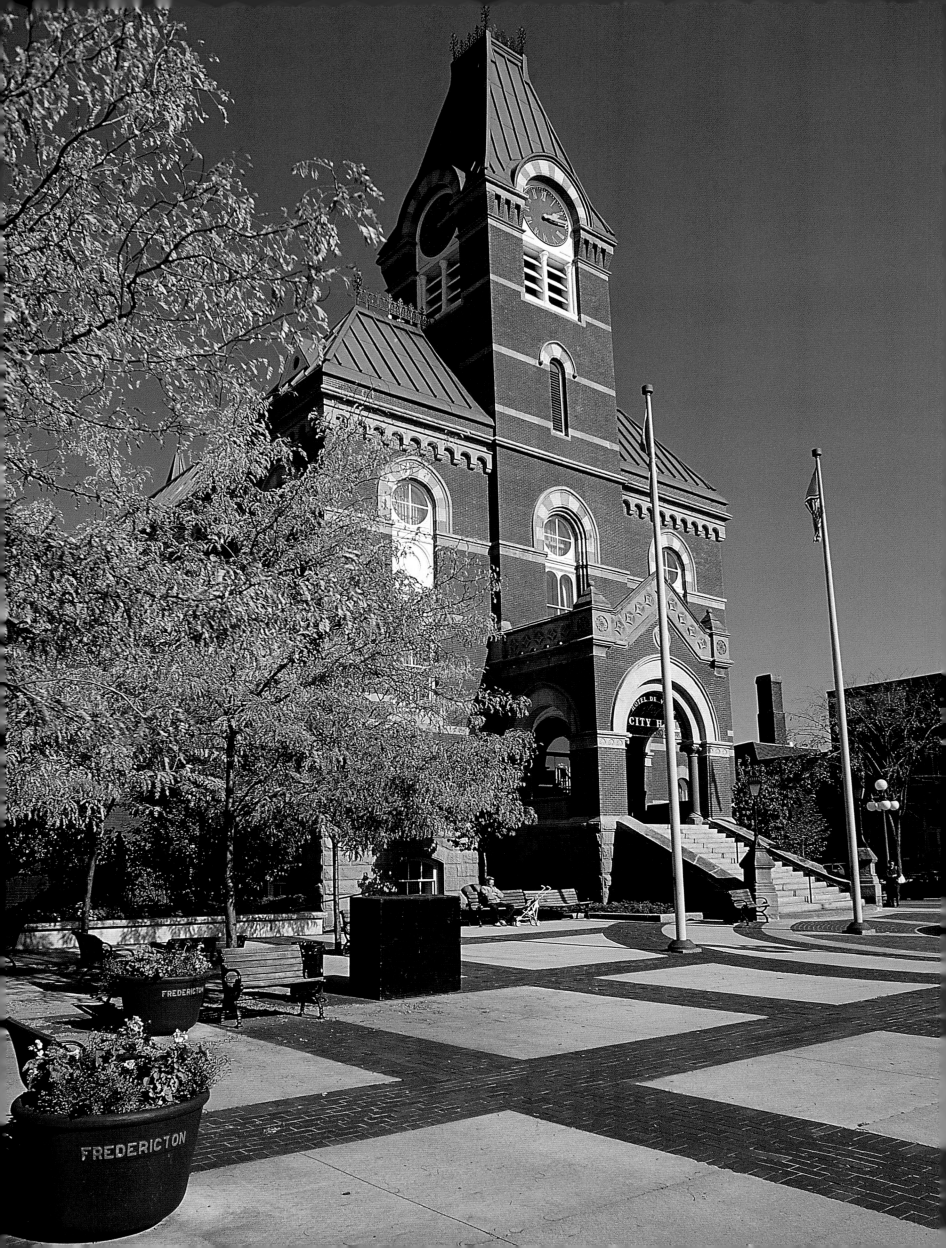

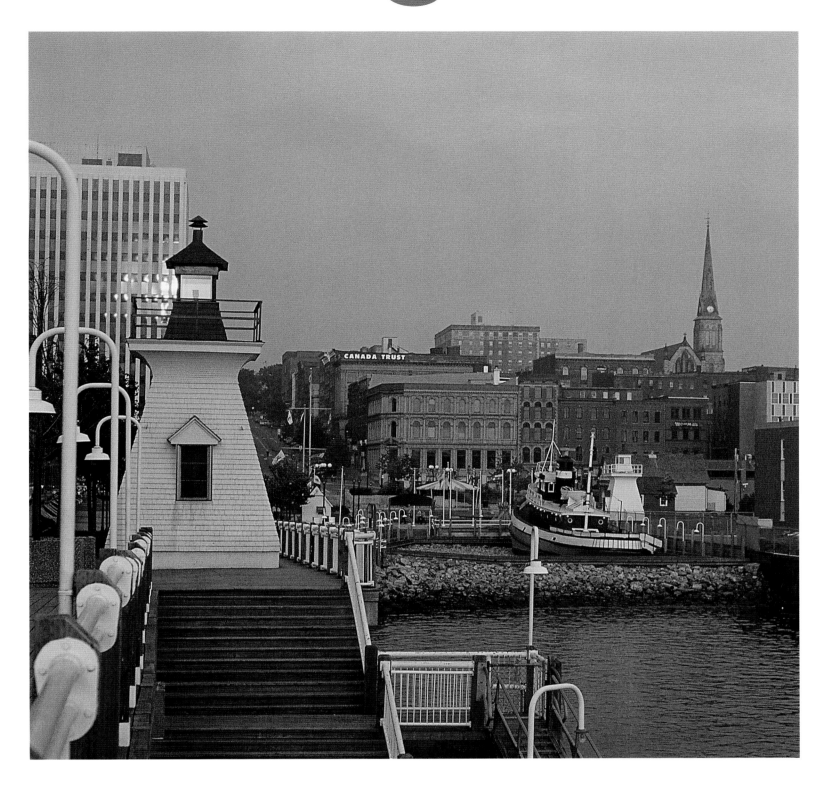

LEFT: When Fredericton's brick city hall was built in 1876, it included offices, council chambers, an opera house, a market, and a jail.

ABOVE: In the late 1700s, 15,000 Loyalists flocked to New Brunswick from the newly independent United States. Saint John was just one of the communities they founded. In 1785, it was the first city to be incorporated in British North America.

PREVIOUS PAGES: The world's highest tides—with a range sometimes exceeding 8 metres (26 feet)—occur in the Bay of Fundy. They are caused by the long, gradual shape of the bay. Water pouring towards the ocean between the funnel-like cliffs meets the incoming tide and causes a swell of water.

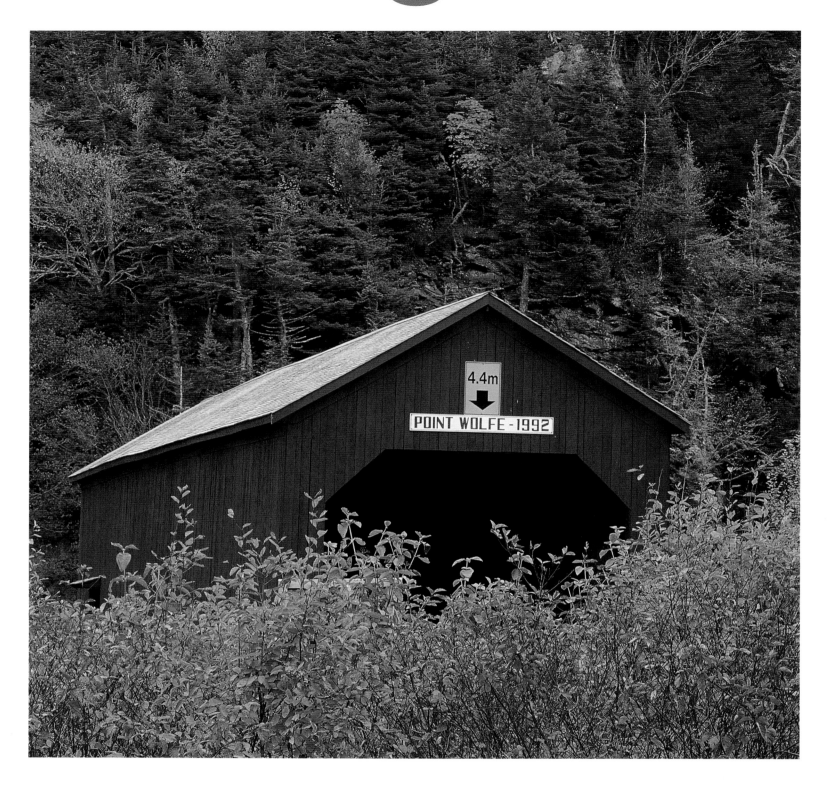

ABOVE: Point Wolfe bridge is one of two covered bridges in Fundy National Park and one of 70 in New Brunswick. This is a reconstruction of the original bridge at the site, which was accidentally destroyed by a work crew in 1990.

RIGHT: A four-kilometre (2¹/₂-mile) hiking trail leads visitors to Third Vault Falls in Fundy National Park. Though famous for its shoreline, this park offers more than 100 kilometres (60 miles) of trails along historic cart tracks and through the backcountry.

OVERLEAF: A boardwalk meanders through the saltwater marshes at Kouchibouguac National Park. *Kouchibouguac* is a Micmac word meaning "river of the long tides."

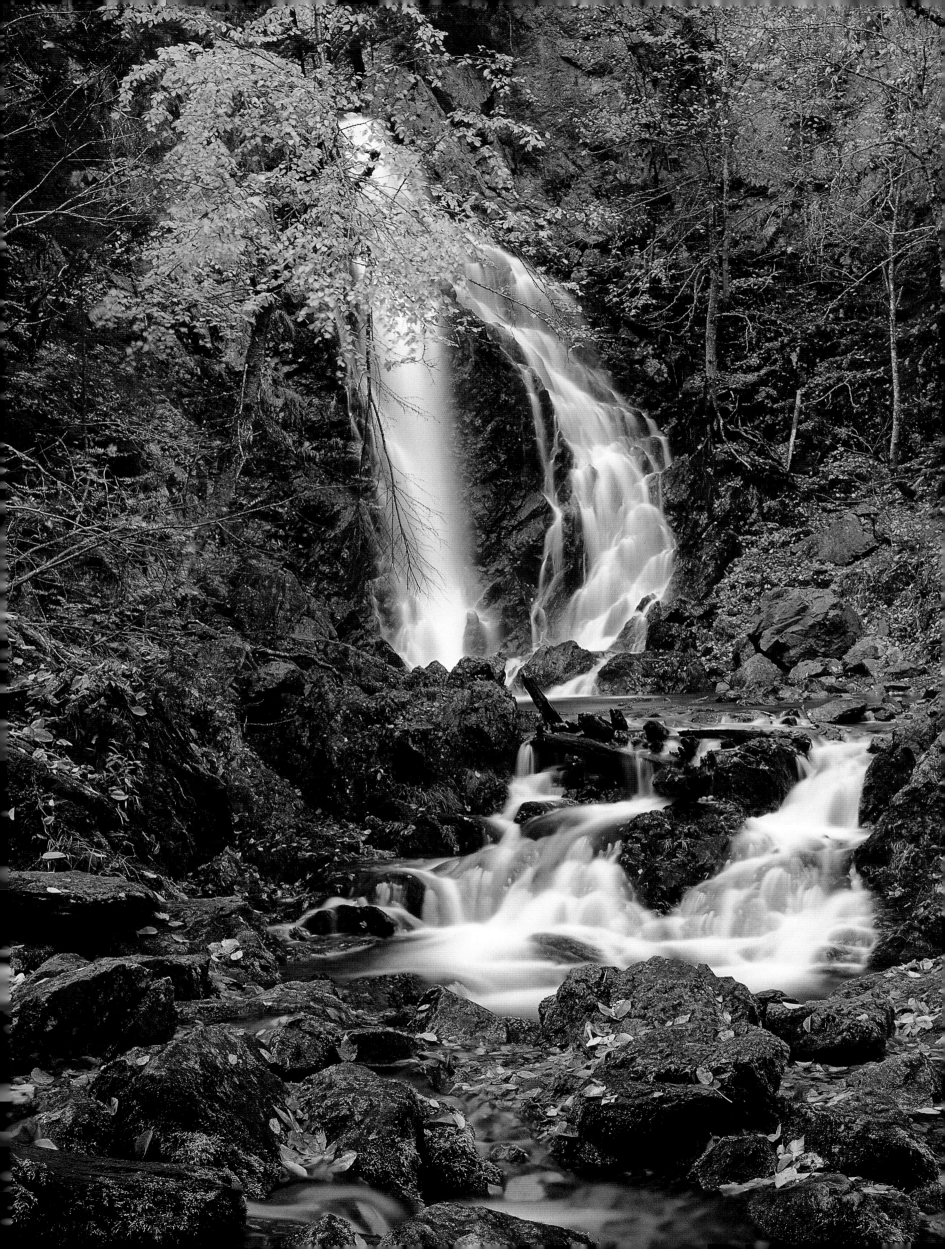

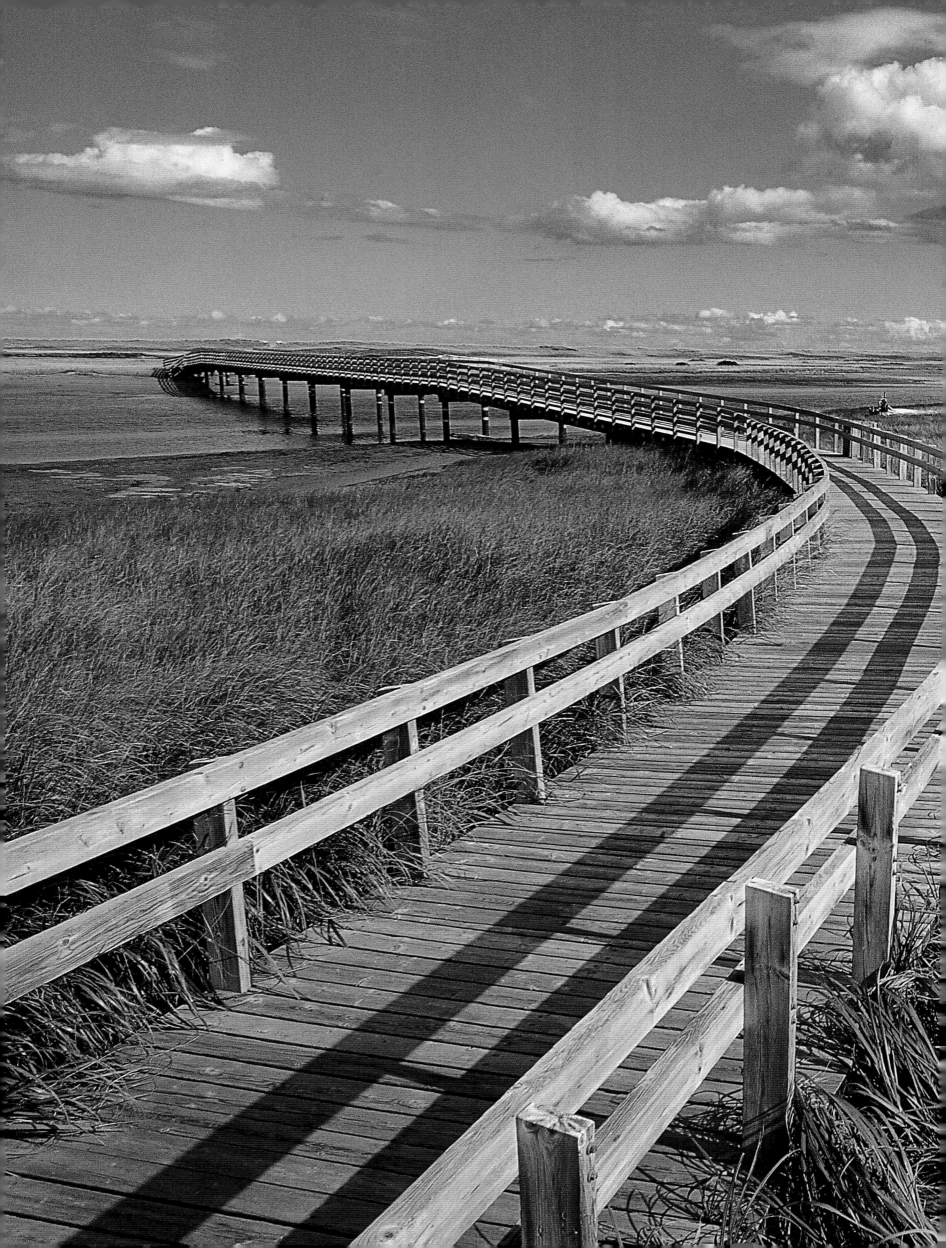

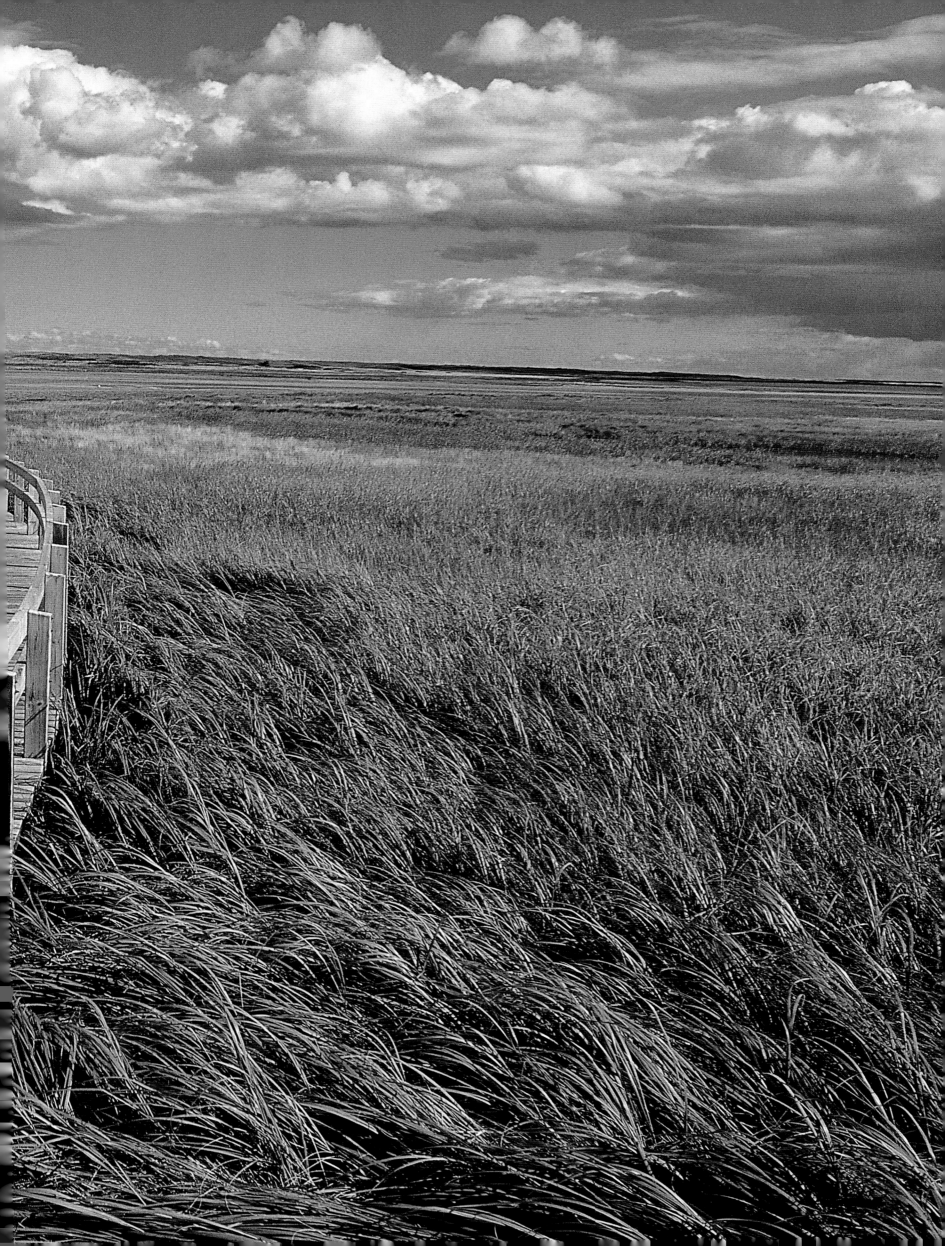

The shores of the Miramichi River burst with colour each fall. The 800-kilometre (500-mile) waterway is renowned for its runs of Atlantic salmon.

ABOVE: The provincial Legislature, known as Province House, was opened in Charlottetown, Prince Edward Island, in 1847. This is the birthplace of Confederation, where the leaders of 19th-century British North America met in 1864 to discuss a possible union.

RIGHT: Although much of Prince Edward Island is composed of neat cropland and small coastal villages, this is actually the most densely populated province in Canada.

OVERLEAF: When the Fathers of Confederation arrived in Charlottetown, they walked from Prince Street Wharf up Great George Street to Province House. In honour of their achievements, the route has been designated a National Historic Site.

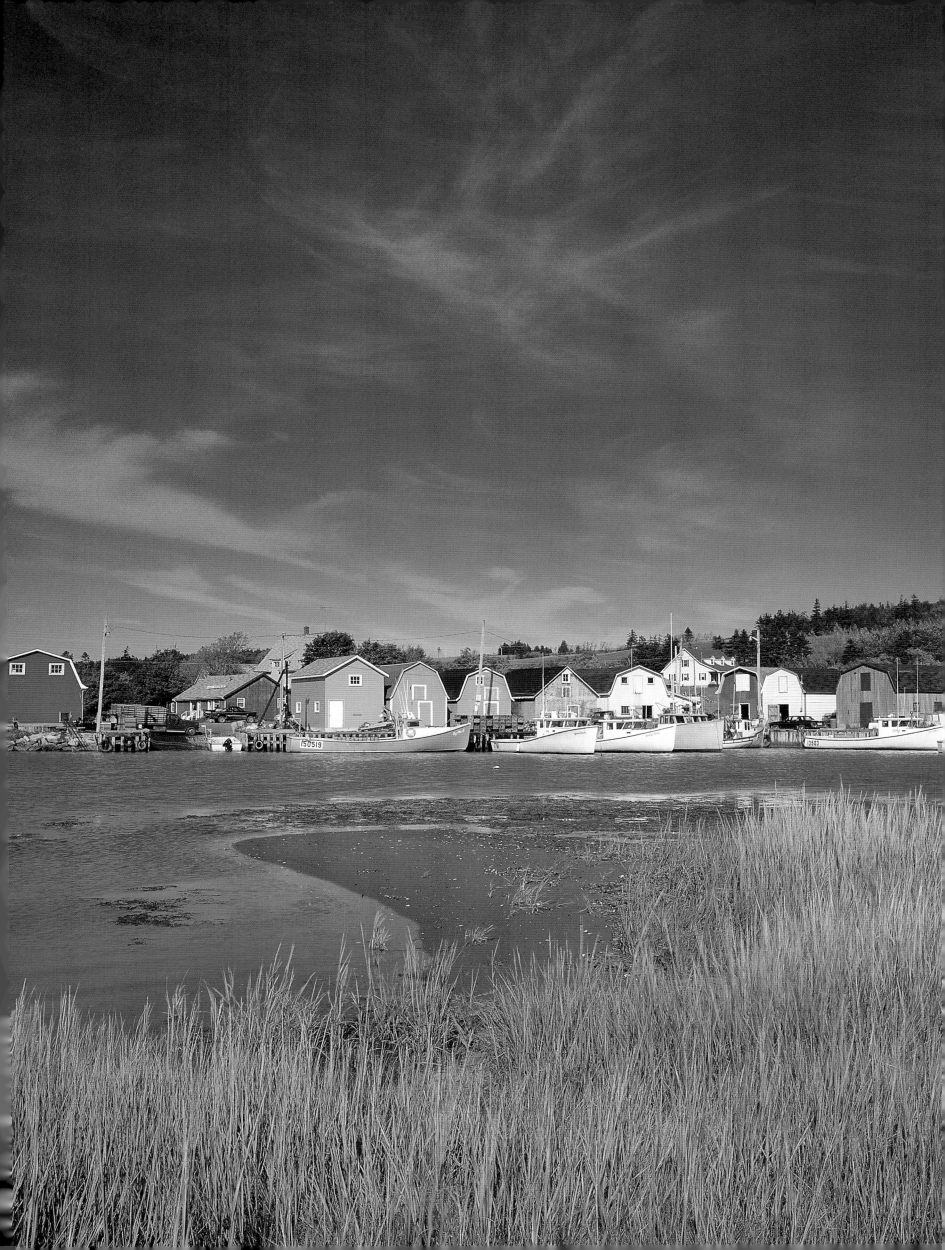

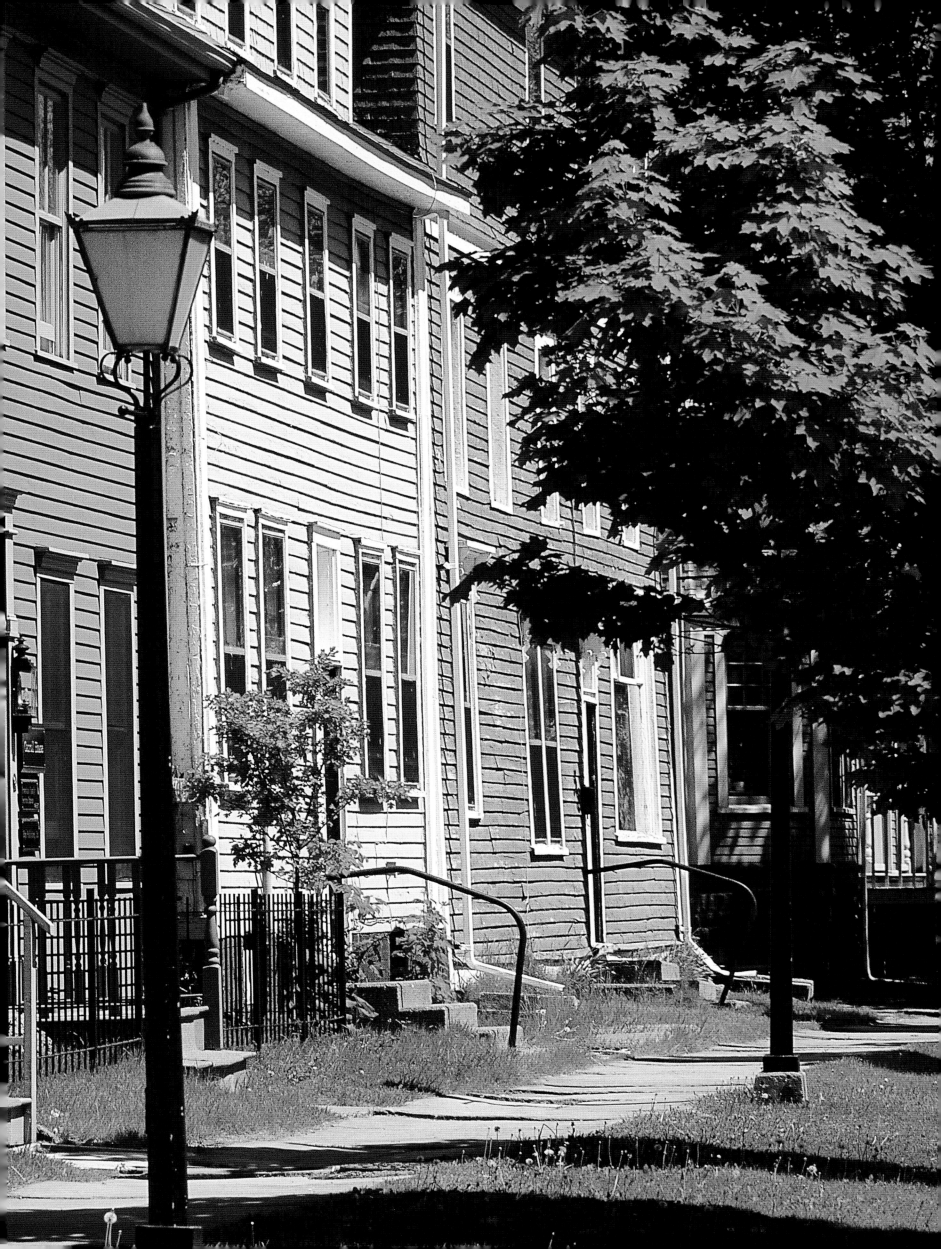

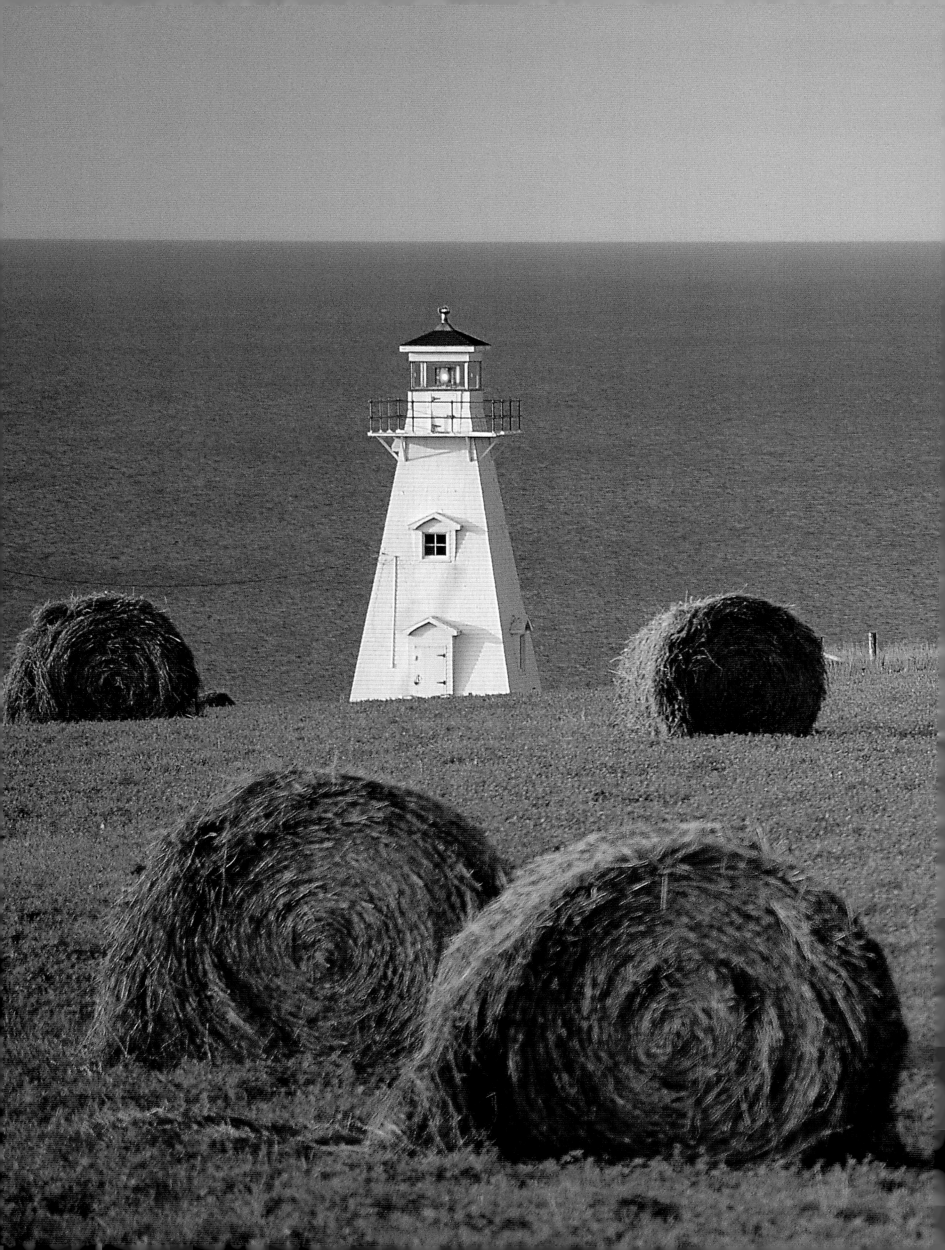

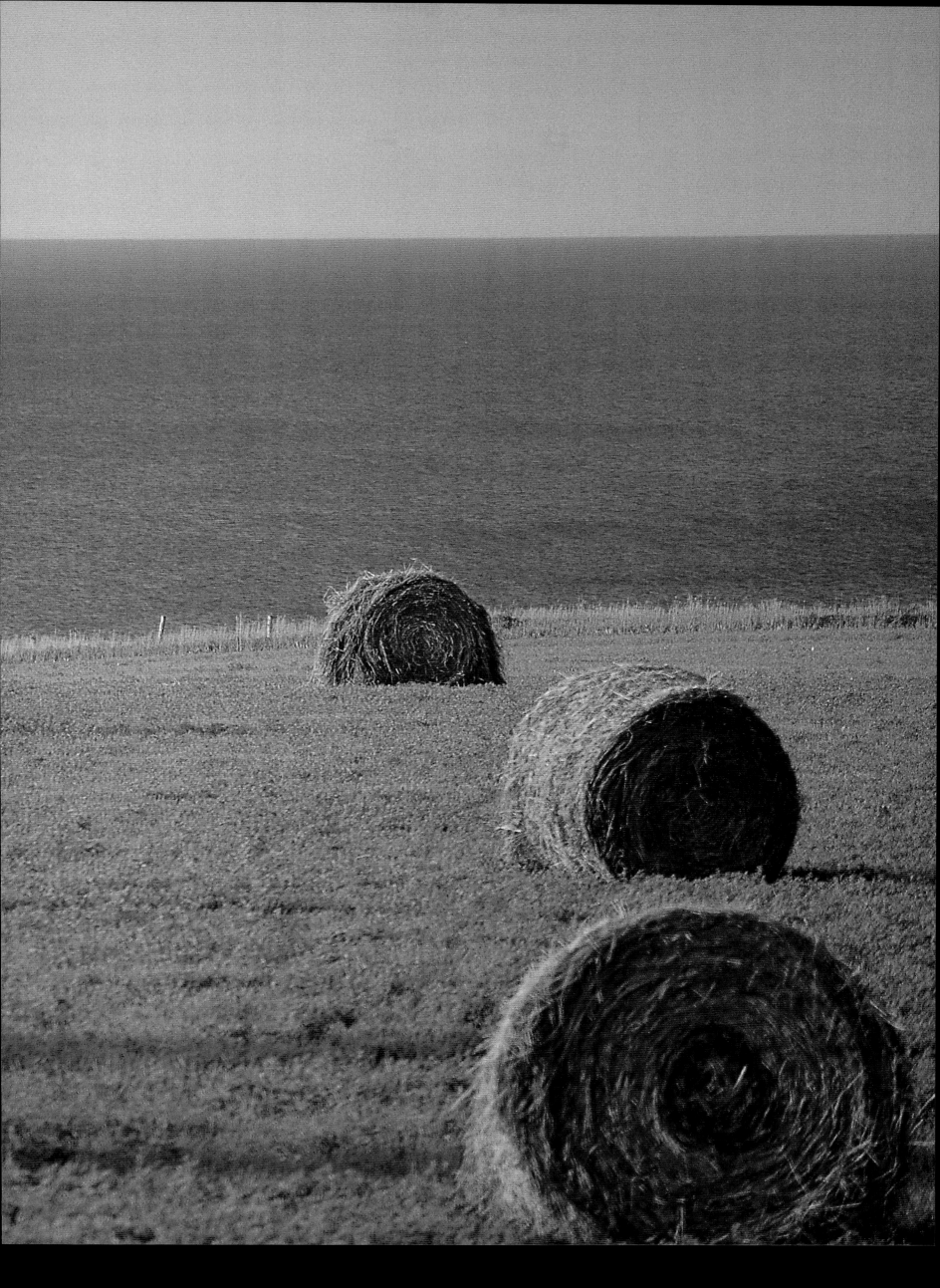

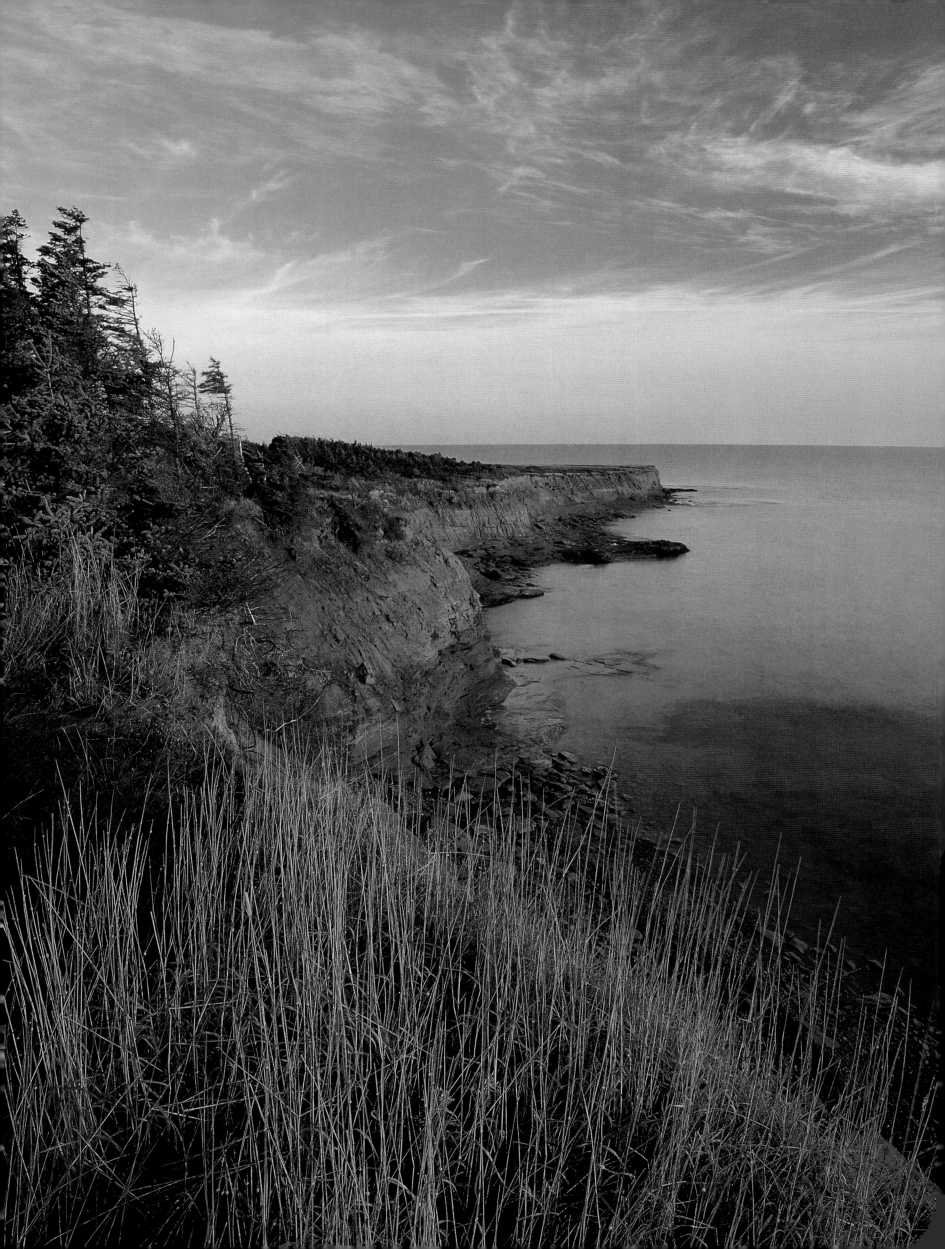

LEFT: Red sandstone cliffs, sculpted by Atlantic swells, extend from each side of Cape Turner in Prince Edward Island National Park. The park protects about 40 kilometres (25 miles) of shoreline.

ABOVE: An artists' retreat, Victoria is a picturesque community just west of Charlottetown. Shops and galleries and a famous chocolate factory draw visitors to the town.

PREVIOUS PAGES: Agriculture is Prince Edward Island's primary industry, contributing about $300 million to the provincial economy each year. More than 2000 farms produce crops from potatoes to berries.

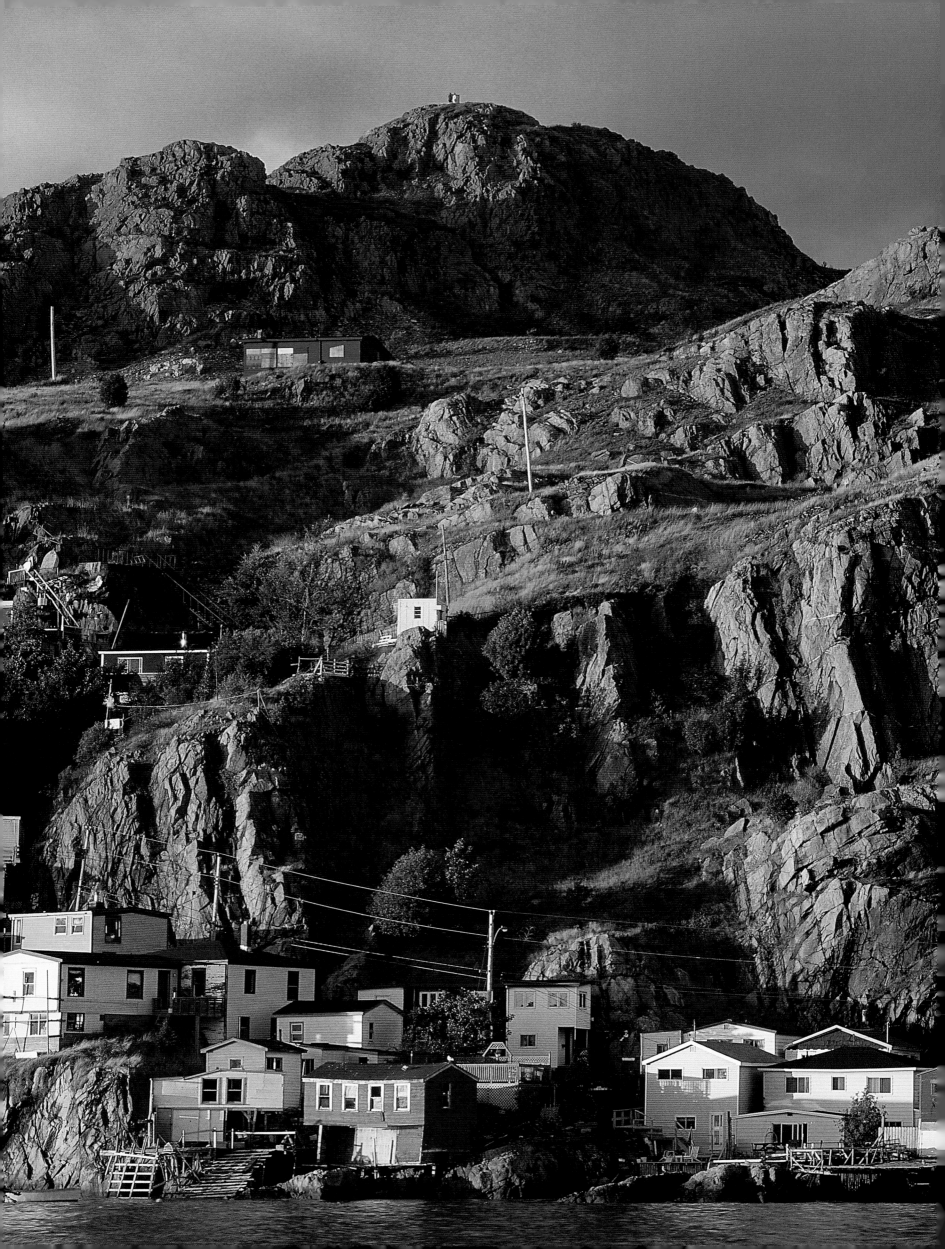

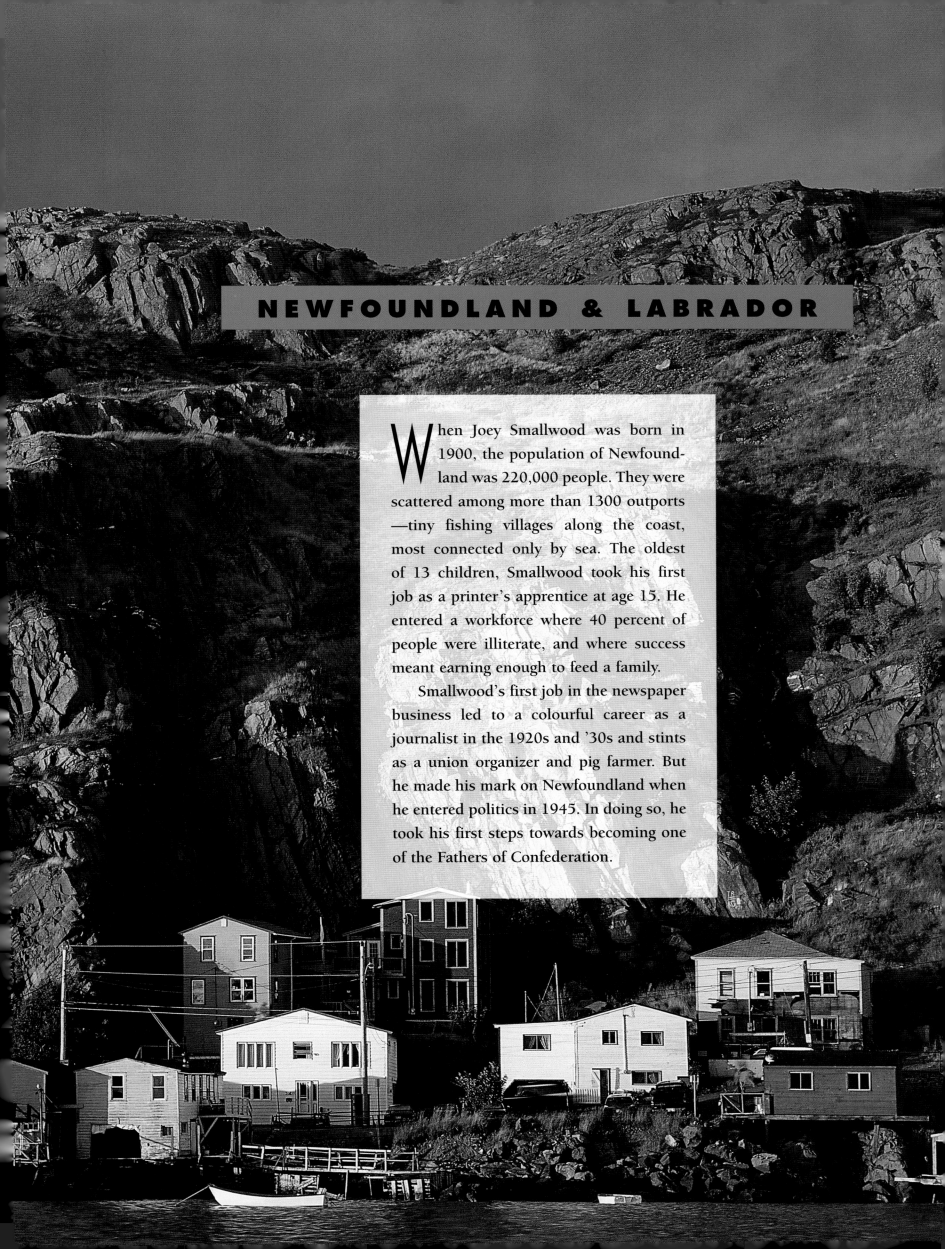

NEWFOUNDLAND & LABRADOR

When Joey Smallwood was born in 1900, the population of Newfoundland was 220,000 people. They were scattered among more than 1300 outports —tiny fishing villages along the coast, most connected only by sea. The oldest of 13 children, Smallwood took his first job as a printer's apprentice at age 15. He entered a workforce where 40 percent of people were illiterate, and where success meant earning enough to feed a family.

Smallwood's first job in the newspaper business led to a colourful career as a journalist in the 1920s and '30s and stints as a union organizer and pig farmer. But he made his mark on Newfoundland when he entered politics in 1945. In doing so, he took his first steps towards becoming one of the Fathers of Confederation.

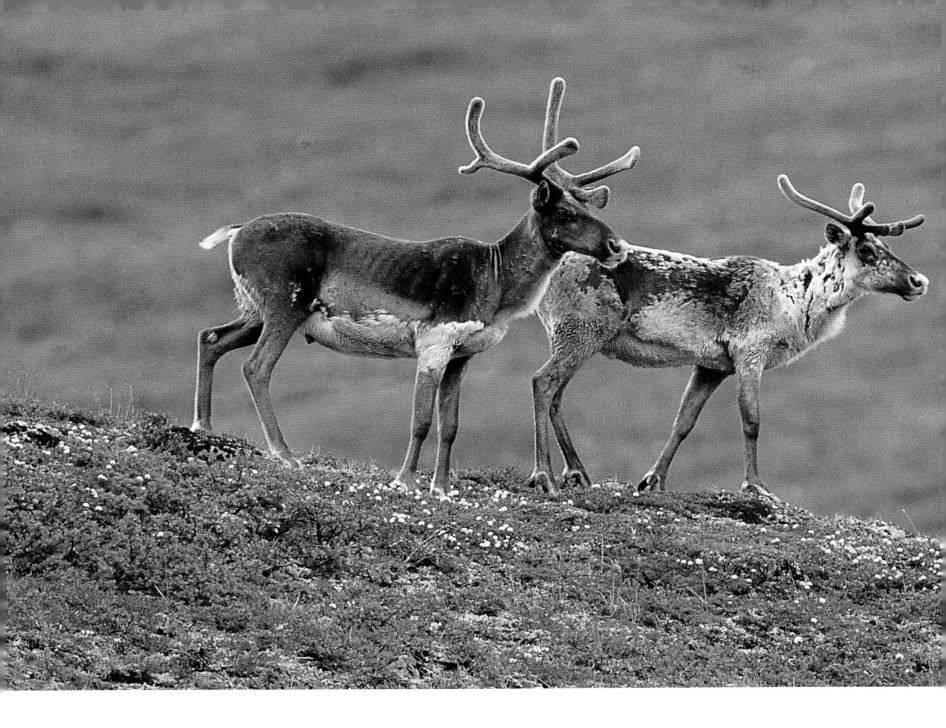

St. John's harbour has a long and turbulent history. It is thought that it was discovered by Cabot and claimed for England in 1497, then named Rio de San Johem by Portuguese explorer Gaspar Côrte-Real in 1500. Later, the Dutch, the French, and the English fought for control of the area.

More than four centuries earlier, when John Cabot dropped his nets off the Grand Banks and drew them up bursting with cod, Newfoundland became a sought-after jewel. Sir Humphrey Gilbert claimed the region as British soil in 1583. The Dutch and the French attacked in turn, but Britain regained control of the colony and St. John's was soon a booming, cosmopolitan city. It was Britain's first colonial outpost, and its growth marked the birth of the British Empire and the start of colonial expansion around the world.

Yet when colonialism came to an end, Newfoundland remained. The region had enjoyed almost 80 years of self-government, but in 1933 financial woes had placed it once again under the control of the British crown. In 1945, when Smallwood was elected, unemployment was rampant and Newfoundland and Labrador were in dire economic straits.

From the beginning, Smallwood believed that the route to success lay in unity with Canada. Within four years, he had convinced his constituents that he was right. In a 1948 referendum, Newfoundland's

population voted — by a slim margin — to become the tenth province of Canada.

Since Smallwood's time, the population has more than doubled, reaching 552,000. Some of the most isolated outports have been abandoned, others connected by roads and highways. And as the fisheries decline, the people of Newfoundland and Labrador work to redefine their province.

Nets and fishing buoys are enduring symbols of the region, but more and more, when visitors travel Newfoundland, they see the dramatic fiords of Gros Morne National Park or the breathtaking views from the peaks in Terra Nova National Park. They wander the historic streets of St. John's or scan the many bays for glistening icebergs.

Joey Smallwood would be proud of the new Newfoundland that visitors experience, including the sign at City Hall in St. John's. Placed at the beginning of the Trans-Canada Highway, it reads "Canada Begins Right Here."

ABOVE: Caribou herds of up to 750,000 animals migrate across Labrador each spring, en route to their calving grounds. Many of the females give birth within days of each other and the entire calving takes only a few weeks.

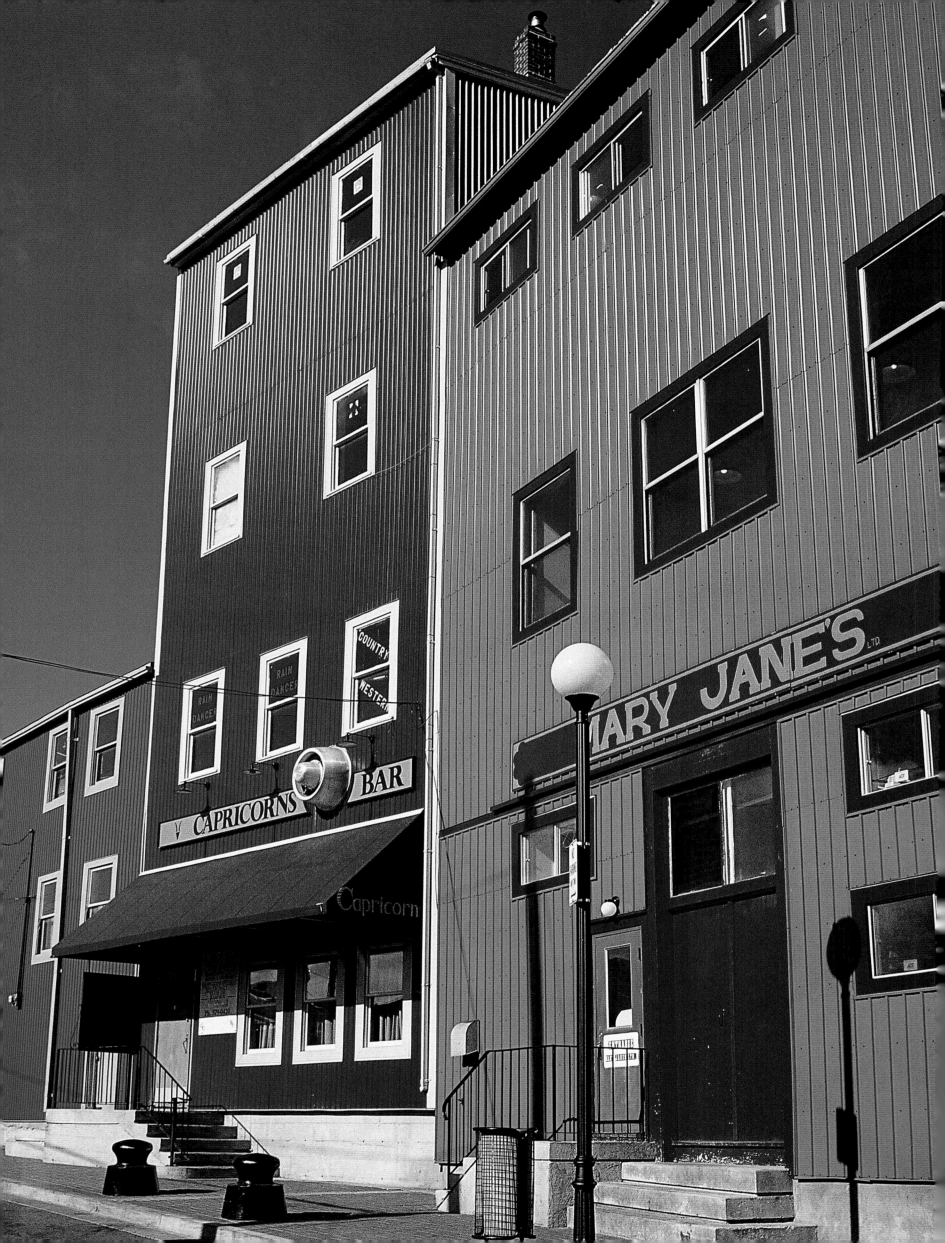

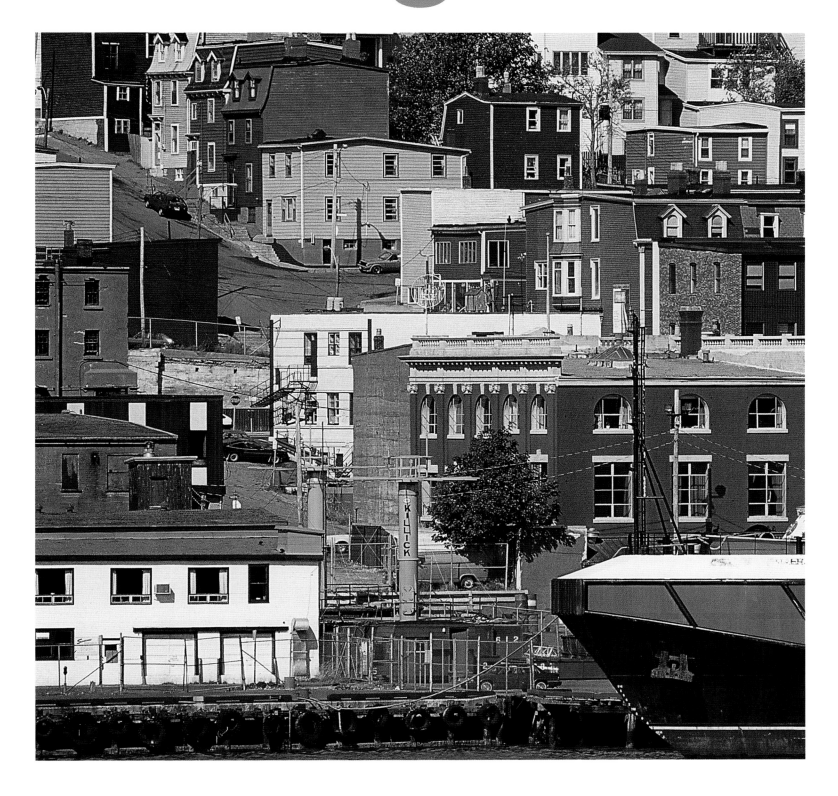

LEFT: The streets of St. John's were once lined with pubs and brothels as sailors from Spain, Portugal, Holland, France, and Britain mingled in the port. Today, the pubs on George Street are more respectable, but still a highlight of the local nightlife.

ABOVE: Stairways and winding streets lend a tour through St. John's shops and restaurants an intriguing historic air. The city's main streets closely hug the harbour, while the rest of the city rises on the hillside behind.

OVERLEAF: In 1901, the world's first transatlantic radio transmission was sent from Cornwall, England. Italian inventor Guglielmo Marconi received the message in Morse code at Signal Hill, now a National Historic Site.

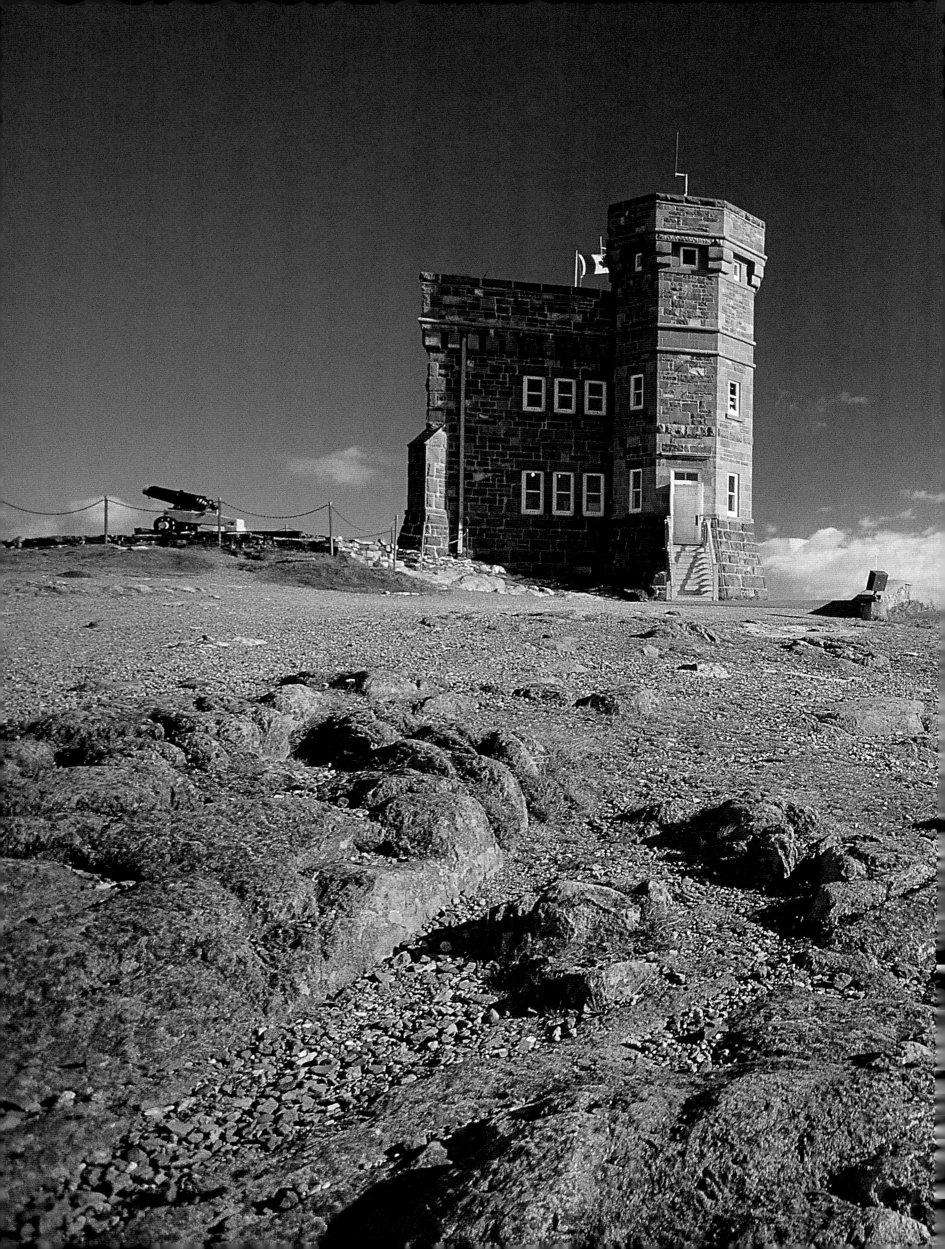

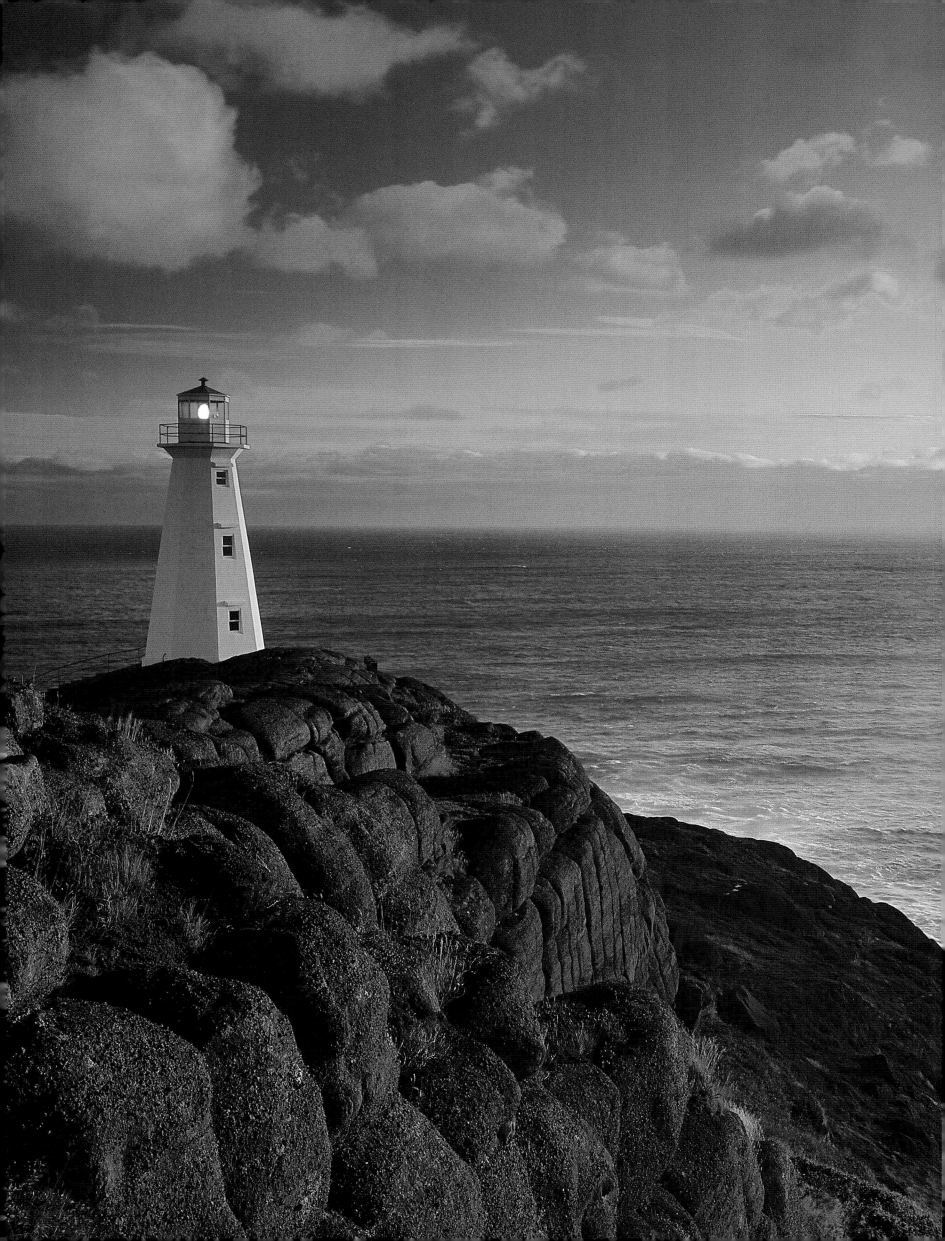

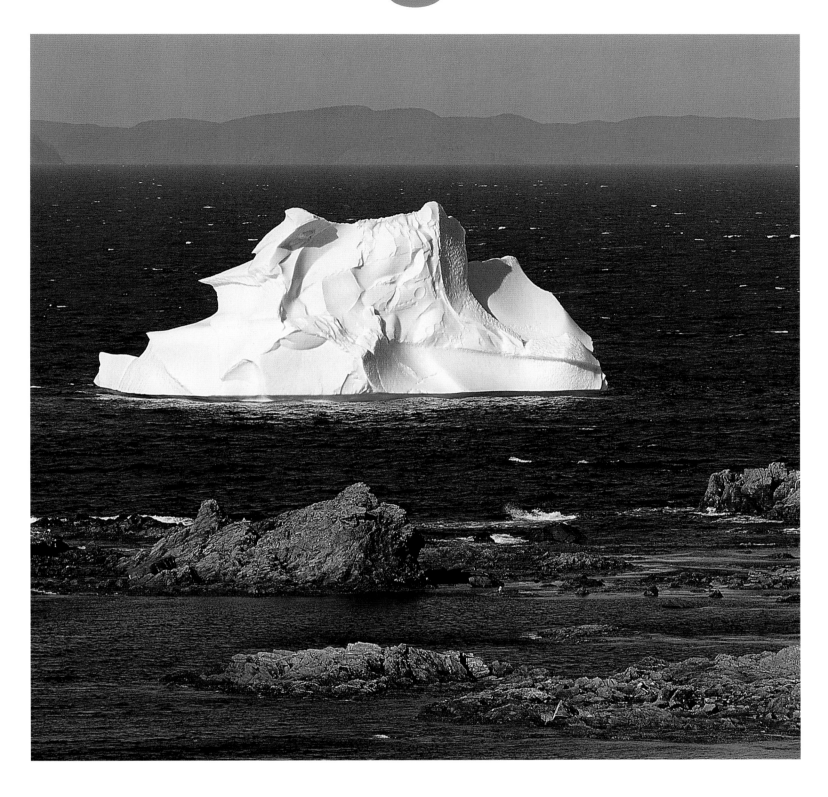

LEFT: Canada's oldest lighthouse stands 75 metres (246 feet) above the Atlantic on Cape Spear, North America's eastern tip. The beacon was built in 1836 and used until 1955. The lighthouse keeper's quarters have now been restored.

ABOVE: Icebergs from as far away as Greenland are common sights in the icy waters of Notre Dame Bay.

OVERLEAF: Five hundred years before Cabot sighted Newfoundland, Norse sailors and explorers founded a village at what is now L'Anse aux Meadows National Historic Park. Archeologists have uncovered remains from 1000 A.D. and visitors to the site can wander through sod buildings and view models of the settlement.

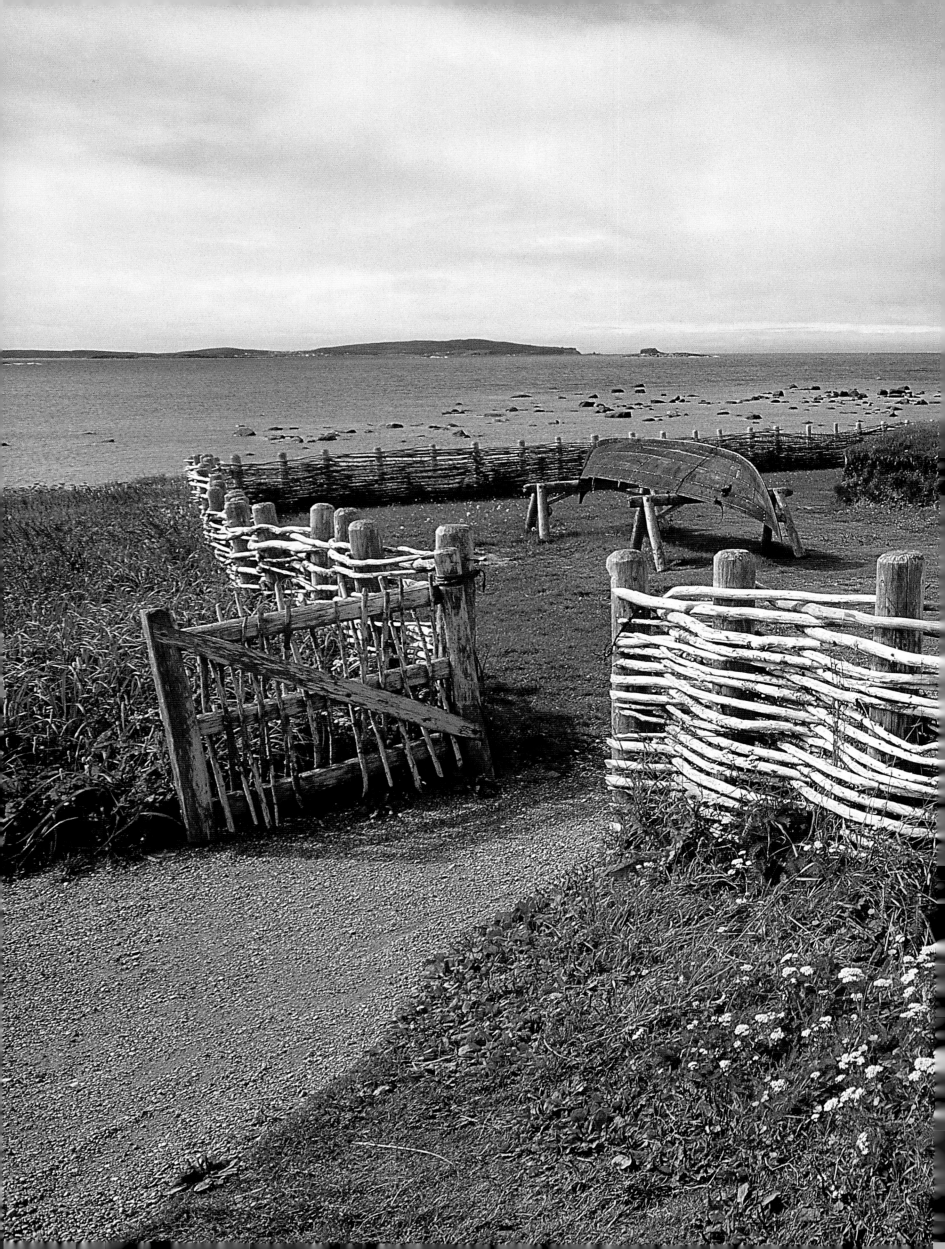

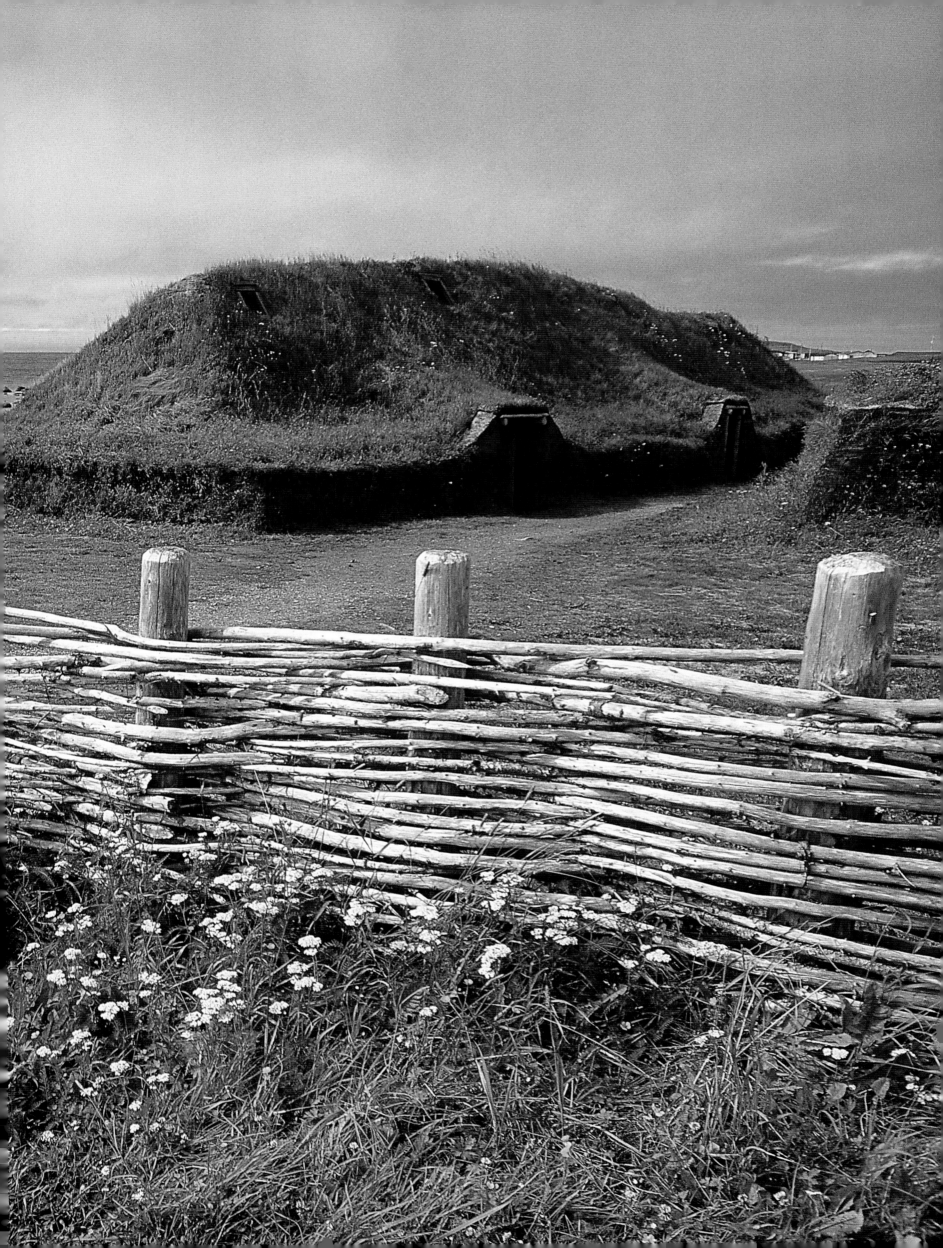

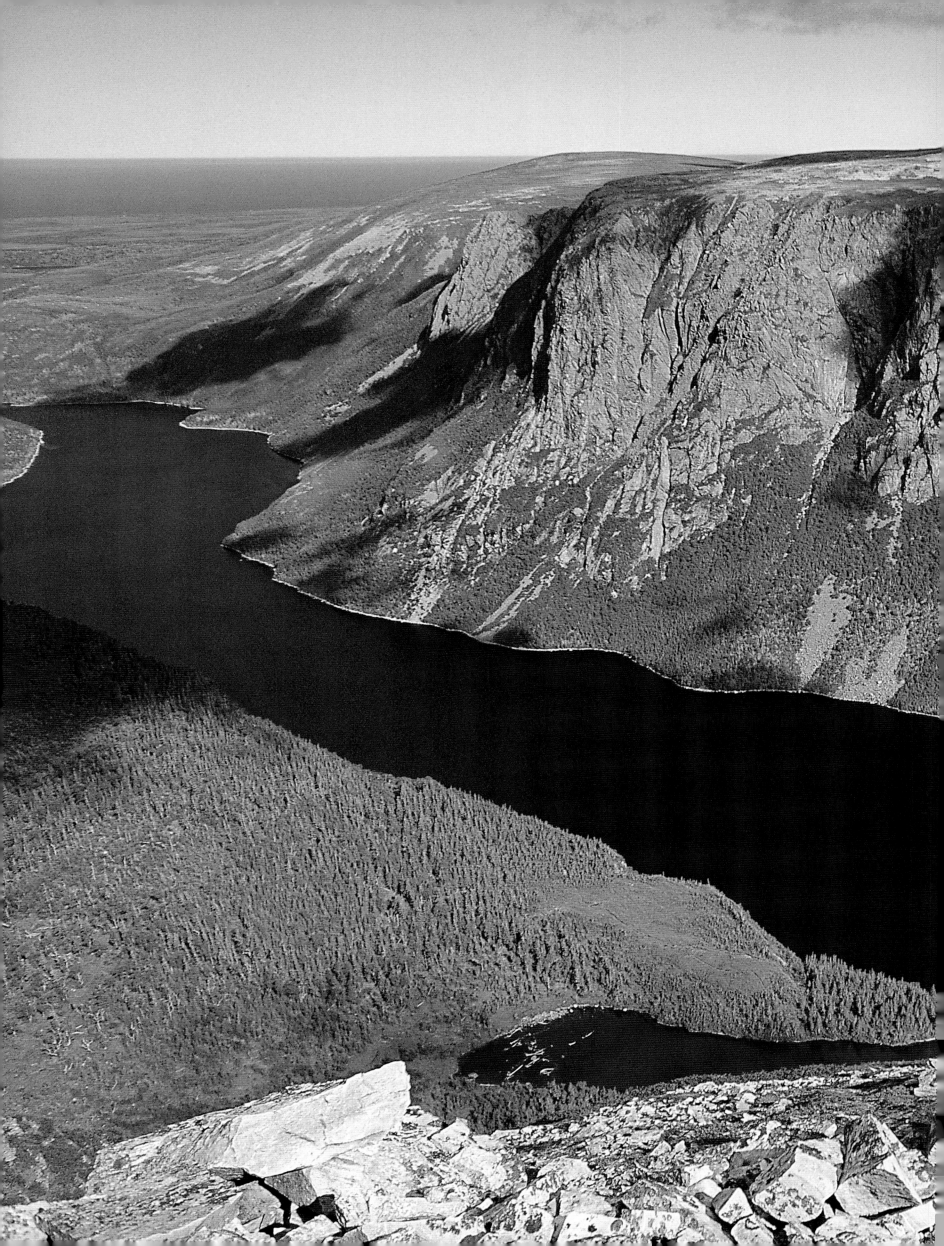

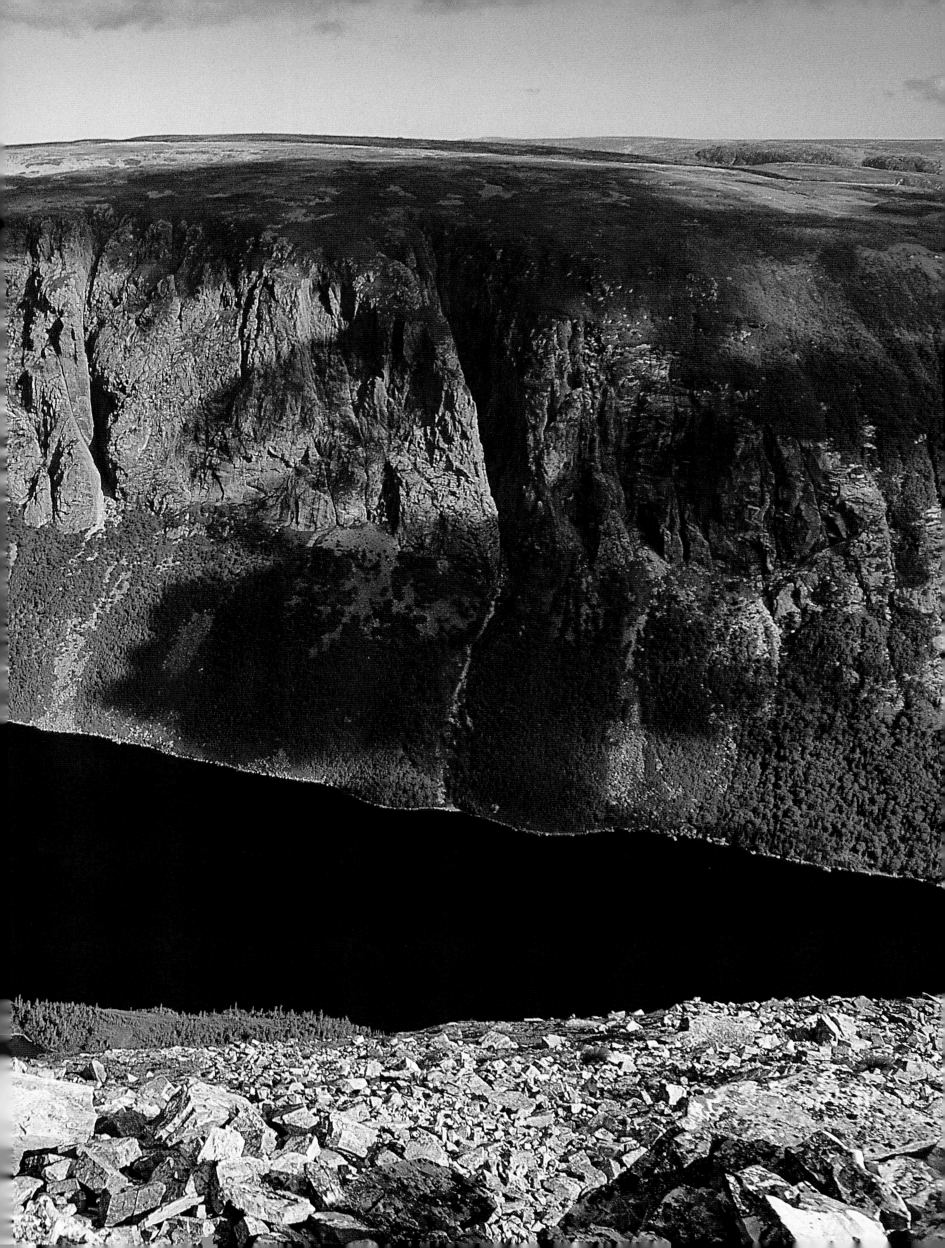

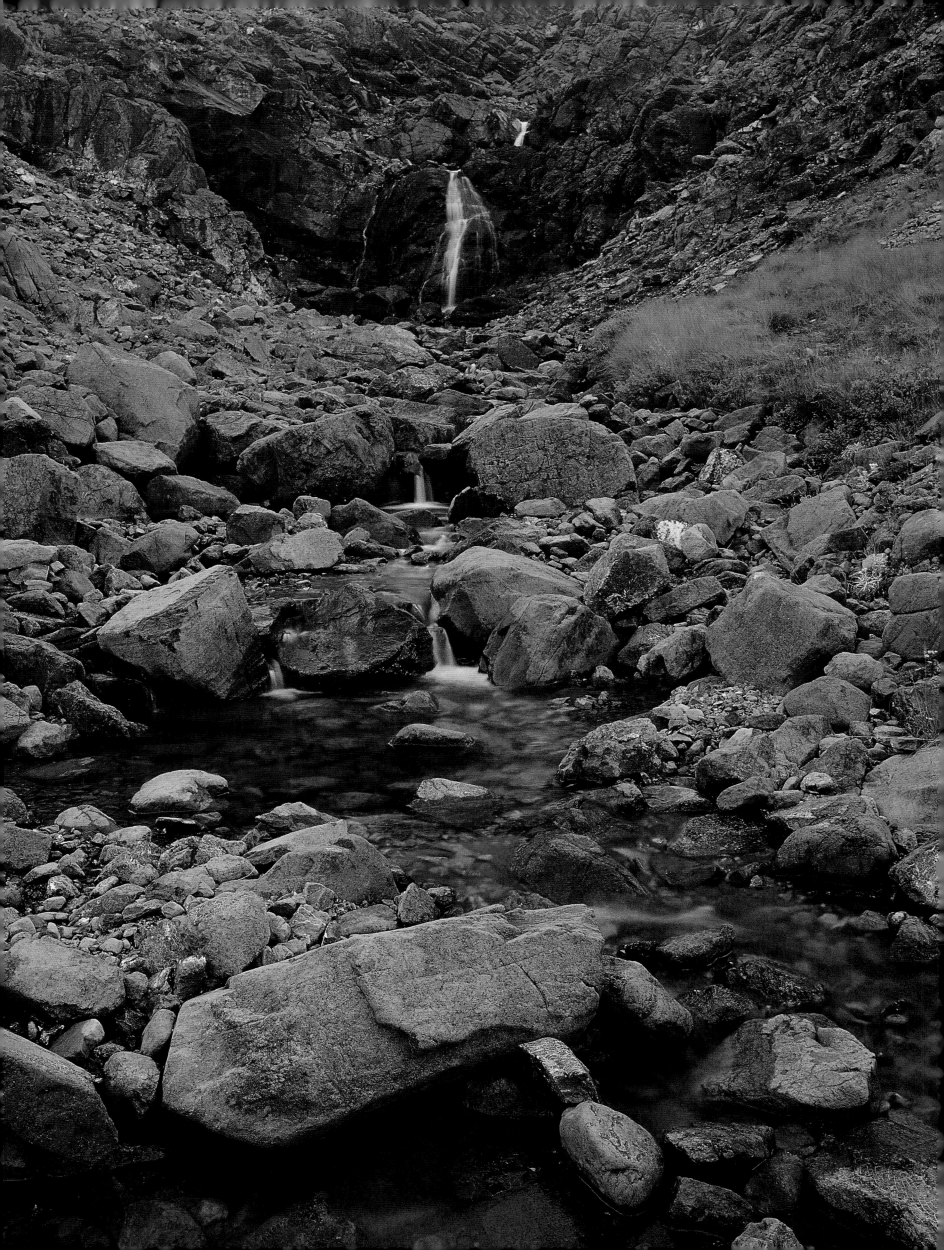

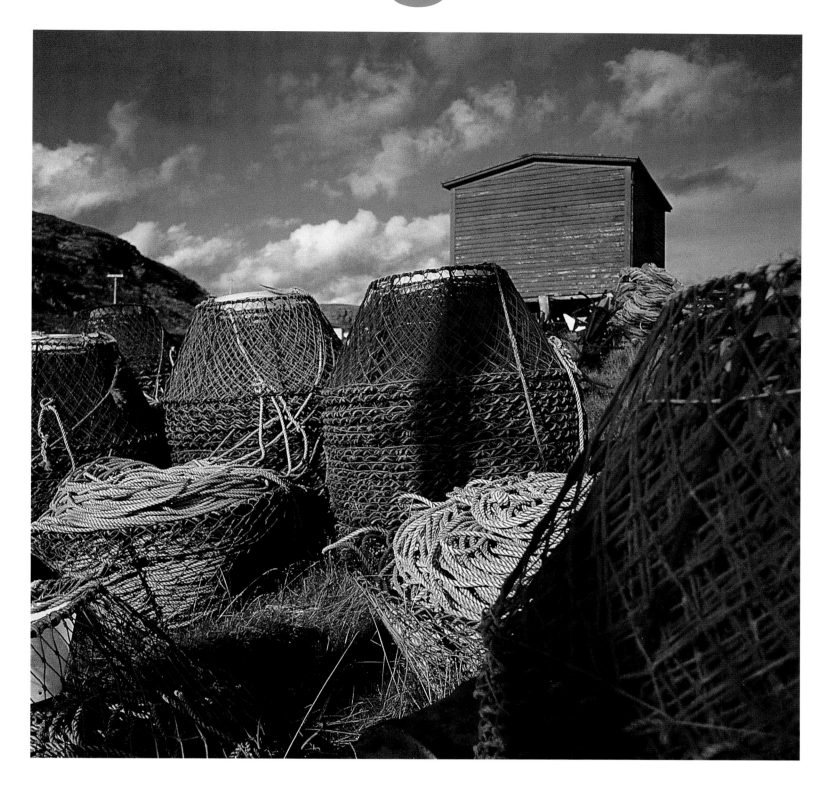

LEFT: The Tablelands in Gros Morne National Park are part of an ancient seabed, lifted high above the Atlantic by upheaval of the earth's crust. Mostly barren of plant life, the Tablelands are home to snow and glaciers.

ABOVE: Fishing villages surround Conception Bay, just east of St. John's. The area was named by early Portuguese explorers in honour of the Virgin Mary.

PREVIOUS PAGES: A UNESCO World Heritage Site, Gros Morne National Park includes stony beaches, cliffs, caves, bogs, forests, and amazing fiords. Scientists value these rocky slopes for the evidence they provide about ancient plate tectonics.

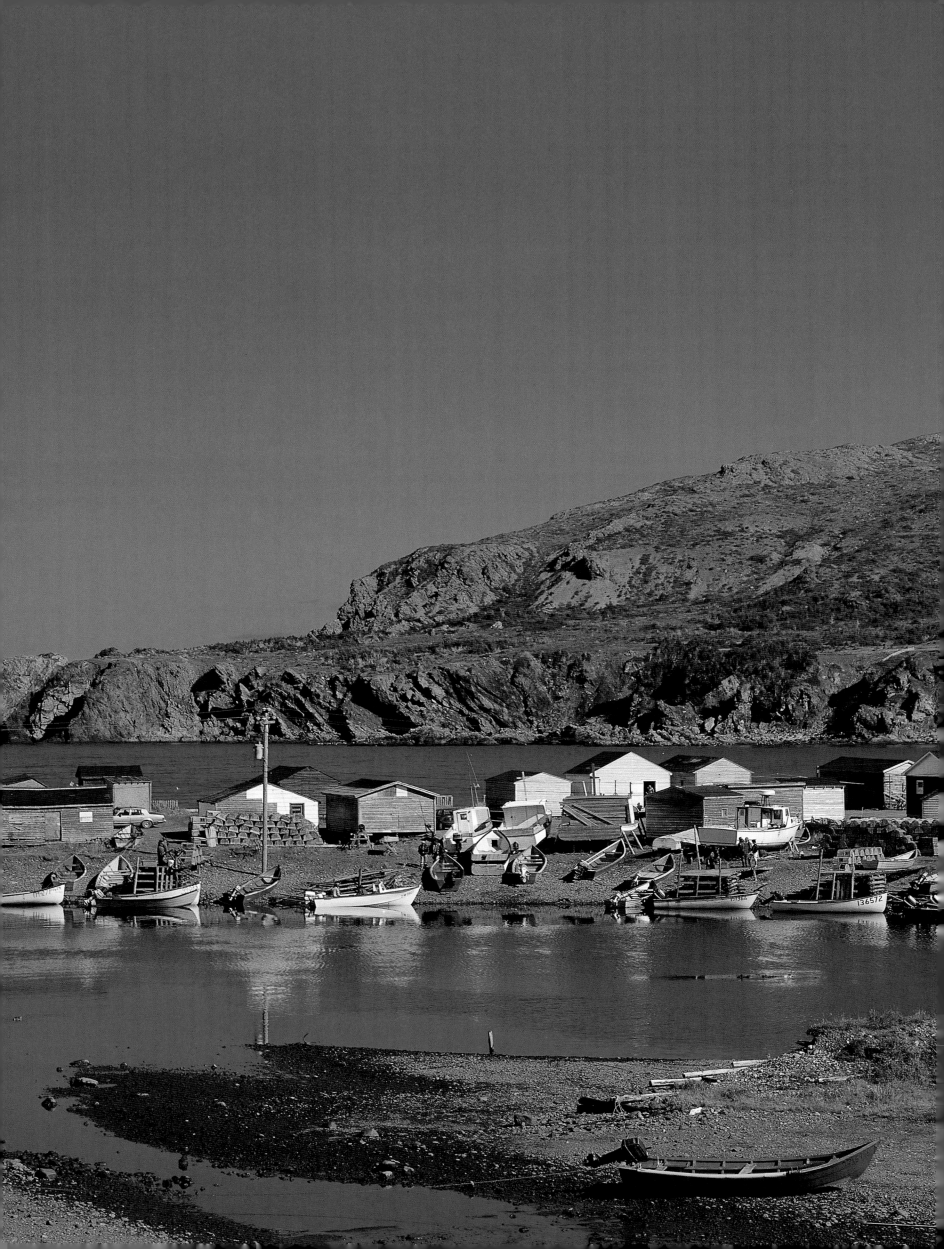

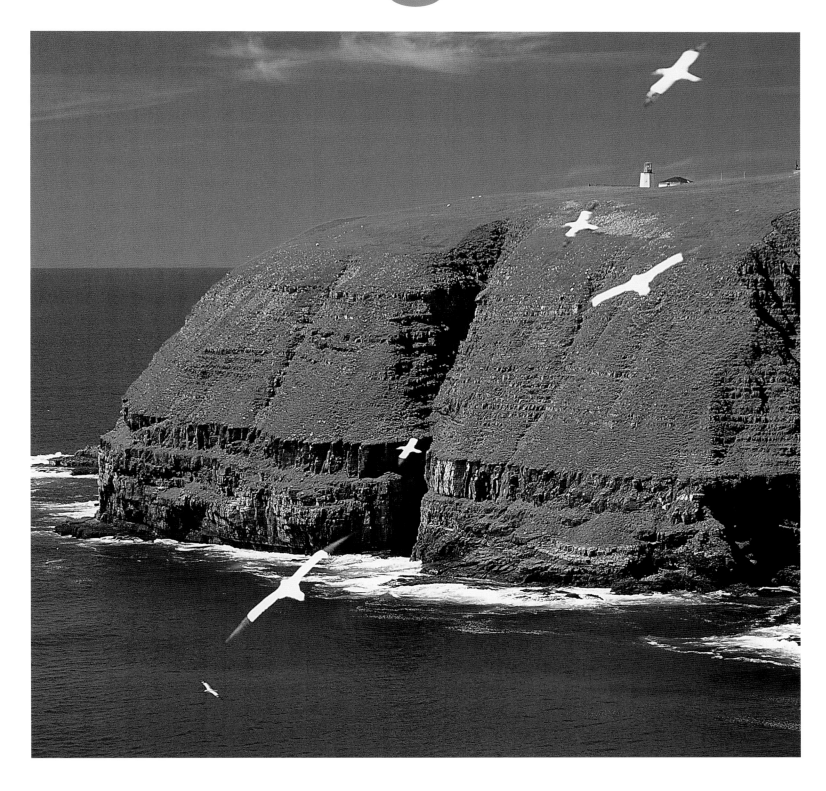

LEFT: Many of Newfoundland's seaside villages began as fishing outposts accessible only by boat. This isolation is partly responsible for the unique dialects spoken in the province.

ABOVE: The second-largest gannet nesting site on the continent is just one of the delicate areas safeguarded by Cape St. Mary's Ecological Reserve. More than 53,000 birds nest here each summer, protected from predators by the steep cliffs.

PREVIOUS PAGES: Terra Nova National Park offers a wilderness haven for bears, lynx, moose, beavers, bald eagles, and nature-seeking city dwellers. More than 100 kilometres (62 miles) of hiking trails wind through the park and along the fiords.

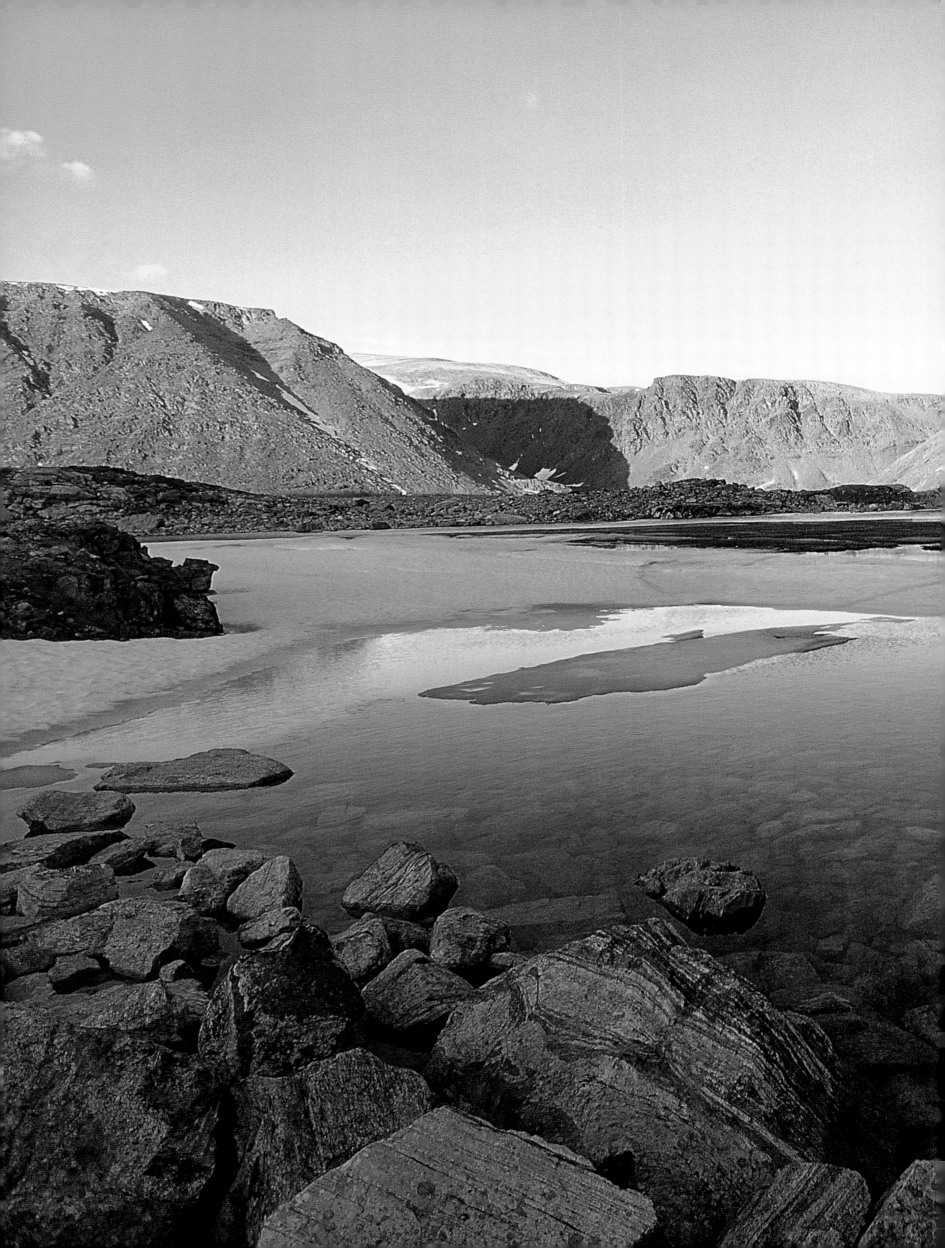

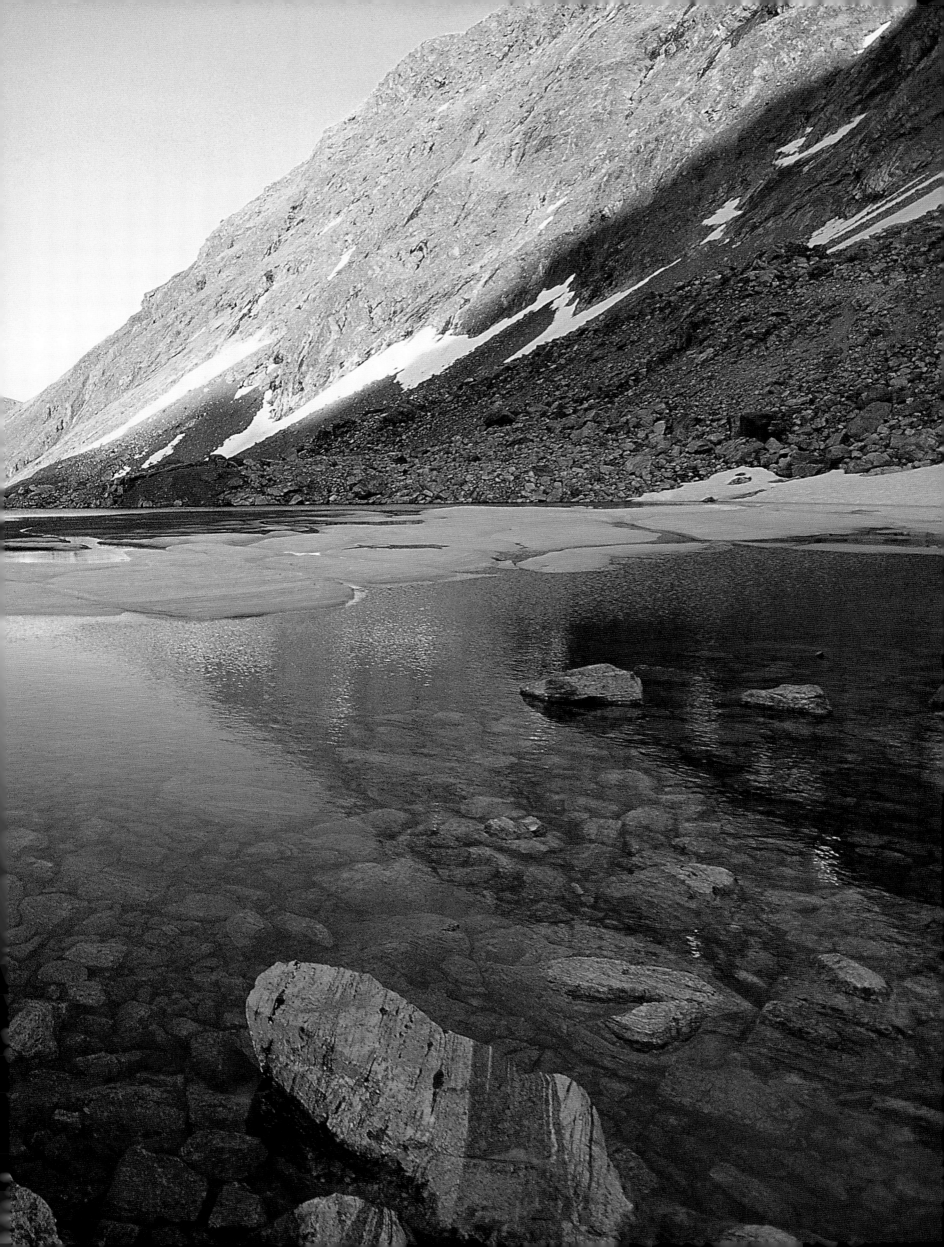

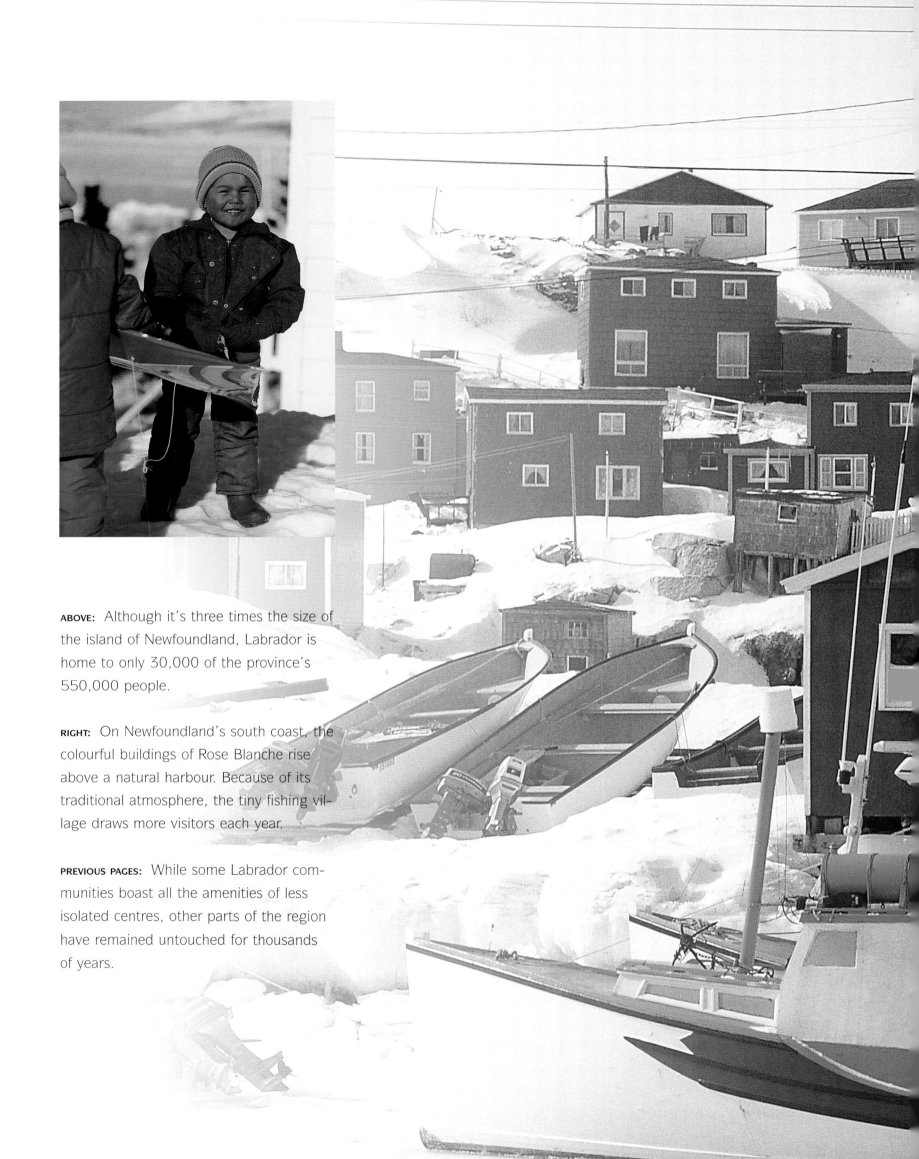

ABOVE: Although it's three times the size of the island of Newfoundland, Labrador is home to only 30,000 of the province's 550,000 people.

RIGHT: On Newfoundland's south coast, the colourful buildings of Rose Blanche rise above a natural harbour. Because of its traditional atmosphere, the tiny fishing village draws more visitors each year.

PREVIOUS PAGES: While some Labrador communities boast all the amenities of less isolated centres, other parts of the region have remained untouched for thousands of years.

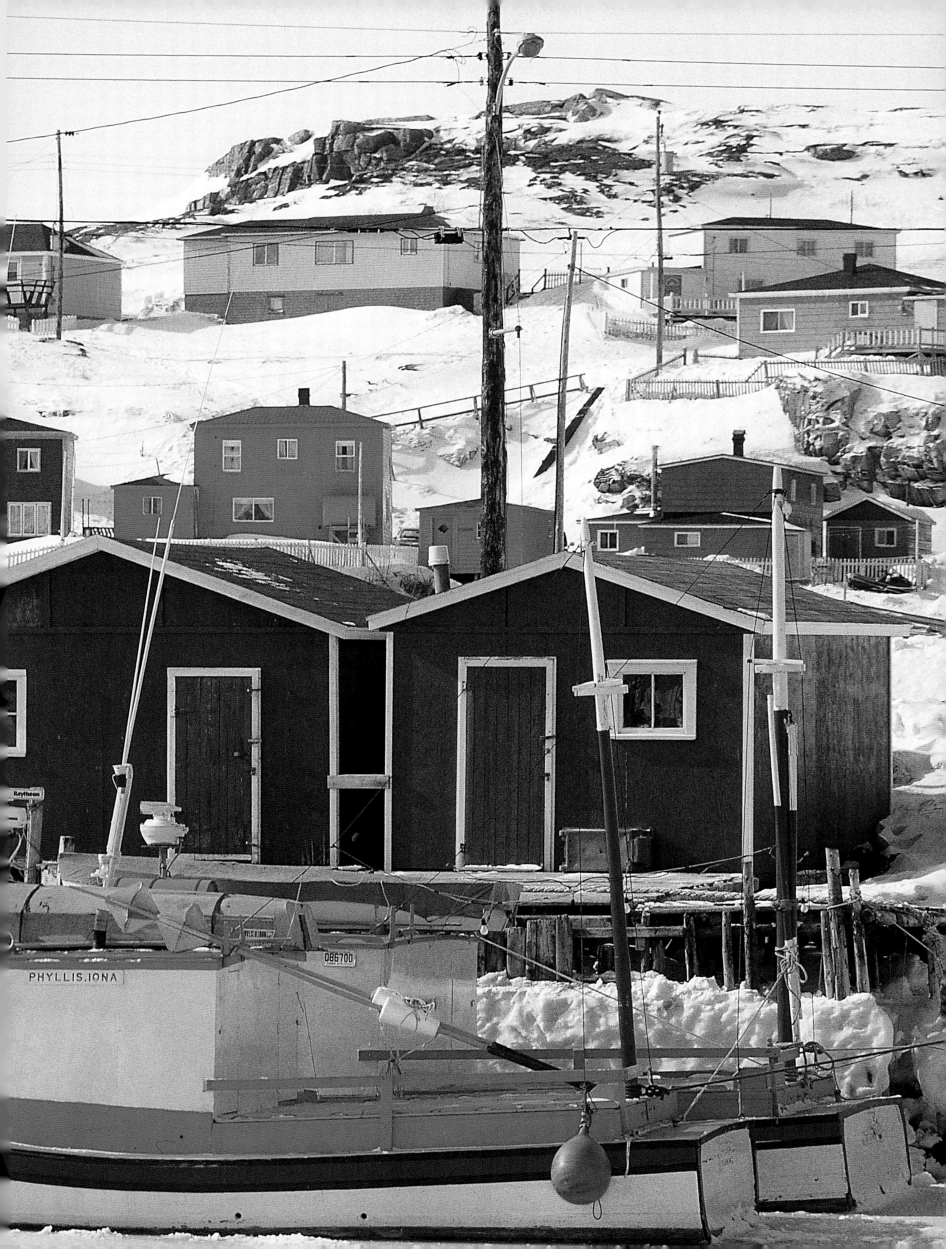

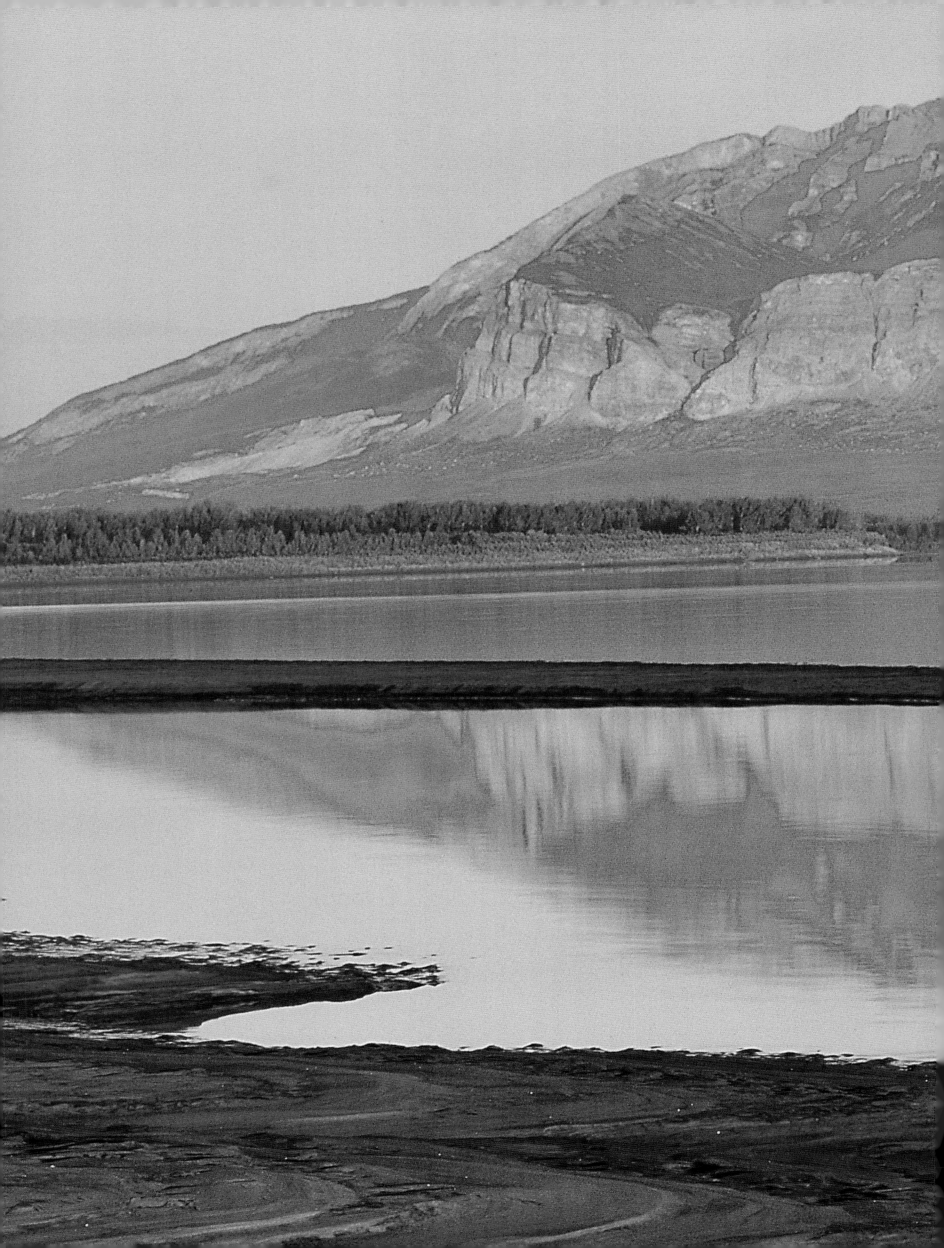

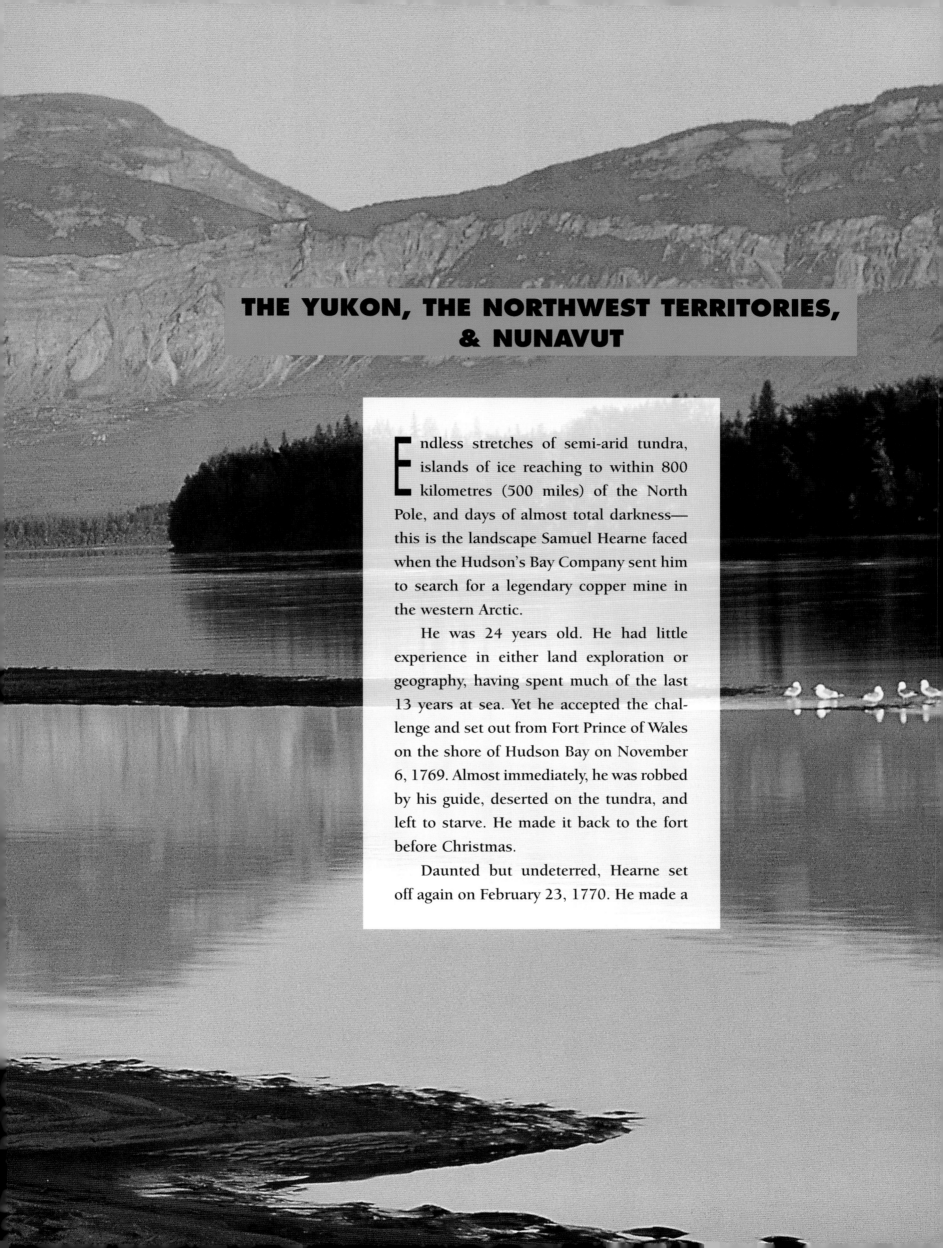

THE YUKON, THE NORTHWEST TERRITORIES, & NUNAVUT

Endless stretches of semi-arid tundra, islands of ice reaching to within 800 kilometres (500 miles) of the North Pole, and days of almost total darkness— this is the landscape Samuel Hearne faced when the Hudson's Bay Company sent him to search for a legendary copper mine in the western Arctic.

He was 24 years old. He had little experience in either land exploration or geography, having spent much of the last 13 years at sea. Yet he accepted the challenge and set out from Fort Prince of Wales on the shore of Hudson Bay on November 6, 1769. Almost immediately, he was robbed by his guide, deserted on the tundra, and left to starve. He made it back to the fort before Christmas.

Daunted but undeterred, Hearne set off again on February 23, 1770. He made a

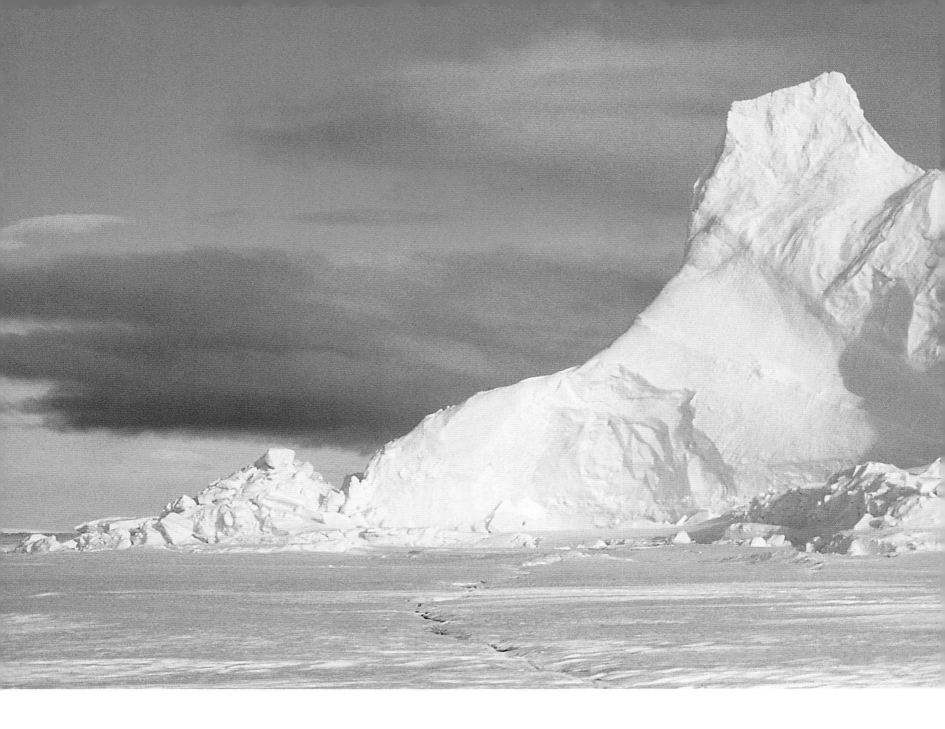

better start on his second mission, but within six months he was again alone on the tundra without food or shelter. This time, he was rescued by a Chipewyan man, Matonabbee, who guided him back to the fort.

Amazingly, Hearne made a third attempt. In December 1770, he and Matonabbee followed the treeline west. In April, they veered north onto the tundra towards the Coppermine River. Eventually, they found the mines — a collection of rocks holding only minuscule amounts of ore. Nonetheless, Hearne successfully claimed the land for the Hudson's Bay Company. He returned to Fort Prince of Wales on June 30, 1772.

His story is one of astounding dedication and perseverance, and one that highlights the unique challenges of life in Canada's northern territories. Today, much of the land Hearne travelled through is the territory of Nunavut, established on April 1, 1999. Home to 27,219 people, including about 70 percent of Canada's Inuit people, Nunavut encompasses 1,994,000 square kilometres (770,000 square miles). Its northernmost communities face winters of 24-hour darkness and bone-chilling cold.

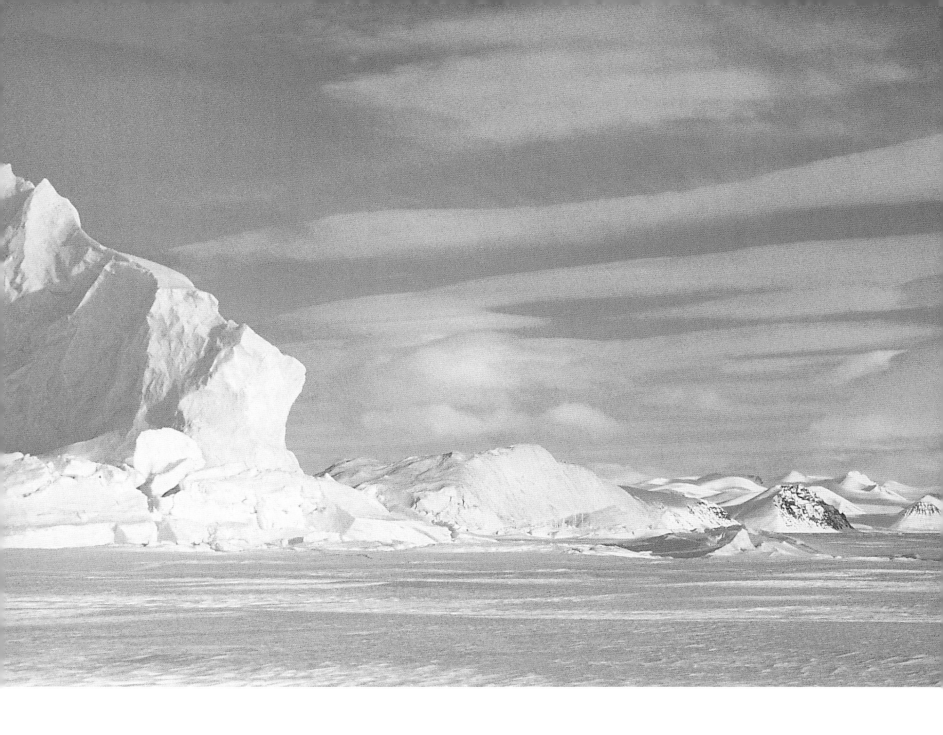

The Northwest Territories endures a similar climate and the territory is made up of vast expanses of barren tundra like that faced by Hearne. Yet, like Nunavut, this region was home to people 40,000 years ago, and the Inuit have thrived here for 4000 to 8000 years. Vast herds of caribou wander the tundra, along with bears, bison, and small mammal and bird species.

The Yukon is the smallest of the territories, with only about five percent of Canada's total land area. Only the Atlantic provinces are smaller. Yet the Yukon makes up for its size with dramatic sights such as those of Kluane Park, where Mount Logan reaches 5959 metres (19,550 feet) above sea level and the world's largest non-polar icefields extend through the range.

In some ways, a journey through the northern territories today is not unlike the ventures of Samuel Hearne. The rich cultures of the First Nations, the otherwordly landscapes, and the harsh climate remain, and make these regions unlike anywhere else in the world.

ABOVE: An iceberg trapped in sea ice glistens off the northern coast of Baffin Island, in Sirmilik National Park. The park's name means "Place of Glaciers."

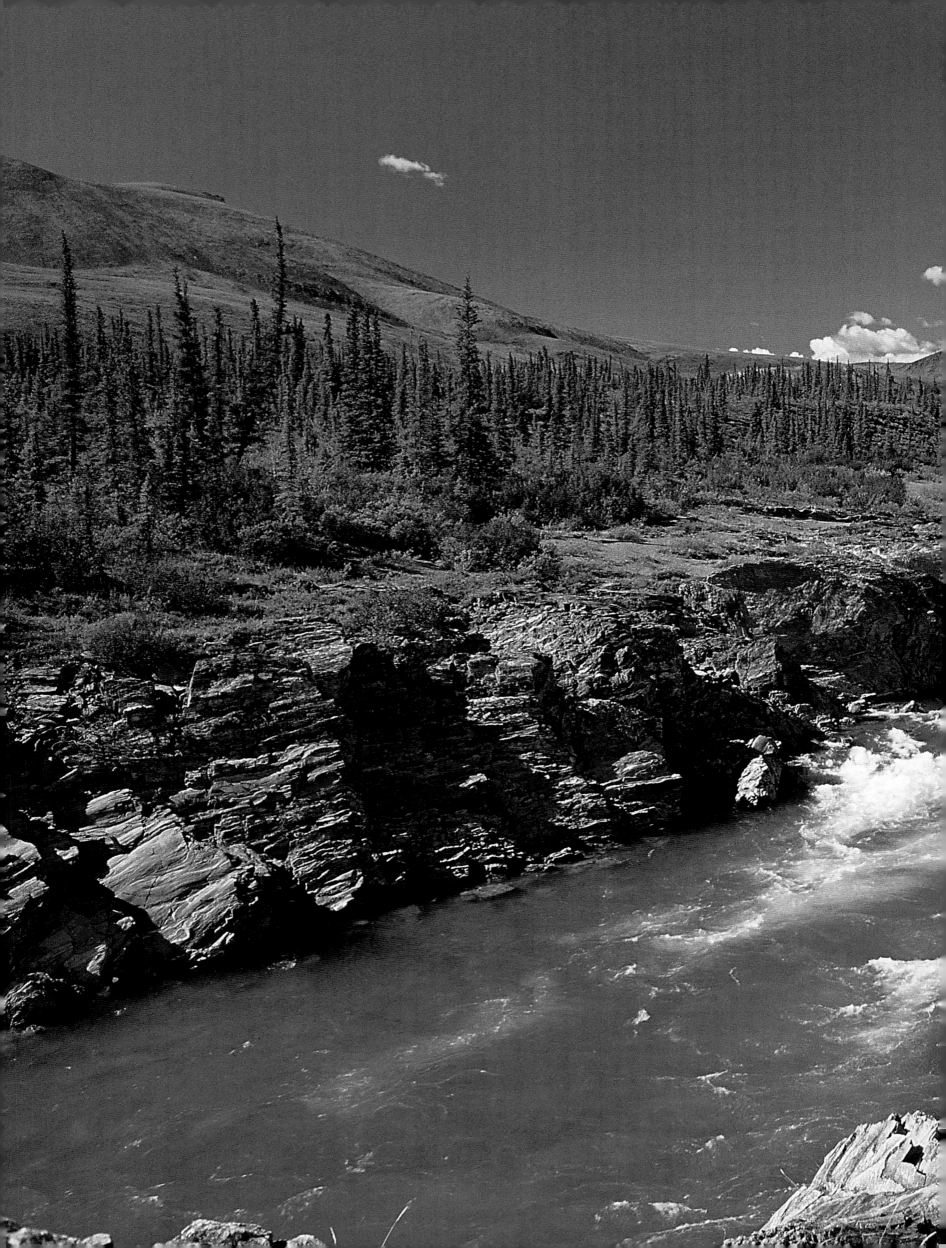

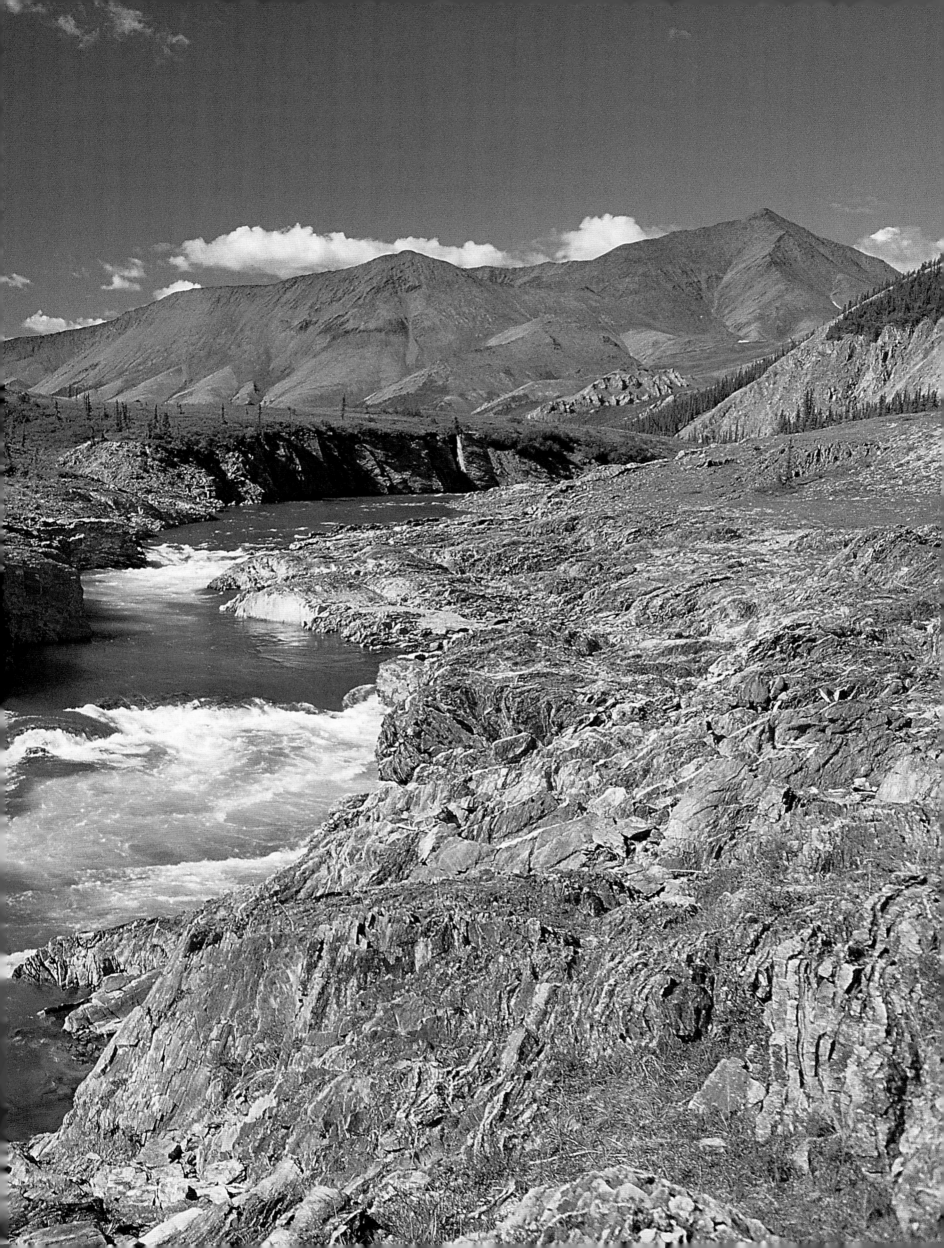

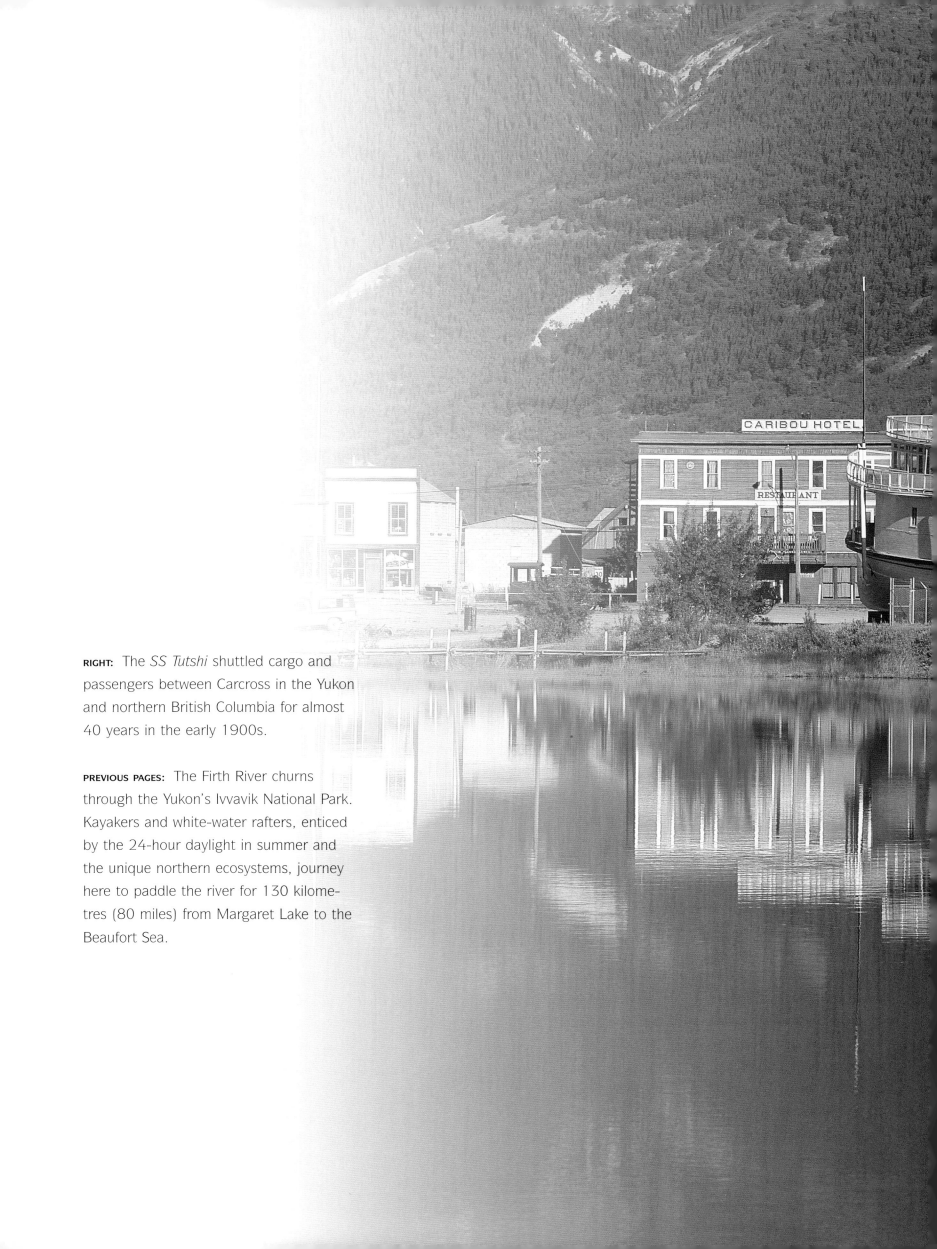

RIGHT: The *SS Tutshi* shuttled cargo and passengers between Carcross in the Yukon and northern British Columbia for almost 40 years in the early 1900s.

PREVIOUS PAGES: The Firth River churns through the Yukon's Ivvavik National Park. Kayakers and white-water rafters, enticed by the 24-hour daylight in summer and the unique northern ecosystems, journey here to paddle the river for 130 kilometres (80 miles) from Margaret Lake to the Beaufort Sea.

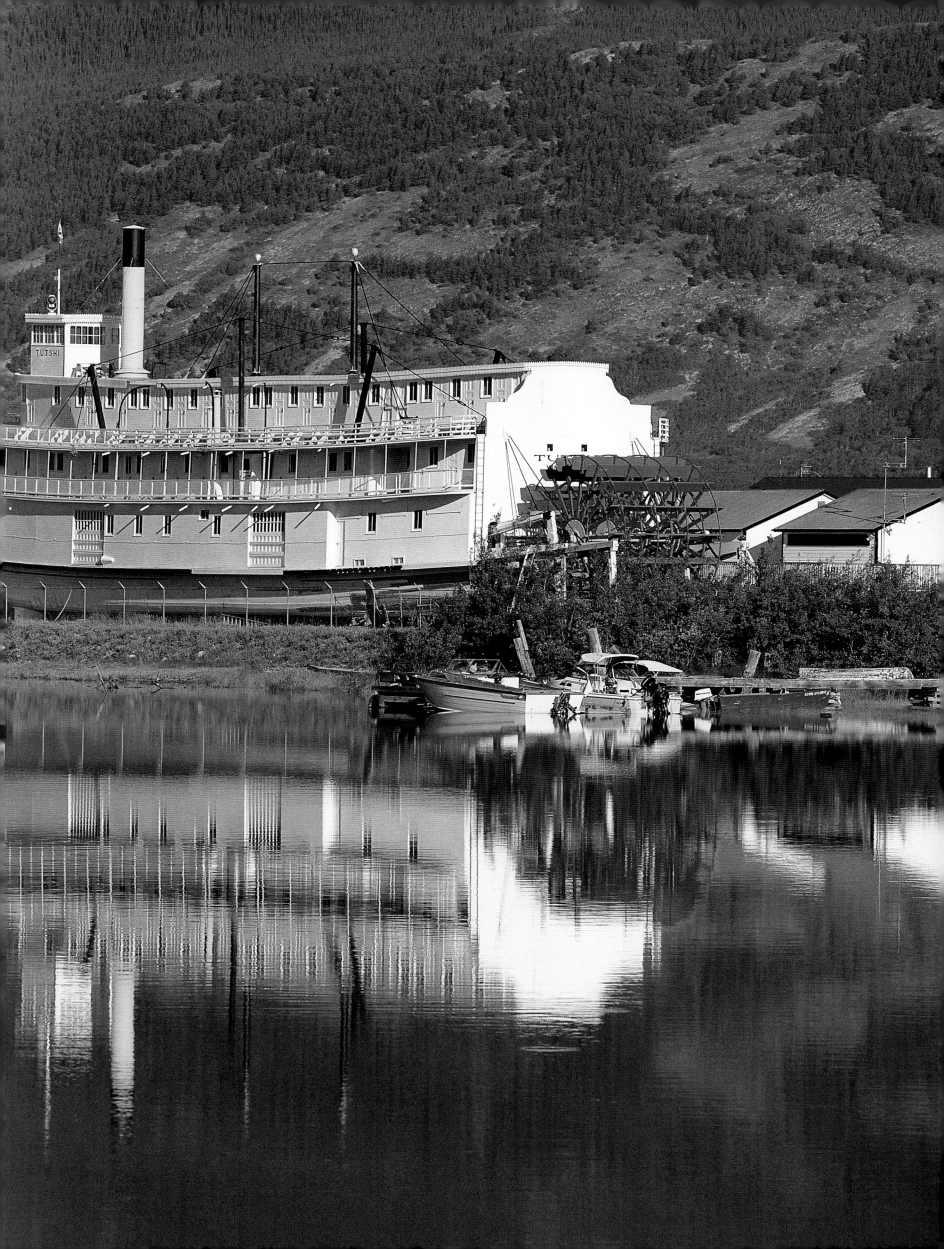

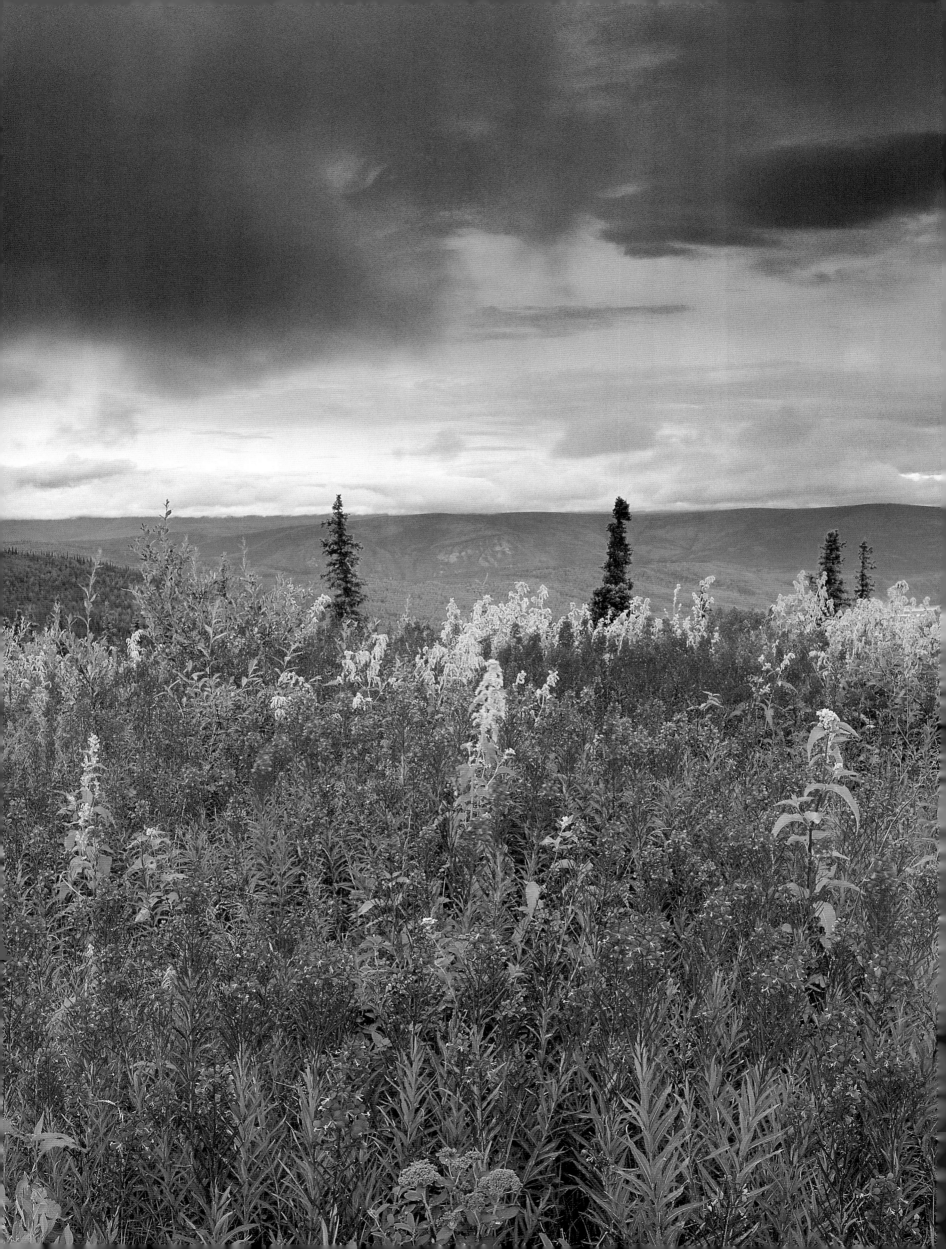

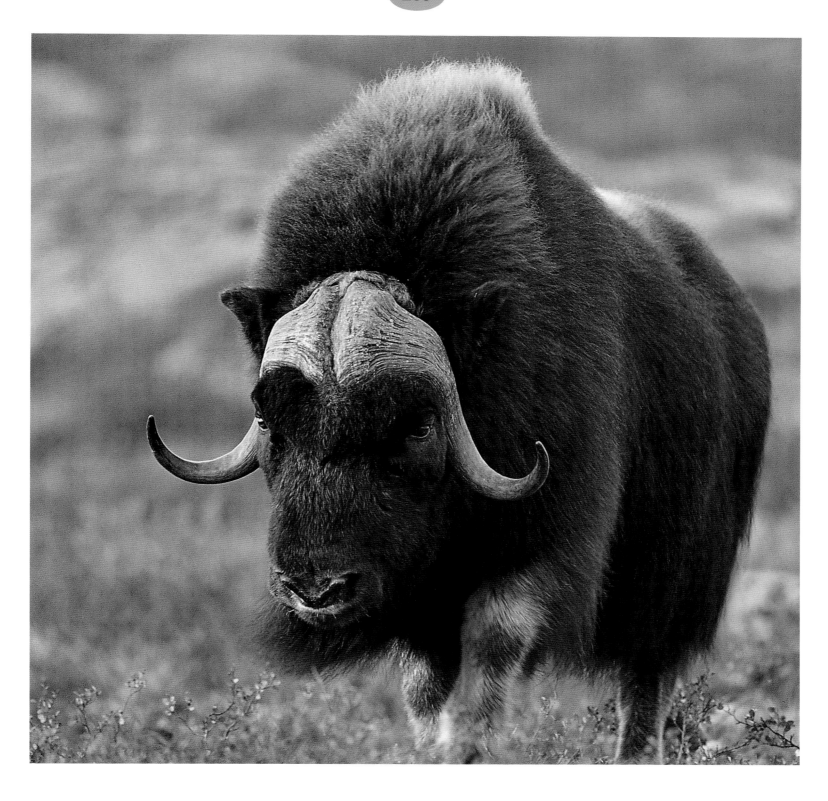

LEFT: More than 300,000 visitors explore the Yukon each year, touring Dawson City, driving the Top of the World Highway, or hiking through the towering British Mountains. These visitors contribute about $124 million to the local economy, making tourism the largest non-government source of employment.

ABOVE: Beneath its long, shaggy outer coat, a muskox has soft hairs called *qiviut*. A dense layer of these hairs traps warmth next to the animal's skin and allows it to survive harsh winters in the Northwest Territories.

OVERLEAF: Most common in spring and fall, the aurora borealis — northern lights — sweep across the sky in patterns of green, blue, rose, yellow, and crimson. The effects are caused when solar winds meet the earth's magnetic field above the North Pole.

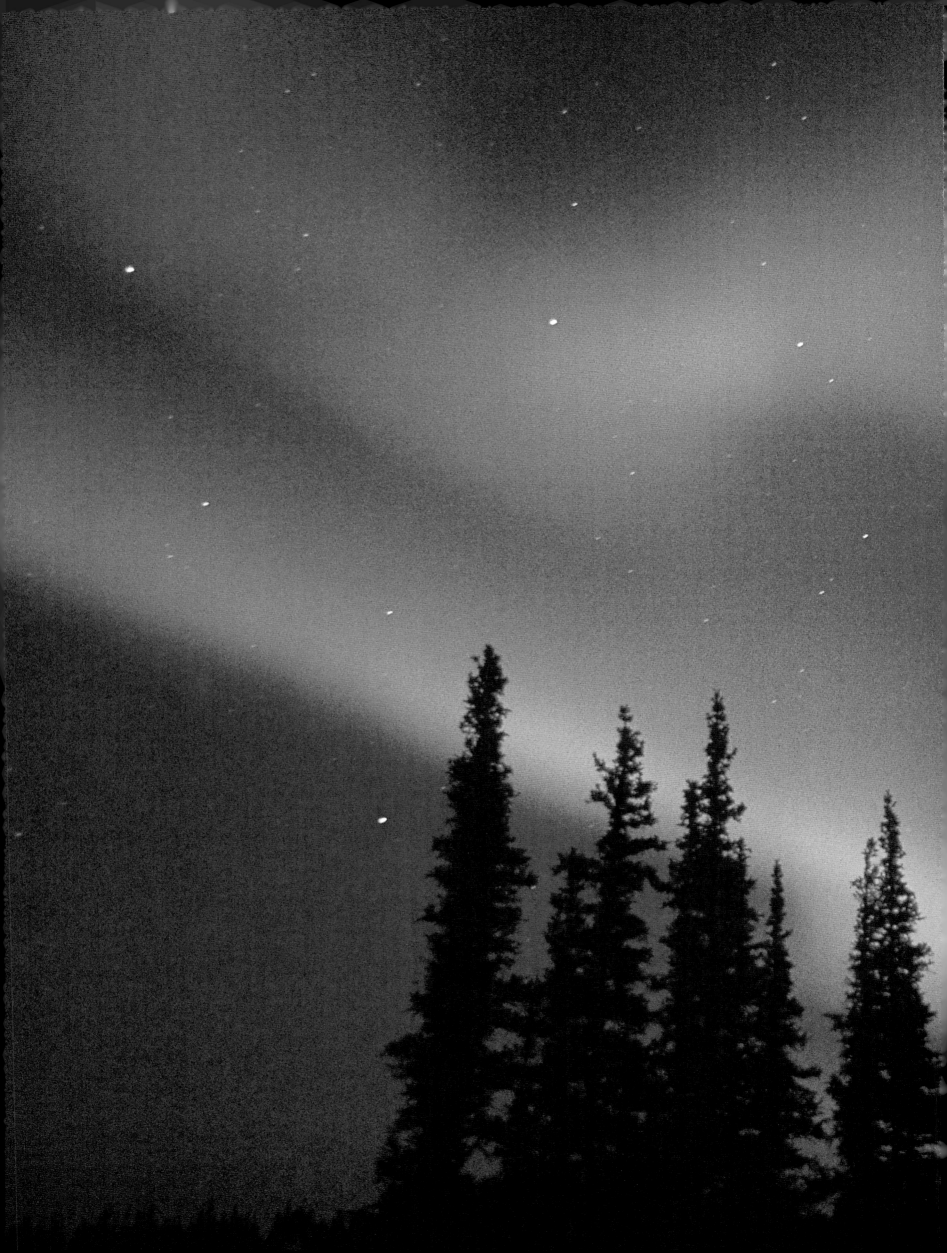

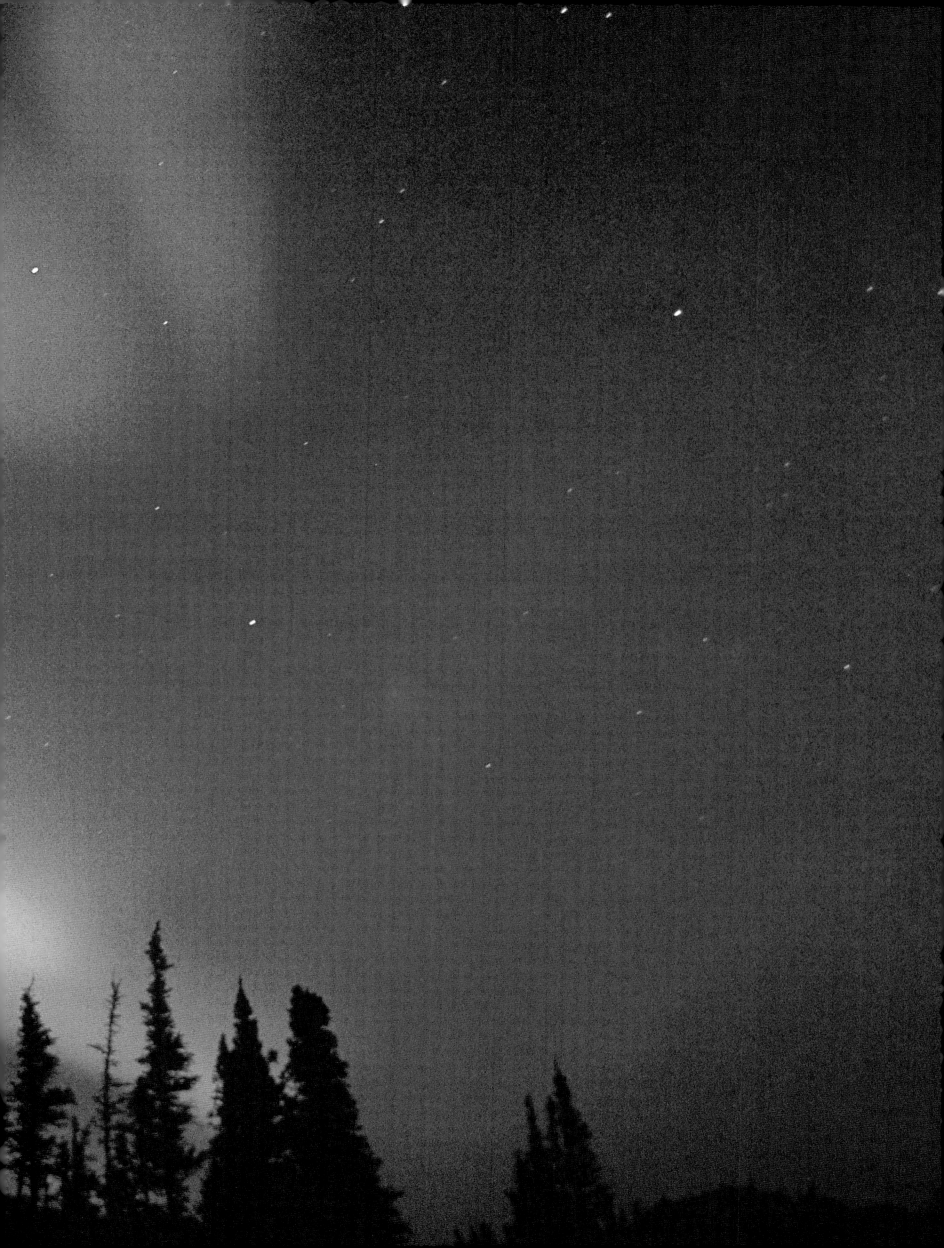

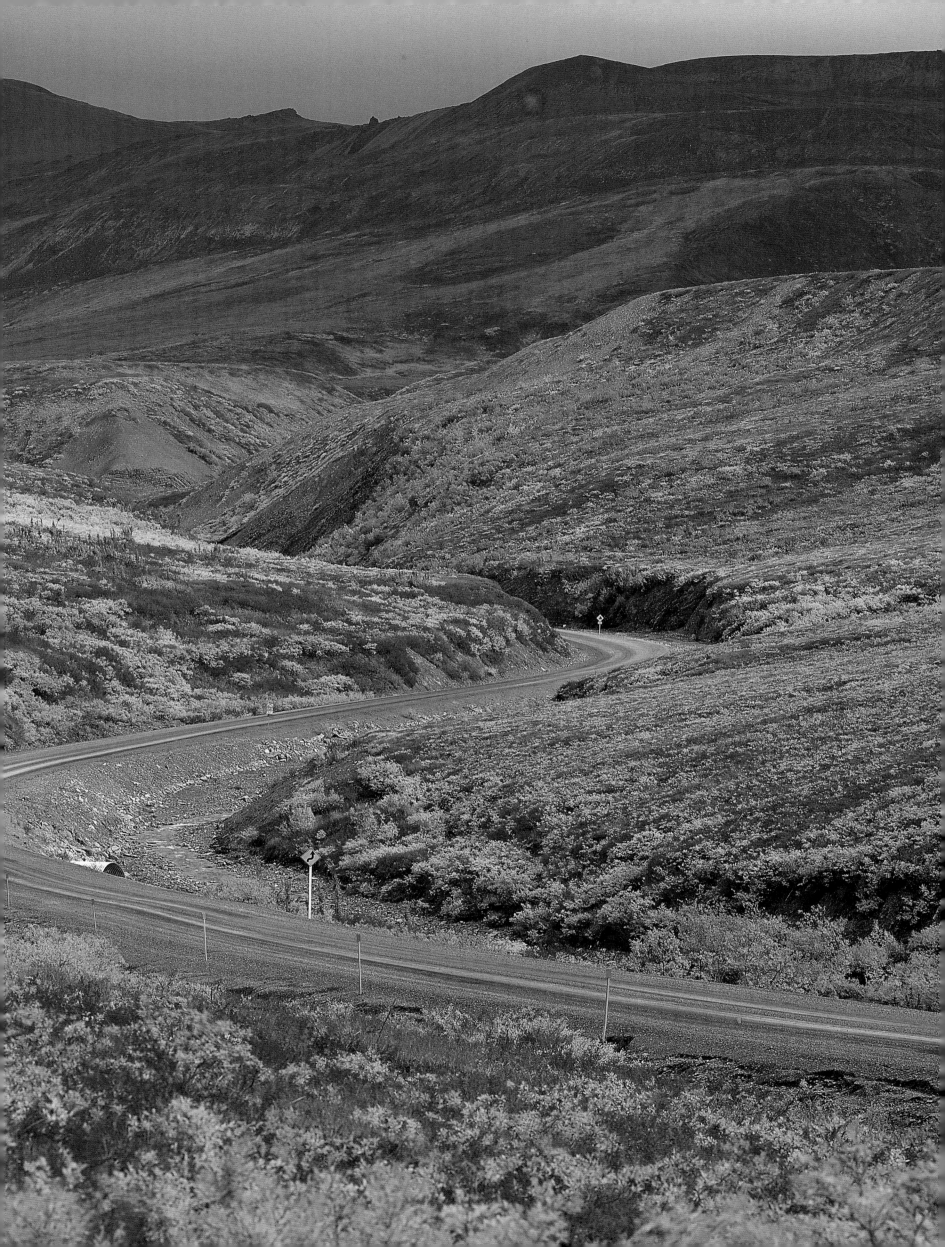

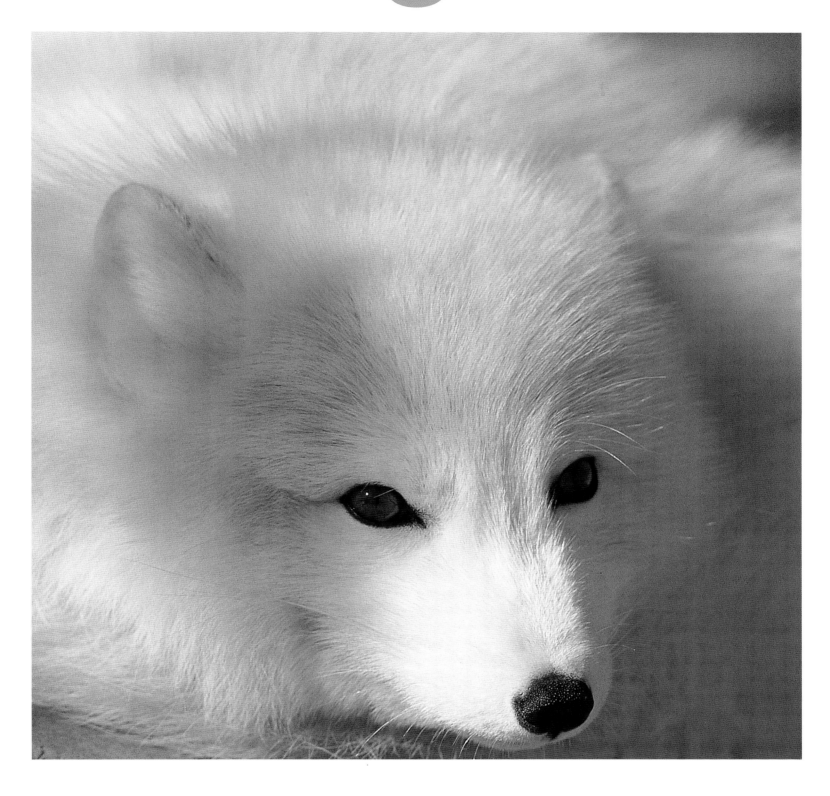

LEFT: The only public road to cross the Arctic Circle, the Dempster Highway winds from the Yukon to the Northwest Territories. It is named for Corporal Dempster, the North-West Mounted Police officer who found the bodies of "the lost patrol," a team of four officers who died attempting the journey from Fort McPherson, Northwest Territories, to Dawson City.

ABOVE: An Arctic fox may eat up to a thousand voles and lemmings in a single summer, then ferret out the animals from under the snow in the winter.

OVERLEAF: More than 350 kilometres (220 miles) north of Resolute Bay, Nunavut's Grise Fiord — population 130 — is Canada's northernmost community. Archeological evidence on Ellesmere Island suggests that people have lived here for more than 4000 years.

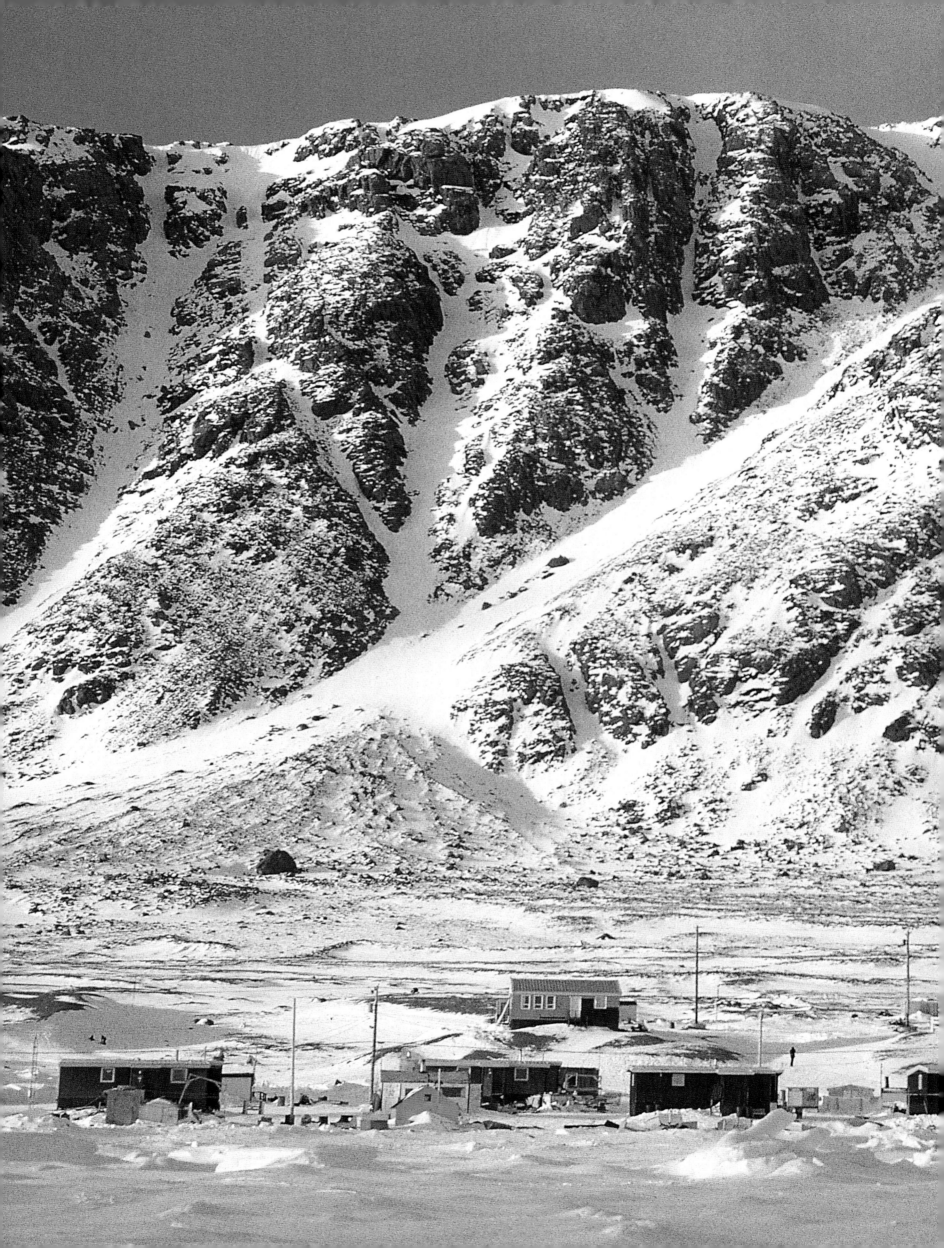

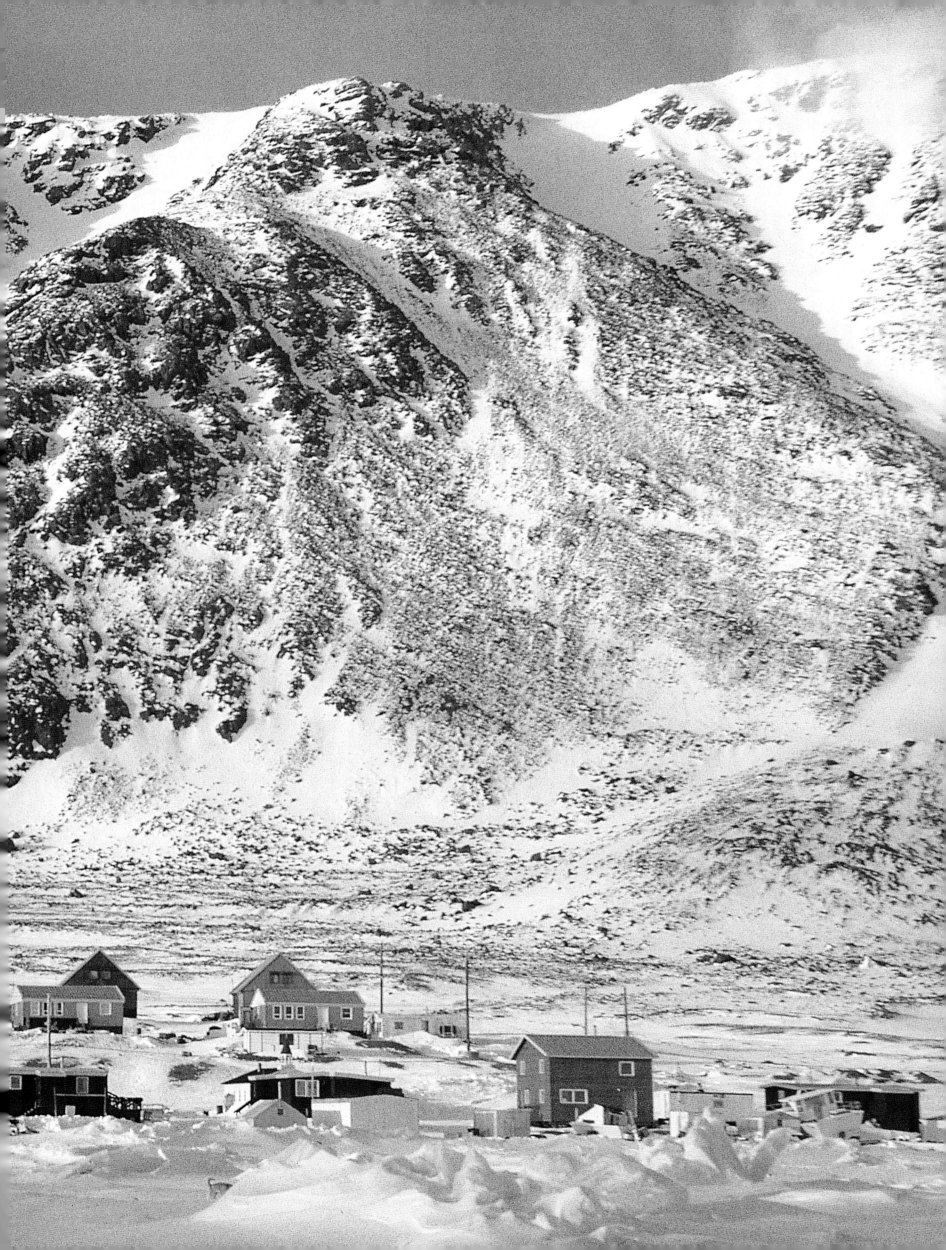

LEFT: The fifth-largest island in the world, Baffin Island lies on the eastern edge of Canada's Arctic archipelago, only 300 kilometres (190 miles) from the shores of Greenland.

OVERLEAF: Quttinirpaaq, or Ellesmere Island National Park, was established in 1988. Though only a tiny portion of Nunavut, the park encompasses 37,775 square kilometres (14,586 square miles), more than six times the area of Prince Edward Island. Glaciers have carved the island into deep valleys and fiords.

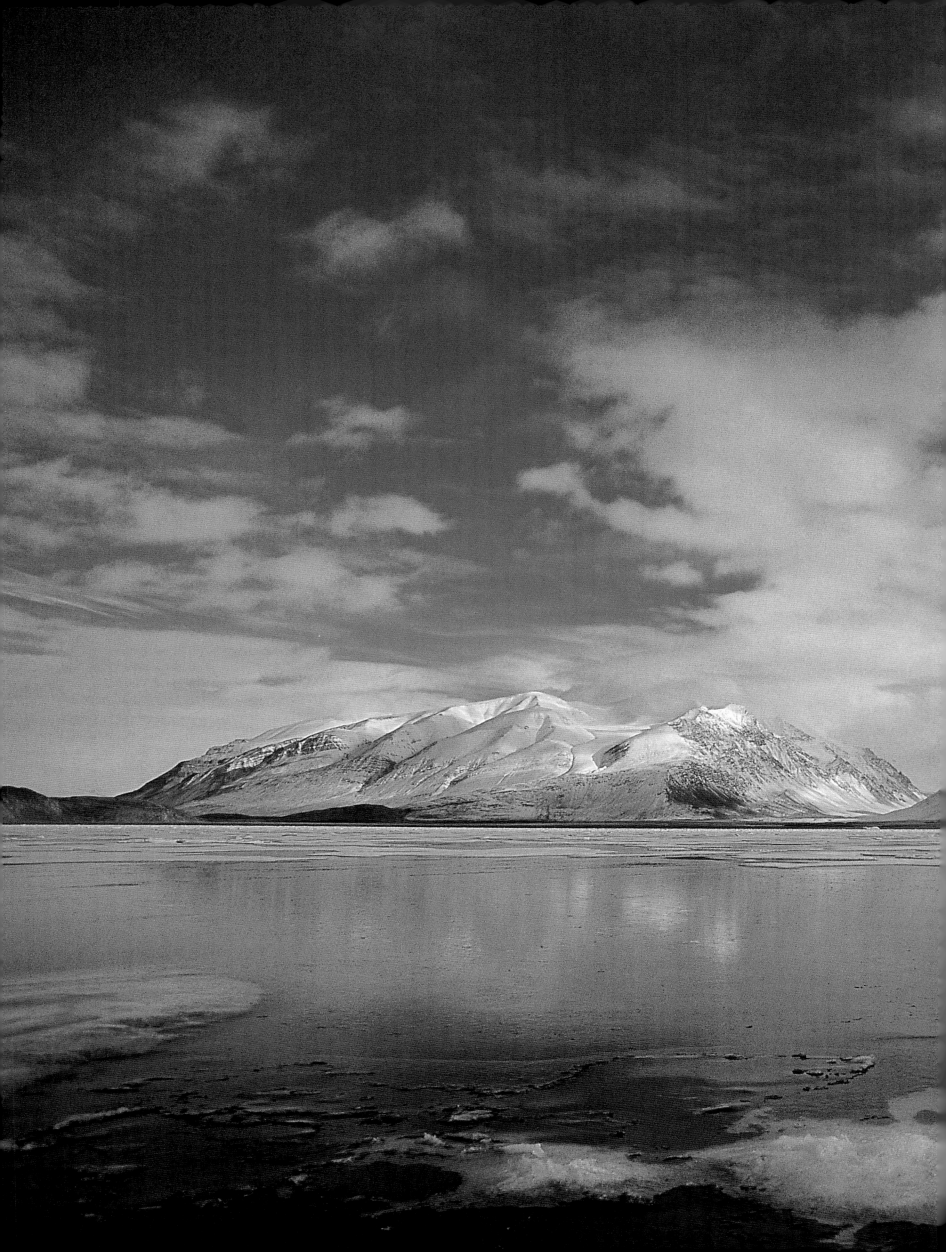

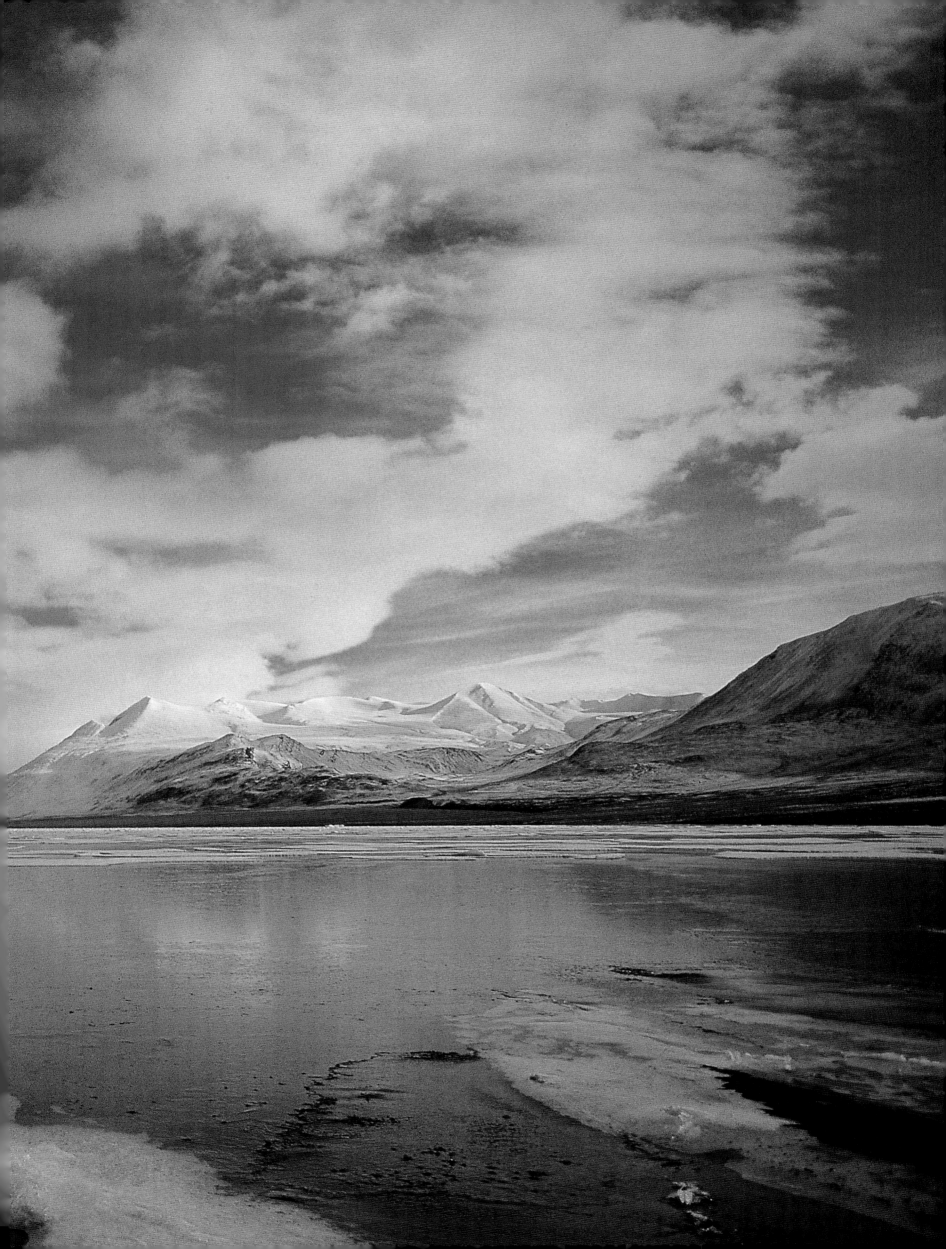

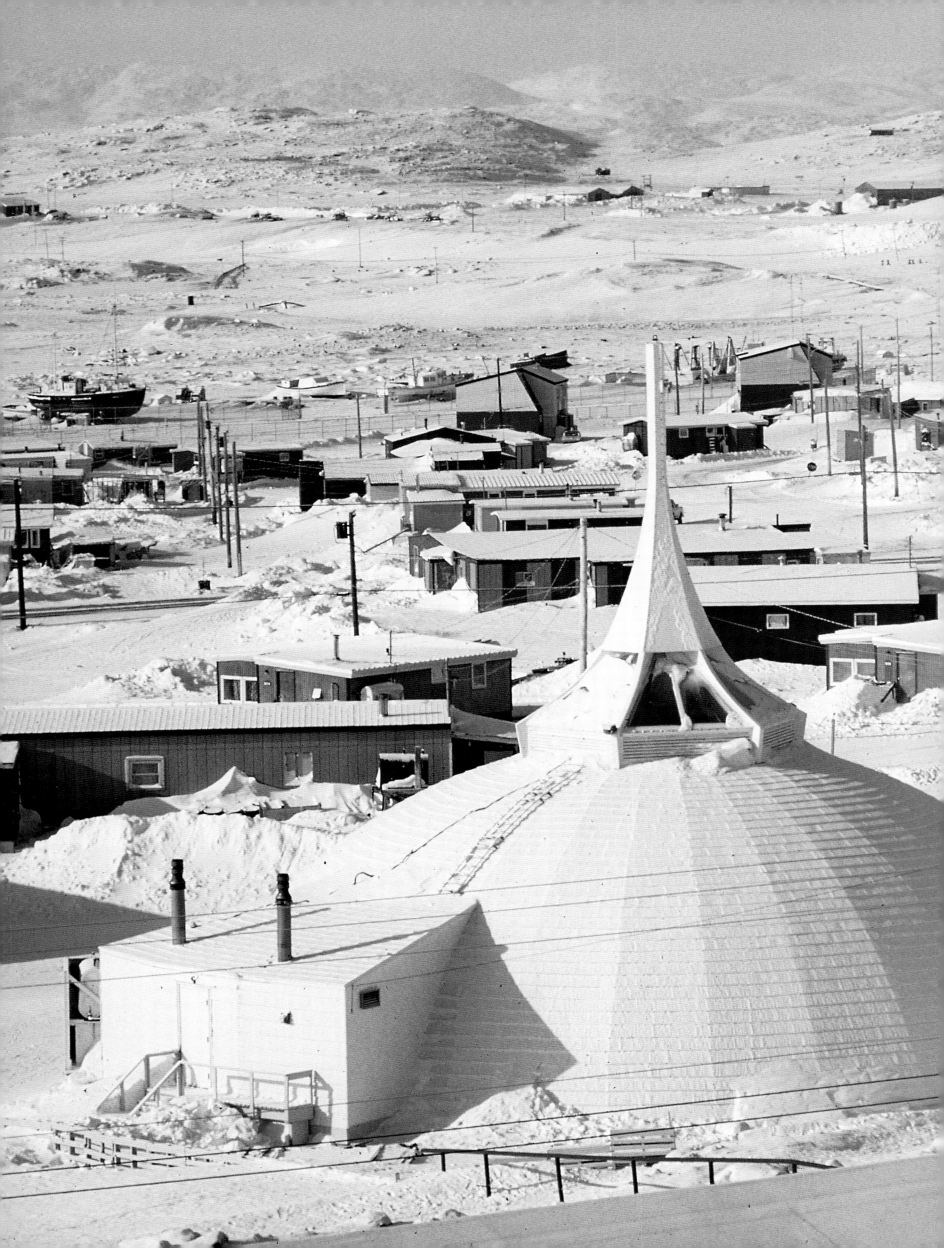

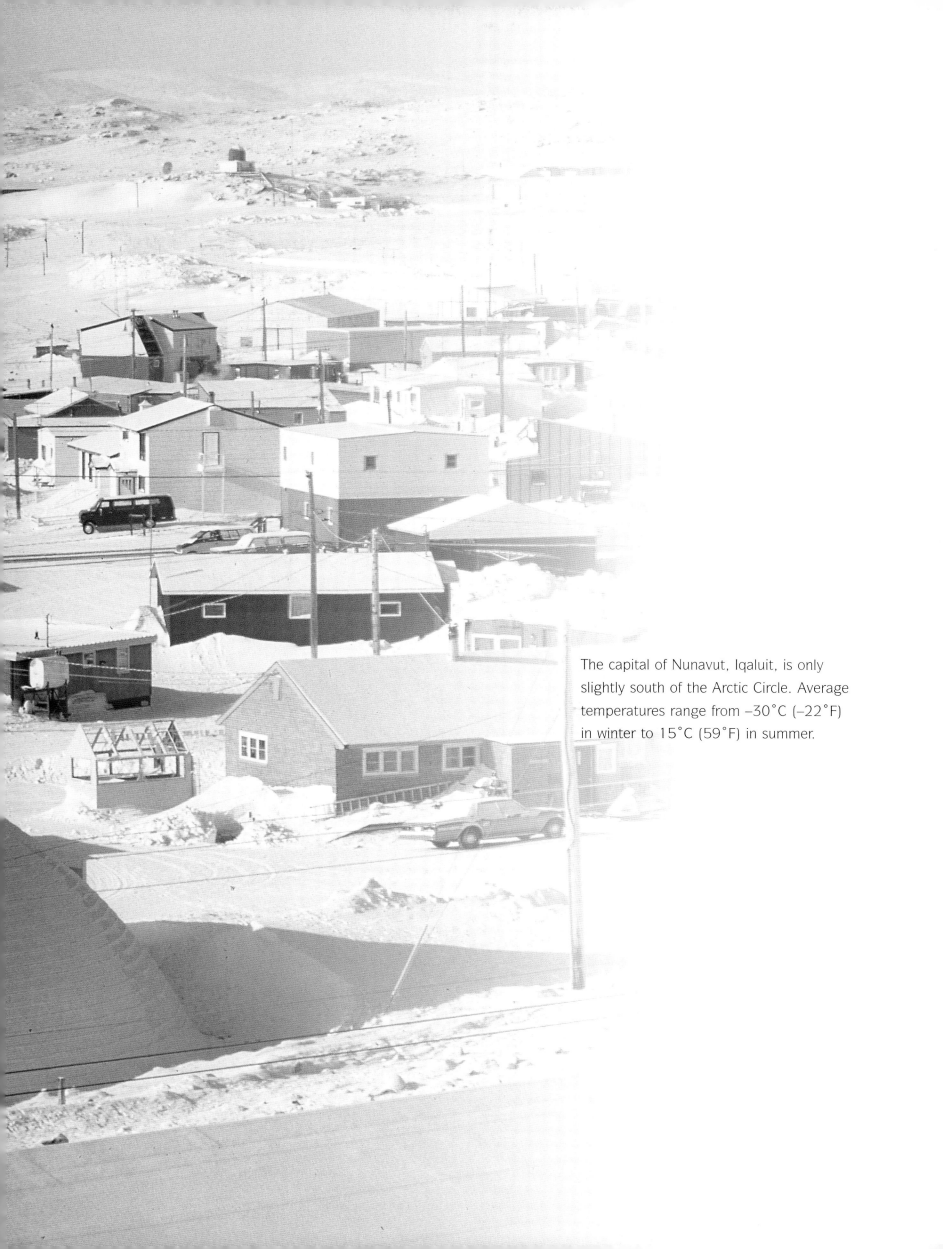

The capital of Nunavut, Iqaluit, is only slightly south of the Arctic Circle. Average temperatures range from −30˚C (−22˚F) in winter to 15˚C (59˚F) in summer.

I N D E X

P H O T O C R E D I T S

Jerry Kobalenko/First Light 1, 12-13, 138, 204-205, 222-223, 240-241

Darwin Wiggett 2, 10-11, 20, 22-23, 32, 40-41, 43, 56-57, 60, 68, 70-71, 72, 76-77, 82, 83, 86, 91, 108, 110-111, 117, 134, 156, 174-175, 178, 182, 184-185, 189, 192-193, 195, 202-203, 210, 216, 220, 234

John Sylvester/First Light 3, 168-169, 180-181, 183, 186, 190-191, 198-199, 201, 211, 212, 214-215

Ron Watts/First Light 4-5, 15, 16, 17, 160

Richard Hartmier/First Light 6-7, 33, 232-233, 238

Thomas Kitchin/First Light 8, 21, 54-55, 74-75, 80-81, 87, 114, 120, 121, 146-147, 154, 158-159, 172-173, 176, 177, 194, 196-197, 235

Trevor Bonderud/First Light 9, 30-31

Jürgen Vogt 14, 155, 161

Greg Griffith/First Light 18

Michael Kevin Daly/First Light 19

Mike Grandmaison 24, 90, 92-93, 101, 104, 106-107, 116, 118-119, 124, 125, 126-127, 131, 135, 139, 150, 162

Chris Harris/First Light 25

David Nunuk/First Light 26-27, 66-67

Darwin Wiggett/First Light 28-29, 36, 48-49, 62-63, 73, 78-79, 94-95, 130, 164-165, 167, 188, 218-219, 226-227

Steve Short/First Light 34-35

Victoria Hurst/First Light 42

Michael E. Burch 37, 44-45, 46-47, 50, 51, 58-59, 61, 69, 77, 143

Adam Gibbs 38-39, 52-53

Larry MacDougal/First Light 64, 65

Dave Reede/First Light 84-85, 96-97, 98-99, 100, 102-103, 105

A.E. Sirulnikoff/First Light 88

Alan Marsh/First Light 89, 115, 132-133, 140-141

Wayne Lynch 109, 228-229, 230-231, 239, 246-247

Brian Milne/First Light 122-123, 145

Mark Burnham/First Light 112-113, 128-129

D. & J. Heaton/First Light 136-137

Ken Straiton/First Light 142, 163, 187, 206, 207, 208-209

Chris Cheadle/First Light 144, 153

Jean B. Heguy/First Light 148-149, 157

Jessie Parker/First Light 151

Bernd Fuchs/First Light 152

Irwin R. Barrett/First Light 170-171

N. Wheeler/First Light 217

G. Petersen/First Light 221, 224

B. & C. Alexander/First Light 225, 248

R. Semeniuk/First Light 242-243